MW00781702

Things That Move

Things That Move
A Hinterland in Architectural History

Tim Anstey

THE MIT PRESS
Cambridge, Massachusetts . London, England

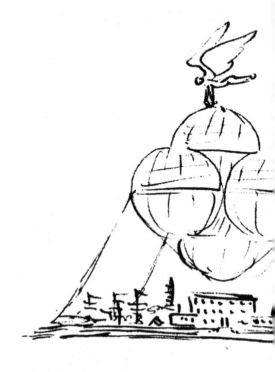

Sicilien

Carl August Ehrensvärd. Project to move Stockholm from Sweden to Sicily, ca. 1780.
Private collection.

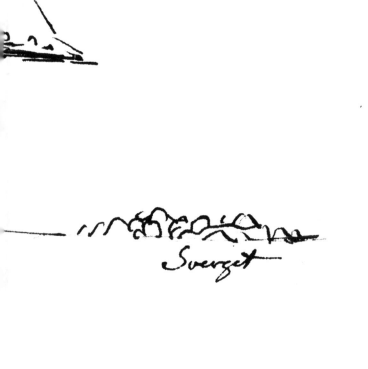

Sverget

For Disa, Edgar, and Noah
For Peter, Janet, and Jo

Introduction: Cinnabar and Quicksilver

In the preface to the 1999 English translation of *De architectura*, that great treatise on building by the Roman author Vitruvius which the modern world inherited from antiquity, there stands a revealing sentence. "Any successful attempt to interpret Vitruvius must deal with the most salient feature of the *Ten Books*: that over half the material does not deal with architecture per se, but with other, supposedly supportive, fields of knowledge."[1]

Just what is architecture per se? On whose terms is it predicated? What fields of knowledge lie outside and inside it? And why, for Vitruvius's millennial commentators, did half of his treatise deal with other (supposedly) supportive matters? These questions overlap and usefully introduce the broad themes of this book. The chapters presented in the following pages all return to the question of what architecture is. And in most cases, they suggest that to produce an account of architecture and its history we must go beyond our assumptions of what such a text might consider. This introduction maps out that terrain and advertises the preoccupations of the individual chapters. All of them entail issues of the fluid, of the unstable, or the out of place; all of them return to questions of translation, of removal or relocation; of reclassification or repositioning. In *Things That Move* I argue that we cannot—we should not—construct an account of architecture predicated only on how things stay still.

The earliest extant copy of Vitruvius is kept at the British Library in London, next door to St. Pancras railway station where Eurostar trains still deliver Europe into England. Copied in Aachen at the court scriptorium of the emperor Charlemagne during the ninth century, it traveled first to the monastery of St. Pantaleon in Cologne, then to Utrecht in Holland and Düsseldorf in Germany, and was finally netted as part of a collection established by Robert and Edward Harley in the early eighteenth century.[2] In 1753 this collection became a foundational acquisition for the British Museum Library, and since then the manuscript has been known as Harley 2767.[3] Thanks to enlightened patronage and the internet, anyone can access it online. To try to understand the perplexity of

Vitruvius's recent interpreters—and to introduce much of the thematic content treated in the following chapters—we might start from this copy of the treatise. It contains 322 blocks of Carolingian script written out on 164 parchment folios, each section of text covering a rectangle about 210 × 145 mm (slightly smaller than the page you are looking at now). There are two nontextual figures in the manuscript: a diagram of the winds on f.16v (in the margin of page 33 of the text) and another of a cross on f.145r (occupying one of the two pages in the manuscript not covered by the copyist's markings). The ten books that treat the broad subject divisions of Vitruvius's enquiry into architecture occupy varying numbers of folios.[4] The boundaries between them are signaled by slightly enlarged lines of title script drawn in red ink, with a paragraph break and in some cases a line break between, but no other graphic separation. Visually, the text sits as a continuous plane, with minimal interruptions except the movement between folios as you turn a page and a vermillion-red "thanks be to God, Amen" as each book is successfully concluded.

One section in the text that is marked off corresponds to that which modern editions define as chapter III of book I, "The Departments of Architecture."[5] In the British Library manuscript the title of this excerpt (in red vermillion ink) reads "VI *De partibus architecturae*."[6] Its first sentence marks the beginning of a possible perturbation about the width of Vitruvius's definition of architecture: "*Partes ipsius architecturae sunt tres, aedificatio, gnomonice, machinatio.*"[7] The parts of architecture, that is to say, are three: *aedificatio*, *gnomonice*, and *machinatio*. What are these parts? *Aedificatio* might be described as the process of bringing materials into positions of rest in order to create buildings, streets, and cities, an endeavor that English translations have often called the "art of building."[8] *Gnomonice* relates the geometric projection of shadows cast by the sun to the measurement of time and the definition of orientation. It concerns the "making of timepieces" not as mechanical contraptions but through the construction of "shadow-trackers," spatial assemblies that convert movements in the heavens to tabulated predictions on the ground.[9] As such it has a strong alignment with the wider studies of astronomy and cosmology, and it is beholden to the cyclical nature of the world. *Machinatio* has been translated as the "construction of machinery."[10] It might concern the movement of materials using mechanical inventions, or the behavior of objects cast into flight by catapults, or indeed the alluvial behavior

of rivers and hydraulic systems. But *machinatio* has also a strong prevailing connection with notions of machination, the predicting and artificial creation of effects, often at a distance, at particular places through time.[11]

From a certain perspective *gnomonice* and *machinatio* seem mysterious addendums to a definition of what architecture might include. Architecture is about buildings, about streets, cities, and their construction; about edifying—*aedificatio*—not shadow-tracking or the interrelationship of machination and effect. In terms of its title, the first treatise of what became modern architectural theory reflected this limitation: Leon Battista Alberti, writing on architecture in the fifteenth century, offered his readers a study of *De re aedificatoria*.[12] In this adaptation, Vitruvius's concern with *aedificatio* was visible; his interests in *gnomonice* and *machinatio* were not. The intellectual tradition that evolved from this treatise also tended to equate *aedificatio* with architecture. Italian and English translations of Alberti produced a translational identity between his title and that of Vitruvius: Cosimo Bartoli gave the world *Della architettura di Leon Battista Alberti* in 1550; Alberti's were *Ten Books of Architecture* in the 1726 English Leoni translation.[13]

The reading that aligns architecture with *aedificatio*—and which is perhaps reflected in Thomas Noble Howe's comment about extraneous content and "architecture per se"—relies in turn on a series of parameters that can be met by *aedificatio* but not by the other "parts" suggested by Vitruvius. On one side, *aedificatio* has focus. It speaks about a limited and not a general set of problems. It is a synthetic category under which empirical evidence from a variety of scientific, historical, and philosophical contexts can be focused, can be woven together to solve singular problems. *Gnomonice* and *machinatio*, on the other hand, with their close links to astronomy, metaphysics, and mathematics, appear more generic: they are component parts of that empirical material that *aedificatio* combines. At the same time, *aedificatio* has an evident political and moral component: it produces the conditions for habitation, projects ideas about how lives should be lived, and inscribes specific codes of social behavior. None of these characteristics can really be claimed by *gnomonice* or *machinatio*. Most of all, *aedificatio* appears to embrace a notion of destination, of permanency, that *gnomonice* and *machinatio* purposefully avoid. If the endeavor of *aedificatio* is to produce unique, immobile, built arrangements that endure through time, *gnomonice* and *machinatio* embrace infinite variety,

endless possibilities of recombination, continuous translation. If *aedificatio* is witness to the importance of stasis, *gnomonice* and *machinatio* attest the significance of fluidity and of the temporal.

Somehow, this understanding that architecture finds its core in *aedificatio* continues to dominate. The whole business of how things move about; the notion that they might not stay where we put them; that there might be a lot of trouble involved in getting them there—all these matters have traditionally been difficult for architecture as *aedificatio* to contemplate. To be architectural, implies, at one level, to be stationary. An architect's proper task in this reading is to define all the lines and angles that say where things should be put in order to edify. As studies about the architectural theory of the early Renaissance show, this was the engine of concern that drove the development of architectural representation.[14] This is what we define as architectural. Questions about how things arrive in those positions—those are instinctively thought of as pertaining to another mode of enquiry.

What if, for a moment, we were to turn around the self-defined problem that confronts contemporary interpreters of Vitruvius? What if, instead of observing how much of his text does not concern architecture per se, we were instead to ask, "What kind of architectural body is Vitruvius describing, when its parts can be said to consist of edifying, shadow-tracking, and machinating?" What if we were to suggest that in any exclusive identity between *aedificatio* and architecture something is lost in translation? To argue that the very translative aspects of *gnomonice* and *machinatio* are fundamental to, not supportive of, a definition of the architectural? What would happen if we tried to trace a course through history that followed the architectural significance of all these gerunds? In the most basic terms, these are my aims and ambitions in this book. Before explaining how such a history might be constructed, and before investigating some of the theoretical preoccupations such a history might have, I need to reflect a little further on these questions at source, to suggest some of the contours of the architectural body one might define out of reading Vitruvius's *De architectura* with these predilections.

If you look at page count in relation to the subject headings of Vitruvius's *Ten Books* you find that a little over a quarter of *De*

Introduction

architectura concerns itself with definitions and discussions of principle (books I to III, which occupy the first 47 folios of Harley 2767).[15] These books contain the prerequisites, one might say, for a discussion of architecture in Vitruvian terms. The themes here are the education of the architect together with issues of site, climate, and the layout of the city (book I); the mundane methods of construction architects use and the materials they employ, discussed in the context of the fundamental profane building type, the dwelling (book II); and the divine principles of proportion that guide architectural work, discussed in relation to the temple and focused on the physiognomy of the column (book III). Three short books (IV to VI) occupy the subsequent 43 folios of the British Library manuscript. They provide recommendations about creating particular building types, once you have taken your education, thought about site and climate, picked a location, absorbed the rules of construction, and understood proportion. Book IV provides histories of the "orders" of architecture—its decorative languages from Doric to Corinthian—and instructions defining the layout of various kinds of temples; book V deals with public buildings including the forum, theater, and baths; book VI concerns private dwellings and their adaptation to various places and societal contexts. Here the text shows how to define the superficies of projected constructions, the "edges" of built works, from their foundations to their tympana: the number of columns in a temple; their proportion, the exact details of their outline, and so forth. These recommendations are frequently communicated via numerical recipes that define curves, distances, locations.

Together these first sections of *De architectura*, particularly books II to VI, provide an account that overlaps rather precisely the notion of *aedificatio*. The emphasis is on the fixed nature of architecture; on its duty to predict permanent position for building elements (and, in an important extrapolation, for the societal status of building occupants); on its potential to predicate arrangement and proportion according to static rules; on pinning down the fluidity and temporal nature of the free-flowing world, giving it order and enduring pattern. This first section of Vitruvius's treatise is a hymn to stasis; to the importance of identifying the rules that place things appropriately and permanently. But this description of architecture in terms of the creation of built works, of *aedificatio*, also predicts the necessity of *gnomonice* and *machinatio* to its process. The emphasis begins already in the introductory book of the

treatise. The model city that the architect lays out in book I (the section defined as chapter VI in modern translations and titled *XI De divisione operum quae intra muros sunt . . .* in the British Library manuscript) must contain at its center an absolutely level platform and, at the center of that platform, a gnomon, or shadow-tracker, from which time and direction can be ascertained: *Gnomonice* is central to setting up the orientation of streets.[16] *Machinatio* also looms large in this description. The walls that surround the city, discussed in chapter V in modern translations and under the heading *X De fundamentis murorum et turrium constitutionibus* in Harley 2767, must deal with the demands of movement and force implicit in *machinatio*.[17] Walls must resist battering rams; their earthworks must be set like "teeth in a saw," so that "the enormous burden of the earth will be distributed in small bodies."[18] Indeed, *machinatio* casts its shadow even over considerations of a city's site. The discussion of city walls is preceded by the question of what to do when it becomes evident that a whole city is sited on inhospitable ground. *De municio de loco in locii translato*, reads the vermillion text of the subheading for this section in Harley 2767.[19] If the predictions of augury fail to a ensure a healthy location and a city is mis-sited, it must be physically translated to a better location. Skills of machination may be demanded of an architect in this, the most literal sense, to ensure health and propriety.

Movement is already implicit in these first sections of Vitruvius, which describe architecture in terms of that which stays still. The rest of the text describes, in very great detail, a set of problems that are concerned specifically with motion and the relation between the static and the temporal. Here the navigation of fluid conditions, the calculation of time and the motif of translation dominate. Book VIII concerns water, the cycles that produce it, how to lead it from one place to another; book XI unravels the movements of the heavens, planetary orbits, and specifically the issue of dividing time and the art of *gnomonice*; book X concerns the movement of objects, from building materials to ballistic missiles; it outlines the principles of machines and engines for constructing and destroying cities, outlining the central significance of *machinatio*.

So the shape of Vitruvius, read in terms of an equivalent significance for *aedificatio*, *gnomonice*, and *machinatio*, is of an introductory discussion of prerequisites (education, siting, and principle) in book I; a description of architecture as that which gives enduring

position both to materials and to the humans that inhabit cities and buildings in books II to VI; and a description of architecture as dealing with movement—of courses of water; of the stars, sun, and planets; and of projectiles and objects—in books VIII to X. Notably the books that describe architecture's role in creating permanent placement (books II to VI) and the books that describe its mastery in controlling movement (books VIII to X) occupy rather less than a half versus slightly more than a third of the entire treatise (71 and 53 folios out of 164).

If Vitruvius's story moves from a consideration of the fixed to a rumination on the fluid, how does it navigate the transition between these two conditions, which seem to be exact opposites? Book VII of *De architectura* is sandwiched between the discussion of projected form, permanency, and propriety contained in books II to VI and the account of movement, temporality, and translation contained in books VIII to X. Its introduction, which serves as a kind of literature review of the sources that have enabled Vitruvius to discourse authoritatively on *aedificatio*, maintains that his seventh book will concern the "finishing" (*de expolitionibus*) that architectural works require. Having defined the superficies that produce appropriateness in form, and having ensured that buildings are favorably sited and well founded, a special process is needed to cement all these disparate decisions in place. This completion is clearly central to architecture: it endows buildings with "beauty and durability" (*venustatem et firmitatem*).[20] Like the layers of painting, wet sanding, waxing, and polishing that produce the final surface on a perfect automobile, finishing in some sense creates the object, turning a building from a technical assemblage into an emotive whole. Finishing concerns primarily, although not exclusively, the internal surfaces of buildings, articulating the meeting between the body and eyes of an occupant and the interior environment that a building produces. And it includes both chemical and artisan processes; book VII contains not only recipes about the mix and application of materials to create surfaces but also a discussion of the proper figurative representation that may enliven them: "harbors, promontories, seashores, rivers, fountains, straits, fanes, groves, mountains, flocks, shepherds . . . figures of the gods or detailed mythological episodes."[21]

Vitruvius is very detailed about the material processes that take place during finishing. Typically they involve conglomerates that change their state with time. Concrete floors convert individual bricks or tiles into a jointless amalgam as they harden. Plaster, blended from lime, sand, and marble dust in various proportions and applied in repeated layers to walls, creates continuous, uninterrupted surfaces; vaulting work erects an armature in light construction—reeds and timber—and clads ceilings with a seamless casing of stucco. All these applications, in their material nature, occupy a problematic category that includes the fluid and fixed together. They require working methods that navigate a strange temporal and motivational caesura between a state of potential flow—these are materials that slump, drip, splatter—and a singular, pristine, fixed form. Percussion is part of working these materials ("Bring in your gangs," says Vitruvius in Morris Hicky Morgan's English translation, "and beat it again and again with wooden beetles"); so is the technique of floating—the almost magical process through which a slurry just firm enough to stick to a rough wall is smoothed out to produce a plane where the finest particles in the mix rise up to, and shine on, the surface.

Having explained with great precision the creation of these systems of continuous material support, Vitruvius describes in the final paragraphs of book VII the extraction and manufacture of the pigments and compounds that can be introduced into this process of smoothing and finishing to enliven surface with color and design. These are divided between natural pigments (ochres, chalks, orpiment) and manufactured compounds (black, blue, white lead, brown ochre, sandarac, verdigris, and purple). And in between these categories, finally, Vitruvius focuses on cinnabar and quicksilver in relation to the production of vermillion.

If book VII in its overall dimensions deals with those components of architecture that sit most naturally between the durable and the protean, between the static and the slippery, the account about cinnabar and quicksilver seems to complete this ontological circle. Where all the other material systems described here will predict a final condition of stasis out of an initial existence of wayward possibility, cinnabar upsets this order and reminds the reader that the relation between fluidity and repose can be bivalent. Concrete, stucco, and plaster set; surface layers of paint harden; but cinnabar and quicksilver are caught in an endless exchange between the solid and the liquid. "I shall now proceed

to explain the nature of cinnabar," Vitruvius writes. It is an ore "like iron, but rather of a reddish color and covered with red dust. During the digging it sheds, under the blows of the tools, tear after tear of quicksilver, which is at once gathered up by the diggers."[22] Here, then, is a rock that weeps when struck. Under its working, solidity produces fluidity. This constant trading between the solid and the volatile continues in Vitruvius's description of quicksilver, which runs on to a furnace floor or melts into air; which evaporates and recondenses as a liquid; which can catch gold out of ashes thrown into water but gives up its prize as it drains through a mesh.[23] This effervescent dimension characterizes as well the color pigment that the working of cinnabar produces. Burn cinnabar, extract its quicksilver, and you have vermillion, the best of reds. It is a color fit for the apartments of nobles, as Vitruvius notes, and was much used in fresco work with raw plaster (to dramatic effect in Pompeii among other places).[24] But its color is hard to keep. Sun and moon drain its virtue; used externally in peristyles or exedra, it must be shielded with a layer of wax, lest its vibrant tone vanish and it turn "mottled and ugly."[25]

All this to-ing and fro-ing between the solid and the liquid, between the durable and the decadent, occupies folios 103v to 105r of the British Library Vitruvius, three sheets of velum out of 164, situated exactly two-thirds of the way though the treatise, and sandwiched between chapters on the permanent and the fixed on one side and on the fluid and transient on the other. The discussion about vermillion, about cinnabar and quicksilver, marks this watershed in the text. Before it, every subject is destined for a final set form: propriety, order, repose, fixity. After it, subjects slide, move on, escape, resonate, revolve. With the treatment of vermillion that which has been solid in the text melts into air; the color of this change is red.

This transition from the fixed to the fluid through the consideration of a building's finishing points to an irresistible logic in the claim that for Vitruvius's treatise, movement is equally as architectural as stasis. On one side, book VII shows that there is finally no absolute boundary to be found between these two conditions: although they might appear opposed, they are in fact contiguous. At the same time, the discussion in which this contiguity is revealed concerns exactly that which gives buildings beauty and durability: what is at stake, in the instant where the static and the motive meet, is an emotive quality as well as a practical one. Without the

fluid characteristics exhibited by the material systems involved in finishing, the production of emotive architectural spaces might prove impossible, or at least, we might argue, the production of emotive effects would be compromised.

Questions about architectural emotive effect, then, are intimately bound up in this watershed case with the temporal characteristics of process. This represents a hole in the dyke for any reading that limits architecture to the realm of stable *aedificatio* on the one side, and that sees questions of technique—finishing, *gnomonice*, *machinatio*—as supportive and, essentially, antearchitectural, on the other. It is not only the decorous arrangement of elements in a weighty construction that has the power to move. Rather emotive architectural potential leaks into, is even the product of, a context of formal becoming, a condition of hiatus and transition. Not only stationary buildings and interiors wake the emotions, but so too do the experienced conditions of mobility that surround these destinations. Architecture, suddenly, is not discovered only in the judgment of fixed formal compositions but in the swirl of activity that accompanies building though time.

By the time the Harley 2767 was produced, vermillion's emotive capacity to signal hiatus had been inscribed into the very mechanics of textual production. From the fifth century to the fifteenth, vermillion ink was used by copyists to mark points of transfer—the movement in a text from one topic or section to another—and to signal where the process of copying introduced corrections and alterations. In the British Library Vitruvius vermillion does a similar job. Each title; each "here ends . . . thanks be to God, Amen. Here begins . . ."; each section heading or point of emphasis is distinguished from the rest of the flowing script exactly by the fact that it is rendered by vermillion ink flowing from the pen of the stylist. Graphically, the manuscript's organizational divisions are more muted than printed editions lead us to expect. Economies of velum production mean that the text fills up the folios like liquid flowing into a vessel, leaving no gaps. But materially, in terms of production process, the hiatus between different sections was sharply marked: a change of ink in the quill; sparing use of a pigment much more expensive than the iron gall black ink used for the main text. The emotive effects of moving from one subject to another would have been introduced by the voice of the reader of such a manuscript—a whole dimension of performative emphasis that is necessarily absent in the dead, textual object.

But the hidden qualities of vermillion incorporated an experience of change, effervescence, and pregnant effect that adumbrates this oral experience, a kind of material intelligence residing in the book itself.

How, then, to reintroduce this material intelligence into a contemporary reading of architecture and its history? If it is impossible to construct an account of architecture predicated only on how things stay still, neither can a holistic description be created by thinking of architecture as embracing a binary opposition between how things stay still and how they move—for there is, finally, no architectural boundary between these two categories. Rather we must find, somehow, a way by which to study the moments of hiatus where these two conditions meet. Because, in its effects, architecture is mortgaged to this place between—dependent on the moment, explicit or intuited, when states change—descriptions of architecture must, in whatever way, instantiate this situation. They must distill something vague, sensed, widespread, elusive, into a vessel where it can be observed.

An architectural history based on such prerequisites explores a hinterland: a backlot full of forgotten materials, parked awaiting classification according to canonical destinations. The subjects in such a history might vary wildly; the physiognomy of the objects addressed is likely to be heterogeneous; very different kinds of situations concern the architectural implication of things that move. There are disciplinary things—the charted boundaries of what architecture is in terms of its discourse. There are physical things—objects in transition; materials moving around the world. There are semantic things—examples of word uses and slippages with architectural implications. There are image things—representations, their circulation and their architectural significance. And there are idea things—concepts that change location, significance, portent, in ways that inflect architectural contexts. This is a history of mobile interiors and of transported objects; one of sliding meanings, disciplinary parallels, wandering images.

What follows is an aggregate of texts written over a fairly long period, grouped in a structure that takes a thematic approach to this impossibly wide field. All the chapters in the three sections in the book are concerned, in one way or another, with issues

of translation; all begin with seemingly inconsequential details that stick out, phenomena that cannot conveniently be explained according to existing definitions, or which appear curiously linked to things elsewhere; all of them reappraise seemingly trivial overlaps, attributing a structural importance to resonances that might otherwise appear inconsequential. Five of my chapters take their departure in the interrogation of single pieces of textual evidence; two are best described as building histories.

In part I, "Cargoes," I address the mobile peripheries of an architectural history. In each of its three chapters I examine a piece of textual evidence situated in that periphery: in the first, a treatise on naval architecture, *Architectura navalis mercatoria*, published in Sweden in 1767; in the second, a work on interior architecture titled *Household Furniture and Interior Decoration*, published in London forty years later; in the third, a story contained in the *Illustrated London News* seventy years after that about moving Cleopatra's Needle, an ancient Egyptian obelisk, from Egypt to England in 1877. These chapters raise the question of semantic construction: What kinds of knowledge can be included under a discussion of something called architecture? They note the interrelation between discourses that interrogated the design of the lithe and the technical—things such as ships, for example— and those associated with the production of monumental, static compositions. They consider the highly sophisticated systems of drawn representation that tie architecture to other fields of enquiry, and they observe how things that might be considered under the rubric of "engineering" often combine a sensibility both technical and emotive. The period considered, from the mid-eighteenth century until the end of the nineteenth, is crucial for redefining architecture in terms of how things move. Describing it, chapters in this section are awake to scale and distance in negotiating the boundaries of what architecture might be, and they note the geographical and geopolitical origin of key architectural terms such as "interior." They consider the link between hidden spaces of continental expansion and burgeoning urban development in Europe during the nineteenth century, observing how architectural constructs compressed huge distances, and how architecture embraced a sense of double removal, choreographing a meeting between the familiar domestic and the absolutely alien. The space of travel, and traveling spaces, are considered here. Architecture, according to the analysis outlined in this section,

indexes at once the construction of objects that wander, and the geographical space through which such objects move. This potency was catalyzed during the nineteenth century in an industrialized world of mass media, tourism, rabid colonial expansion, and heroic engineering endeavor, endowing objects with a quality of "flipping," or "tipping," that emerged when architecture was described. The resulting notion of hiatus, emerging out of a symbiotic relationship between objects and their images, circulating within an ever-expanding system of infrastructure, became a trope in the conceptualization of buildings, engineering projects, and designed objects.[26]

My narrative in part II of the book, "Dispatches," is slightly different. Here, I reinterpret early architectural theory in relation to assumptions about the stationariness of its defining concepts. Leon Battista Alberti's *De re aedificatoria*, which circulated in manuscript from around 1450; and Domenico Fontana's *Della trasportatione dell'obelisco vaticano*, published in Rome in 1590, form the subject of these dispatches. The first examines the significance for architectural history of the notion of decorum; the second focuses on the nature of the architectural work and the ways in which architects are constituted as authors. These three constructions—the notion of decorum, the idea of the work, and the centrality of the author—cement together some of the preoccupations with stasis that characterize modern architectural discourse and produce in that discourse a predisposition to treat architecture as an art of the stationary. To challenge the implications of these constructs, to flip their meaning, creates a space for fluidity, transition, and process in that account. Vitruvius identified architecture as the production of static, rule-bound *aedificatio* in combination with the orchestration of slippery *gnomonice* and translative *machinatio*. Alberti's fifteenth-century interpretation enriched the notion of *aedificatio* outlined in the first sections of *De architectura* with a febrile attention to the emotive potential of misplacement, allowing a more lithe, more flexible, and less predictable course for architectural design. That construction flickered in later textual accounts produced in the sixteenth century. Drawing habits established in architectural treatises, and an obsession with Vitruvian rule, underlined the importance of decorum, emphasized the effect of idealized, self-contained architectural composition, and demoted the significance of the processes that realized buildings in providing an account of architectural work. In that

history the second and third of Vitruvius's three parts of architecture were suppressed. Even as they were illustrated in the great sixteenth-century projects to translate Vitruvius's treatise itself, a discussion of *gnomonice* and *machinatio* was largely absent from the works of Serlio or of Vignola or of Palladio, all of whom identified architecture as something very akin to Vitruvian *aedificatio*. This narrowed idea of the architectural work would in its turn be challenged through the subversion of the same systems of representation that established it. At the very end of the sixteenth century a small window opened in which the orchestration of mobile process was admitted as being as central in defining the architectural work, and in constructing the architect as an author, as was the projection of monumental, static composition.[27]

In part III of *Things That Move* I consider the intersection of architectural phenomena and memory by examining how movement wakes emotion. Comprising two building studies, one of a series of architectural projects commissioned by a set of remarkable clients, and one of an extraordinary piece of modernist traffic infrastructure, this section provides a final panel in my fragmentary tryptic, this time titled "Vehicles." Vehicles have extremely interesting capacities in relation to architecture. They perform acts of translation that drag associations and experiences into new locations. They are agents of repetitive exchange—of commuting in the original sense—that imprint experience onto memory, just as they are often messengers of the unexpected, of the exotic or the untoward. Internally they play host to human occupants as well as cargoes, producing a series of "little rooms" that cater to the comfort of occupation at the same time as they screen an infinite variety of location through their windows. Externally they create spaces that have architectural characteristics of enclosure yet are ephemeral, emerging and dissolving as vehicles move relative to each other and relative to the permanent environments they occupy. Over and above these spatial potentialities, vehicles *wait*. They produce particular moments of tension, either out of a sense arrest when a vehicle stops or of progression when it resumes on its way. In their quality of imminence, in their ability to signify a different state, anticipated or remembered, vehicles embody a potential for architecture similar to that discovered in the account of cinnabar and quicksilver in Vitruvius. In most of the cases investigated in this book, from the eighteenth-century merchant ships analyzed in Fredrik Chapman's *Architectura navalis mercatoria* to the

ponderous, slowly moving obelisks that made their way across the Bay of Biscay in the nineteenth century, or around St. Peter's church in the sixteenth, this potent intersection between architecture and the vehicle is implicit in one way or another. In all of these accounts there is an interaction between the vehicular and the architectural that, extracted, provides a rich and alternative way of accounting for the cultural meaning of architectural action.[28]

An architectural history focusing on vehicles might consider them as models for efficient, hi-tech dwelling, celebrating their implicit monumental quality—parallels that informed Le Corbusier's visual citations of the transatlantic liner and Goliath aircraft, or his juxtaposition of the Parthenon and a 1923 Delage motorcar. Or it could note how vehicular qualities of unfettered power or high speed inspired the architectural imaginary—a phenomenon exemplified in the work of the Futurists. My concerns are somewhat different. Instead, in part III of *Things That Move* I consider a mnemonic dimension that emerges when architecture and vehicles meet, a phenomena that became especially evident in the years around 1900. The late nineteenth and early twentieth centuries, we might say, was the age of the automotive vehicle: ships powered by screws or paddles; steam trains; electric trams; airships and airplanes supported by lighter-than-air gas or dragged by powerful kerosene engines. These vehicles possessed an elusive quality that enticed experimentation in media—from painting and writing to photography and finally film—and inspired new ways of interpreting both culture and history. I follow this trail in the last two chapters, first by examining a set of architectural interiors that were commissioned as "image-vehicles" themselves, spaces in which texts and images could be carried through time and made available for study, in this case via the library of the German historian Aby Warburg. In these buildings, produced in a period dominated by the enormous hiatus created by two world wars and by discourses that swung between revolution, continuity, and return, *Things That Move* encounters the powerful idea-world of Warburg and his followers. My analysis of this "Warburgian" architecture ties an idea of vehicularity to an interpretation of cultural identity and memory. If the presence of vehicles in this penultimate chapter is metaphorical, their significance in the last is absolutely visceral. In the final chapter I examine how the design of 1930s urban infrastructure in Stockholm, Sweden, was informed both by the potent imagery of vehicles and by the

equally potent medium through which vehicle-imagery gained cultural traction, the movie camera.

From the preceding descriptions it will be abundantly clear that *Things That Move* is not based on a linear narrative. Its structure is something more akin to a busy nineteenth-century throughfare on which heterogeneous narratives cross, rather than to a road in the Roman sense, moving its traveler from one securely signposted location to another. If the collection resembles anything, a reader might point at Jorge Luis Borges's Chinese encyclopedia—an eccentric collection of stories with not much binding them together except the will of the organizer.[29] But in *Things That Move* resemblances surface between the chapters, I claim, not only because of obsessions that are personal, but also because of ties and common themes that are more structural. One such is the constant presence of the ancient past in narratives that are often about the immediate future. Another related issue is the intimate connection between the technological and the emotive. A third is the implicit connection between dwelling and translation—little houses, cabs, ships' cabins, folding furniture, railway cars; elevators, airships, the occupied interior that moves; the film camera, crated chattels. There is a tie between chronology and thematic across the three areas these concerns define, as well as a kind of effect of acceleration in temporal duration. The chapters in part I ("Cargoes") have end dates set at 1530 and 1910 (a span of 380 years), a long history developed across a period of revolutionary change. Those in the second section span what I take to be the critical period that shaped central aspects of the modern architectural discourse, between 1450 and 1590 (140 years). The final two chapters cover cases closest to our own time, their building histories encased by events that took place between 1890 and 1960 (70 years).

Because I treat this historical sense of movement as something hectic and at the same time very slow—an acceleration measured in centuries and decades rather than in minutes and seconds—*Things That Move* differs from other architectural histories that point to the architectural significance of the motive. Studies that read architecture in terms of its attention to movement often attend to narratives of the recent past, and equally often focus on explaining the formal attributes of static architectural

compositions. Such developments are of course important to understand, whether they concern how architects during the digital turn of the early 2000s began to explore animation software as a form generator, or whether they highlight how the formal language of modern architecture, or that of the Baroque, were influenced by ideas of mobility. My concern with things moving is somewhat different, suggesting a sense of movement in areas less expected and addressing how architecture works, not how it looks. If I succeed in conveying this sense, *Things That Move* will show how a broader attention to movement can change an understanding of what architecture is and how it is produced. Put in rather grandiose terms, the potential is to invert the hierarchical relationship between the permanent and the transient that often emerges when architecture is described.

The effects I claim to trace through emphasizing the role of movement for architecture are several. Movement might be considered in terms of its convenient significance (acknowledging how materials must move to allow architecture to happen). It might be identified as central to an epistemology connected to the discipline (that there might be a shared intellectual acknowledgment of the importance of movement in conceptualizing architecture). But I also suggest that this system of accounting for architecture in terms of things that move might explain the way in which actions of building resonate within a cultural context: that movement creates, or responds to, shared cultural experiences, either sensed or projected, in the architectural examples described. I call this account of architecture "vehicular," in as much as it suggests that the experience and impact of architectural projects is connected to the way in which things—image things and material things—are carried about, as much as to the permanent formal compositions that assemblies of material take on within a permanent architectural frame.

The bifurcation in the previous statement—describing "material things" and "image things"—is important. Throughout this book the implicit symbiotic exchange between the material and the imaginary harbors many motive paradoxes. Sixteenth-century calls for a return to Vitruvian decorum in architecture—to the static ideals of rule-bound ancient precedent—were promulgated within a system of publishing that was experiencing rapid and revolutionary change: ideas about stasis circulated like slippery fish in a new sea of printed material. Domenico Fontana's architectural

work with the Vatican obelisk was by definition, transient: it consisted of a process that took a year and a day. Its representation in print, on the other hand, was endowed with the monumentality of the permanent and long lasting. In the nineteenth century, heavy objects became fleet of foot; images of them gained weight; both required massive infrastructures to circulate. This book, then, refuses to draw a strong distinction between architecture as a practice of design and construction and architecture as a practice of writing and image making. It focuses on the contiguous interface between objects and their mediation, as well as on the multivalent roles technology plays in cultural development. It is based on an instinct that an account of architecture as comprising all these aspects will be mortgaged to notions of mobility.

"Nothing has really happened until it has been described," the English author Virginia Woolf reportedly said.[30] Histories of mobility in architecture must focus similarly on this issue of mediation: on the writing, drawing, and publishing of architecture; of its place in newspapers, photography, and film. At one level this is because mediation reveals the centrality of movement for architecture in terms of its theory. The evidence that reveals Vitruvius's definition of architecture as an art of positioning versus translation is textual rather than archaeological. A similar existential link between architecture and movement emerges in Alberti's account of an art of building that distinguished between *lineamenta*, "where things should be placed for effect," and *structura*, "what is placed there." We might go further to suggest that mediation has some agency in allowing such translative definitions to arise. Domenico Fontana's exercise in publication at the close of the sixteenth century surely contributed to a conceptual apparatus that admitted the ephemeral and the translative as fundamental elements in the architectural work. The system of drawing developed by the shipwright Fredrik Henrik Chapman articulated the relation between the fleet and the fixed that his 1767 *Architectura navalis mercatoria* defined. Around 1800 the representation of the geographical interior in literary texts and financial instruments, together with the translation of landscapes and monuments in image, allowed "interior" to be interpreted, instantiated, and inaugurated as an architectural term.

Introduction

But there is more at stake in the interrogation of these materials of mediation, for they reveal how movement is central to architecture in terms of experience as well. In text, Alberti described how the dome of Santa Maria del Fiore might cover all the Tuscan people under its (moving) shadow, while Domenico Fontana evoked eloquently the hush that reigned over Piazza S. Pietro in the moments before a single trumpeter sounded the call to commence the obelisk's elevation. In drawing, Chapman provided emotive portrayals of an architecture aslant: a reduced language of technical line spoke eloquently of litheness and life. Engraving and etching provided the medium in which Dominique Vivant Denon attempted, and the *Description de l'Égypte* succeeded, to communicate the vertiginous effects of the Egyptian interior for a clientele that occupied the newly created domestic architectural interiors of the European city in the first years of the nineteenth century. In the decades that followed, as the number and kind of images depicting architecture multiplied, so too did the evocative significance of movement in them: the illustrated press highlighted time and again how acts of translation created an impact that was at once experiential and architectural. By the beginning of the twentieth century, moving film revealed previously hidden ways in which the motive constructed experience in architectural settings.

This doubled condition of architecture, as simultaneously a construction of the material and of the mediated, lies at the center of *Things That Move*. And here I lay out the unexpected conclusions of this enquiry: to emphasize the extent to which mediated description and the material artifact create emotive effects in superimposition; to suggest that movement, in one way or another, is key to the functioning of this mechanism; to argue that, as a phenomenon with emotive appeal, architecture is mortgaged exactly to its simultaneous construction in media and in res; to suggest that movement is one means by which this simultaneity acquires an emotive, and therefore a meaningful, dimension. The final task for an examination of the media around architecture, therefore, is to uncover how these restless series of movements create this last potential in architectural projects: to become meaningful. I suggest that, through the movement of materials and images, architecture establishes a kind of "resonance" within a cultural context. But how could such resonance be created? How could an architecture of movement interface, or interfere, with a potential to carry meaning that is often connected specifically to qualities of stasis,

to the endurance of built compositions through time? I deal with this thorny question in the final and concluding section, but I offer some advanced warning of its implications here.

The subject is inherently mnemonical. Resonance is a state of activation in which form, memory, and—in literal terms—material performance are linked. It requires action—the percussive beat, the sound wave, breath—and an answer to that wave produced in a container: a vessel, or a string, or a sounding board. This answer is dictated by something the resonant artifact recognizes, already "knows" in some material sense. In a musical instrument we might call this a "material memory," one that dictates the frequency of reactive movement caused by the elastic nature of the structure, the span of the string, the thickness of the construction. In a sounding vessel or room we would call it "material form": the relation between geometry, volume, and surface reflectivity. But whether in material memory or material form, we find an implication of repetition: achieving resonance requires intelligence that what has happened before will happen again. In resonance things are re-membered.

In applying that metaphor to a condition of cultural experience, one must be open to several suggestions. Partly that certain kind of actions, or signals, impart energy to a cultural system to awake resonance. Partly that some cultural equivalent might be found for the kind of material intelligence residing in a fiddle string: that cultural subjects have a predisposition to react to certain kinds of signal in certain kinds of way. Partly, that the condition in which this resonance can occur is, in whatever way, connected with repetition. Accepting the need to justify the assumption that such a cultural "material intelligence" might exist (and in anticipation of locating a parallel intellectual model that posited something not dissimilar), the claim that architectural meaning can be carried through movement suggests a history of echoes, of actions whose repetitive nature is either openly admitted or dimly sensed. Whether connected to the self-awareness of figures like Domenico Fontana moving an obelisk in Rome, or Apollinaire Lebas moving one to Paris, or Benjamin Baker moving one to London (all of whom looked over their shoulders and pondered how such objects had been translated in the past); or whether linked to a more general kind of cultural interpretation, as is evident in Alberti's paean to Brunelleschi, whose dome was large enough to cover "all the people of Tuscany in its shadow"; whether linked to the feelings

of fifty thousand people watching a ship launch, or to a single figure gazing from a train window at a sequence of monuments, the argument is that the architectural power of movement has to do with an acknowledged or unacknowledged memory: meaning through movement relies on repeats and the apparatus of representation that identifies them as repeats. In terms of the resonant metaphor proposed above, these image/objects might be said to provide the percussive force whose energy is required in order to set a cultural resonance in motion. This then is the theme running through the concluding discussions on architecture and vehicles: to suggest that architectural memory comes out of an awareness that one action recalls another, that actions of movement are actions recognized.

Are these chapters about a condition of mobility associated with the modern? Is the concern with fluidity a statement about modernity—as intuited by Walter Benjamin or Marshall Berman, or as supposed by Marx or Cerdà? The fact that this introduction begins by emphasizing the centrality of volatility for Vitruvius in part answers that question. The intuition remains throughout this book to question the possibility of any categorical divorce between a premodern and a modern condition; to undermine the search for a break that defines an episteme. These stories, then, are classicizing in their tendency to conclude that it was ever thus. They talk of returns and reverberances, of unexpected historical survivals, of an ever-expanding present moment in which the past is discovered even in the eye of a storm of change. In their intuition about the link between the present and the past they look to Georges Didi-Huberman, and to Jan and Aleida Assmann among living writers; to Aby Warburg and early literary modernists such as Virginia Woolf among historical exemplars. At the same time, it has to be admitted that in their focus on the mobility of things, these narratives clearly relate to a set of contemporary concerns that *do* focus on an epistemic shift. Scholars such as Meredith Martin, Christopher Wood, and Lorraine Daston have all interrogated the lives of things, often moving things, within the early modern world. The studies presented here, like theirs, must navigate the risk of romanticizing "the free-floating mobility of elite persons and things at the expense of the labor and violence that made it possible."[31]

They must also navigate an issue that characterizes hinterlands in general: a condition of belonging at once to nobody and

to everybody. Peripheral spaces, visible from all sorts of perspectives, hinterlands wake the interest of actors with widely differing agendas, and they impinge on multiple discourses. A circle that I cannot square, finally, is the breadth of secondary literature that this scope implies. The problem materializes itself in various ways. In the first chapter of *Things That Move* I consider the relationship between architecture and naval architecture, an issue that has remained outside the main focus of architectural discourse and which, as such, seems a logical place to begin the narrative. In trying to open up this subject a dilemma manifests itself immediately in terms of a disparity in the types of sources encountered. The architectonic aspect of ships is a problem for a scientific discourse on ship design, a sociotechnical discourse on their history, an art-historical discourse on ship decoration, and a social-historical discourse on labor and exploitation. Because these together form a vast field, one which can be surveyed only in the sense of viewing it from a distance, the risk is that interpretation is reduced to the figure of the surprised toddler pointing at everything new and saying "look!" In every direction there is an adult who knows more. In other chapters the same problem emerges in different ways. The nineteenth century, like its novels, teams; the interpretive space it overshadows teams with as many disciplinary possibilities for analysis. The movements of Aby Warburg and Renaissance Studies make an equally rich tapestry, one in which multiple perspectives are woven. The hinterland between architecture and moving film deserves, and has received, an attention that is at once minute and extensive. *Things That Move* tries at least to outline the different discourses that have been brought to bear on the hinterland it discovers. And it aims to offer an analytical pattern that goes beyond the toddler pointing in one respect: its use of images. Not only have images been conceptually important for the book in terms of defining the edges of objects in a new way ("things" in this text are usually thought of as including their various representations in media), but the book itself is made of images. There are 160 altogether, a series of 72 black-and-white pictures through parts I and II, "Cargoes" and "Dispatches," a suite of 24 color plates drawn from all the chapters and placed at the center, and a second black-and-white sequence, 64 images in all, accompanying part III, "Vehicles." The black-and-white images appear throughout the chapters with captions but without figure-number callouts; marginal notes in the chapters alert the reader to locate relevant

color images within the center suite. The argument in this book cannot really be separated out from the visual juxtapositions and the sequential series that run through these pages.

There is a beautiful parenthetical passage in Virginia Woolf's 1927 *To the Lighthouse* that both identifies a classicizing reading of fluid modernity to which this book responds, and which points to the range of phenomena that might exist in the architectural hinterland surrounding things that move.[32] *To the Lighthouse* is a deeply architectural, as well as a seminally modern novel. Published in the same year as the English translation of Le Corbusier's *Vers une architecture*, exactly contemporaneous with the Weissenhofsiedlung in Stuttgart and Ludwig Hilberseimer's *Hochhausstadt*, its rendition of the modern condition seems revolutionary in a very different sense to these, pointing rather to the inescapable recurrence, and fractured rerendering, of past experience than to a future free from the chains of history. The passage in question presents the experience of Mr. Bankes, the detached yet intimate friend of the story's central character Mrs. Ramsay. He talks to her by telephone, she 300 miles from London on an island in the Hebrides, he in his flat at the center of the metropolis. As he hears her over the wire, Mr. Bankes sees Mrs. Ramsay in his mind's eye in far-off Scotland at the same time as he watches workmen building "an hotel" opposite his window. The text combines a deep sense of repose, of a classical depth in time, with a description of the absolutely immediate and mundane. It juxtaposes a disembodied rural idyl with the urban flow of materials, labor, and transport:

> ("Nature has but little clay," said Mr. Bankes once, much moved by her voice on the telephone, . . . "like that from which she moulded you." He saw her at the end of the line, Greek, blue-eyed, straight-nosed. How absurd it seemed to be telephoning to a woman like that. The graces assembling seemed to have joined hands in meadows of asphodel to compose her face. Yes, he would take the 10.30 from Euston . . .
>
> "But she's no more aware of her beauty than a child," said Mr. Bankes, replacing the receiver and crossing the room to see what progress the workmen were making with an hotel

which they were building at the back of his house. And he thought of Mrs. Ramsay as he looked at that stir among the unfinished walls. For always, he thought, there was something incongruous to be worked into the harmony of her face. She clapped a deer-stalker hat on her head; she ran across the lawn in galoshes to snatch a child from mischief. So that if it was her beauty merely that one thought of, one must remember this quivering thing, the living thing (they were carrying bricks up a little plank as he watched them), and work it into the picture . . .).[33]

In its description of the way in which actions of building create effects, this passage comes very close to the means of accounting for architecture suggested in this book. Its component parts—the contemplative figure in an interior; its screening for that occupant of a scene in the mind's eye; its window; its collapsing of distance through an infrastructure of exchange and communication; its reference to the power of movement in invoking memory; its identification of building as part of this action; its sense of resonance and reverberation—all these aspects identify a very particular kind of mechanism in which architecture is absolutely implicit. Remove the window, the builders, the "stir among unfinished walls," the crossing of the room, and the scene collapses. Remove the little plank flexing under its moving load, and the "shivering" that articulates Mrs. Ramsay's remote, disinterested beauty, is lost.

The direct line it draws—the extraordinary tension—between an antique canon and a contemporary, utterly mundane building operation (Mrs. Ramsay's profile Greek, inviolate, composed by the Graces; the plank springing, muscular, material) is one identified in several of my own chapters here, and would be worthy of an image in Warburg. The passage also projects its beam back into the middle of Vitruvius—to the description in book VII, where processes of "finishing," organized around material oscillation, guarantee the emotive effects of building. In 1927 it was but a short step from the address where *To the Lighthouse* was published—the Hogarth Press occupied the basement of Woolf's home at 52 Tavistock Square in Bloomsbury—to Sydney Smirke's Rotunda and the library stores of the British Museum. There, in some vault, cinnabar wept and quicksilver jumped from liquid to gas on the pages of Harley 2767; there concrete hardened and frescoes dried; there one

could read of vivid colors disposed in outline on a stuccoed wall conjuring up, perhaps, the Graces assembling in fields of asphodel.

There is no way of knowing whether my partisan and contemporary reading of Vitruvius's structure—its simplified movement from the static to the fluid through the hiatus of temporal material change—is more than a convenient chimera, a construction made to make a point. But, if you are tempted to see in book VII of *De architectura* the place where truth will out, to acknowledge the perspicacity of its unfolding of the hiatus between stasis and fluidity, I suggest reflecting on the parable that introduces this account of finishing. Book VII has much the longest introduction of any section in *De architectura*, bar book IX that speaks of *gnomonice*. In the fourth paragraph following the title, Vitruvius narrates the ancient story of Aristophanes judging the poetry competition that inaugurated Ptolemy's newly established library in Alexandria, one of the great architectural projects of antiquity. Aristophanes is appointed, late on, as the seventh judge for the competition, six more canonical figures having been selected first. At the trial he dissents from their majority verdict about the victor, revealing that only one of the competitors is eligible to be evaluated, because only one is presenting his own work; all the pleasing voices that the judges have heard, including that which both they and the crowd esteem highest, turn out to be the honeyed sound of charlatans passing off others' work as their own. Only the seventh judge speaks truth. The story is linked to an acknowledgment on Vitruvius's part of the sources he himself is reciting, together with a claim to a true originality in his own endeavor. In this seventh book, then, he identifies himself with Aristophanes, revealing his knowledge of a corpus of texts by genuine authorities on the rule and tradition of architecture and using this knowledge to judge the value of originality in the work he is presenting. Thus his investigation of hiatus and the curious importance of material changes-of-state to the finishing, and therefore to the beauty and durability of buildings, is couched within a structure suggesting that it is just here, in its seventh opinion, that the text of *De architectura* approaches the profound.

Things That Move claims a similar hidden truth and significance. *Lege feliciter.*

Part I: *Cargoes 1530–1910*

Architecture Aslant

In the second half of the 1760s the Swedish surveyor and engraver Olof Årre received a commission to design a frontispiece for a treatise with the title *Architectura navalis mercatoria*.[1] The book presented a collection of engravings by Fredrik Chapman, shipwright to the Swedish inshore fleet. Some of the plates reproduced designs for which Chapman himself was responsible; others depicted ships he had observed and surveyed (or had others survey for him) in Sweden and abroad. The work was published in Stockholm with captions in three languages—Swedish, English, and French—together with information concerning the technical aspects of the ships represented; these details were translated into the various systems of measurement used in those three countries. Chapman's treatise was funded in part by the Swedish Crown and in part through subscription fees to cover the costs of production; the initial installments appeared with a publication date of 1768 in the frontispiece (which formed part of the final batch of plates, together with instructions for binding them and a promise to supply a theoretical and explanatory text to accompany the drawings at a future date).[2]

Årre was resident draftsman for the Royal Swedish Academy of Science (Kungliga Vetenskapsakademien, founded in 1739, the Swedish equivalent to the Royal Society in London [1660] or

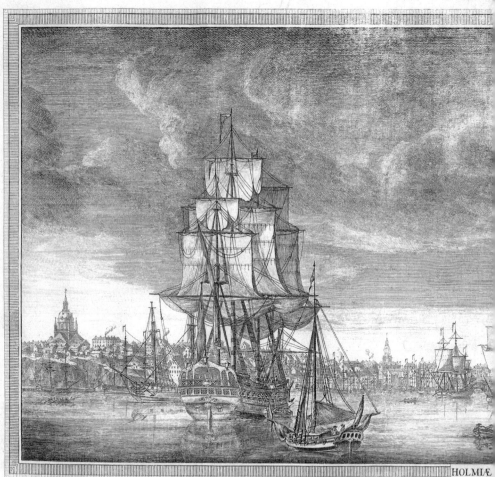

ARCHITECTURA NA

NAVIUM varii generis *MERCATORI*
ALIARUMQUE, cujuscunqve conditionis
exemplis
Demonſtrationibus denique, Dimenſionil
A
FRIDERICO H
S.R. Maje
R. Acad. Sci

HOLMIÆ

Olof Årre. Engraved frontispiece to Fredrik Henrik Chapman, *Architectura navalis mercatoria* (Stockholm, 1768). National Maritime Museum, Stockholm.

S MERCATORIA,

APULI CARUM, CURSORIARUM,
lis, Formas et rationes exhibens:
fis;
disque accuratisfimis illuftrata.

PMAN.

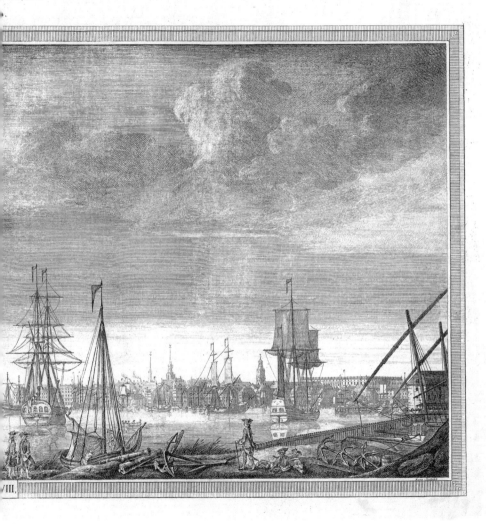

the Académie des sciences in Paris [1666]). He had been director of the Royal Survey, thus accurate observation and depiction were in his training.[3] To introduce his subject he provided a panoramic view of Stockholm's inner harbor and the long sweep of the city's waterfront. The view speaks nicely of the absolute fixity of architecture on land, and of how a complete picture of that phenomenon might be gained from a single point, at a single moment. Overlaid on a contemporary map, the view reveals itself to be a precise rendering of the buildings in Stockholm as they existed at the time, based on a rotating projection with a view point on Kastellholmen, a small island in the city's harbor. Framed by two great contemporary building projects, the dome Katarina Kyrka (St. Catherine's Church) on the left and by the large square block of the royal palace on the right, the city is shown from the humble sheds along Glasbruksgatan (Glassworks Street) under St. Catherine's to the great houses of the merchants along Skeppsbron toward the castle.[4] The ornate towers of the churches in the quarters behind are located exactly; the whole is motionless except for the occasional wisp of smoke emerging from chimneys on the skyline.

The fixed frontages of Stockholm's buildings, pinpointed with cartographical accuracy, serve as the background to a second city of ships shown at rest before the first. There are around seventy in all, their representation varying from the indexical to the precise. Ships move in another order of time to buildings, and this temporality emerges in Årre's view. Hanging flags and pennants speak of an absent breeze; in the foreground crewmen strain at the halyards of small craft; behind them a menagerie of ship types—frigates, yachts, hoys, schooners, brigs, pinks, hagboats, catts, flutes, and barcasses—sit on the perfectly flat plane of the harbor water in the multiplicity of orientations produced by a fleet becalmed.

Årre's image, a fitting introduction to a treatise on the architecture of ships, sets all these examples of its object of study against the backdrop of architecture on land. This chapter concerns the implicit continuity between these two categories and investigates the implications that exist for analyzing the "fleet" (a collection of moving ships) and the "fixed" (permanent buildings located in one particular place) under the same theoretical banner. Like land-based architecture, the art of ship building in Europe after 1500 began to be theorized within a field of enquiry that stretched beyond its own borders.[5] This involved two kinds of contextualization. On one side ships were provided with a

history, one which read the present in terms of its relation to an antique—specifically Greek and Roman—past. On the other, visualizing "naval architecture," and articulating its urgency for actors who were not artisans in ship construction themselves, required that the internal means of communication used by shipwrights be transformed and opened up, thus introducing a potential to carry other kinds of information. In both these respects the development of treatises on the construction of ships provides something of a mirror to the way in which architectural treatises evolved from Alberti to Serlio, Vignola, and on through the sixteenth and seventeenth centuries. Both kinds of theoretical text were concerned with how modern design was informed by ancient precedent, as well as with the technical challenges construction itself posed. And although the assembly of ships and the assembly of buildings involved very different parameters, flattening the lore that governed these varying forms of construction onto paper led to a common interest in orthographic projection. Early naval architecture treatises, like early architectural treatises, used text almost exclusively; through time both increasingly used graphic means to accomplish their tasks. The challenges that shipwrights met led to a particular flowering of this potential; by the mid-eighteenth century naval architecture had developed systems of drawing unexamined in contemporary architectural production, and which would only really be emulated by land-based architects with the development of computer-aided technologies two and a half centuries later.[6] The physiognomy of the *Architectura navalis mercatoria*, and the energy involved in creating the beautiful plates it contains, is conditioned by this endeavor to represent the world of shipping, in all its various forms and intricacies, within the format set by high-quality printing and engraving.

A second and equally fascinating story, also evident in Chapman's plates, links naval and land-based architecture in terms of design. At the center of the panorama in Årre's frontispiece, before the encircling harbor-front of buildings, one ship is portrayed in more detail than the rest. The morphology of this object is so familiar, so ingrained on the retina of expectation, that it hardly awakes comment. We can tell at a glance that the ship is represented in three-quarters view from behind. It has a recognizable rig: three masts; cross yards with furled sails; a steeply angled bowsprit. And it presents us with a feature that appears to be a consistent and indelible sign of the "shipness" expected in such objects: its stern,

the rear, rears up. There is a hint of decoration about this rearing, of flamboyance. There is architectural detail—windows, a recessed balcony. There are glazing bars, mullions, balustrades, basketwork, arches, cartouches, supporting sculptural figures. And there is the presence of implied rooms within the ship that open onto these windows, this balcony. In this physiognomy, and its decorative articulation, ships borrowed architectural details from buildings. The changing mores that governed the appearance of land-based architecture were reflected, albeit in a distorted fashion, in the architecture of the sea. You could say that naval architecture bent the expressive rules of its land-based twin, as well as reflecting its ambitions and systems of representation. Perhaps unsurprisingly the fluid forms of the baroque, with their potential to blur the distinction between the sculptural and the architectural, appealed greatly to ship builders—they are much in evidence in Chapman's work.[7] But it becomes obvious that even the most rigid motifs of neoclassical repose, especially during the later eighteenth century, could equally well cross into the heaving world of oceanic seafaring. These systems of expression, and the architectural echoes they entail, did not emerge only from whimsy or simply from fashion. In ships, as in buildings, there was a fundamental link between the expressive means manifested on the outside (personifications of virtues; architectural ordering; scrolls, swags and balustrades) and what was going on inside. Ships, like buildings, organized social space, and in this parallel there was also a set of continuities and exchanges. Much of the decorative tradition and almost all of the organizational principles that governed the design of ships were carried from generation to generation of mariners; naval mores were as informed by tradition as any other kind. There are reasons to believe that the articulations and constitutions elaborated in the design of architecture at sea effected organization in fixed, land-based buildings, as well as the other way around.

In the following pages I sketch out moments of significance in both these stories—that which concerns the parallel between the mediation of ship design and architectural design in illustrated treatises, and that which concerns the fluid and hazy boundaries that existed between building practice applied on land and at sea. In architectural histories this story has not really been presented before in a cohesive fashion, yet it is an important story to tell. My presentation of it may sound more like a monologue than a conversation with interpretive partners, but in taking that risk I signal

where my narrative overlaps with other contemporary analyses. The suggestive quality of much of the material I present here has been "hidden in plain sight," to use the words of two recent skillful interpreters of the cultural significance of maritime decoration.[8] In order to rethink the boundaries that habit places around architecture, such qualities should be highlighted, even if by methods that can appear crude.

Fredrik Henrik Chapman's work on ship design is generally seen as instaurational for the development of naval architecture as a modern, science-based, discipline.[9] That status is based partly on the implications of the set of plates collected in *Architectura navalis mercatoria* and largely on the significance of his *Tractat om skeppsbyggeriet* ("Treatise on Shipbuilding") published in 1775, translated into French by 1780. The latter provides an interpretive text, which included the mathematical calculations that made possible the graphic analysis contained in the *Architectura navalis mercatoria*. To enter into Chapman's world, we can start by turning from the Årre's frontispiece to the first plate in that treatise.

Architectura navalis mercatoria presents 62 engravings in large format (52 × 43 cm) describing 124 ships.[10] The vessels are portrayed using a system based on four orthogonal views. In the lower region of the paper (usually) a side elevation or profile surmounts a half plan. Above these float what is known as a body plan, most often shown to the right, and a stern elevation generally shown on the left. The basic system, combining elevations and plans, has been familiar to architects since the Renaissance. Indeed, Chapman's layout conforms to the advice famously given to Pope Leo X by Raphael: that descriptions of built works require a combination of plan, section, and elevation.[11] What is unfamiliar is the degree to which these views compound different layers of information into a single projection. The side elevation of plate 1 in the series, for example, the beautifully and precisely engraved "Frigate built," conveys not only a sense of the external effect of the ship—positioning elements that pertained to that exterior (canon ports, decoration, handrails, rigging)—but also sectional information about the space within. Deck planking and deck beams are included in an incredibly fine dotted line, cut along a section exactly on the center line of the ship. Stairways, mast-steps,

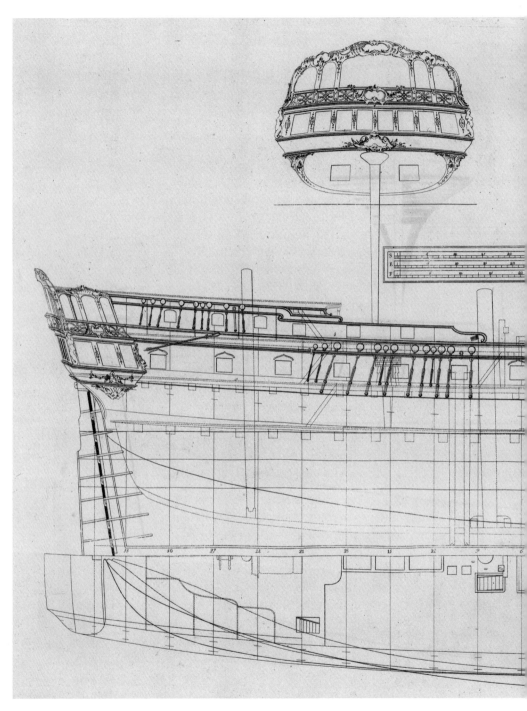

"Frigate Built, Ships Rigging." Fredrik Henrik Chapman, *Architectura navalis mercatoria*, plate 1. National Maritime Museum, Stockholm.

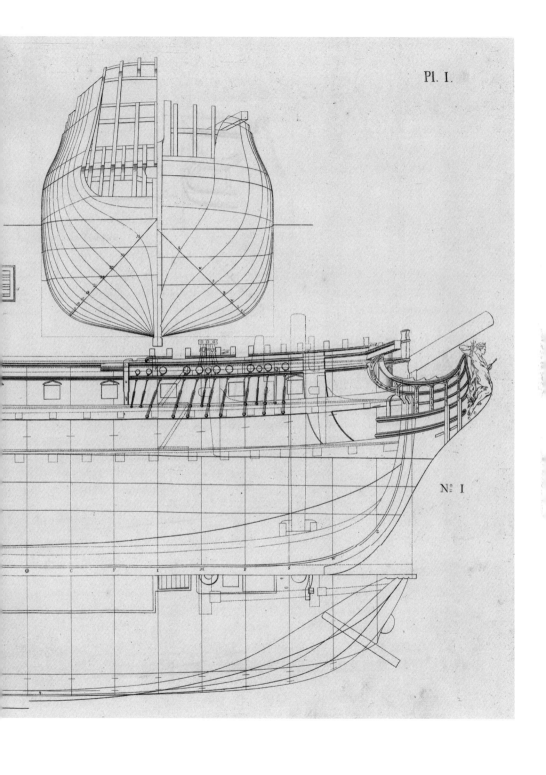

Pl. I.

N.º I

capstans, bitts, gratings—some along the centerline, others adjacent to it—are all represented. Unlike an elevational drawing of a building, this view presents an outside and a ghostly inside simultaneously; it speaks both about external and internal organization and hierarchy.

The same characteristic of doubled information applies also to the half-breadth plan views presented immediately below the profile elevations, their center lines identical to the line of the base of the keel. (Note that each ship in the *Architectura navalis* sits on the projection of its own plan as it would on the "ways," or slipway, on which it was built.) These communicate a view of the ship's deck as it would be seen from the rigging, but they also record, to greater and lesser degrees, what takes place below the deck in several planes. In plate 1 the sinuous curving walls and partitions that divide the principal staterooms at the back of the ship are shown, as well as the great bitts that take the force of anchors and mooring lines in the bows.

Both plan and elevation involve a projection unexplored in contemporary architectural drawing in which multiple planes are given a similar hierarchical status. Or perhaps more accurately, we could say that compared to architectural drawings of the time these drawings represent, to a much greater extent, the possibility for including elements that lie behind the principle surface of the projection into the communicative act of the drawing. This doubling of view—conceptually the observer is asked at once to consider themselves as looking at the ship from the outside and from the inside—was a characteristic of naval architectural process. These engravings translated a system of design in which different colored inks were used to represent different planes within a single drawing simultaneously.[12]

Aside from recording the outline of constructional elements—such as decoration in relief, openings, masts, and cabin walls—*Architectura navalis* communicates the nature of the continuous surface that forms a ship's hull. For each vessel portrayed, the combination of profile elevation and half-breadth plan is overlaid by a set of vertical lines lying perpendicular to the center line in the plan and to the base of the keel in the elevation. These lines, or stations, mark the position of a set of transverse sections used to trace the form of the ship's hull as it evolves from bow to stern, shown in turn in the body plan that usually surmounts the profile to the right. They are normally numbered from the midship section (at

which the ship is broadest) using numerals toward the stern of the ship on the left of the sheet and letters toward the bow on the right (when ships were represented in elevation across various European countries in the eighteenth century, they conventionally sailed across paper in the same direction as text, from left to right).[13] The drawing of the frigate, then, is dominated not just by lines recording constructional elements outside and inside the surface of the hull, but by a set of lines articulating the three-dimensional form itself.[14] On the plan view of the ship, these additional lines represent a series of lateral cuts made at various heights, which reveal developing form in a similar way to the series of transverse sections marked on the body plan, in this case a development vertically from keel to deck rather than laterally from bow to stern. The vertical position of these "waterlines" is marked carefully on the profile above the plan. There are three in plate 1; the uppermost is marked with a slightly heavier line to denote it as the intended design waterline, defining the amount of water displaced by the ship under the combined weight of its own hull and rig, all its gear, and any cargo. A careful look at the plan reveals a system that would make architects wince and screw up their eyes: these lines are almost, but not quite, perpendicular to the exactly vertical lines on the paper that mark the stations defining sequential sections from bow to stern. There was not any reason why a ship should float such that its waterline was parallel with the base of its keel. Indeed most ships did not; their sailing abilities were understood to be improved if there was a slight drag on the keel such that the ship drew most water right aft at the rudder stock. And thus the definition of these waterlines on Chapman's plans represents an astonishing (and new) act of prediction: the spatial matrix, or three-dimensional grid with which the form of the vessel will be defined, has been distorted by a precise amount defined in its turn by a prediction of how the completed form will float.[15]

This deviation in the spatial grid is clearly visible in the body plans of the *Architectura navalis* because all the lateral sections defined by the stations on the profile are superimposed in one drawing. As with the compound plan and elevation, looking at this view involves a conceptual dance on the part of the observer. Here, rather than situating ourselves inside and outside the ship simultaneously, we must imagine looking simultaneously at the abstract form of the hull from ahead and behind: the drawing shows the sections of the front part of the ship on the right and those of the

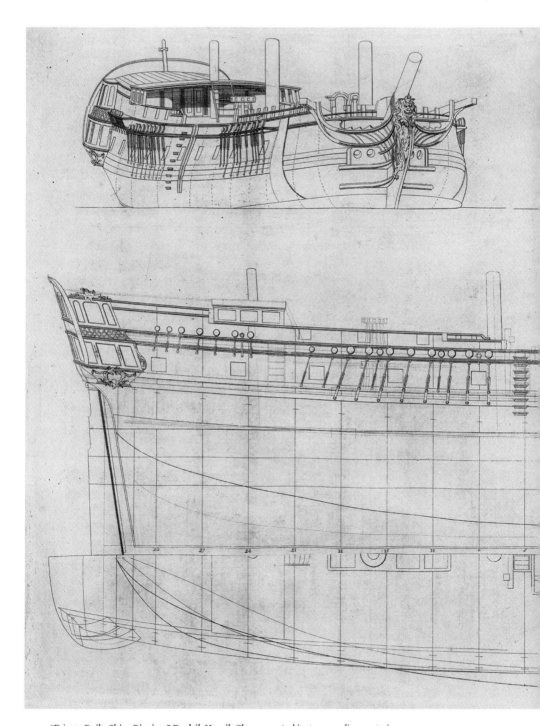

"Frigate Built, Ships Rigging." Fredrik Henrik Chapman, *Architectura navalis mercatoria*, plate 9. National Maritime Museum, Stockholm.

Pl. IX

Nº 12

hindquarters to the left. And on each side we see the waterlines drawn, falling in a sinuous curve as the projection moves forward and rising gently as it moves aft. In the whole there is a great deal of movement; the notional quality of a vessel afloat, and the transience of view and orientation this implies, seems built in to the projective scheme of the work.[16]

Aside from and contrasting with these three kinds of projection that emphasize a doubling of location on the part of the observer and a vibrancy of effect, *Architectura navalis mercatoria* always presents a view of the ship that is more fixed, as if it has indeed been frozen on the paper, pinned down to be looked at from one position only. Architectural in their directness (here the observer can stand as if on firm ground; no conceptual flitting about is necessary to understand them), these engravings evolve in their format from presenting something very like a facade elevation of the vessel from behind, to showing complex oblique views in which the vessel's form is revealed in all its three-dimensionality. Plate 1 of the treatise presents the most standard form, showing the stern facade complete with its architectural features—balconies, window openings, and sculpture. Other orthographic views in the treatise assume that only half of the symmetrical body of the ship needs to be represented in order to communicate all the relevant information. But in this case, as with the drawings of an architectural elevation or a face, to fulfill its communicative task the projection must represent every detail and its mirrored twin balanced on either side of the vessel's center line. Turning the pages of the treatise, the pure elevational facade in plate 1 is replaced by an oblique stern view in plate 3, and a similar view from ahead in plate 9, as if the form of the vessel has been slowly rotated, the changing contours of its hull carefully traced.

Having shown how precisely his system can represent the effect of ships moving through 360 degrees of lateral rotation, Chapman goes on to demonstrate mastery over how to show their forms as they heel. Where the "hagboat" in plate 9 swings to its moorings bows-on, level in the water, that in plate 10, pictured obliquely from astern, is shown aslant, listing as if to a sudden breeze. The "catboat" in plate 15 has rolled suddenly in the opposite direction, whereas the one in plate 16 has been laid on its beam-ends—viewed from ahead, its masts and decks are invisible behind the shoulder of its forecastle. The "bark" in plate 21 is shown at the same wild angle from astern: masts, decks, companionways and hatches all

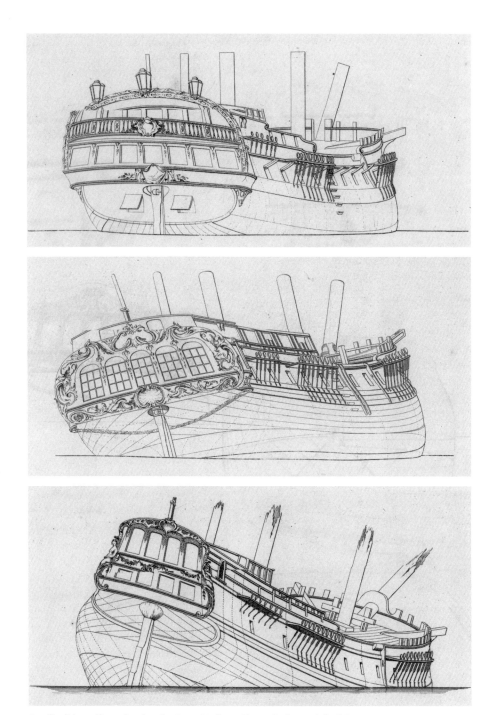

Details of three-dimensional projections: "Hagboat, Sloop Rigging," "Pink, Ships Rigging," "Catt, Ships Rigging." Fredrik Henrik Chapman, *Architectura navalis mercatoria*, plates 3, 10, and 15. National Maritime Museum, Stockholm.

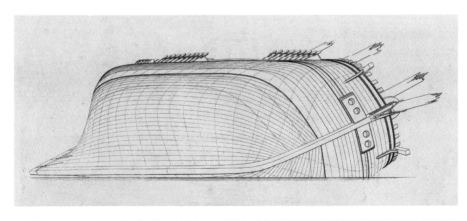

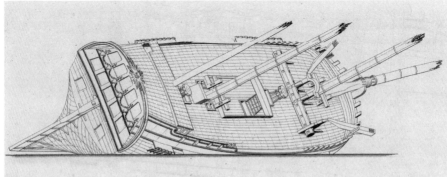

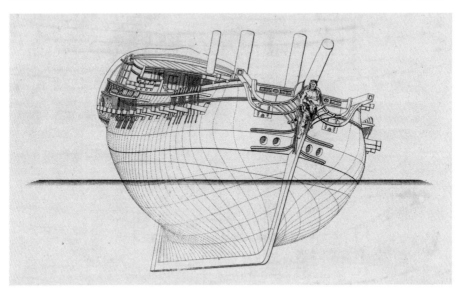

Details of three-dimensional projections: "Catt, Ships Rigging," "Bark, Ships Rigging," "Privateer, Frigate." Fredrik Henrik Chapman, *Architectura navalis mercatoria*, plates 16, 21, and 31. National Maritime Museum, Stockholm.

visible, its lee rail making a tangent to the absolutely flat plane of the water, the architecture of its stern galleries tilted to an impossible angle.

In the communication of the *Architectura navalis mercatoria* these drawings are hierarchically important. They are the only views in the treatise that are not expected to provide two kinds of conceptual viewing simultaneously. They are the only views in which any redundancy of symmetry in representation is allowed (elsewhere there is an economy based on mirroring the least possible amount of information). They are the views in which the most experimental effort is invested, their format evolving in a fugue-like procession. They are, indeed the only of Chapman's images whose creation involved a set of actions outside those used in creating the construction information needed to produce the craft.[17] Perhaps unsurprisingly, these very special types of constructed views—which Chapman used on a scale and with a refinement never seen before—are also used to structure the treatise. The drawings structure it spatially, in that their positioning speaks to the categorical system that Chapman is introducing to order the *Architectura navalis*. And they structure it conceptually in the alignments and distinctions they reveal between the condition of architecture at sea and of architecture on land.

Architectura navalis identifies two major ship "families" (*generii*, in the Latin title) in the "Index and description of the draughts" that accompanies the treatise, the first described under the heading "Merchant Ships or Vessels," the second as "Privateers; Vessels for Swift Sailing and Rowing."[18] Within the first family Chapman provides examples of six "classes": frigate, hagboat, pink, catt, bark, and "vessels of small draught of water." The distinction between these is based on type rather than size, the difference between types emerging from a combination of load-carrying capacity and stability (how easy the ship was to push over). The three-dimensional drawings that show how ships change appearance as a result of rotation accompany and structure this explication of the various classes and types of merchant ships. Swinging hull forms are shown using two views of frigates and one of a hagboat; heaving and rolling compositions with views of hagboats, pinks, catts, and barks (one image for each, two for catts).

These three-dimensional views are evolved through two more iterations introducing the following main sections of the treatise. The second family of ships identified, "Privateers; Vessels for Swift

Sailing and Rowing," is introduced by a beautifully constructed image of a privateer suspended as if in air, no longer seen at distance from across the water, but from a viewing point that sees above and below the waterline simultaneously. Situated in the top right-hand corner of plate 31, this view combines lateral and vertical rotation and shows the lift of the batteries of guns and how their employment depends on the heel of the ship. The ensuing plates (31 to 50) develop a taxonomy of the differences among "Privateers" and the various "Vessels for Swift Sailing and Rowing." As with merchant vessels, the plates devoted to each kind represent ships of the same type decreasing in size.

The last, and most spectacular, kind of three-dimensional projection in *Architectura navalis* introduces the final section of the treatise, "Several Kinds of Vessels Used by Various Nations," and shows a wildly heeled British East Indiaman (plate 51). Here the view returns to emphasize the facade-like nature of a ship seen from astern. While the side elevation shows elaborate decoration surrounding windows and stern lantern, angled distortions suggesting the rake of the decks within, the architecture of the ornate stern galleries in the three-dimensional view has been turned violently on its side. This third part of the treatise employs a system of comparison that is distinct from those used earlier. In it each rather short series of plates collects vessels with similar functions from different geographical locations. The sleek lines of the Indiaman are juxtaposed with those of the high-pooped French flute and a squat Dutch hoy, with its bluff bows and lee-boards: all the ships carry cargo, but they do so by employing different hull-forms in wholly different environmental conditions. Fighting ships are compared from various locations, as are fishing craft. The penultimate two plates extend this comparative analysis to the various means of launching ships: French ways support their vessels up to the waterline; the Dutch launch their ships back to front, bow first (the ship in this view is one of only two in the treatise to be represented in elevation pointing the wrong way across the page). The table of contents for this section provides a kind of index for the treatise as a whole: self-evidently, the various types considered comparatively in the last section can also be considered in terms of the families and classes established earlier.

The elaborate three-dimensional views of the *Architectura navalis*, then, support a structure that divides the world of ships into two major genera—heavier ships to be handled expressly under sail

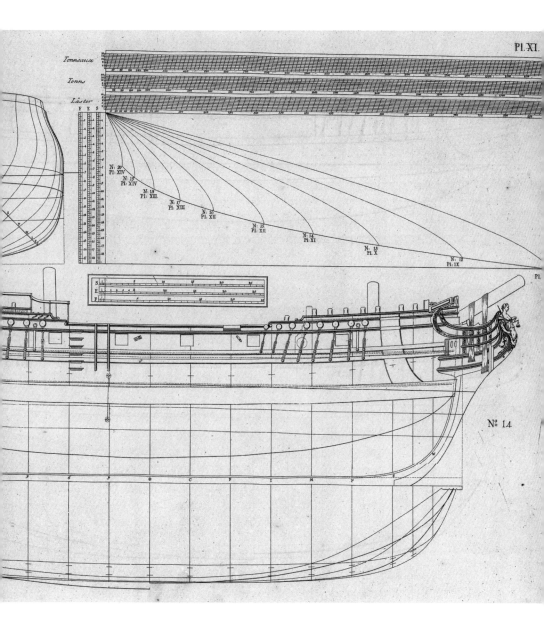

Detail from "Hagboat, Sloop Rigging." Fredrik Henrik Chapman, *Architectura navalis mercatoria*, plate 11. National Maritime Museum, Stockholm.

and lighter vessels built for speed and maneuverability, the latter to be handled under sail or, in many cases, under oars. The treatise describing this world properly carries a third section (". . . Vessels Used by Different Nations"), again signaled by a three-dimensional view, which shows how vessels relating to these differing formal classes can evolve to perform similar tasks in different places. That there is a hierarchy between these two types of analysis is clear: the first and second sections of the treatise describe a fundamental order for an *Architectura navalis*, identifying areas of coherence in its variety; the third section shows how this order can be used to support different kinds of use, and indeed that the same primary function can be performed by vessels from across the different genera and classes earlier defined.

Underlining the fact that the former system of genera, rather than the latter system of use, creates a fundamental coherence in this world, Chapman provides a final and absolutely innovative kind of image, noted in his title. He emphasizes the grouping of plates into descriptions of classes or types by an additional engraved projection, squeezed in above the profile and adjacent to the body plan and stern elevation of the central plate in each series. These relate together all the ships described in the class. The frigates shown in plates 1 to 7 are all grouped in plate 4; hagboats and pinks in plate 11; catts in plate 17; barks in plate 23; vessels of small draft of water in plate 29; privateers in plate 37, and so on. In each case a table positions the various visual examples as single instantiations of a quantitative relationship between length, displacement, and the stability or "stiffness" characteristic of the class itself. Chapman, then, identifies the similarity between his various examples almost like a mathematician revealing a function that links a set of points along a line in a graph.

Drawing and the Academy

Chapman's ambitious efforts in *Architectura navalis* to tabulate variety, and to relate this to an underlying structural logic as well as to numerical or formal characteristics, have an affinity with contemporary studies of nature and mathematics. Stockholm created a fertile context for this kind of thinking. Chapman sat on a royal commission to improve the science of ship design during the 1760s. He was also closely associated with a series of

Part I: Cargoes 1530–1910

members of the Swedish Academy of Science.[19] His patron Augustin Ehrensvärd (who commanded the Swedish inshore fleet, built the Swedish fortress Sveaborg outside Helsinki where Chapman superintended ship construction early in his career, and was an accomplished painter as well as a soldier), was an early member.[20] The royal architects Carl Johan Cronstedt and Carl Hårleman, to whom Chapman was connected both through Ehrensvärd and his son, the architect and theorist Carl August Ehrensvärd, were members (Cronstedt from 1740; Hårleman from 1745), as was the aged Christopher Polhem (founder of the Laboratorium mechanicum in Stockholm and author of a treatise on the stability of ships).[21] Chapman studied during the 1740s with the mathematician and engineer Fredrik Palmqvist (elected to the academy in 1745) and during the 1750s with the English autodidact mathematician Thomas Simpson (member of the Royal Society in London and foreign member 37 of the Swedish Academy, elected in 1758).[22] He fought about his ideas on ship design during the 1760s with Gilbert Sheldon, fellow member of the royal commission and member 19 of the academy, and was voted a member of the academy himself in 1768, in the same year as Henri-Louis Duhamel du Monceau, Inspector General of the French Marine, with responsibility for the Atlantic (Ponant) and Mediterranean (Levant) fleets, and the author of his own *Elémens de l'architecture navale*.[23] Their contributions were later compared, in a speech to the academy, by Daniel Melanderhjelm, professor of astronomy at the University of Uppsala.[24] Chapman's *Tractat om Skeppsbyggeriet*, which explained the plates in the *Architectura navalis*, "set the rare example of combining extensive and rigorous theory with a commendable [skill in] practice," Melanderhjelm claimed. Du Monceau's treatise, on the other hand, was "mere practice": it charted craft but did not develop theory.[25] Melanderhjelm's balance of praise might be regarded as partisan.[26] But Chapman's simultaneous standing as a theoretician of underlying principle, a chronicler of traditional variation, a skilled draftsman, and a master shipwright was clearly exceptional. Du Monceau, a nobleman, botanist and agronomist, could codify knowledge in his role as inspector, but there is no evidence that he could have produced drawings as elegant as those of Chapman.[27]

In one sense Chapman did for shipping what Carl von Linné, the most famous Swedish academician, had done for the world of animals and plants. Linné, a founding member of the academy,

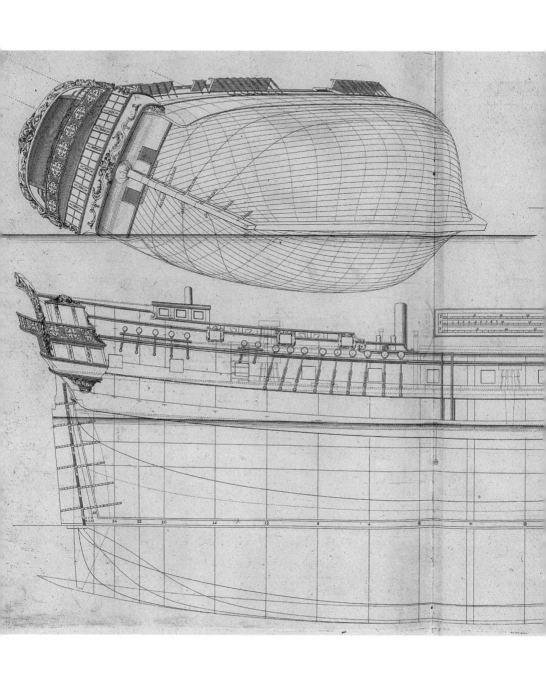

Detail from "British East Indiaman." Fredrik Henrik Chapman, *Architectura navalis mercatoria*, plate 51. National Maritime Museum, Stockholm.

revolutionized the study of botany and provided the framework for the modern nomenclature of species.[28] Chapman's *Architectura*, like Linné's various herbaria and his published systematization, pressed flat and brought together for comparison specimens collected across an extended geography, represented them with beautiful and precise engravings, and organized them according to families and classes. It even, whether or not as a homage to Linné's *Systema naturae*, adopted a binomial system for describing variation, in Chapman's case based on hull-form and rig. Whereas Linné would identify *Physalis angularis* as the definitive name of a species of plant, Chapman would identify "pink, snow-rigged" as that for a particular species of ship. As with illustrations collected in eighteenth-century flora (Linné's *Hortus cliffordianus* might serve as an example), Chapman's three-dimensional views in the *Architectura navalis* portray their subjects in a way at once analytical and momentary.[29]

In the various displacements they suggest, whether of vessels swinging, rolling, capsized or, almost, flying, viewed from beneath—and in the vivid juxtapositions they create between an analytical, orthogonal, projective frame and an instantaneous impression of this order at sea—the three-dimensional views of the *Architectura navalis* speak also to the central technical contribution of the treatise, which again responds to developments in contemporary mathematical theory. Although the tilting motion of various vessels filling the pages of the *Architectura navalis* would have certainly upset cabin furniture, and no doubt the captain of the East Indiaman portrayed in plate 51 would have had difficulty pouring coffee at table behind the wildly tilted windows of its stern gallery, it is equally clear that these are not images of objects in free fall. These ships may be heeled, yes. But the condition eloquently conveyed in these representations is one of stability: of that very special characteristic of vessels occupying water rather than objects lying on land, that the mechanics of this mobile system are all directed to returning it to an upright position. As a ship tips, unlike a vase of flowers, its righting moment increases. This is what allows ships to work. In terms of its theory, particularly as explained in the *Tractat* that Chapman completed in 1775 to accompany the plates, *Architectura navalis* concerns exactly how to calculate this sea-going condition of stability. The images of nautical revolution that Chapman cultivates through the *Architectura navalis* concern an elastic notion of stability (and, by implication,

comfort, commodity, and delight) in which movement itself is no threat to the central decorum of the system; in which order, security, and survival are not themselves threatened by displacement or deviation from a static datum: coffee might be spilt; the vessel rights itself.

This concern and Chapman's endeavor to create diagrams that place the variation in the bodies of ships on a single graphical curve can also be related to the wider discussions between members of academy in Stockholm. In 1770 Chapman presented a paper to the Swedish Academy of Sciences titled "Changes Fighting Ships Have Undergone Since Canon Began to Be Used on Them."[30] In it he acknowledged his debt to theoretical works relating to the behavior of ships by the French geodesist and astronomer Pierre Bouguer (member of the French Academy and author of *Traité de navire* (1746), who first defined theoretically the idea of a metacenter, or center of buoyancy) and Leonhard Euler (Swiss-born mathematician, active in St. Petersburg and Berlin, a member of the academy established by Peter the Great and of the Swedish Academy from 1755, who pioneered the use of mathematics to calculate the area of irregular surfaces; author of *Scientia navalis seu Tractatus de construendis ac dirigendis navibus* [1749]).[31] Chapman's plates contain the first systematic application of this method of numerical analysis, based on calculating sectional areas off a lines plan, to establish how a vessel would float, not only in terms of its displacement but also in terms of its behavioral properties ("trim," which defined the waterline that the projected hull form would adopt, "stiffness," or resistance to lateral turning moment, "roll," which determined how quickly the hull would right itself after being heeled, and "pitch," a description of the longitudinal oscillation a vessel would make in a seaway). Chapman's method for doing this took the abstract and theoretical work of Bouguer and Euler (who wrote primarily as mathematical analysts) and applied it amid the traditional methods and projection systems used by shipwrights.[32] What resulted was an account that clarified which characteristics of a ship's hull produced the gyrations so evocatively demonstrated in the tilted three-dimensional views that structured his treatise.

This analysis is also graved into the plates of *Architectura navalis*. Near its center, each profile view in the book is marked, almost invisibly, with a figure comprising two pairs of concentric circles divided by crosshairs and joined by a vertical line. The

Doubled circles marking the center of gravity (below) and center of buoyancy (metacenter, above). The distance between points (the metacentric height) is an index of the stiffness or righting moment of the ship. Detail from Fredrik Henrik Chapman, *Architectura navalis mercatoria*, plate 51. National Maritime Museum, Stockholm.

lower represents the center of gravity of the vessel in question (positioned by calculating the volume of the ship's physical structure); the upper represents the "metacenter," the effective center of buoyancy for the vessel as it heels or tips (and whose position depends on hull form and requires a whole set of steps to analyze). The distance between these determines the righting moment of the ship, and its size predicts most of the various types of behavior described above. Elaborate as the whole endeavor of the *Architectura navalis* is as a work of drawing, engraving, and reproduction, its analytical significance lies in the ability to position, with pinpoint accuracy, these almost invisible circles. They represent the last layer of information incorporated into the multidimensional renderings of the treatise, each plate presenting at once a record of the outline, construction, and decoration of the body of a ship; a record of the continuous curved surface that defined that body; and a record of the behavior that the particular form of that body would produce when it sailed in its element. Almost invisible in the final drawing, for each ship the projection of this layer took pages of carefully written calculation.

Naval Architecture and the Antique Past

If, for Melanderhjelm, Chapman's work was exceptional in its parallel pursuit of theory and practice, we can ask: Exceptional in regards to what? What was the history, what the eighteenth-century expectation, of a treatise dedicated to the architecture of the sea? Aside from providing links to contemporary discourse within mathematics and the natural sciences, Chapman's architectural theory of ship design recalibrated a longstanding tradition that linked architecture at sea and architecture on land in terms of how both related to ancient precedent. The debate as to whether ships were part of architecture began early. The first modern treatise on architecture, Leon Battista Alberti's *De re aedificatoria*, noted a controversial aspect of classification already in the fifteenth century: "Some, perhaps, would not accept that a ship is a maritime camp, but would claim that the ship serves as a type of water elephant, controlled by its own form of bridle."[33] For other others "the ship is nothing but a floating fortress." But ships, clearly, like buildings, could be analyzed in terms of their belonging to various families, or genera. And the art of ship building was clearly

Part I: Cargoes 1530–1910

one with antique roots. Like buildings, ancient ships appeared in, and could be studied through, the histories that were transmitted in written form from the past. Physical remains were hard to find and harder to preserve—Alberti's attempt to raise a Roman barge from Lake Nemi had brought the remains only to the water's surface; the wreckage was soon reclaimed by the lake, and Alberti's book on the subject, *Nave*, lost—but visual representations of military encounters carved into antique buildings revealed what such vessels might have looked like.[34] From the sixteenth century to the eighteenth, links between naval and civil architecture were made using projections colored by such evidence.

In 1536 Lazare de Baïf, the ambassador to the Venetian Republic for François I of France from 1530 to 1534, produced a treatise called *De re navali* (On ships).[35] For de Baïf there were two antique genera of vessels that underlay contemporary types. On one side he provided an analysis, *De navibus longis*, that gathered all the information to hand concerning antique "longships," the fighting triremes and biremes of the ancients, lightly built for speed in hunt or flight and propelled primarily by oars. On the other, he covered "roundships"—the heavy trading ships of the Roman world, whose form and details were known from antique texts, and which relied primarily on sail for propulsion. De Baïf connected the forms he read about with those that could be seen at the Arsenale, that great dockyard where Venice's fleet was maintained and provisioned, seeing longships as ancestors of the swift, modern Mediterranean oared galley, favored equally by Venetian sea captains and Algerine corsairs, and roundships as progenitors for contemporary deep-displacement, long-distance sailing craft, whose networks stretched farther and farther across the known world. *De re navali* was published, after de Baïf's return to Paris, by François Estienne, son of the celebrated Robert Estienne, printer to the king. Thus while Sebastiano Serlio worked in Venice on the first of his books that related contemporary building to antique archetypes, the French ambassador there, at work for Serlio's eventual patron, was studying the art of the ancients in relation to ships.[36]

In the development of the discourses that theorized building on land and building at sea, the Venetian perspective was to remain central for the next fifty years. That Venice—a place of shifting sands and uncertain ground—should provide a locus that focused attention on the foundations of architecture both naval and terrestrial is a fact that might bear more reflection. In

Hepteres, quæ septem ordinum nauis erat.

D.iii.

Ancient longship. Woodcut from Lazare de Baïf, *De re navali* (Paris, 1536).
National Library of Sweden.

civil architecture Daniele Barbaro's fundamental interrogation of the texts of Vitruvius, as well as Palladio's equally foundational illustrations of that interrogation—visualizing Barbaro's philological endeavor; projecting and constructing buildings informed by it—was performed in a context where the experience of being waterborne was central.[37] Certain of Palladio's commissions rose, literally, out of the water: building foundations in Venice could not be conceived without this parameter; neither could the transport of materials to the building site. The growth of a Renaissance discourse around the architecture of ships, and of the role of antiquity in informing that design, also evolved out of knowledges and practices enacted in cities where sea and land met: Venice, Genoa, Livorno, Palermo, Naples, Barcelona, Valencia, Palma de Mallorca, and Lisbon.[38]

Thirty years after Lazare de Baïf's treatise was published these connections informed widely shared interpretations of the Battle of Lepanto. Lepanto pitched four hundred Mediterranean galleys against each other in an engagement that became symbolic for an alliance of Christian European states antagonistic to Ottoman interest.[39] The Christian fleet comprised vessels constructed at the locations listed above (half supplied from Venice) assembled under the banners of the Venetian Republic, the Spanish Empire, the Papal States, the Dukedom of Savoy, and the republics of Genoa and Tuscany. All this happened in 1571; the interpretation and mediation of the event continued in centers of Christian power until the end of the century.[40] Representing and internalizing their victory, European writers identified a balance between Lepanto and the antique sea battles of Actium (31 BCE, in which Octavian Augustus conclusively defeated Marc Anthony to take control of the Mediterranean world), and Salamis (480 BCE, in which the Greek city-states in alliance defeated the Persian invasion fleet of Xerxes among the islands of the archipelago). The mirror that permitted this identity was the connection already perceived by de Baïf between the modern Mediterranean galley and the longships—triremes and biremes—that faced each other in Herodotus's, Strabo's, Polybius's, and Tacitus's accounts of the great sea battles of antiquity.[41] This identification played in to a contemporary architectural revival that staged *naumachia* (sea battles) in the courtyards of great buildings, flooding them to allow miniature craft—usually fighting galleys—to enact ritual warfare. Part of a series of such spectacles, the wedding of Phillip II

to Anne of Austria was celebrated in this way in the courtyard of the Prado in 1570; that of Ferdinando de' Medici to Christine de Lorraine inside the Palazzo Pitti in 1589.[42] The architectural overtones in this connection are distinct. Sixtus V's actions in Rome—facing up to and subjugating the pagan monuments of the city; adopting the structures of the ancients into a story of Christian victory through technological *virtù*; boarding ancient colossal columns and hoisting Christian colors over them; taking obelisks as prizes and employing them for his own purposes—can also be seen in light of this tradition of *naumachia* in which rituals of cultural victory and defeat are played out through moving *batiments*.[43] Indeed, Sixtus gave audiences from a throne in the Sala Regia at the Vatican situated beneath two frescos of the Battle of Lepanto (by Giorgio Vasari), in which antique resonance and latent architectural significance are both apparent: in one, galleys are shown in seething engagement, with oars, blood, masts, and men in a confused profusion echoing the textual accounts
COLOR PLATE 1 of Actium and Salamis; in the other, Christian ships are ranged against their Ottoman foes for all the world like buildings in a precisely organized city plan.[44]

Land and Sea

This division of the seagoing world into two genera of vessels, one descended from antique longships, the other from roundships, and a link to the settings of architecture on land, was celebrated again by Joseph Furttenbach, who studied in Italy at Genoa, Pisa, and Florence during the early seventeenth century.[45] Returning to his native Ulm, Furttenbach published a book detailing his years of study in Italy, followed by a remarkable series of treatises that defined various forms of architecture: *Architectura civilis* (1628), substantially inspired by the books of Serlio; *Architectura navalis* (1629), which dealt with the architecture of the sea; *Architectura martialis* (1630) on military hardware and fortification; and an *Architectura universalis* that treated all these as subdivisions of one art (1635; the series ended with an *Architectura recreationis* produced in 1640, a bewildering speed of production for five highly illustrated treatises).[46] Furttenbach's *Architectura navalis* is divided into two books, the first devoted to the class of longships and the species that fall within that class ("of the manner of Galleys, Galleases, Galottas,

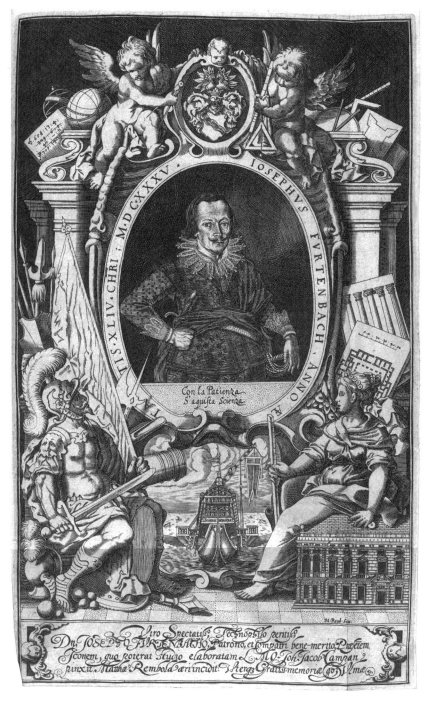

Joseph Furttenbach. Frontispiece to *Architectura universalis* (Ulm, 1635).
National Library of Sweden.

Joseph Furttenbach. Frontispiece to *Architectura navalis* (Ulm, 1629).
National Library of Sweden.

N

N

R

M

M

M

R

S

Q

H

V

Q

R

Q

G

B

T

O

L

AVALIS.

N ZWEY THEILEN

ch, Im Iahr, 1629.

a. Iahren nicht nachzutrucken.

D

A

E

Iacob Custodis
Scalpsit

Brigantines, Feluccas, Frigates, Barchettas and Piattas"); the second devoted to deep-displacement sailing craft ("of the manner of [sailing] Ships, Polaccas, Tartanes, Barcones, Caramuzalas"). The third section describes the architecture of the Battle of Lepanto, showing how the ship types described in book 1 were dispersed in combat, illustrated with minute precision in two plates showing plans of the battle.

In Furttenbach's work, whatever an *architectura navalis* might be, it is encompassed by the decorous rules of an *architectura civilis* or *martialis*, a conclusion suggested strongly by the frontispiece to the *Architectura universalis*, where a tiny galley, stern on, sails into the paper, hemmed in by all the trappings that guarantee architecture's propriety on land—compasses, plans, facades, orders, ornament—and surveyed by personifications of architecture martial and civil.[47] In the *Architectura navalis* the same galley is portrayed, *Fulmen in hostes* ("blast your enemies") writ in tiny text on its stern, receding from the viewer, sculpturally frozen in an absolutely symmetrical composition using the same aerial perspective Furttenbach employed elsewhere to illustrate palaces and gardens. The port shown in the frontispiece, filled with the vessels that are the subject of the treatise, takes the form of a Roman theater, complete with a *scenae frons* containing the title inscription, the organizing grid of a stable terra firma visible in front of it. These images articulate the relationship between land-based architecture and its sea-based twin in rather the same way as did representations of antique and contemporary *naumachia*. In such tableaux, however chaotic the warring and whirring of the fighting ships could be, the confusion is safely contained within a decorous, stable architectural frame: the diversity of ships, their sometimes chaotic and catastrophic interaction, is articulated within the fixed and certain form of orthogonal architectural composition. It seems a profoundly Mediterranean vision of sea-architecture, in which the water is safely surrounded by the land.

A hint of a wider vision of an *Architecture navale* is contained in the 1677 treatise published by François Dassié, superintendent of design at the French naval base in Toulon.[48] Dassié echoes Furttenbach in linking naval to civil and military architecture but with a quite different emphasis. The New World would never have been discovered, Dassié claims, its peoples would still live "without policing or religion, or the light of the gospel," neither could princes control their empires, without this art:

Part I: Cargoes 1530–1910

Many authors have dealt with . . . architecture, Civil and Military. But it seems that they have neglected to instruct us about Naval Architecture, which, as well as discovering the New World, has made known peoples living without policing and without religion, and who without the help of this admirable science, would not [yet] have been instructed in the lights of the Gospel. Not only this, but it is also through [Naval Architecture] that Princes make their glory known to the most distant Nations, and by the movement it gives to their Naval Armies, it guarantees the grandeur, the happiness, the brilliance and the power of their Empires.[49]

Magnificent and terrifying, this paragraph suggests that an architecture of the sea is connected to the action of relocating social systems into wild, uncharted locations. Ships move mores. They transport social hierarchies and practices, and in doing so they encode such practices into physical construction. This 1670s vision implies a new relationship between the architecture of the sea and that of the land. The sea is wider. The ships it contains are no longer surrounded by any known land-based societal order. Where an early seventeenth-century *naumachia* articulates naval chaos surveyed by polite society from the windows of a surrounding, ordered architecture, ships in Dassié's vision must internalize order and project it onto surroundings that are unknown.

Like Furttenbach (and de Baïf), Dassié suggests that two genera underlie the diversity of modern shipping, but here the hierarchy between the two types is reversed. The first book of the treatise explains the geometry of deep-displacement, ocean-going fighting ships, vessels that can support the kind of agency Dassié reserves for naval architecture in his preface, and defines both their construction and all the objects, including human actors, necessary to their operation. The fast-moving galley, limited to coastal warfare but crucial to Louis XIV's political ambitions in the Mediterranean, is treated in the second book, which describes its geometry and construction and all the components required for its provision and working.[50] A separate work, *Le routier des Indes orientales et occidentales, Traitant des saisons propres à y faire voyage* . . . is presented as an integral part of the same project in Dassié's introduction (and usually bound into the same volume). It concerns the dangers involved in the global mission of the naval architecture he envisages: the navigation of various seas; positions of harbors

NAVMACHIA

Idest Naualis pugnæ ex uetusteis lapidum et nummorũ
Sub colle Hortulorum nimirum sub

Naumachia ita dicta a prælio nauali. ad exerẽdã enim iuuentutẽ Roman·
quã castris Romanũ prorogãretur imperiũ. Hanc Domitianus Imp. extr·
terant aquæ per aquæ, ductus ex locis editiorib' deduci Effossa enim terr·
pelagus efficiebat latissimũ ita ut nauib' ac triremibus esset locus ualde ·
ubi modo pelagus, nunc tellus uideretur; cũ peregre aduentantiũ præse.
modo colligitur quãta fuẽrit eius magnitudo, nõ desunt qui uolunt ad Tibe·
prælia, nõ minore spectatiũ uoluptate quã ea geretiũ utilitate, eo modo in Cr·
stabatur et otiũ pelleretur ex Vrbe, populus teneretur, et Rom' præsertim iuue·

Giacomo Lauro. "Naumachia Domitiani," from *Antiquae urbis splendor* (Rome, 1625).
National Library of Sweden.

monumenteis graphica deformatio

Monte Sanctiss.ᵃ Trinitatis.

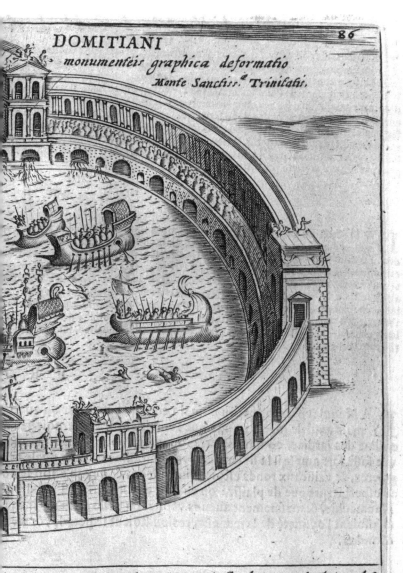

estri, sed etiã nauali prælio Naumachiæ instruebãtur, quod nõ minus classe
hortuloꝛ, loco sane cõmodo, quod facile in ualle hanc̃, Martia dicebatur, po-
muro cinxit fossam amplissima, in quã ex aquæductis émissa aqua, lacuꝛ seu
enim artificio nũc educebatur aqua nunc reducebatur finito prælioꝗ ut
atque oblectatione Adhuc supersũt nõ nulla uestigia ex quibus aliquo
xcurriꝰe nauibꝰ enim hic triꝛemiũ instar naualiã ut dixi, cõmittebatur
theatris terrestria prælia inibatur. Ex hrs enim exercitationihꝰ ille fructus con-
o otio asuefieret prælijs quibꝰ Romanũ ꝓpagãdũ et tuendũ erat imperiũ cõmittedꝭs.

in the New and the Old World; seasonal perils. Where Furtten-bach ends with a description of the land-circumscribed Battle of Lepanto, Dassié ends with movement toward an open horizon.

Patrons and Protagonists

From the mid-seventeenth century, in this evolving idea of a naval architecture, there was a living overlap between the pro-jection and construction of buildings on land and the projection and construction of ships. In France, Charles Le Brun, as well as supervising much of Versailles, had oversight responsibility for the decoration and design of all of Louis XIV's navy, including ves-sels constructed at Toulon where Dassié was superintendent.[51] As well as critique and regulation, his role included direct proposals for the visual articulation of galleys and men-of-war, which piled up scrollwork and glass-screens into ever more elaborate compo-sitions. Le Brun's successor Jean Bérain, as well as designing the-ater sets for Jean-Baptiste Lully's Théâtre du Palais-Royal, drew up facade drawings for the "château arrière" of over one hundred fighting ships.[52] Both translated the motifs and flowing lines asso-ciated with monumental architectural detailing in stone across to the medium of moving timber. Those who realized these works worked in fluid ways between sea and land too. During the same period Le Brun supervised the visual appearance of the French navy, Pierre Puget, who had a background as a naval decorative carver at Toulon, assisted in the decoration of the Palazzo Barbe-rini in Rome for Pietro da Cortona and with the garden sculptures at Château Vaux-le-Vicomte for Nicolas Fouquet, before returning to work in the French royal dockyards in Toulon and Marseilles.[53] As well as contributing to the development of Louis XIV's galley fleet, he designed warships' stern galleries covered in sculpture so monumental that Colbert was forced to issue orders forbidding their execution on the basis of architectural overloading: Puget's Tritons and Neptunes were considered unseaworthy.[54] Another Le Brun contemporary, Philippe Caffieri, moved from working as a sculptor at Versailles, via a commission to decorate the Venetian gondolas designed for its canal, to become master carver for the naval dockyard at Le Havre.[55] Slightly later François-Antoine Vassé, whose father ran the academy set up by Jean-Baptiste Colbert to train wood carvers in ship decoration at Toulon, won the Prix de

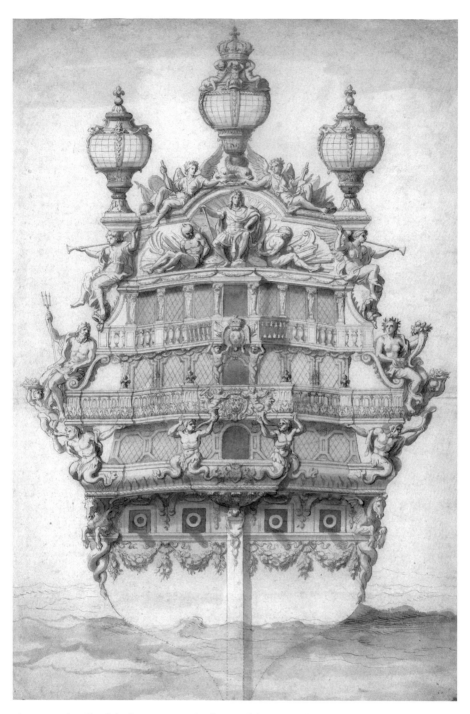

Pierre Puget / Studio of Charles Le Brun. Design for a royal ship, pen and watercolor, ca. 1670. RMN Grand Palais, Paris.

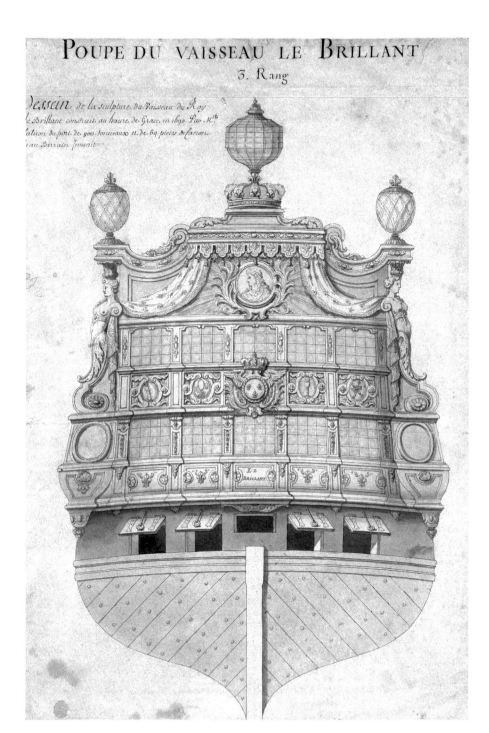

POUPE DU VAISSEAU LE BRILLANT

3. Rang

Dessein de la sculpture du Vaisseau du Roy
le Brillant construit au havre de Grace, en 1690. Par M.
...ation du port de 900 tonneaux et de 64 piéces de canon
...ean Berain fecit

Jean Bérain. Design for the French ship *Brillant*, pen and watercolor, after 1670.
Musée national de la Marine, Paris.

Rome, executed decorative sculptures at Versailles and at the Hôtel de Toulouse in Paris under Robert de Cotte, Premier architecte du Roi, and became a member of the Académie royale de pienture et sculpture, who commissioned from him a figure in marble representing "la Marine."[56]

The same kinds of transference occurred also internationally. The subject of the first ever monumental engraving to be commissioned in England, the decorative scheme of the *Sovereign of the Seas*, built for Charles I by the shipwright Phineas Pett, was developed by Charles's court dramatist Thomas Heywood, designed by the court painter Anthony van Dyck, and executed by John and Mathias Christmas, ship carvers by training, who in their turn worked in stone on the royal palaces at Greenwich and Whitehall for Inigo Jones.[57] A little later Samuel Pepys's protégée, the shipbuilder Anthony Deane, produced yachts for Louis xiv and also wrote a treatise on naval architecture during the same years that Antoine-François Vassé was using skills acquired in the ship-carving academy in Toulon to decorate hotel interiors in Paris.[58] In both countries architects, artists, and craftsmen were part of a state endeavor to create, in one way or another, an image of potency via the celebration of a ruler: "Nothing strikes the eye nor signals the magnificence of the King better than a well adorned ship parading on the sea," Jean-Baptiste Colbert observed.[59] Colbert it should be remembered was simultaneously Secrétaire d'État de la Maison du roi and Secrétaire d'État de la Marine. French naval ships touched both categories: separate from the land, they were nevertheless one more part of the king's estate, part of the *maison* that Colbert was responsible for administering, their form and decoration understood to articulate a very global idea of possession and inhabitation.

The division of shipping into genera, the claims for the contemporary significance of ancient naval technology and form, and an assumption that linked the architecture of ships and buildings in terms of their similar status in reflecting state power was carried from the seventeenth century into the eighteenth. Around 1692 Henri Sbonski de Passebon dedicated a *Plan de plusiers bâtimens de mer* to Louis-Auguste de Bourbon (General of His Majesty's Galley Fleet stationed at Marseilles and the illegitimate son of Louis xiv).[60] A picture book more than a treatise, it commences with seductive views of the major cuts through examples of the two genera of ship and provides detailed plates on particular specimens

within them, first of deep-laden, ocean-going military vessels, then of galleys. Architects remained preoccupied by objects that were part ship / part house. Bérain's proposals for *Le Soleil Royal* or Puget's for a royal vessel with Le Brun from the 1670s and 1680s, could be balanced by William Kent's designs for Prince Frederick's barge executed for the Prince of Wales and George I of England in 1732.[61] In the 1750s Henri-Louis Duhamel du Monceau would explain naval architecture using detailed description of the same two genera with reference purely to fighting vessels, and in 1768 André-François Boureau-Deslandes could still hope for an audience for his *Essai sur la marine des Anciens et particulièrement sur leurs vaisseaux de guerre*, analyzing the characteristics of ancient longships.[62] But following Dassié, the kind of order that naval architecture described was changing. In the century that saw the birth of modern economic thought and the domination of large areas of the world by a few powerful actors led by merchant adventurers, the development of shipping was informed both by the balance of power and the issue of exchange. This challenged some of the logical affordances that ship building tradition assumed. Speed and maneuverability, associated with light hull forms and rowing propulsion, had been essential for ancient fighting ships; sail power, low speed, and load-carrying capacity, associated with the ancient form of the roundship, were the primary quality for trading vessels. In a context of global dominion, however, trading ships took on something of the character of fighting vessels. They collected goods from destinations where they frequently needed to be armed; they projected and represented systems of order from one part of the globe on to another; their goods needed to travel effectively through different kinds of waters. At the same time fighting ships required many of the qualities of heavy-displacement wind-powered trading vessels: they carried very heavy guns and hundreds of men; they had to be equipped for long voyages without reprovisioning; they fought at low speed to maximize the time in which guns could be brought to bear on an enemy. Chapman noted these evolutions carefully in his 1770 paper to the Swedish Academy on the changes vessels had undergone since they began to carry canon.[63]

The implications of these changing emphases can be seen in the work of Chapman's contemporary Julien-David Le Roy. Trained as an architect, Le Roy's tenure as an academician at the French Academy in Rome from 1751 and 1754 included a trip to Athens,

Corinth, and Sparta to record their architectural remains, an endeavor that mirrored that of James Stuart and Nicholas Revett during the same period, and which lead to the publication of *Les ruines des plus beaux monuments de la Grèce* (Paris, 1758, revised in response to critique from Stuart and Revett in 1770).[64] His journey from Rome to Venice, to Constantinople, and on to the Peloponnesus immersed him in the experience of travel by sea, and specifically by sea in the Levant. After his return to Paris, and having established himself as an international, if not unchallenged, authority on Greek architecture, Le Roy turned his attention to studies of ship design, advocating the contemporary potential of ancient technology in confronting problems of exchange and distribution. For Le Roy the urgency of naval architecture turned on the question of guaranteeing political stability through the provision of goods at the right time and in the right place.[65] This was a sentiment repeated widely in the eighteenth century across European seafaring states. As Lord Haversham had it in an English House of Commons speech in 1707:

> Your fleet and your trade have so near a relation and such mutual influence on each other, they cannot well be separated: your trade is the mother and nurse of your seamen: your seamen are the life of your fleet: and your fleet is the security and protection of your trade: and both together are the wealth, strength, security and glory of Britain.[66]

Le Roy bemoaned how it could take longer for goods to reach Paris by boat from Rouen than it did to cross the Atlantic or to make the journey from the Baltic to the mouth of the Seine.[67] His interest in providing a better aquatic infrastructure hinged on finding a kind of vessel that could iron out these differences. The means he chose for doing so echoed his earlier studies of architecture. The ancients, he claimed, owned the technology that could solve these urgent contemporary problems; the moderns' duty was to understand, and so to use it. Where his studies of architecture provided a taxonomy of Greek building across two volumes—one historical, collecting textual references to the works, one comparative and architectural, recording their remains and projecting their original forms through drawing—his studies of naval architecture extended a tradition of studying the fleets of the ancients through texts (as had Lazare de Baïf or Boureau-Deslandes) and combined

this with empirical investigation (his experiences of voyaging "on the seas of the Levant, in oared vessels of all kinds"), to find, in the form for the antique longship, the solution to the modern quandary about how vessels could move their cargoes across open sea and into the land.[68] Where sailing warships had taken on some of the characteristics of antique roundships, modern trading vessels might look back to the feats of those legendary triremes and biremes that fought at Actium and Salamis. This conclusion was directly informed by Le Roy's experiences of the Greek archipelago and the Black Sea and was voiced both in a research publication, *On the Longships of the Ancients . . .* (1786), and in his "Letters to Benjamin Franklin" (1788):

> The Archipelago offers those who sail there a fascinating spectacle. On Greek ships and a diversity of other craft one sees every rig conceived by mariners ancient and modern.[69]

> In the ports which the Russians have at Kherson, on the Black Sea, one would not find [now], I wean, a vessel which, setting sail, went as far as the first cataract of the Nile. Ancient ships made this immense journey. Starting from the Palus-Méotides they crossed in continuous navigation the Black Sea, that of Marmora, the Archipelago; they slashed across the Mediterranean to the mouth of the Nile, sailed up that river, and reached Ethiopia in less than twenty-five days.[70]

The special thing about these ships, their potential as a key to unlocking the problems of maritime distribution, lay in their design. They had, the classically trained Académie française architect observed, "a very elongated shape, almost parallelepiped, little displacement, little width, rigged with lateen sails." In this case a land-based architect's sensibility concerning form and design was used to speculate on the future of an *architecture navale*: "this property of the ships of the Ancients resulted mainly from being flat below: they drew little water."[71]

The Future and the Mobile Interior

The fluid relations that linked actors with interests in shipping and building extended directly from France and England to

Sweden throughout this period. Chapman's competitor, the Swedish academician Gilbert Sheldon, was the grandson of the Francis Sheldon who oversaw the architectural decoration of the *Sovereign of the Seas* for Charles I and who later built the *Naseby* for the commonwealth forces of Oliver Cromwell.[72] Swedish naval architecture was linked with French royal architecture in the later seventeenth century through the association of Jean Bérain and the Swedish royal architect Nicodemus Tessin. As well as providing designs for the French fleet, Bérain was commissioned by Tessin COLOR PLATE 2 to provide drawings for the decoration of the Swedish warship *Segern* (Victory) in the early 1690s.[73] Tessin, who superintended the rebuilding of Stockholm's royal palace, intended that the master carver René Chauveau, who was trained by Philippe Caffieri at the ship-carving workshop in Le Havre and who moved to Stockholm in 1693 to work on the decorative scheme for the palace, should execute this work.[74]

These international and interdisciplinary links remained strong in the generation of Chapman and his nearest collaborators. Entrusted to Carl Hårleman, Carl Johan Cronstedt, and Carl Fredrik Adelcrantz after Tessin's death, the project for Stockholm's royal palace involved decorators and carvers recruited from Paris throughout its construction.[75] Among them Hårleman recruited Jean Eric Rehn, who was asked to design the interiors at the summer palace of Drottningholm outside Stockholm as well as to prepare a decorative scheme for the Chapman-designed ship *Adolf Fredrik*; Hårleman himself produced designs for the Swedish cadet training vessel *Prins Gustaf* in the 1740s.[76] In the 1760s Chapman's friend the architect Carl August Ehrensvärd purchased copies of Bérain's designs for the French fleet on a study visit to France paid for by the Swedish navy (these included the first-rate ship *L'orgueilleux* (1691), the third-rates *Agréable* (1693) and *Brillant* (probably 1691).[77] Ehrensvärd had ambitions to succeed Adelcrantz as architect of the royal palace. He studied the architecture of antiquity in his own Italian journey from 1780 to 1782, drew fantastical sketches in which he envisaged moving Stockholm to Sicily by air FRONTISPIECE balloon, became an admiral, and designed buildings for the royal dockyards in Karlskrona in southern Sweden.[78]

Chapman's own trajectory can be seen as quintessentially part of this fluid pattern: he studied ship design at the royal docks at Chatham in England and at the royal naval base at Brest in France during the 1750s, where he recorded the architectural decoration

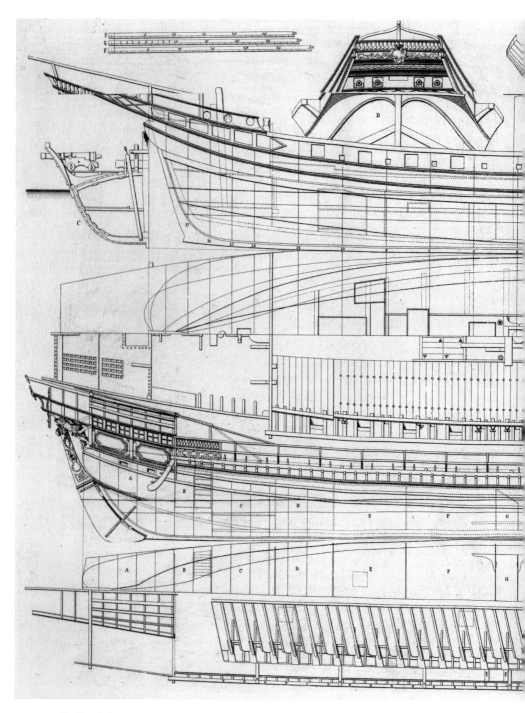

"An Algerine Chebec"; "*La Capitana*, a Row Galley of Malta." Fredrik Henrik Chapman, *Architectura navalis mercatoria*, plate 58. National Maritime Museum, Stockholm.

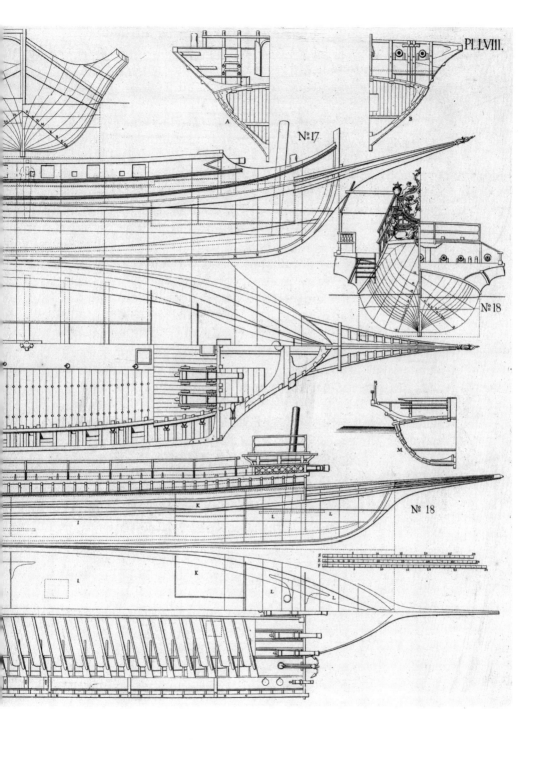

Pl. LVIII.

A

B

Nº 17

Nº 18

M

Nº 18

of vessels including the English *Victory* (1737, forerunner to Nelson's) and the French *Fleuron* (1729); he produced a series of naval buildings in Karlskrona, discussed figurehead decoration with the great Swedish sculptor Johan Tobias Sergel, and designed his own country estate, its composition aspirational and in part neoclassical, but not really as good as those of his friend Ehrensvärd.[79]

Chapman was also aware of the nuances that attended the division into two types of vessel that articulated earlier treatises on the architecture of ships. Like de Baïf and Furttenbach, like Dassié, Deslandes, and Duhamel du Monceau, like all his practical and war-minded contemporaries, Chapman lived in a context that understood the strategic and historical significance of the swift-moving galley contra slower-moving, deep-displacement sailing ships, merchant or military.[80] Årre's frontispiece to the *Architectura navalis* makes a nodding reference to this division: the round-bodied merchantmen that occupy most of its panorama contrast with the sharp noses and frowning oblique rigging of a collection of galleys at the extreme right of the picture, muzzled and separated from the other shipping by a picket fence. Comparing vessels of war from different nations in the *Architectura navalis*, Chapman, as had Dassié and Furttenbach before him, juxtaposed the full-bodied, ocean-going sailing warships of northern Europe with their oar-propelled Mediterranean equivalents, illustrating *Unicorn*, *La Sirenne*, *Jaramas*, *Blau Hagern*, and *Neptunus* (frigates from England, France, Sweden, Denmark, and Holland respectively, plates 55–57) against the outlandish forms of the Algerine chebec and the Maltese galley (plate 58). Galleys were still of sufficient importance for him to produce drawings of a reformed version in 1769 for the Swedish navy.[81] And Chapman, as did shipwrights from Venice to London, used the form of the galley as a template for projecting designs for ceremonial barges and pleasure craft. In 1770 he completed a royal yacht for Gustaf III. Named *Amphion*, her similarity to Mediterranean fighting galleys is emphasized in the colored drawings Chapman produced during the process of her commissioning. Like the surprising and unlikely experiments made during the same years by Julien-David Le Roy (who constructed three yachts, the most successful named *Naupotame*, to demonstrate his theories about how the form of the longship might provide a vessel able to carry goods both across the ocean and far into the land), *Amphion* can be seen as a semisuccessful longship *manqué*, her name suggesting both hybridity and an

antique heritage: Amphion was the builder of the walls of Thebes, dweller in two worlds, lover of Hermes, and doubly celebrated for his prowess in battle and in music.[82]

Thus Chapman's adoption of *Architectura navalis* as the title of his treatise can hardly have been accidental. The works of de Baïf, Furttenbach, Dassié, de Passebon, Boureau-Deslandes, and Duhamel du Monceau were available for study by those associated with the Swedish court, the navy, and the academy.[83] And when he chose to describe the world of shipping as architectural; to divide that world into two major families of craft, the one fleet the other heavy; to represent these vessels through beautiful and seductive images, and to celebrate their architectural detailing with such virtuosity, Chapman was at once speaking to a contemporary field of analytical, scientific achievement, and to an international context of artistic experimentation, at once naval and architectural, that situated visual projections in the present within a deep and enduring sense of the past.

Exchange

Yet, in its interrogation of architectural detail, and in its analytical perspectives that record the areas of a ship that most literally resemble a building in wildly oblique projections that no land-based architecture could endure without catastrophic results, *Architectura navalis mercatoria* exhibits a line of thinking that appears strikingly new. It screens variety. Where previous treatises sought to exemplify principle (how a section was constructed; the primary characteristics of a type), Chapman's *Architectura navalis* is built upon an exhaustive survey of minute difference (in form, in surface detail). And where Dassié and Duhamel du Monceau represented vessels only in an undeviatingly stable condition— upright, orthogonal, architectural—Chapman disturbs this tradition with images that remain analytical but which view ships as mobile, pliant, alive. To understand quite how prescient these innovations were, and to follow the meticulous way in which they forecast future relationships between the architecture of land and sea, we must return to Årre's frontispiece. As the engraved title shows, Fredrik af Chapman is unlike any of his literary predecessors in that he frames the whole of his enquiry about naval architecture in terms of trade. Where for Duhamel du Monceau

or François Dassié, naval architecture could be explained through the contrast between two types of fighting ship, for Chapman fighting is another of the activities in which ships take part. Chapman's work does not limit its attention to a particular kind of vessel (military or merchant); rather it identifies with precision an objective that applies to all naval architecture and which conditions its theory: to characterize, and to reveal the common rules that governed objects moving in actions of exchange. In order to describe the phenomena of ship design, this transnational, transactional, and translational aspect—implicit in the last word of the title (*mercatoria*)—has to be captured.

This new kind of insight posited a connection between shipping and architecture based on exchange. Although such a connection was implicit in Dassié's claim for naval architecture it remained undeveloped in his treatise, which was limited to the description of fighting ships. Shipping, the infrastructures of exchange it entailed and the interfaces between life afloat and life on land that it created, was a vivid part of Swedish experience in the mid-eighteenth century, not only in terms of military encounter but also in terms of economic security and intellectual identity. Timber and timber derivates such as tar, supplied from the Baltic to Europe, underlay much of the geopolitics of eighteenth-century warfare and trade.[84] The contemporary initiatives pursued through the Swedish Academy of Science to measure and understand the earth all involved ships. Almost every specimen of plant and animal life that Linné collected through his wide network of contacts was moved by ship, including those provided by Daniel Solander, who traveled with James Cook on the first of his voyages of discovery on the *Endeavour* from 1768 to 1771.[85] Pierre Bouguer, whose work on mathematics Chapman adapted, wrote his treatise on ships during a five-year expedition to Peru, part of a bifocal initiative by the Académie des sciences and the Swedish Academy to determine the radius of the earth at the equator and poles—the other half of the expedition traveled to Meänmaa in northern Lapland under Anders Celsius.[86] These experiences—military, intellectual, economic—were also personal to Chapman. Aside from acting as a main consultant for the navy and interacting closely with members of the academy (at his acceptance speech on his election to the academy in 1768 he noted the marine context in which Bouguer's treatise was written), in 1764 Chapman became an owner of the Djurgården shipyard in Stockholm as part of a

syndicate that included Sweden's greatest ship-owner, the merchant Johan Abraham Grill, a major shareholder in the Swedish East India Company.[87] There he designed and built the company's third large trading ship, the East Indiaman *Cron Prins Gustaf*, during the same years that the plates of the *Architectura navalis* took shape. His knowledge of the military significance of timber exports, the naval background to scientific exchange, and the economic significance of shipping to the East must have been intimate.

The grand vessel that dominates the view beneath the title in the frontispiece to *Architectura navalis mercatoria*, its stern situated directly beneath the "*A*" in *Architectura*, has a specific place in that story. Like a warship this object bristles with guns, receding into the perspective beneath open ports. And like the fighting ships Chapman and his contemporaries drew at Chatham or Brest, it has an after-castle, a "château arrière" covered with elaborate decoration. Akin to many royal ships this one is named for a royal personage: the cartouche on its stern (a device adopted from French naval practice) reveals his monogram, an elaborately curled "p.g" for Prince Gustaf. This is no vessel of war, however, but rather a merchantman, or more specifically an Indiaman, or more specifically than that, an East Indiaman. The same East Indiaman in fact, *Cron Prins Gustaf*, that the Swedish East India Company commissioned from Chapman during the 1760s and the same vessel as is portrayed, in plan, section, and elevation, in plate 1 of Chapman's treatise. She was completed and launched in Stockholm, probably from the Djurgården yard that would have lain directly behind Olof Årre as he worked on his panorama, sometime in 1767 and sailed on her first expedition, to Canton, on December 19 of the same year.

As a type, the Indiaman says much about the changes that would redefine the study of naval architecture, previously limited to vessels of war, in terms of trade. Le Roy's eccentric endeavor during the 1770s to claim the form of the ancient fighting longship as the logical receptacle for moving goods might be seen as an inverse reflection of a process already in train from the 1670s, in which the physiognomy of modern deep-displacement fighting ships, with their canon ports, their architectural elaboration, their "maisons arrières," and their military lion-rampant figureheads, began to be adopted by a series of colonializing corporations whose mandate lay somewhere between trading and raiding. As well as the East and West India Companies in England; the Compagnie française

des Indes orientales in France, the Vereenigde Oost-Indische Compagnie in Holland, the Svenska Ostindiska Companiet and Ostindisk Kompagni in Sweden and Denmark respectively, all imported exotic merchandise from far-flung locations, and exported architectural detailing connected to royal display to a marine that was merchant rather than military.

The vessels these companies developed indicate a new dimension in which life at sea became architectural. The logic of exchange in which an East Indiaman such as *Cron Prins Gustaf* was involved assumed a period of continuous habitation on shipboard of eighteen months—having left Sweden in 1767 her first round trip to Canton brought her back to Gothenburg on June 1, 1769.[88] For that period of time she provided a habitat for 154 souls, including Jean Abraham Grill, son to Johan Abraham, who sailed as her supercargo—equivalent in mercantile terms to an admiral or commodore who dictated overall strategy. The experience of this kind of duration applied also to other sea-borne journeys. As Cook's and Bouguer's voyages show, scientific expeditions to the New World took anything between three and five years—as long as a university degree—sometimes oriented around tenure in a single vessel.[89] And largely because of the endeavor by European nations to map and control other parts of the globe, the development of naval warfare in the second half of the eighteenth century placed similar requirements on ships of war: once seasonal, naval tours of duty began to be measured in years—the British fleet that blockaded Brest in the Napoleonic wars at the end of the century had tours of duty of at least sixth months; thirty-six-month terms were not unknown.[90] All these vessels had one thing in common: to function, they required that human actors inhabit them over long periods of time. If architecture is that which gives form to, and whose theory describes, human habitat, the ships that bore these lives must be thought of as architectural.

We might say that this was a period in which architecture traveled further, more often, and in ways it had never traveled before. The lives lived on shipboard were spread out into every corner of a tightly packed vessel of war, and evenly across the upper deck of those vessels involved in global trade. But the lives we know most about—the lives of witnesses like Bouguer on his journey to Peru, or Jean Abraham Grill, returning as supercargo from Canton, or Daniel Solander who accompanied Cook to the Pacific; indeed, the lives of the entire officer class of the sea-going European states

aboard the war vessels Chapman drew—these lives were lived in the hindquarters of the ships that hosted them, on what was known as the "quarterdeck." (The list of Chapman's vessels, the *Unicorn, Sirenne, Jaramas, Blau Hagern,* and *Neptunus,* mirrors exactly the list of countries that set up trading corporations with the East Indies.) And it is in these areas that the *Architectura navalis* charts in microscopic detail how systems of detailing elaborated on land and systems of ornamentation employed at sea overlap.

Stern-Works

For every ship—merchant or military—represented in the *Architectura navalis* there lies, behind the windows of its complete stern elevation, a life of inhabitation. While they varied greatly, the rooms these windows lit—occupied by captains, admirals, supercargoes, scientists, officers—shared certain characteristics. They all rocked; they often included a space the full width of the ship; in all of them occupants had to bend their heads. And they all involved the paradoxical placement of architectural elements that spoke of order, domesticity, delicacy, and fragility—of "home"—in direct juxtaposition with objects and scenes whose nature varied between the orderly and the ungovernable, the wild and the changeable: a native port, the endless sea, canon, strange coastlines. The experiential quality of the apartments that occupied the sterns of great ships is evident in the drawings of the vessel that Chapman uses to introduce the second section of *Architectura navalis mercatoria,* the privateer that is portrayed in three-dimensional view, heeling gently and approaching the viewer on plate 31. The next plate (32) provides an internal section and internal plans of this vessel, atmospherically rendered to give an idea of the lighting of her interior. Sun streams in through the stern windows shown at the right-hand side (the ship sails left to right, as if the sectional drawing was an elevation of a half model of the hull rotated through 180 degrees to show its interior). The view picks out delicate decorative details in two great chambers, numbered 48 and 69 on plans and section, one above the other. In the background, paneled doors open to show the inside of a sleeping cabin and of the "lantern" that projects out as the decorative stern-work on the exterior wraps around onto the sides of the ship. A delicate settee stands in profile against the wall to the rear balcony in the upper room; a

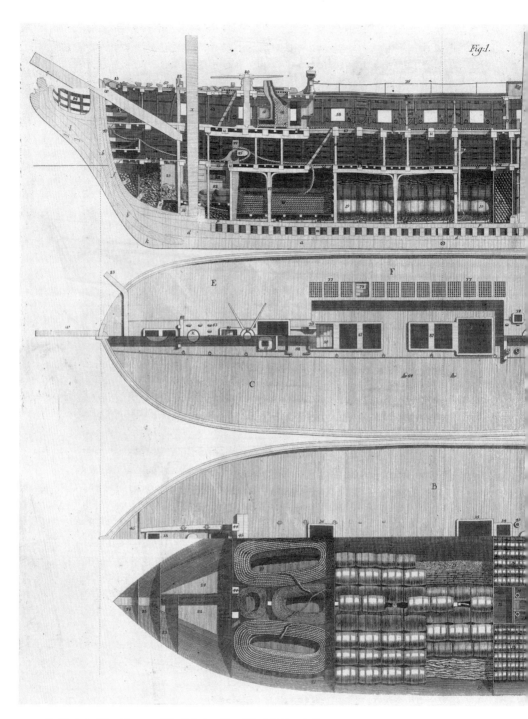

"Sections and Contrivances of the Privateer No. 1." Fredrik Henrik Chapman, *Architectura navalis mercatoria*, plate 32. National Maritime Museum, Stockholm.

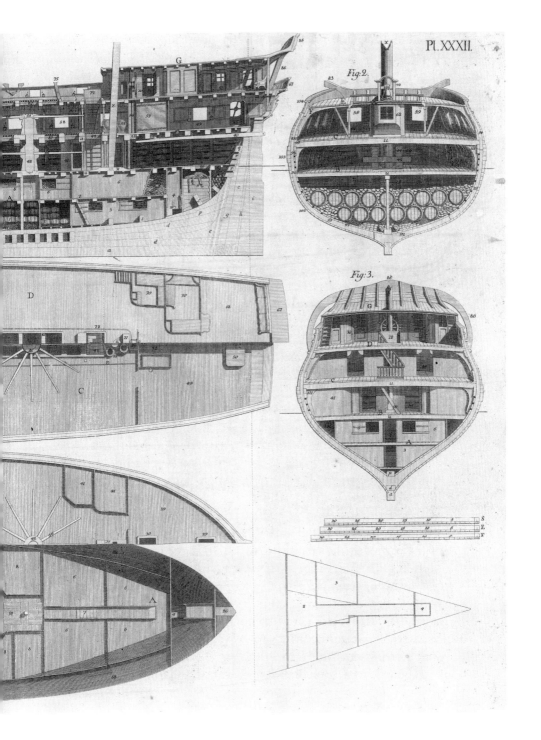

Pl. XXXII.

Fig: 2.

Fig: 3.

great table forms a surface brightly lit below the stern windows in the lower. Curved paneling encompasses sleeping cots.

These rooms provide a kind of metacenter to Chapman's work, the invisible point around which the content turns. The vessel carrying them is introduced at the center of gravity of the treatise, on plate 31 of 62 plates in all; the detailed section lies adjacent to this mathematical center, slightly offset on plate 32. If there is a global geographical span to be read in the journey of *Cron Prins Gustaf* (bound for Canton) that introduces the treatise (plate 1), or that of the British East Indiaman bound for Bombay or Madras that introduced the final section (plate 52), the cabins of the privateer sit at its center. And the presence of these rooms gives a frisson to the heeling, three-dimensional views with which both privateer and East Indiaman are portrayed. Habitation required the cabin to orchestrate things that moved, predictably, unpredictably, cyclically, catastrophically. Glasses and chinaware moved around the table; the cabin moved around the earth; and the officers moved around the cabin. All had to accommodate the yawing conditions that Chapman so accurately recorded and that his theory predicted: the roll of the privateer; the careening of the East Indiaman.

Typically the sterns Chapman draws that fronted these rooms follow the traditions developed through the involvement of seventeenth-century architects in naval design, and they look a bit like buildings (usually two-storied; sometimes more, sometimes less). Big or small, wide or flat, merchant or military, ships in Chapman's world share this feature and this attention. Very often, as is the case with *Cron Prins Gustaf*, the surface is loaded with architectural detail and almost always, as in the example of the privateer, the architectural system at the back of the ship overhangs the hull proper in galleries across the stern and hanging turrets or "trompe" wrapped along the flanks. The intensity with which these areas of a ship's design were studied is evident in scores of autograph drawings Chapman left. His work from Sveaborg, Stockholm, and Karlskrona is littered with detail studies of such stern-works.

There is a curious economy in these constructions. Ships were objects that, in one way or another, were designed to be tumbled around, weather gales, stand up to storms, and in many cases exchange gunfire. That they should carry with them a kind of house of glass, or if not of glass of delicately carved woodwork

reminiscent of a garden pavilion or a rather fancy piece of furniture, seems counterintuitive. In fighting ships these constructions appear now, and appeared to a certain extent at the time, as an absurd Achilles heel. For the majority of its length, from mid-seventeenth up until the mid-nineteenth century, a ship of war was constructed to resist the effects of increasingly effective artillery fire: the hulls would be constructed with massive tumblehome, a rolled back sectional profile above the waterline, to help deflect enemy projectiles upward on impact. Almost three feet of timber would have separated inside and sea. The desire to replace this fortified system at the back end with a language of palatial architecture—complex moldings; swags and banderoles; cupids and goddesses; fans, balustrades, and sconces; gold leaf—was questioned already in the mid-eighteenth century. Preparing his country's support for the American states' War of Independence in 1777, Antoine de Sartine, French Secrétaire d'État à la Marine and the successor to Colbert to whom Julien-David Le Roy dedicated his treatise on the ships of the ancients, considered that such decoration "no longer holds a political message and is no longer an artistic necessity."[91] The argument that the ornamentation of ships was necessary for the glory of the prince no longer held. In merchant ships, the same architectural features seem hardly less contrary. What could an East Indiaman gain from carrying an assemblage of gilt and gingerbread to and fro between homely Europe and the exotic orient? Why, during the period in which naval architecture could be understood in terms of an overall logic of exchange—of goods in exercises of global dominion; of projectiles in cases of military confrontation—were such features preserved?

Later ships reduced the amount of sculpture, but as Chapman's various drawings and the developments in naval architecture after his treatise show, they tended to present even more vulnerable glazing. The *Victory* of 1737 that Chapman drew might be usefully contrasted with that of her later namesake used by Horatio Nelson to indicate this.[92] Sitting in Chatham during the 1750s, probably working from existing drawings of the ship (the vessel herself sank in 1744), or from the very detailed admiralty commissioning model, or by combining both sources of information, Chapman drew a *Victory* with a monumental stern facade articulated in four stories. Three of these have balconies fronted COLOR PLATE 5 by ornate balustrades and surrounded by a riot of sculpture, figures clustering up the sides toward a lion and a unicorn on each

side of an effigy of King George at the top. The whole effect is deeply three-dimensional. The *Victory* that replaced her, launched in 1765 and preserved still as Nelson's flagship, was slightly less flamboyant (three stories rather than four, her decorative detail still gilded).[93] In a reconstruction in 1801 the stern of this ship was rebuilt. Almost all the sculpture was removed along with the open galleries, their balustrading copied instead in relief across two of the stories. But in this stripped-down version the surface of the window glass was pushed out to the edge of the ship. The overall effect was one of increasing lightness and, one might say, domesticity: the thickness of the vessel's skin was reduced from 3 feet of protective timber to strips of sash window holding delicate glass panes, just as you would find in the airy facades being constructed at the same time in English cities that reaped the economic advantages of colonial trade: Bristol or Bath in the west; Edinburgh in the North or St James in London.

Screening

This enduring fragility can be linked to the significance of the rooms that lay behind all these facades. The whole assemblage of decoration at the rear end of ships was called *akterspegel* in Swedish ("aft-mirror"). That term in its evocation of reflection provides a very good sense of the material, ceremonial, and informational roles that these constructions played. In one sense the glass and gilt worked literally like mirrors, reflecting, in combination with the shifting surface of the water beneath, the different lights and shimmers created by the movement of a ship at sea. In another they reflected and articulated to an observer outside the ship the social hierarchy of organization that played out within, in the "state rooms" that occupied the space behind them in great ships or the "great cabins" of small ones. And in a third sense, from the point of view of the occupants on shipboard, the bands of windows that typically spanned the sterns of ships screened, in a fragmentary way, the changing locations of the vessel itself: the view these windows contained reflected the ship's position on Earth. In all three senses of reflection the status of the interior room behind the screen, as of its occupants, is central.

These stern-works on vessels military and merchant thus facilitated a two-way screening, and subtle changes in their

organization can be telling. In terms of social organization, the *Victory* Chapman drew in the 1750s inscribed a model, vertical in emphasis, in which the various tiers of the stern articulated a pyramidal, almost feudal social hierarchy within. The very top story was almost certainly reserved, symbolically at least, for the prince himself: King George belonged behind the windows below his own effigy. The lowest was occupied by the bottom tier of officers and petty officers; the stories between were evenly split between ranks offering allegiance to each other upward and downward. The overall articulative effect was almost like a nautical Hardwick Hall, where the increasing ceiling height of each story reflected the occupants' level of nobility, from least noble on the bottom to most grand on top.[94] The *Victory* rebuilt in 1801 and used by Nelson as his flagship makes a different kind of emphasis. As in a Palladian facade, its top two tiers are articulated, together with their relief balustrading, as a kind of *piano nobile* and attic; the lowest story acts as a base for this organization (Holkham Hall rather than Hardwick, we might say). More horizontal, this stern articulated a slightly changed social division. The principal central story, its importance emphasized externally by two relief figures, held the accommodations for the admiral (Nelson); the captain (Hardy) drove the ship from the uppermost attic story; and his executive officers were gathered on the lowest service level, beneath the decoration that grouped together captain and admiral.[95]

But if decorative detail made evident to the outside world the social hierarchies of a life interior, the great screens that hung on the aft frames of ships also performed a function of representation in the opposite direction. Behind them were assembled the ship's direction, its ratiocination, its will. Once the intelligence of admirals, supercargoes, captains, and scientists was established in the space behind them, these screens inevitably became caught up in gathering the information on which that intelligence relied. The stern-works functioned as a part of a system that screened the world, a retina on which its image was flattened, made visible for observation by the vessel's occupants. Ships had these delicate features on their sterns as a face has eyes; there was something sensory, and necessary, about their transparency. And like most faces, to properly represent them, the whole must be drawn. Chapman's detailed and complete stern elevations talk to this requirement.

In the years after Chapman's thesis, as exterior sculpture was suppressed, the screen-like quality in such stern-works became

more pronounced. The observer within was bought toward the view; the outside and inside were pressed hard together. At the same time, the rooms behind these screens, the spaces that surrounded the actions of viewing within them, took on more and more the quality of domestic rooms ashore. The paneled walls and delicate furniture shown in Chapman's section of the privateer adumbrated other developments. Accommodation plans developed from a single great cabin with a screened-off sleeping area to providing suites of rooms. The *Victory* after her 1801 refit provided her admiral not only with a day cabin, but a paneled dining room, a sleeping cabin, an antechamber, and associated offices for his staff. Glazed screens and double doors allowed light to penetrate deep into this inside; deck lanterns did the same. Not only did the cabin begin to echo more closely rooms ashore, but also a reciprocal exchange was established in the furniture of sea-borne and land-locked rooms. Nelson's suite in *Victory* contained highly refined mahogany pieces that mirrored those he commissioned to furnish the mansion he had just purchased in the leafy village of Merton, outside London. Where in the early seventeenth-century naval architecture could be conceptualized as surrounded by the land-based order of an *architectura civilis*, by the end of the eighteenth century the position had reversed. In the body of a great ship a civil and domestic architecture was itself transported, its systems of order carried as one more item among the chattels, animals, and provisions that such a vessel housed to sustain its crew.

The attention with which Fredrik Chapman maps the architectural features of the various craft he records, combined with his attention to the accommodation that lay behind this decoration, related to a very modern dimension in the definition of an architecture that was naval. And in its projection of such features, the *Architectura navalis* also forecast, early on, a revolution in mediation that would question fundamental aspects of how architecture on land should be conceived. For in relation to the last conditions of reflection mentioned above—the sense in which the stern galleries of great craft screened the world—the assembly of *Architectura navalis* itself participated in a process of global observation. Its endeavor to flatten the rumpled and unruly territory of naval development onto the pristine plane of a 43 × 52 cm printed plate can be related

to a monumental project of screening that, during this period, created a new economy between the world as experienced and the world as represented. Within fifty years of the publication of the *Architectura navalis*, European publics would experience a radical shift in perspective resulting from multiple other processes of flattening and representation. Cook's expeditions charting unknown geographies would be complemented after 1800 by state-funded, institutionalized processes of chart making.[96] During the revolutionary struggles of the Napoleonic Wars at the end of the eighteenth century the geopolitical interior would be drawn into an economy of exchange through its representation on paper.[97] In the early years of the nineteenth, distant geographies would be screened in European capital cities in pay-to-view panoramas.[98] Throughout the period flora and fauna would be systematized in ever more ambitious processes of illustration.[99] All this cornucopia of representation would be made available, large format, for consumption in domestic settings, as large-scale urban projections or packaged as books, more or less costly, more or less learned. And this world of representation would question the nature of the settings in which it was experienced. This new perspective, evident in a mid-eighteenth-century treatise on naval architecture, would change fundamentally what architecture was during the nineteenth century. *Architectura navalis mercatoria* speaks most exactly to a newly evolving sensibility about how architecture might be involved in a principle of movement, of exchange.

Economies of the Interior

At the end of the eighteenth century, countries and continents had interiors; domestic apartments did not. Throughout the 1700s—as ships carried architectural motifs around the globe, as explorers and merchants plotted journeys ever more distant, as Indiamen heeled in trade winds and glasses clinked in the pantries of their great cabins, and as the wealth of the world was directed into the hands of a few, mostly northern European actors—the words *intérieure* in French and *interior* in English commonly described geographical space. This usage had antique roots—Ptolemy's *Geography* noted already the Ethiopian interior—and continued to expand after 1700.[1] Egypt had an *intérieure*, containing *secrets mystérieux*, already in Jean-Baptiste Le Mascrier's *Description de l'Égypte*, printed in 1735.[2] The English philologist and poet Sir William Jones described the lands of the Arabs, Persians, Indians, and Turks in terms of their "interiour" in 1772.[3] The Association for Promoting the Discovery of the Interior Parts of Africa was based in London by 1785; France had a Ministère de l'intérieur based in Paris from 1790; and European books on the interiors of Canada and Brazil were produced soon after 1800.[4] This interior might be characterized as geopolitical, for its axes were at once spatial and economic, cultural and material. "Interior" signified a space unseen by, and only partially known to, the centers of administration and intelligence that conceptualized it. European

93

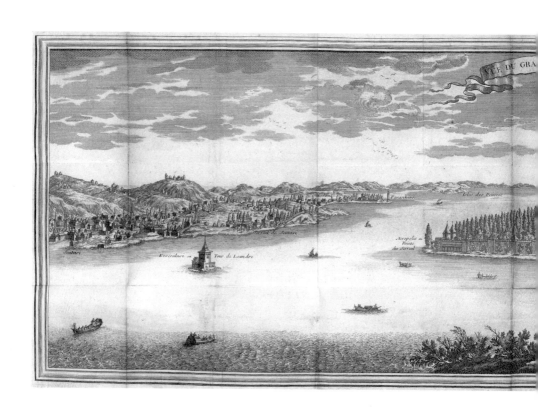

View of the Seraglio from the Bosphorus. Jean-Baptiste Tavernier, *Nouvelle relation de l'intérieur du serrail du Grand Seigneur* (Paris, 1675). National Library of Sweden.

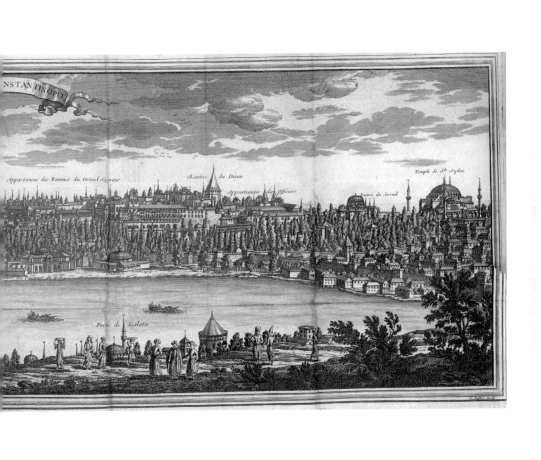

CONSTANTINOPLE

Appartemens des Femmes du Grand Seigneur Chambre du Divan Temple de Ste Sophie

Appartemens des Officiers L'Entrée du Serrail

Porte de Galata

expansion tied a sense of exploitation to this established seman-tic use. Global trade extracted its goods from the interior; naming that space as such not only objectified it as something on which a collective design might be focused but also allowed its hazy poten-tial to be reified.

At the same time, when it came to describing internal spaces in the eighteenth century, this nominative potential of interior was little used. The interiors that naval architecture provided on ship-board, which carried supercargoes toward the unknown space of the geographical interior, were not described using that term. As delicate residential buildings sprang up on streets, squares, and in new residential quarters in European cities, all paid for largely with wealth generated by global expansion, "an interior"—that is, a noun describing particular rooms within a house—was virtu-ally unknown. This lack of architectural interiors is a remarkably consistent trait of all writing on architecture through the century. Jean-Baptiste Tavernier's *Nouvelle relation de l'intérieur du serrail du Grand Seigneur*, first published in Paris in 1675 but an enduring eighteenth-century favorite, brought the Serraglio of the Ottoman court in Constantinople alive for a European audience. It treated that complex as a whole in terms of its social divisions, systems of etiquette, and the nomenclature of its occupants.[5] Like that of Egypt, this interior was spatial by implication, but was not dis-cretely architectural. The 1717 *Traicté de la décoration intérieure*, by Nicodemus Tessin, the architect of Stockholm's royal palace and an associate of Jean Bérain and Charles le Brun, concerned the sur-face embellishment inside buildings: decoration was the subject of his title; interior a qualifying descriptor.[6] In Jacques-François Blondel's *De la distribution des maisons de plaisance* (1737), the use of *intérieure* was purely adjectival and was to remain so in the *Traité de la décoration intérieure des appartements* that formed the second book of his *Cours d'architecture* of 1777.[7] Robert Adam describes "interior" columns in the plate captions for his *Ruins of the Palace of the Emperor Diocletian* in 1764, an inspiration for a whole genre of domestic architecture in Britain. But like Julien-David Le Roy, whose interpretations of Greek architecture he criticized, he never speaks of "an interior" in the architectural sense.[8] The list might be extended. Germain Boffrand's *Livre d'architecture* (1745) and Nico-las Le Camus de Mézières's *Le génie de l'architecture* (1780), discuss *décorations intérieures*, and refer briefly to three architectural con-figurations as possessing interiors: an external courtyard; a sacred

dome, and a university institution.[9] Neither text uses "interior" as a noun to denote domestic architectural space. And at the very end of the century, the explorer James Bruce notes that the interior of the great temple at Baalbec surpasses any sculpture he has ever seen in stone.[10] The temple is a ruin; an open structure seen under a burning sun in a desert landscape.

As the eighteenth century turned to the nineteenth, something shifted in this clear structure. Over a period of twenty years, from 1800 to 1820, "interior" left its traditional service as an architectural adjective and began a new career as an architectural noun. This new role allowed the use of "interior" to embody the totality of what could be found within the surfaces of domestic apartments. Suddenly, "an interior" could be something of almost unlimited extent far away—endless sands in Egypt, Canadian forest, Brazilian steppe—or a place where you left your umbrella. This rapid semantic shift is most evident in Britain and France, two countries where colonial expansion was a central concern. In France, the shift emerged in accounts that conveyed the domestic and the political. Charles Percier and Pierre Fontaine produced designs in Paris for internal rooms that represented French aspirations to exercise power abroad, including in their descriptions all manner of objects beyond the hard architectural surfaces that enclosed these spaces.[11] Their *Recueil de décorations intérieures* was published as a series of plates with descriptions in 1801 and republished with an introductory text in 1812.[12] In England, typically, the change is betrayed not in a text connected to any agenda of the state, or to one that can be linked into a discourse of disciplinary development by experts, but one reliant on the dispersed and almost ungovernable influence of finance. *Household Furniture and Interior Decoration*, published by the exceptionally wealthy Thomas Hope in 1807, presented a series of exotic rooms created in Hope's own house from which he aimed to derive a new sensibility about design.[13] The lexical use of "interior" in both cases—by "Napoleon's architects" expanding their authority over a wider collection of objects; by a rich private citizen presenting his own home—appears poised exactly between its sense as a general descriptive term and its sense as a specific kind of architectural space.[14] For Percier and Fontaine, and for Hope, semantic logic was nudging "interior" toward being the subject, rather than the qualifier in their titles. In that inflection, in both cases, the interiors that are described relate, immediately, to the geographical and

to the geopolitical: Hope's rooms identified distant countries he had visited; Percier and Fontaine's related to lands visited by the French revolutionary and imperial armies.[15]

This ambivalence in the meaning of interior corresponds with a period of upheaval in the societal context that produced it. The extraordinary geopolitical events that affected Western culture between 1789 and 1798 highlighted the significance of distant lands for domestic economies across northern Europe as a whole. European nation-states of the late eighteenth and early nineteenth centuries, together with their new world offspring, set more people in unfamiliar surroundings through war, exploration, and colonization than any previous period had. The translation of bodies and goods into otherwise unknown environments was a central element in global war (mainly via naval fleets, but also through the translation of armies), in colonial expansion and in the exponentially increasing trade that characterized the period. At the same time, this period saw an unprecedented growth in the production of visual and narrative descriptions of far-removed places that moved in the other direction. Because of this the exotic interiors of the world could be glimpsed in entirely new ways by the native populations of northern European countries such as Great Britain and France. A new kind of experience of the proximity of the interior—of the removed geographical interior—within the domestic field of experience was minted at this time.

There is an implicit connection between this mediation of the removed, geographical interior, describing spaces hidden by distance, and the use of interior to describe spaces close at hand, intimately known. For a history of architecture written from the point of view of its implication in processes of movement and translation, of rearranging persons, categories, materials and mediations, this particular identity is of fundamental interest. The curious ramifications of the changing sense of the interior during the early nineteenth century are especially visible in Thomas Hope's book *Household Furniture and Interior Decoration*.

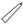

Thomas Hope was an heir to the fortune of Hope & Co., one of the most important financial houses of late eighteenth-century Europe, operating out of Amsterdam and, later, London.[16] Rather like Aby Warburg a century later, Hope used a family fortune

Part I: Cargoes 1530–1910

Thomas Hope. Engraved frontispiece to *Household Furniture and Interior Decoration*
(London, 1807). Internet Archive.

amassed through merchant banking to fund the study of what we today would call material culture. As well as becoming a successful advisor and collector, he became a designer primarily of furniture and domestic spaces. He was also a voracious traveler. From 1790 to 1794 he made a series of journeys in southern Europe, primarily in Italy and the Spanish peninsula, and ventured into northern Africa. He was in northern Europe in 1794 during the period in which the Hope bank transferred its operations to London (on account of the threat posed by the French occupation of Amsterdam). In 1795, he was in Rome and traveled into the Ottoman Empire, living in Constantinople a year and visiting Athens. Finally, he journeyed through the Levant via the coast of Lycia in modern-day Turkey, reaching Cairo in 1797. In 1798, shortly before the French forces under Napoleon Bonaparte arrived in the Egyptian capital, he returned to London and settled as part of the network around the transferred Hope bank. His uncle, Henry Hope, ran the operation and was established at Hopetoun House on the newly developed Cavendish Square in London's West End. From 1799 Thomas lived at No. 10 Duchess Street, a building designed by Robert Adam two streets away.[17] *Household Furniture and Interior Decoration* used a description of rooms and furniture in this house to create a new sensibility about the design of domestic space.

Household Furniture and Interior Decoration has a striking tone. Its author sounds to the modern ear uncannily like Sir Walter Elliot, the pompous paterfamilias of Jane Austen's 1817 novel *Persuasion*, and there are reasons to believe that contemporaries found Hope's demeanor both provocative and overbearing.[18] In the introduction to the book, he complains how "in England much more attention is generally paid to the perishable implements of the stable than to the lasting decoration of the house."[19] Hope's targets are the flashy phaetons and curricles of London society: he admonishes those who are "disposed yearly to lavish enormous sums in the trifling and imperceptible changes which every season produces in the construction of these transient vehicles."[20] For Hope, investment in interior decoration should not be identified with either the frivolity or the transience of fashion, a position that qualified the judgments of certain of his contemporaries.[21] Indeed, he suggests that household furnishings and the decoration in buildings have a lasting, sober, and instructive potential. Anticipating a similar moralizing tone in the later commentaries of Percier and Fontaine, *Household Furniture and Interior Decoration* claims it will

communicate "attributes of elegance and of beauty conducive . . . above all, towards forming the entire assemblage of productions of ancient art and of modern handicraft . . . into a more harmonious, more consistent, and more instructive whole."[22] To accomplish this aim, in the first section of the book Hope describes some of the rooms in his house with short textual commentaries on a series of central-perspective plates.

Duchess Street and Interior Decoration

Although the building is long gone, drawings prepared for Hope by his architect, Charles Heathcote Tatham, show plans and sections of the intended scheme for the house.[23] Robert Adam, who had designed No. 10 Duchess Street, organized it like a Parisian *hôtel particulier*, with a screen wall to the street, two side wings behind, a main block spanning the width of the site behind them, and private gardens at the rear. Hope remodeled this plan and interiorized it. The facade to the street took on a fortified

Plan of No. 10 Duchess Street after reconstruction by Thomas Hope, ca. 1807. Author.

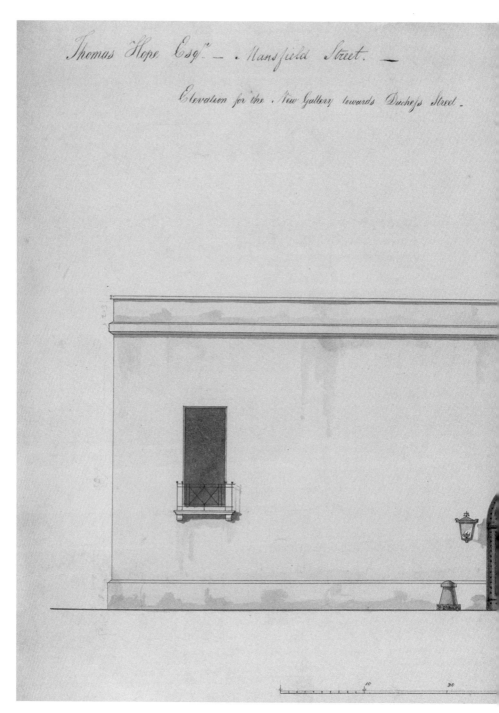

Charles Heathcote Tatham. Facade for 10 Duchess Street as reconstructed by
Thomas Hope, 1799. Drawing Matter.

quality, somewhat outlandish in early nineteenth-century London, although not unlike facades Hope had drawn in Eastern capitals such as Constantinople and Cairo. The entrance sequence took the visitor through a low opening in the otherwise blank street facade, across the courtyard, through a vestibule in the center of the main block, and up a grand stair to the living spaces on the first floor. A series of rooms encountered in sequence on this level displayed objects from Hope's collection, and both the geographies associated with these objects and the decoration of the rooms they occupied mirrored the development of his extensive tours. Around the *cour d'honneur* of the house a sculpture gallery showed work principally from Rome; a picture gallery had a specifically Attic character, its architectural detailing collected from the Erechtheion on the Acropolis; and a series of vase rooms displayed Hope's collection of Greek and Etruscan ware, much of it gathered in southern Italy and Sicily and purchased from Sir William Hamilton.[24] These rooms all collected objects and experiences that would then have been termed "European."[25]

Plates I to V of *Household Furniture and Interior Decoration* describe this set of European rooms, which formed a single spatial sequence on the south side of the house. Plates VI to VIII articulate a second series of spaces that were experienced enfilade on the north side. These rooms can all be related to locations Hope had visited outside mainland Europe, and within them questions begin to gather concerning the relationship between the architectural and the geopolitical interior. The drawing room, shown in plate VI, repeated the disposition of spaces Hope had drawn during his year-long sojourn in Constantinople.[26] It had a low perimeter sofa with a series of window-size panoramic panels behind. Three were by Thomas and William Daniell, who painted them in giant format after drawings from their series *Oriental Scenery*, published from 1795 to 1807.[27] These views looked east toward exotic monuments and landscapes in India. One panorama looked back west, to the ruins of European antiquity, portraying ruins in the Roman Forum.[28] Thus, the drawing room was positioned in relation to a vast territory, perched between two powerful geopolitical theaters: that of old Europe, riven by revolutionary war, and that of India, already the focus of British colonial expansion. Its Near East location was articulated also in every surface that the eye encountered or that the hands touched. According to Hope, "a low sofa, after the eastern fashion, fills the corners of this room.

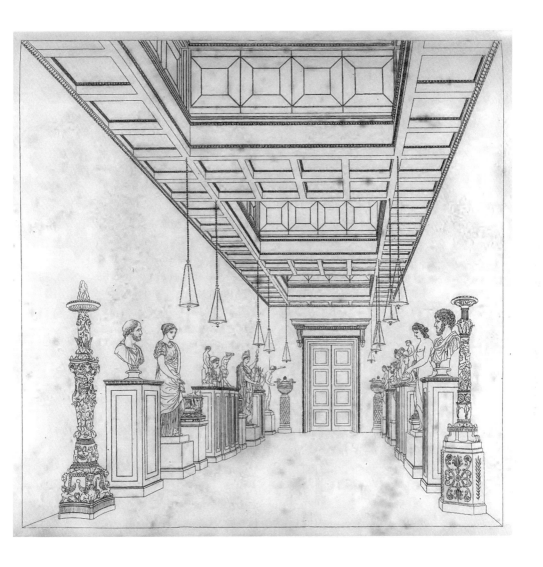

"The Sculpture Gallery." Thomas Hope, *Household Furniture and Interior Decoration*, plate I. Internet Archive.

The ceiling . . . imitates those prevailing in Turkish palaces. . . .
Persian carpets cover the floor." Indeed, the very air took on an
Eastern atmosphere: "round the room are placed incense urns,
cassolettes, flower baskets, and other vehicles of natural and arti-
ficial perfumes."[29]

Turning the page, the reader of *Household Furniture and Interior
Decoration* leaves the drawing room for the Aurora room (plate VII).
"The central object in this room is a fine marble group, executed by
Mr. Flaxman, and representing Aurora visiting Cephalus on Mount
Ida."[30] This room also related to Hope's travel beyond mainland
Europe. While Ovid had located the tale of Aurora seducing Cepha-
lus on a ridge outside Athens, Hope moved the action to Mount Ida
at the mouth of the Hellespont, a location he must have passed on
his journey from Constantinople along the coast of Anatolia. Like
the drawing room, the Aurora room played games with an implied
space beyond its interior surface, using atmospheric effects cre-
ated with light, fabric, and glass to do so.

> The sides of the room display, in satin curtains, draped in
> ample folds over panels of looking-glass, and edged with
> black velvet, the fiery hue which fringes the clouds just
> before sunrise: and in a ceiling of cooler sky-blue are sown,
> amidst a few still unextinguished luminaries of the night,
> the roses which the harbinger of day, in her course, spreads
> on every side around her.[31]

The implication here is of a room external, its walls dissolved in
mirrored reflection and textile folds; its curtains reading as clouds;
its ceiling a sky sown with stars.

Hope traveled farther down the coast to the ancient city of
Antiphellos, which he also drew, and finally on to Cairo. In *House-
hold Furniture and Interior Decoration*, behind the mirrors of the
Aurora room, lying within the infinite space they created, one
enters finally the Egyptian room (plate VIII). Hope explains how
the room communicates the character of that faraway space from
whence its objects originate:

> The ornaments that adorn the walls of this little canopus
> are, partly, taken from Egyptian scrolls of papyrus; those
> that embellish the ceiling, from Egyptian mummy cases; and
> the prevailing colours of both, as well as of the furniture,

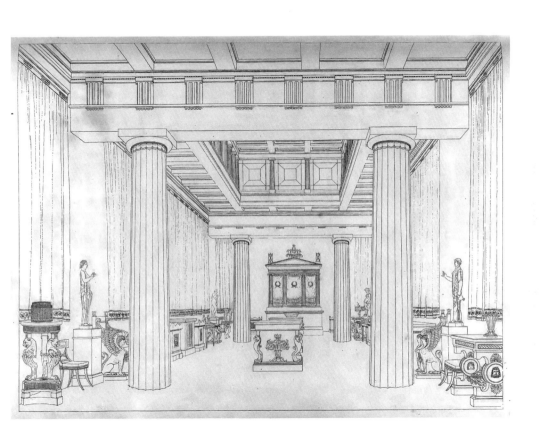

"The Picture Gallery." Thomas Hope, *Household Furniture and Interior Decoration*, plate II. Internet Archive.

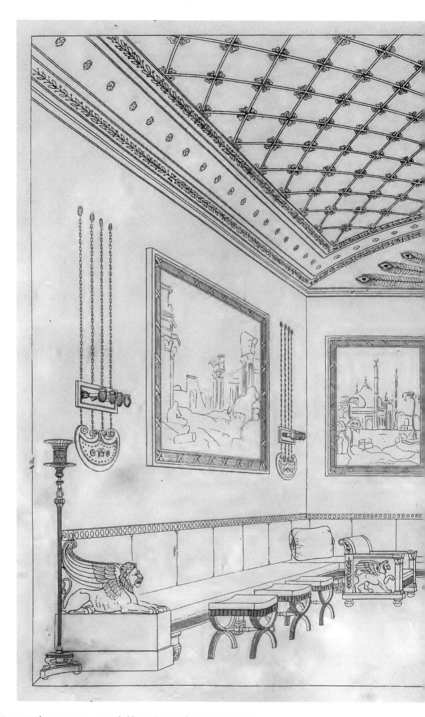

"The Drawing Room." Thomas Hope, *Household Furniture and Interior Decoration*,
plate VI. Internet Archive.

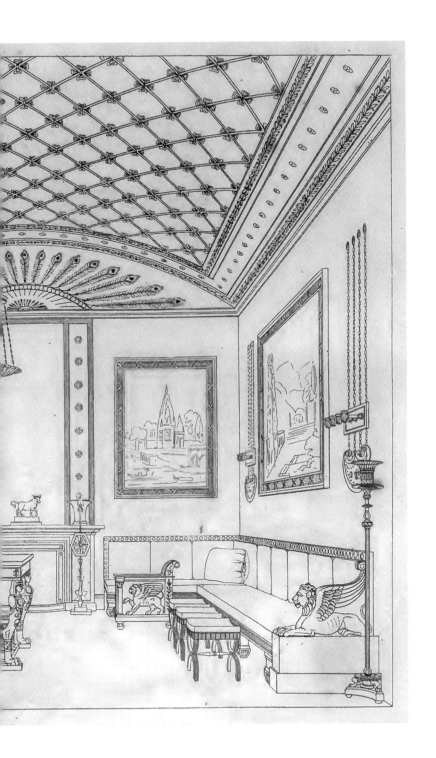

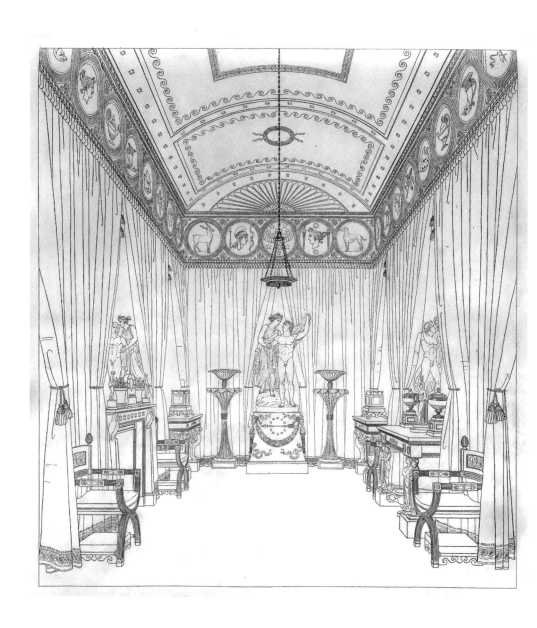

"The Aurora Room." Thomas Hope, *Household Furniture and Interior Decoration*, plate VII. Internet Archive.

are that pale yellow and that blueish green which hold so conspicuous a rank among the Egyptian pigments; here and there relieved by masses of black and of gold.[32]

Unlike the drawing or Aurora rooms, the enclosure of the Egyptian room was complete, like a tomb. The fireplace was even copied from a tomb at Antiphellos, and the room contained a mummy in a small glass case. The Egyptian pigments Hope refers to were discovered hidden in airless chambers underground.

These rooms, represented through text and image, each conjure some kind of greater entity, then, a space that goes beyond—is wider than—the edges of their architecture. In the drawing room, this is a space surveyed. In the Aurora room it is a space foreshadowed, stretching away beyond the curtain, lit by a sunrise. In the Egyptian room it is a space implied, of passages hidden behind closed doors. In all three interiority seems to have a geographic dimension, signaling faraway places within the confines of the house. In Hope's work the geographical interior becomes part of a novel system of decoration.

Habits of Representation

Hope's later novel *Anastasius*, which he published at first anonymously with the great producer of travel guides John Murray in 1819, makes a similar projection of the geographical into a new form by inserting his autobiographical experience of the East into a narrative telling that traverses Greece, Turkey, and Arabia over thirty-five years.[33] But as he was writing *Household Furniture and Interior Decoration*, a genre already existed for presenting the remote, ancient, geographical interior in evocative formats that could be consumed in domestic settings. In his bibliography Hope helpfully cites examples of this genre, from Egypt to India: "Pococke's Description of the East, Wood's Palmyra, Norden's Egypt, Denon's Egypt, Daniell's Indian views."[34] All of these were richly illustrated and, to varying degrees, created immersive experiences for their readers.[35] The most dramatic and recent were the publications by the Daniells in *Oriental Views*, which provided the scenes of India that adorned the drawing room in Duchess Street, and Dominique Vivant Denon's *Voyage dans la Basse et la Haute Égypte*.[36] The *Voyage* recounts the French encounter with Egypt during Napoleon's 1798

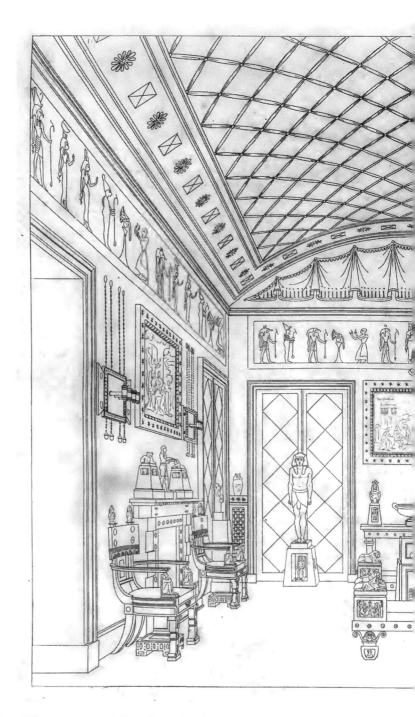

"The Egyptian Room." Thomas Hope, *Household Furniture and Interior Decoration*, plate VII. Internet Archive.

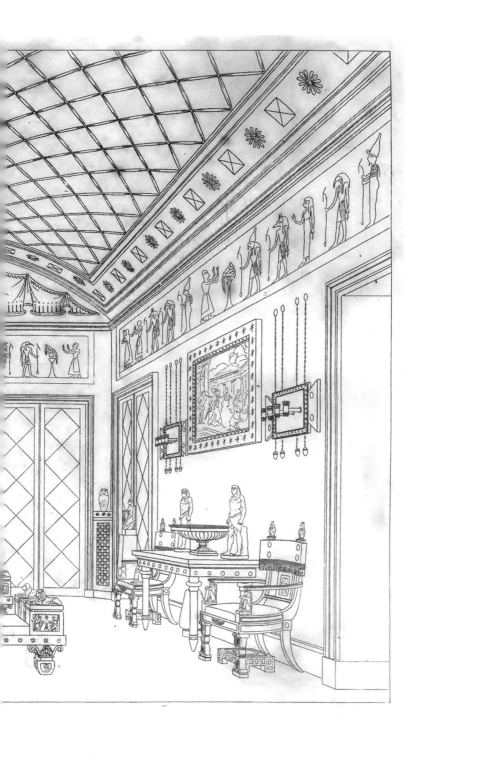

invasion; it was published in Paris in 1802 and in London, with the title order reversed, as *Travels in Upper and Lower Egypt* in three translations within a year.

The representational techniques Hope used in *Household Furniture and Interior Decoration* had important affinities with the genre to which the Daniells' and Denon's work relate. Late eighteenth- and early nineteenth-century travel descriptions recorded the space of the geographical interior (landscape), together with its species (flora and fauna), its geology, and its human history (architecture, ruins, objects). The habits of representation that developed through these descriptions sought perspectival realism recording geographic landscapes—characterized by picturesque three-dimensional views—and a flattening in depictions of the living species, rocky samples, and traces of material culture that were collected in them. Landscape representations tended to be summary and embodied great depth that encapsulated the whole. Representations of species, geological samples, and cultural traces were necessarily multiple and often portrayed objects out of context, flat as if against a wall.[37]

A variety of examples might be used to demonstrate this evolution. William Hamilton's *Campi Phlegraei*, printed in Naples in 1779, is one such account in which dramatic landscape views that communicated the emotional drama of Vesuvius erupting were combined with flattened representations of petrification.[38] Another is the major project Hamilton undertook with the French antiquarian Pierre-François Hugues d'Hancarville to catalogue in drawing his vase collection. Meticulous line drawings in the *Antiquités étrusques, grecques, et romaines. Tirées du cabinet de M. Hamilton* (1766–1776) isolate these rotund objects and present them like anatomical specimens against a clinical white background, flattening out their surface designs the better to convey their elegance. The tendency can also be seen in early nineteenth-century examples of cataloguing flora—for instance, John Sibthorp and Edward William Smith's monumental *Flora Graeca Sibthorpiana*, whose first volume was printed in London in 1806.[39] Denon's 1802 text also relates to the genre. *Voyage dans la Basse et la Haute Égypte* is dominated by landscape views that present the monuments of Egypt in the order that the invading army met them (images "drawn on horse-back," Denon boasts) and that vividly communicate spatial depth. As it moves to record the finds that were made in those places, Denon's *Voyage* uses fragmentary and flattened systems

COLOR PLATE 6

COLOR PLATE 7

Part I: Cargoes 1530–1910

of drawing. The same system is perfected in the extraordinary *Description de l'Égypte*, which the French government sponsored as a result of the expedition into Egypt from 1798 to 1801, and which was under production by 1807.[40]

The journey through the interior of Duchess Street is rendered through a similar juxtaposition of techniques. *Household Furniture and Interior Decoration* begins with a series of eight plates using central point perspective, images that emphasize depth of view. A further fifty plates in the book show "specimens" of furniture and ornament that occupy and characterize this space.[41] These samples are arranged often three, four, or five together, pressed flat against the page like specimens in a botanical atlas. Both kinds of drawing—deep perspectives and flat elevations—are produced in hard, dry, technical line, and Hope emphasizes his desire to avoid the technique of "lights and shadows" that engravers use.[42] Hope's system was unlike anything that had gone before it for representing the internal architecture of rooms.[43] Neither the *Cabinet-Maker* of Thomas Sheraton nor *Recueil de décorations intérieures* by Percier and Fontaine possesses such a clarity of structure.[44] Instead Hope's graphic technique echoes that used earlier in Hamilton and d'Hancarville's *Antiquités étrusques, grecques, et romaines*. These drawings have some of the characteristics that can be discerned in the scientific record of geographical interiors, landscapes, and objects. They present first the region in a perspectival convention that gives a picture of the whole. They then develop a taxonomy of the species of object to be found within this region. They share a concentration on line that was to be found in works describing the natural world (like Hope's images of building elements, flora was often drawn in clear line without shading in the engraved copy). And they juxtapose techniques of projective deepening and flattening used by archaeologists and explorers. Hope mapped the spaces in his house and the objects they contained with a diligence worthy of a geographical engineer (as the French who mapped Egypt were called) or a naturalist.

Bankers' Draughts

These early nineteenth-century constructions of geopolitical and architectural interiors were implicated in systems of accounting and consumption. Denon's *Voyage* allowed "elsewhere" to be

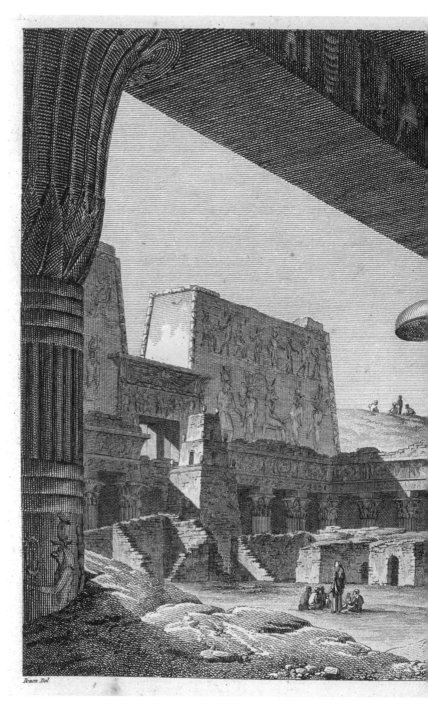

"Intérieure du temple d'Apollinopolis à Etfoù." Domenique Vivant Denon, *Voyage dans la Basse et la Haute Égypte pendant les campagnes du général Bonaparte* (Paris, 1802), plate 57. New York Public Library.

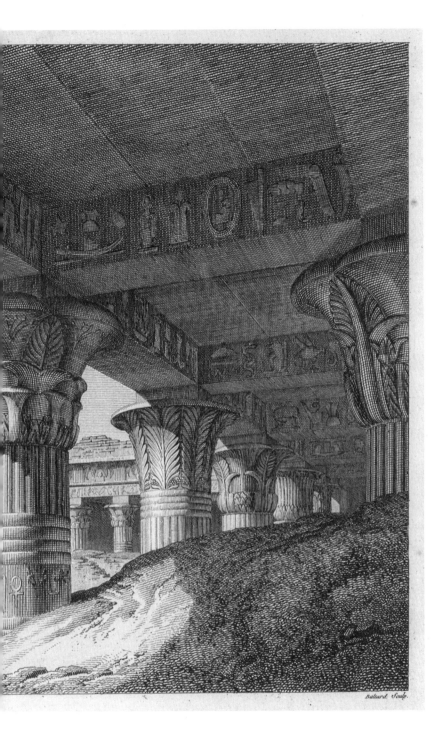

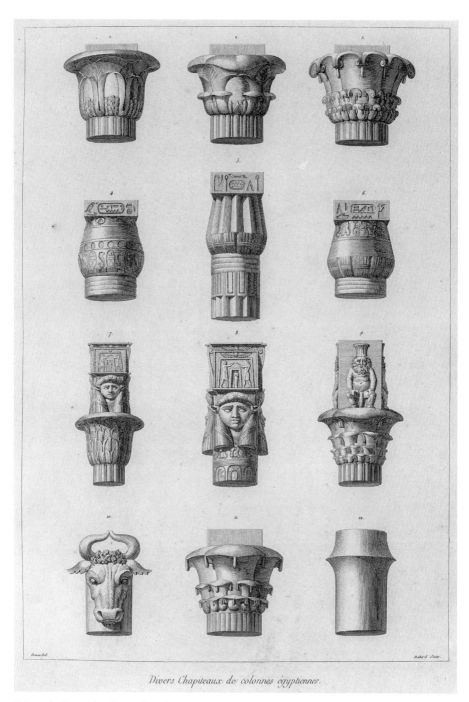

Divers Chapiteaux de colonnes égyptiennes.

"Divers chapiteaux de colonnes égyptiennes." Domenique Vivant Denon, *Voyage dans la Basse et la Haute Égypte pendant les campagnes du général Bonaparte*, plate 60. New York Public Library.

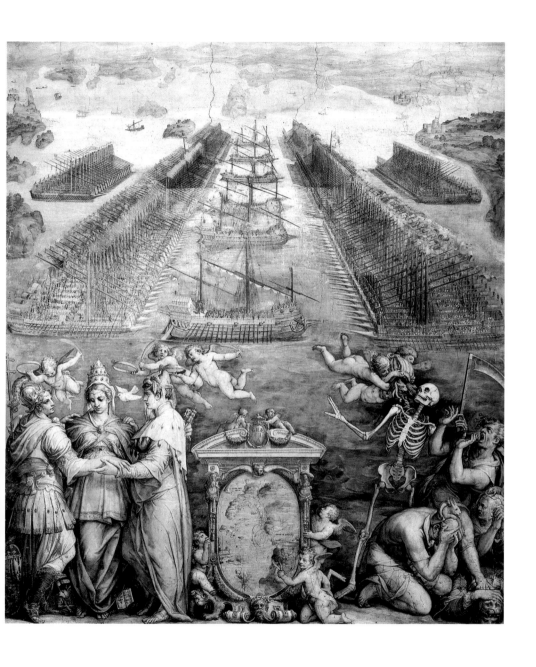

Color plate 1 Giorgio Vasari. *La battaglia di Lepanto*, fresco, Scala Regia, Vatican, Rome, 1571.
Wikipedia Commons.

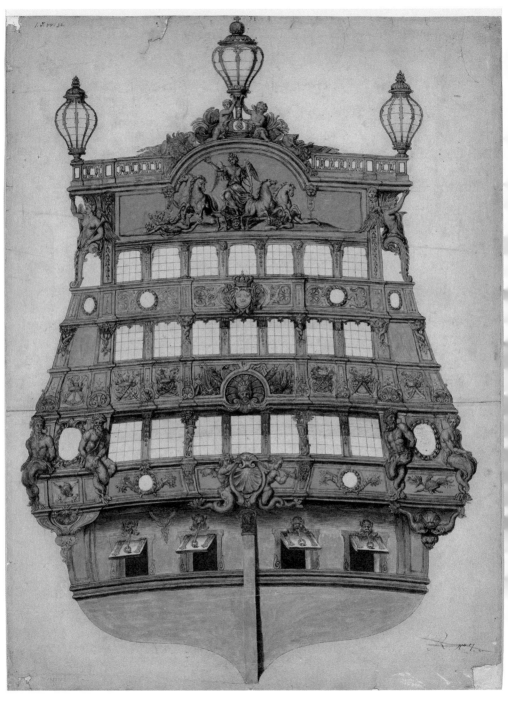

Color plate 2 Jean Bérain. Design for the Swedish ship *Segern*, ca. 1680. National Maritime
Museum, Stockholm.

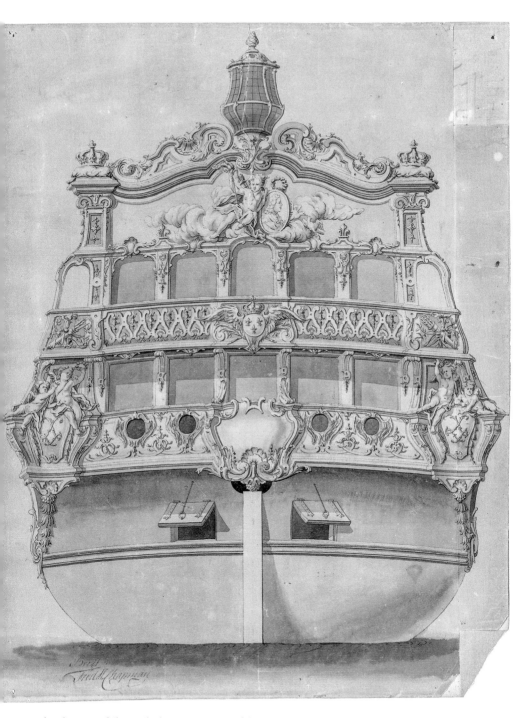

Color plate 3 Fredrik Henrik Chapman. Drawing of the French ship *Fleuron*, ca. 1753.
National Maritime Museum, Stockholm.

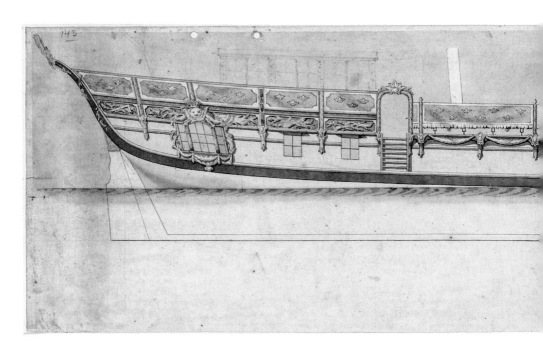

Color plate 4 Fredrik Henrik Chapman. Pen and wash drawing of the Swedish royal yacht *Amphion*, ca. 1770. National Maritime Museum, Stockholm.

Approberat
Stockholms Slott den 24 Augusti 1777.

Gustaf

är 100 fot lång öfverstäf, men bör vara 104 fot.
Bred 22 ft.
Diupgående 6¼ ft.

Fredr. Haf Chapman.

blefwer 113 fot lång
23½ fot bred.

Equip till et Hirroma Fartyg,
för Hans Kongelige Majestät at bruka
på Mälaren; detta Fartyg kan föra 2 st.
6 tt. Stycken fram i Bogen, samt 12 par 2 tt.
stücklakt: på sidorne; och sådana (i enighet)
et wigtigt Hirroma Fartyg
att ro med 16 par åror 2 man till åran.

1751

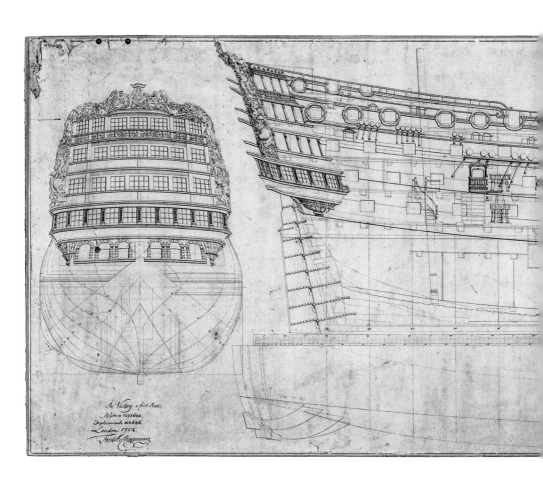

Color plate 5 Fredrik Henrik Chapman. Drawing of HMS *Victory* (1737), ca. 1750. National Maritime Museum, Stockholm.

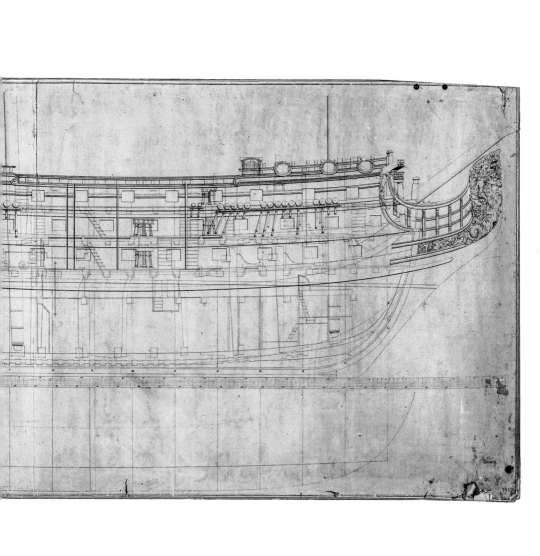

Color plate 6 Plates X and xx from Sir William Hamilton, *Campi Phlegraei: Observations on the Volcanos of the Two Sicilies as They Have Been Communicated to the Royal Society of London* (Naples, 1776–1779). Swedish National Library.

FLORA GRÆCA Sibthorpiana.

CENTURIA PRIMA, 1806

MONS PARNASSUS.

Color plate 7 Ferdinand Bauer. Frontispiece and "Salvia Viridis" from John Sibthorp and Edward William Smith, *Flora Graeca Sibthorpiana* (London, 1806). Biodiversity Heritage Library.

Salvia Horminum

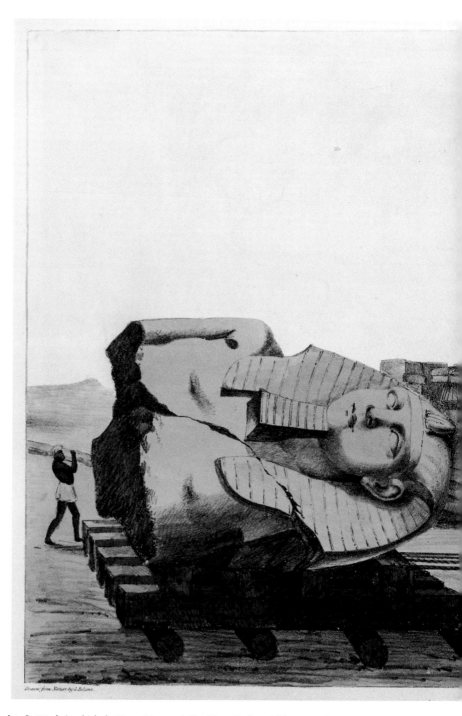

Color plate 8 "Mode in which the Young Memnon's Head (now in the British Museum) Was Removed by Belzoni." Lithograph by J. H. Newton after a drawing by Belzoni, from Giovanni Belzoni, *Six New Plates Illustrative of the Researches and Operations in Egypt and Nubia* (London, 1822). New York Public Library.

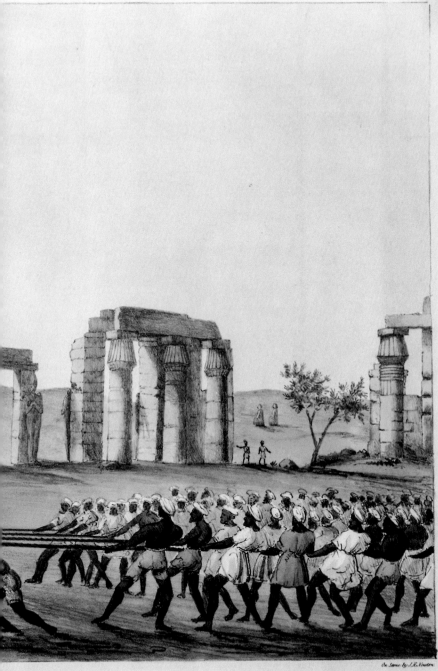

On Stone by J.R. Newton

Plate 3 Vol. 6

Color plate 9 Morgan and Sanders. Metamorphic Library Chair as advertised in
Ackermann's Repository of Arts, July 1811, 40–41. Brooklyn Museum of Art.

Color plate 10 Johann Erdmann Hummel. *Die Granitschale im Berliner Lustgarten*, 1831. Alte Nationalgalerie, Berlin.

Color plate 11 Johann Erdmann Hummel. *Das Schleifen der Granitschale für den Berliner Lustgarten*, 1831. Alte Nationalgalerie, Berlin.

Color plate 12 François Dubois. *Érection de l'obélisque de Louxor sur la place de la Concorde, le 25 octobre 1836*. Musée Carnavalet, Paris/RMN Grand Palais.

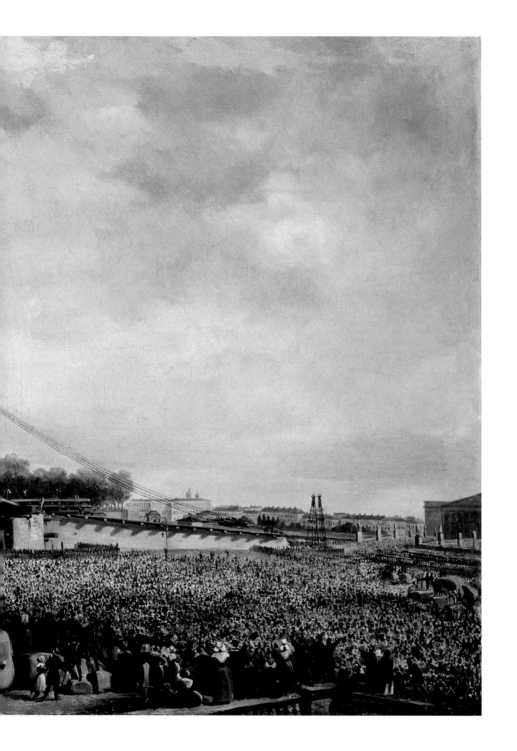

Color plate 13 Charles Robert Cockerell. *The Professor's Dream*, 1848. Royal Academy, London.

Color plate 14 Pernille Ahlgren. Model of an unbuilt house for Fritz Saxl and Gertrud Bing (the 1935 "Cottage at Bromley"), 2021. Oslo School of Architecture and Design.

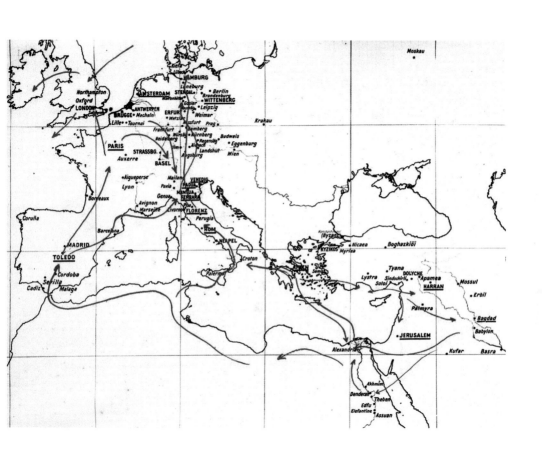

Color plate 15 *Wanderstrasse* showing cultural exchange between north and south, east and west. Facsimile of map of Europe and the Middle East, marked up with routes showing the flow of cultural ideas, images, and artifacts. Prepared at the Kulturwissenschaftliche Bibliothek Warburg, 1928, and redrawn by Roberto Ohrt und Axel Heil, 2021. Warburg Institute Archive/Roberto Ohrt and Axel Heil.

Color plate 16 Gerhard Langmaack. Long section of the Kulturwissenschaftliche Bibliothek Warburg, annotated by Aby Warburg, 1926. Warburg Institute Archive.

K.B.W = 39.000
A.H = 5.000
44.000

Atlas Carl:

Zukkfin-
Ausst
500

Goethe 300
Dr. 1500

"Freiheit"
Symbole
-
Drama
1500

Mary
1000.-

Holland:
800

24 Juli 1926
43.889 Mk

Zeitschriften
2500

allgem.
Handschr.
1500

SAAL

±0

Kulturwissenschaftliche Bibliothek Warburg
Erbaut v. Gerhard Langmaack 1925/26

Color plate 17 Gerhard Langmaack. Ground-floor plan of the Kulturwissenschaftliche Bibliothek Warburg, 1926 (overlay by Gertrud Bing showing catalogue subject headings in the reading/lecture room). Warburg Institute Archive.

Archäologie

Kunstgeschichte

Heraldik

Altertumskunde

Religions-
Encyklopädie

Religion Psychologie
Orient. Bücherkunst.
geschichte

Biographie
geschichte

Sprachen
Literatur
Photographie

Lesesaal

[37]

ROHRPOST

HEBETISCH

Color plate 18 Sandro Botticelli. *Primavera*, ca. 1480. Uffizi Gallery, Florence. Wikipedia Commons.

Color plate 19 Tage William-Olsson. Rendering of a preliminary project for Slussen, ca. 1930. Stockholm Stadsmuseum.

Color plate 20 Fritz August Brehaus and Caspar Pinnau. Passenger lounge, LZ 129, 1929–1930. Hamburger Staatsarchiv, Hamburgisches Architekturarchiv.

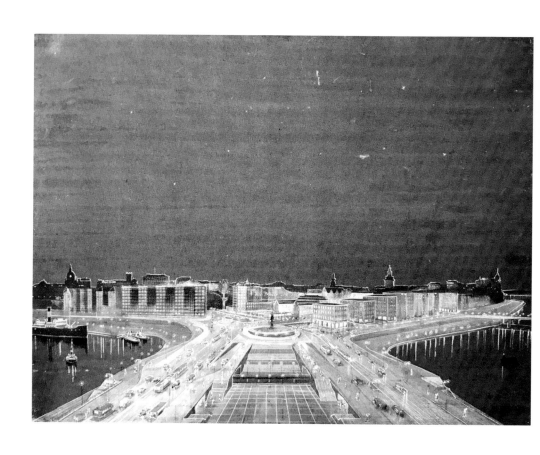

Color plate 21 Tage William-Olsson. Slussen by night, ca. 1930. Stockholms Stadsmuseum.

itemized, to be put in a book and kept. It also projected a powerful image of that "elsewhere," which literary audiences of the time were hungry to ingest, thus satisfying "the impatient anxiety of the public mind," as a reviewer for the *British Critic* wrote in 1803.[45] Hope performed a similar double act at Duchess Street. He used architectural means to project a geographical space within the confines of his house and then promoted that interior, organizing tours and representing it in print.[46] This awareness of the power of mediated projection was widespread. The same potential to summon up distant geographies using architectural technics was evinced in the development of panoramas and dioramas in Paris, London, and Berlin from 1798 to 1816.[47] And Hope knew of one contemporary example where such a system was employed to reconstruct the temporally distant. The bibliography of *Household Furniture and Interior Decoration* includes, among the works that will give "an appropriate meaning" to his book, Alexandre Lenoir's description of the Musée des monuments français in Paris.[48] That museum, which existed in the deconsecrated monastery of the Petits Augustins from 1798 to 1816, and which Hope certainly visited, used architectural means to categorize French history. Visitors moved through a sequence of rooms, each of which presented artifacts associated with a particular century and whose lighting communicated a steady development from darkness and ignorance to clarity and light. Like Lenoir, Hope combined an interest in immersive effect with a desire for dry taxonomy. And like Lenoir, Hope saw the need to create a textual account of the workings of the architectural assembly he had created.[49]

This habit of using media to create marketable constructions of the distant existed also in one final area that formed a context for Hope's work in Duchess Street: banking. Until 1801 Hope owned 20 percent of Hope & Co., the family bank run by his uncle, and from 1790 until 1801 he claimed 18 percent of the company's profits.[50] These enormous sums were generated by the firm's success in controlling international trade and in exploiting the geopolitical sphere. From the 1780s Hope & Co., as the bank for the Portuguese colony of Brazil, traded diamonds in Amsterdam mined in the Brazilian interior. During the 1790s Henry Hope was banker to Catherine the Great and had the monopoly on trades relating both to sugar imports into and grain exports out of the interior of Russia.[51] In the period when Thomas Hope was completing Duchess Street and preparing *Household Furniture and Interior Decoration*, the

Hopes' activity in such global trades intensified, as did the scale of their ventures. In 1801, Hope & Co. obtained preferential terms in loans to the Spanish Kingdom that gave them control over trade in all the silver extracted from the interior of Spanish Venezuela. From 1802 to 1807, they failed, narrowly, to create a joint monopoly with the French speculator Ouvrard on *all* trade in *all* raw products exiting Spanish South America.[52]

Like geometers and naturalists, these early nineteenth-century bankers were engaged in processes that recognized and commodified the geopolitical interior. The most iconic example of this is provided by the trade that cemented the Hopes' authority as bankers to the colonial powers. In 1802 and 1803, Henry Hope & Co. in London and its subsidiary Hope & Co. in Amsterdam partnered with Francis Baring & Co. in underwriting the Louisiana Purchase, a trade which Henry Hope's representative Pierre César Labouchère called "an operation of the utmost magnitude and importance [that] might stagger us in ordinary times."[53] By October 20, 1803, the ownership of 2 million square kilometers of the North American interior—from New Orleans in the south, along the length of the Mississippi in the east, to the Rocky Mountains in the west—passed from France to the United States in a single, huge land transaction. The Louisiana Territory was sold, not ceded, yet the purchaser had not the gold to pay for it. For the trade to be possible, the bankers had to devise a method by which the value of this enormous space could be transferred to and held on paper: thus they created "Joint Properties" in "original Louisiana Stocks" (in effect, bunches of bonds), in which individual traders could purchase shares.[54] In this way the bankers articulated a landscape of almost infinite dimension such that it could be purchased via a very wide and domestically located system of small transactions. Like the publishing endeavors of naturalists and explorers, this act of mind by the Hopes and Barings represented the interior and allowed its dispersed consumption. Just as Denon's *Voyage* made the geographical interior available to a literary audience, these bankers draughts made the geopolitical interior visible, and attractive, for traders across Europe.

Hope's technical knowledge of banking is difficult to assess, but the significance of the Louisiana Purchase was not likely to have been lost on him.[55] Not only did deals like this provide the buying power that enabled him to formulate his ideas about the architectural interior, but their success depended on a powerful

ability to articulate and exploit—to "recognize," in the terms used here—the geographically remote near at hand. Some indication of the imminence of this geopolitical sensibility to Hope's thinking can be gleaned from his choice of Egypt as the destination for the reader's eye in *Household Furniture and Interior Decoration*. The Egyptian room completes the series of three-dimensional views presented in the book and is followed by pages of flat elevational drawings of furniture species. Thus, Egypt marks a point of hiatus in the text—as it did not in the house, where, by all accounts, the Egyptian room was not last in the sequence—the place where one system of representation gives way to another. This central positioning can hardly have been a neutral choice. In France, Egypt signified Napoleon's spectacular 1798 invasion of the country; in England, Nelson's thwarting of that invasion. Thus *Household Furniture and Interior Decoration* celebrates a single geopolitical entity that appealed to both sides of an enormous geopolitical divide. For Hope this doubled nature had a specific potential. From 1803 to 1807 the Hopes and the Barings continued to generate large sums for themselves and the French treasury via trades in Louisiana stock, even as Britain and France were at war. If the bankers had somehow succeeded in creating a financial structure that framed geopolitical conflict, Hope created an architectural structure that encapsulated one of the primary spaces in which that conflict unfolded.

The significance of the geopolitical interior, explored through careful observation, constructed through media, and exploited in contexts far from its origin, only increased during the first decades of the nineteenth century. The twenty-two-volume *Description de l'Égypte*, which published text, maps, and enormous images of the country from 1809 to 1828, contributed to debates about time, history, cultural appropriation, and aesthetics that became central in European culture.[56] During the same period Alexander von Humboldt's thirty-two-volume *Voyage aux régions équinoxiales du nouveau continent*, published in Paris from 1807 to 1834, provided the basis for a new European understanding of nature.[57] Even as French imperial glory continued to be articulated via the *Description*, von Humboldt's text affirmed the cornucopian potential of territories that the Hopes' interior trades had sought to control.

Such mediated descriptions also formed one of the first places where the architectural interior as a category was identified and set against vivid images. The Daniells' *Antiquities of India*, part of

the *Oriental Scenery* series published in 1799, repeatedly uses the word *Interior* in plate titles describing the insides of "primitive," often subterranean, Indian temples.[58] And when Hope listed the group of texts that described Egypt for his contemporaries ("Norden's Egypt, Denon's Egypt"), he was referring to a corpus in which the doubled significance of the interior—geopolitical and architectural—was embedded. Frederick Ludvig Norden had already described an interior buried inside a pyramid in 1765.[59] Denon's *Voyage*, published in 1802, used *intérieure* to describe both architectural and geographical spaces: landscapes and deserts possess interiors; so, too, did tombs and temples.[60] By 1819, John Lewis Burckhardt's *Travels in Nubia* could describe interiors of tombs, pyramids, temple courtyards, islands, harbors, deserts, countries, and continents. And here, for the first time, the term nuzzled against domestic routine:

> Every tent is furnished with two or three Angareygs [low divans], which take up nearly the whole of the interior, so that a very small part remains for anyone to stand in; nor is this very necessary, as the Bisharein pass the greater part of their time reclined upon the Angareyg. . . . They possess cattle, which feed in the summer on the bank of the river, and in winter in the interior of the desert.[61]

The Bishari nomads recline in one interior; the cattle they own graze another. In terms of architecture, the interior is moving toward the description of domestic life.

This expansion in meaning—from denoting geographies, to describing the bounded subterranean spaces of sacred architecture, to defining the spatial quality of domestic rooms—is distinct. During the 1820s, again with reference to Egypt, the transference of *interior*—from describing the realm of the sacred, subterranean, and eternal to the domestic, elevated, and lively—is repeatedly marked. Egyptian tomb architecture itself began to be likened to spaces that emerged out of the new domestic accounting systems of interior decoration that descended from the work of Hope, Percier, and Fontaine. Giovanni Belzoni, describing the tomb of Seti I in 1820, identifies its chambers as "the entrance hall," "the drawing-room," and "the sideboard room."[62] The French traveler Nestor l'Hôte, describing the same space in 1828 or 1829, compares the experience to "entering into the boudoirs of our most elegant Parisiennes."[63]

Part I: Cargoes 1530–1910

Species of furniture. Thomas Hope, *Household Furniture and Interior Decoration*, 1807, plate 41. Internet Archive.

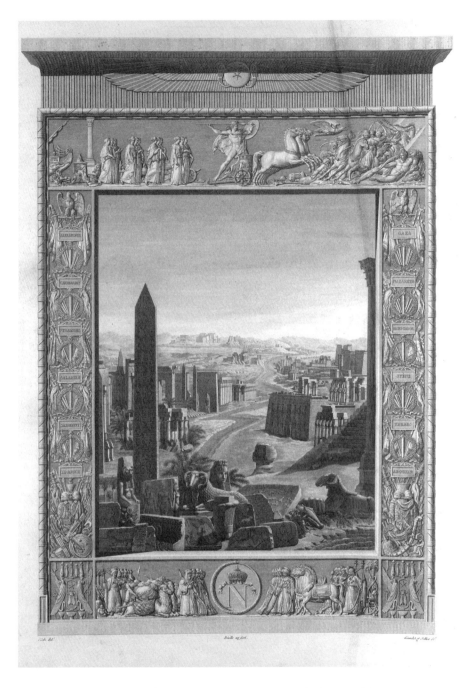

Frontispiece from *Description de l'Égypte ou Recueil des observations et des recherches qui ont été faites en Égypte pendant l'expédition de l'armée française*, vol. 1 (Paris, 1809). Etched engraving by Abraham Girardet and Charles Sellier finished by Jean-Baptiste Réville, after a drawing by François-Charles Cécile. New York Public Library.

Seventy years later the doubled significance of *interior* as a term to describe at once a space of domestic, architectural intimacy and a space of geographical dimension had been fixed. When the first edition of *A New English Dictionary* was published in 1901, it identified the interior part of something as "the inside"[64] and defined the word to mean both "that part of a country, island or continent lying at a distance from the frontier or coast" and "the inside of a building or room . . . ; also, a picture or representation of the inside of a building or room." The latter was anchored in a pronouncement made in 1864 by the editors of the periodical *Realm*: "everything that brings nature into our interiors deserves encouragement." *A New English Dictionary* added to this a further, pregnant, psychological significance: interior could also denote "the inner nature of being; the inner mind; soul, character." Both the architectural and the psychological definitions of interior were new, unknown in the eighteenth-century *Dictionary* of Samuel Johnson or the nineteenth-century one of Joseph Emerson Worcester.[65]

These semantic changes introduced categories that were to become central to the narrative of the nineteenth century. To occupy (or to be at rest in) the interior required an epistemology of distance, of errantry and return. In the domestic environment of a space in London's Fitzrovia or Marylebone (Thomas Hope's house at Duchess Street lay on the border between the two), another kind of space was being reassembled. This second space, a vast and removed territory called the interior, became visible in glimpses, fragments, echoes—in objects, paintings, artifacts that were found, assembled, transported, redistributed, and copied. "Interior decoration" was one mechanism by which this enormous (at the end of the eighteenth century) geographical construct could be contained and mastered in the minds of the culture that was inventing it. By this means a vast space could be removed and enclosed with all its potential intact within a domestic container, in a similar way as the powerful genie was contained in Aladdin's magical lamp. (The stories of the *Arabian Nights* in Britain, and *Les mille et une nuits* in France, had been best sellers since their translation and release by Antoine Galland in Paris between 1704 and 1717.) The interior, then, operated in a dynamic

that brought the familiar into intimate juxtaposition with a profound sense of the other.

Once the domestic architectural interior was named it began to be interpreted for its meaning. Interiors began to speak, not only to contemporaries who visited them—John Lewis Burckhardt, or Giovanni Belzoni, or Nestor l'Hôte, or the editors of *Realm*—but to a rich stream of historical analysis that sought to understand nineteenth-century culture in retrospect.

Two evocative dimensions of this interior "other" deserve mention. For the British art historian Stephen Bann, writing in the 1980s, nineteenth-century interiors created a living sense of the past for their occupants, bringing them into a position of parley with the absent dead.[66] Walter Benjamin's searing analyses in the *Arcades Project* (German edition 1957, English translation published in 1984) highlighted a similarly uncanny relationship between the psyche of the individual and the architectural character of their surroundings: the interior's other space was a space of the mind. Both these characteristics—the summoning of lost time and the indexing of a psychological interior that mirrored architectural surroundings—are adumbrated in the overlap between the architectural and geographical senses of the interior that marked the years around 1800.

For Bann the architectural interior was a privileged site where an epistemological shift in society's conception of the relation between past and present was manifest.[67] With reference to Paris's Hôtel de Cluny, where in the 1830s Alexandre du Sommerard reinstalled artifacts that Hope knew from Lenoir's Musée des monuments français, Bann explored how interior display created a new reality, which he called "'lived' history, or history as 'le vécu.'"[68] Where Lenoir had treated the objects he assembled as unrelated "specimens" from a universal historical atlas, linked only by their presence within a particular room and under a particular heading, Du Sommerard re-created rooms from the past together with the constellations of objects that belonged to them. This created a new condition, characteristic of the nineteenth century. Objects from the past had become "the basis for an integrative forming of historical totalities," separate from—and greater than—the thematic room and assembled objects that created them.[69] The architectural interiors created in the early years of the century by actors such as Hope or Percier and Fontaine had a similar immanent reality in relation to distant geopolitical spaces, making these immersive

in a way akin to the "lived history" Bann discovered in Du Sommerard's Hôtel de Cluny. In its evocation of the distant other, the early nineteenth-century interior presaged the sensation of living history that Bann was to associate with the category much later.

At the same time, the overlap between the psychological and architectural meanings of interior codified by *A New English Dictionary*, which informed the dreamlike invocation of the lost nineteenth century in the work of Walter Benjamin, also finds its prehistory in the link between the geopolitical and the architectural sense of an interior.[70]

In his *Arcades Project* Benjamin wrote: "The nineteenth century conceived the residence as the receptacle for the person, and it encased him with all his appurtenances so deeply within the interior that one might be reminded of the inside of a compass case [*Zirkelkaste*], where the instrument with all its accessories lies embedded in deep, usually violet, folds of velvet."[71] As several twenty-first-century cultural critics have proposed, the nineteenth-century architectural interior can be interpreted as being necessary to, and reflective of, the psychological constitution of the individual it encased.[72] Again, this insight is adumbrated in the translation between a geographic and an architectural sense of the interior. At the beginning of the century, domestic rooms began to be used to conjure up spaces hidden and much larger than themselves. Works such as *Household Furniture and Interior Decoration* suggest that, at its invention, the architectural interior had a fecund quality—already in 1807 it contained an elsewhere. And from the outset the larger spaces contained could refer to the occupants and their individual histories. While Hope claimed that his manifesto described a generally desirable interior condition, the rooms he drew projected a lived experience that was his own. Beyond re-creating a sense of the past, then, early nineteenth-century interiors reveal that extensive geographies and "secrets mystérieux" were fundamental to the link historians have made between the "furniture of rooms" and the "furniture of minds."[73] The architectural interior, as it developed during the early nineteenth century, is redolent of such geographical and geopolitical sensibility.

A difference in charge between the domestic and the distant, between the familiar and the outlandish, produced the energy that drove the development of the architectural interior. What other kinds of energies were released in that process of fusion in which the space of continents was compressed within the walls of domestic apartments? The carefully drawn vases in plate III of Thomas Hope's *Interior Decoration* had a peculiar history. Hope purchased the bulk of them as they were being prepared for auction at Christies during winter 1801. Occupying a hinterland between unique collectable objects and traded commodities, they had been put up for sale by Sir William Hamilton, who was retiring as Ambassador Extraordinary to the King of Naples after his return to England in 1800. Hamilton had sourced them during the 1780s out of an established network of trade in collectibles within the Italian peninsula, and they had formed part of his second collection of antique pottery at Palazzo Sessa.[74] The double shadow of geopolitics and commercial exchange that hung over the development of the architectural spaces of the early nineteenth-century European city is made rather literal here. The vibrant market in antiquities that Hope patronized in London was created partly through political unrest in Europe (whole collections were being moved and sold in order to realize capital or to fund exile). Hamilton's fortunes, very famously, intersected with those of the British Navy during this unrest, and his collection traveled to England aboard two British naval transports (one, and around a third of Hamilton's pottery, was lost en route).[75] The naval transports were available because Horatio Nelson's squadron, after its success at the Battle of the Nile, had been ordered to Naples as part of the power play between French and English forces over the Italian peninsula. The French ships that the British attacked off the Egyptian coast at Aboukir Bay had just transported Napoleon into Egypt, where he sought to control access to the vast African interior. And British resistance to this effort was concerned with protecting its trade interests at a general and particular level (preserving communication links to British possessions in the East, protecting vast shipments of grain out of the interior of Russia, and, for the French, potentially opening up Africa).[76] There was, then, a very real global network of physical movement implied in creating the immersive effects that summoned up distant geographical interiors in the polite settings of London or Paris. Vases had to be purchased, messages sent, ships chartered, admirals persuaded, auctioneers

primed, coasts charted, landscapes surveyed, and enemies foiled within the system of mechanics that made the architecture of the interior important.

In this context the ghost of a global network of physical movement had an increasing significance for the conceptualization of architecture, engineering, and artifact design. This happened, both in Europe and in the areas of the world European culture manipulated, through an increasing recognition of the infrastructure that was necessary to facilitate such systems of exchange. Physical movement required, on one level, assemblies of persons and contract; constructions of the kind that allowed the Baring and Hope banks to facilitate transactions such as the Louisiana Purchase. At the same time, movement depended on the spaces where exchange was negotiated—magazines, inns, customs houses, governor's mansions, shipping offices, and the rooms in which administration was carried around the globe: the rhythmically moving spaces of ship's cabins. (In these last spaces the juxtaposition of the domestic and the exotic that gave the early nineteenth-century architectural interior its resonance was in some sense reversed. In the transaction that extracted goods and images from out of the geographical interior, an image of the order that was orchestrating this process had to be projected right up to the first site of contact. The evolving delicacy of ships cabins toward the end of the eighteenth century—the domesticity of their accoutrements and the architectural references they carried—attests to this dynamic, in which the trappings of life "at home" in Europe were carried far and wide.)[77] At a third level movement relied on assemblages combining technologies and spatial relationships that supported actions of transfer in a physical way. Into this last category might be included the hinterland of trading ports; the packing used to wrap objects for transport; wagons, cranes, and windlasses; the "ways" used to launch great ships; even the ships themselves. All these physical armatures that facilitated movement began to be mediated during the first decades of the 1800s. And, just as the circulation of images relocating distant geographies did, the representation of systems that moved or stored objects changed ideas about how architecture could be assembled. As the next chapter will show, this doubling would lead to truly extraordinary developments in the conceptualization of architecture during the nineteenth century.

Moving Large Things About
in the Nineteenth Century

On a double-page spread from the *Illustrated London News*, October 27, 1877, a ship founders at sea. The ship is an odd one—a very large cigar, topped by something like a submarine's conning tower. Part Zeppelin, part London Underground carriage, it lists dangerously as mountainous seas break over its decks. On its bows, the name *Cleopatra*. Inside, an obelisk, Cleopatra's Needle, on its way from Alexandria (where it has spent nineteen centuries buried in the sand) to London (where it will later be placed on the newly constructed Victoria Embankment). The picture records a storm in the Bay of Biscay at dawn on October 15. *Cleopatra*'s captain, Henry Carter, has just issued the command to abandon ship; her towing vessel *Olga* is standing by to rescue survivors; and the obelisk itself is about to be lost. This potent image was seen in turn on a Saturday morning two weeks later by perhaps half a million people: on trains and omnibuses, in London clubs and rural parsonages; in breakfast parlors and tea-time conservatories all across the United Kingdom.[1]

The *Illustrated London News* covered the story of moving Cleopatra's Needle in great detail. The loss at sea provided unlooked-for drama in a meticulously documented narrative that was articulated in print from the planning of the obelisk's eventful journey from Alexandria (March 1877) to the celebrations that accompanied its

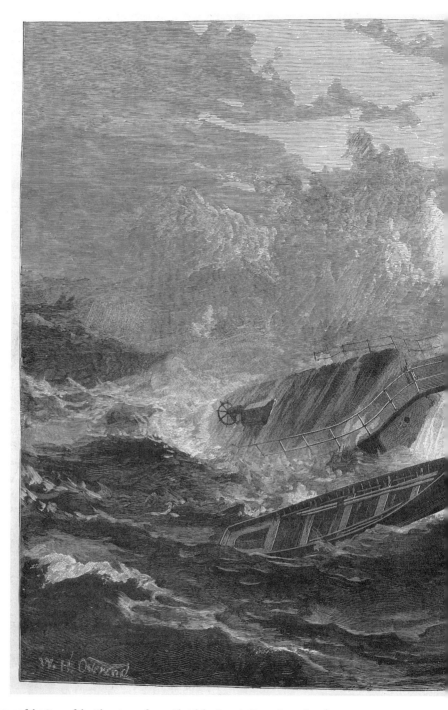

"The Rescue of the Crew of the *Cleopatra* . . . from a Sketch by Captain Henry Carter."
Illustrated London News, Supplement, October 27, 1877. National Library of Sweden.

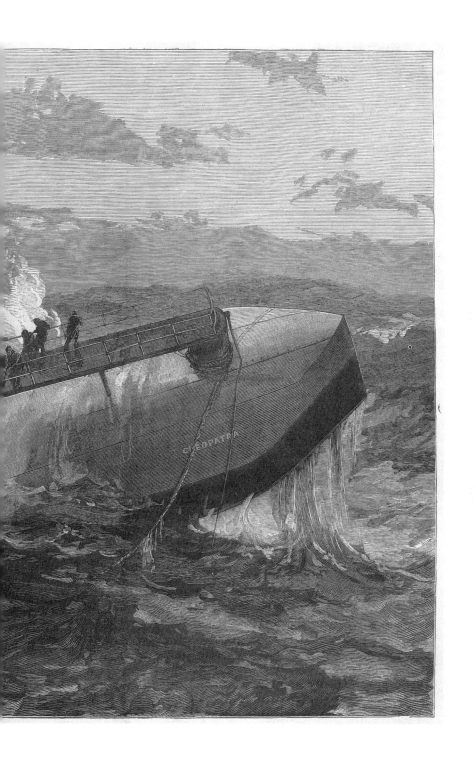

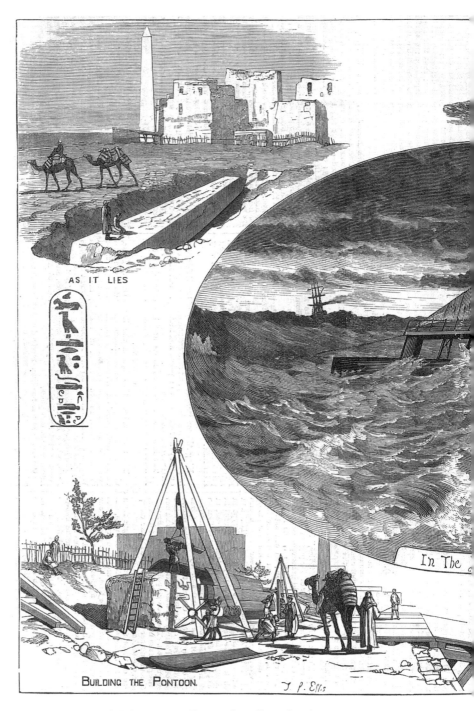

AS IT LIES

BUILDING THE PONTOON.

J. P. Ellis

"Proposed Method of Removal of Cleopatra's Needle to London." *Illustrated London News*, March 10, 1877. National Library of Sweden.

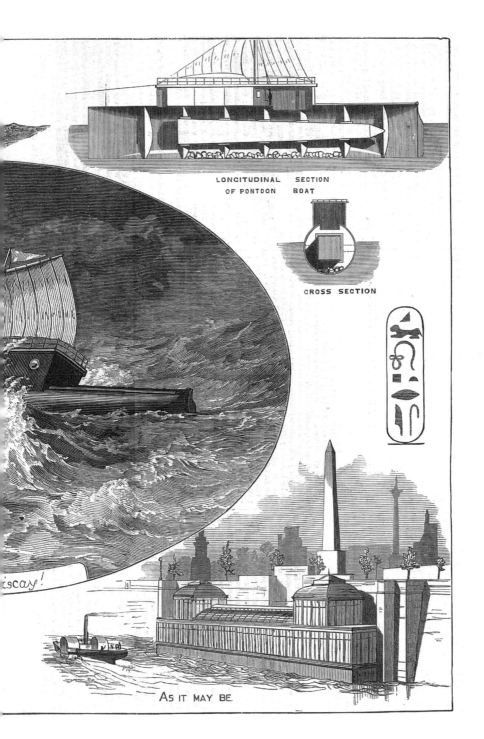

LONGITUDINAL SECTION
OF PONTOON BOAT

CROSS SECTION

iscay!

AS IT MAY BE

final arrival at Gravesend at the mouth of the Thames in January 1878 (happily *Cleopatra* was sighted afloat, against all odds, three days after her abandonment and was towed into Ferrol harbor by October 19). The coverage continued until after the obelisk was erected along the Thames in 1879.[2] The sequence of images produced during this reporting articulated a moment of uncertainty as central to the story. A double spread from March 10, 1877, which shows the proposal for transportation, provides a first indication of this principle. A collection of vignettes that describe the technological process of moving the obelisk (bottom left to top right) and the geopolitical significance of its arrival (its situation in Alexandria top left, and a projection of its placement in London bottom right) formed the basis for the design. This sequence, however, was positioned around an image that emphasized neither the obelisk's antique place of origin nor its imperial destination, but rather its condition in transit. This central moment of transitional instability recorded the obelisk where it had no fixed bearings at all, at sea "in the Bay of Biscay." Here, the vessel that bears the obelisk is shown in the foreground, isolated and alone, dwarfed by its surroundings. A second ship, retreating over a broken horizon, emphasizes the isolation of the first. Nothing is still; all things that have direction and intention—ships, masts, needles, engineering, imperialism—appear to be lost in a constant flux of rolling, gyrating movement.

That real events confirmed this instability can be seen as both unfortunate and, for the news value of the story, serendipitous. The unexpected storm that hit *Cleopatra* and her towing vessel on October 13—inevitably in the Bay of Biscay—reified potentials that the paper had already communicated to its readers in March. It became clear that *Cleopatra* had no stability at all; she was abandoned when she turned and lay on her beam-ends in the engulfing sea. And this sensitivity to instability continued to inform the graphics describing the project after the obelisk's surprising and delightful recovery. Despite the good fortune of getting the needle back, the moment of uncertainty, rather than that of recovery, continued to drive the visual account. With one exception, *Cleopatra* lists in every image of her that the *Illustrated London News* produced, from the full-page spreads that reported her design, through the October issue that recorded her catastrophic capsize, to a final January 1878 supplement that narrated her recovery, repair, and final towing to London.[3]

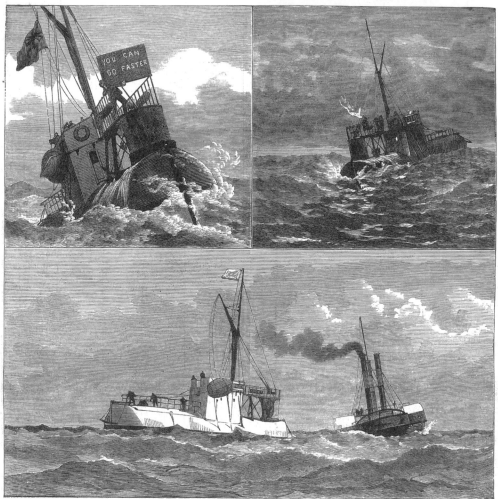

"Sketches in Route from Ferrol to London." *Illustrated London News*,
Supplement, January 26, 1878. National Library of Sweden.

THE "GREAT BRITAIN" STEAM-SHIP.

CUTTING THE TRENCH IN THE SAND.

In addition to these shores, were many immense wedges, hauled in at the fore-keel and bilges; stones were also put under her with long slutes from the deck.

Among Mr. Mahony's Illustrations, the first shows the huge vessel as she appeared when beginning to rise.

The Engraving on the opposite page represents the busy scene of the men cutting a deep trench in the sand, at low water, from the stern of the vessel, outseaward.

To protect the stern of the ship from the gales of last winter, it became necessary to devise some means; and this was done by Messrs. Brenner, constructing a breakwater, which Mr. Mahony has sketched. It was composed of piles or of balk, of from 15 to 17 inches thick, and arranged in the manner shown in the cut; but, scarcely had this work been completed, when a fierce gale, on November 9th, in a moment laid this labour of men's hands prostrate, smashing the beams like so many reeds.

Subsequently, Captain Claxton designed his Breakwater, and submitted it, by order of the Directors, to Mr. Brunel, who approved of it highly; but, at the same time, suggested some important improvements, which were made, and found to answer the purpose. Captain Claxton, in its construction, as is usual in out-of-the-way places, had many difficulties to contend with, and had to try different sorts of timber, but found, in the end, that young beech-trees were preferable for their elasticity; and those persons who saw this Breakwater, when first finished, describe it as an interesting object, undulating with the mighty waves, like the trees of the forest in a gale of wind. It was not only a barrier against but an exceedingly efficient one, as it protected the ship from many a winter storm, and ultimately became, towards its base, a solid mass; so that its removal had been an exceedingly difficult work. Mr. Mahony has sent two sketches of this Breakwater; one, the elevation, showing its height and length on the ship side, the manner of framing it, as also the portion filled with sand-bags and fagots, denoted by the dotted line; the detot line underneath indicating the stern of the ship; the masts, the portion protected by the Breakwater; and the line from the stern, the cable, &c., to keep her in place.

The gratifying result of all these preparations was, that, on Thursday, the 29th July, the ship was raised to the required height, so that the boiler-builders could get at the bottom to make it water-tight.

SECT. NO. 2.—THE BOWS, SHOWING HOW THE CROSS WEDGES WORK.

The second Illustration of Captain Claxton's Breakwater, at page 122, shows the foundation, with its distance from the Ship, and the means taken for keeping down the fagots at the commencement of the work, by placing all the spare chains, pieces of the ship's engines, and each dead weights as could be obtained from the stores, to the weight of from 70 to 80 tons, before it could be raised eight feet above the level of the foundation. Yet, with all this precaution, Captain Claxton assures us that from 80 to 100 bundles of fagots were washed away during the month of February, when the sea was most violent, and was constantly sent to wash over the ship's funnel. Captain Claxton adds that the Breakwater took above 8000 fascines in its construction. In the Engraving are shown the chains, and the pieces of machinery, and other dead weights; 1, chains and cables, made fast to propeller; (2 lines of ship;) 3, sand-bags placed at the bottom of Breakwater and Ship; 4, stones, placed between sprights; 5, fagots; 6, cables, cut from Breakwater.

Our Artist has next applied himself to the illustration of the means adopted for lifting the leviathan Ship, a dead weight of from 1500 to 1800 tons, and in which the Messrs. Brenner have been so pre-eminently successful. The "means and appliances" are shown in the following Sections.

Sect. 1.—Showing the bilge wedges, and how worked. 1, the upright for the box to work on; 2, the Ship's side; 3, the wedge; 4, the rope passing over, at each side of the joint; 5, platform for wedges to work on; 6, foundation stones.

Sect. 2.—Close by the Bows of the Ship, showing how the wedges crossed each other, and were worked from above, by a monster, the arrows denoting the upward movement of the rope. The dotted line shows the sand-line, and the basement, the stones driven by Captain Claxton and Mr. Brenner.

Sect. 3.—Means by which the shores raised and placed themselves securely in their proper positions, when the Ship had reached her intended height, all extremely simple in themselves, but, by an means, less ingenious. 1, Ship's side; 2, shore; 3, cleat, made fast to ship's side by two bolts; 4, cleats, to keep the preceding steady; 5, shoot for shore to work in; 6, piles driven names to rock, to secure the the foundations; the arrows marking the motion of the rope, worked by 7, from above.

SECT. NO. 1.—THE BILGE WEDGES, AND HOW WORKED.

Sect. 4.—Showing the shoes for conducting stones under the Ship's bottom, as well as the rammer; 1, line of Ship's side; 2, sprights; 3, shoot; 4, rammer, shod with iron; 5, men casting stones from above, into shoot, the arrows marking the rope's motion for working the rammer; 6, section of the Shoot, by which stones were conveyed under the bottom, and then rammed down, so as to form a foundation for after-work.

Next, are two views of the sand-boxes, no three of which are alike, as they have to be used afterwards as camels, to float the ship. In the Cut is shown how the chains passed through and around the boxes, as well as how they were placed —1, out of one of the ship's portholes—2, out of the balk; each box holds 30 tons of sand.

SIDE AND FRONT VIEW OF SAND-BOXES.

Lastly, are the Bows of the Ship, with the remains of the great lever under them, loaded with old anchors and other deadweights; the props fixed around the stern, when raised; and men removing the remains of Captain Claxton's Breakwater.

Our Artist relates that while the ship was rising, the rattling of the chains was very extraordinary. The men (riggers) shown at work in the last sketch, were brought in the Government steamer, Birkenhead, to assist in the great labour; there were 60 of them.

On Monday, the Birkenhead arrived in Kingstown harbour, from Dundrum Bay, and reported that the result of another experiment made on Saturday had

SECT. NO. 3.—THE SHORES, AND HOW WORKED, SO AS TO FOLLOW THE RISING OF THE SHIP

SECT. NO 4.—SHOOT, FOR CONDUCTING STONES UNDER SHIP'S BOTTOM.

The mid-nineteenth-century illustrated press specialized in portraying stories of heavy engineering projects in uncertain waters, using elaborate sequences of images to record moments of crisis—points at which objects were either stranded on the verge of their becoming, or in which some kind of prosthetic operation was needed for them to realize their identity. Close in subject to the story of Cleopatra's Needle are the careful rendering and explanation of the means and devices to move the stranded steamship *Great Britain* (published in the *Illustrated London News*, August 31, 1847) or drawings of her refusing-to-be-launched sibling *Great Eastern* (published in the *Illustrated London News*, November 14, 1857). Designed by the famous railway engineer Isambard Kingdom Brunel, *Great Britain* spent most of 1847 beached at Dundrum Bay in Ireland due to a navigational error; his later *Great Eastern* appeared to be so vast she might prove impossible to launch at all.[4]

Three questions: First, from where did this habit of articulating technological achievement together with underlying uncertainty derive? It was an intriguing trope of nineteenth-century mediation, one that predated the evolution of illustrated news media, and one in which a sensation of rolling, of imminent tipping, emerged in a series of stories. Notably, these tipping stories related explicitly or implicitly to the affirmation of European cultural hegemony. To explain the *Illustrated London News* focus on Cleopatra's Needle requires a narrative that starts in the early years of the nineteenth century, within the same context of exotic approach that informed the development of the architectural interior discussed in the last chapter. A second conundrum: How should the repeated emphasis on upset in the *Illustrated London News* account be read? It is clear that the actions the paper was describing demonstrated an aspiration to global power in one way or another, with all the political and moral problems such a position implied. But the nineteenth-century image of economic and colonial might was an ambivalent construction rather than a victoriously certain one. Set in a wider historical context it becomes clear that something of the flickering outline of this uncertain projection was being revealed in the kind of coverage the *Illustrated London News* obelisk story provided. Finally one can ask: What were the projective implications of this habitual way of seeing the world? And more particularly, what were the design sensibilities afforded by this emphasis on tipping that characterized

nineteenth-century narratives of movement? In the following pages I suggest that this pendant condition of instability became inherent in the conceptualization of design during the nineteenth century: that the architecture and engineering of this monstrous age was redolent of fluid, destabilized experience. At the century's start, this instability appears wayward; toward the century's end it appears more controlled. Cleopatra's Needle, and the curious iron cigar-case that encased it, floated (at various angles of heel) midway in that narrative. The story of the obelisk evidenced a moment in which a quality of unstable hybridity began to be exploited as a quality among designed objects.

From 1800 systems of representation began to record the movement of objects great and small in all directions. Already in the first decades of the new century sizable architectural fragments were being removed from areas subject to interference, control, and exploitation by European nations.[5] The biggest of these objects were stolen out of Egypt in the wake of Napoleon's invasion; their destinations varied—the Italian and German states; Spain; most famously England and France. In these last countries visual mediation played a part in narratives of removal. The French extraction of the magnificent zodiac relief from the roof of the Hathor temple at Dendera was anticipated in print. The relief was portrayed in situ in Dominique Vivant Denon's *Voyage dans la Basse et la Haute Égypte pendant les campagnes de général Bonaparte* published 1802 (on plate 130); as a fictively displaced fragment in the 1809 frontispiece to the monumental *Description de l'Égypte*; and as an isolated detail in *Antiquités planches* (vol. IV, plate 21) of the same work, published in 1818.[6] Its physical rape—dislocated "by means of saws and chisels and gunpowder" by the stonecutter Claude Lelorrain in 1820, shipped down the Nile by the collector Sébastien Louis Saulnier and exhibited in the King's Library in Paris in 1822—materialized a translation already performed on paper.[7] The same reiteration of printed and physical removal emerged in other celebrated circumstances. The work of the ingenious mover Giovanni Battista Belzoni, who was recruited in 1816 to clear Egyptian monuments from debris and devise ways of getting them to London, was mediated even as it was conceived. Percy Bysshe Shelley's poem "Ozymandias," inspired by the news of Belzoni's success in the initial

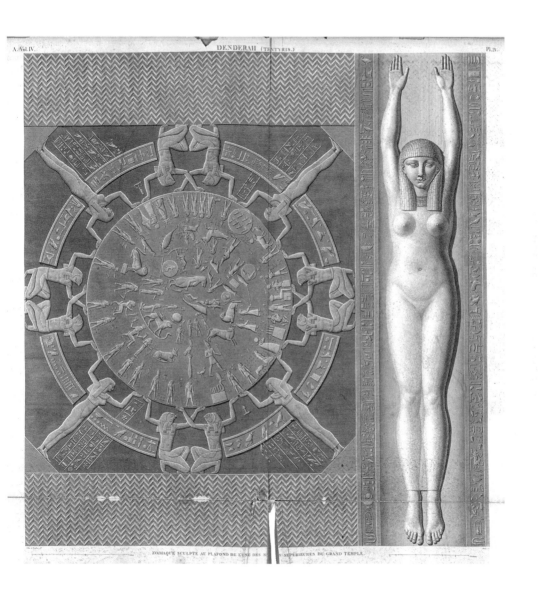

ZODIAQUE SCULPTÉ AU PLAFOND DE L'UNE DES SALLES SUPÉRIEURES DU GRAND TEMPLE.

"Denderah (Tentyris). Zodiaque sculpté." Engraving by M. Allais, after a drawing by Jean-Baptiste Prosper Jollois and Édouard Devilliers. *Description de l'Égypte. Antiquités planches*, vol. IV, 1817, plate 21. New York Public Library.

stages of removing the 27-ton bust of Ramses II from its resting place on the edge of the Nile Wadi opposite Luxor, was published in the English *Examiner* in January 1818.[8] When Ramses was installed at the British Museum three years later the orchestration of his journey—first across the Egyptian sands, then by barge to Rosetta, ship to London and cart to the British Museum, where the perimeter wall had to be breached in order to get him in—was celebrated in images that emphasized a connection with feats of

COLOR PLATE 8 movement recorded in ancient reliefs.[9]

Through this process a curious overlap began to develop between the imagination of distant geographies carried on paper, the objects of this imagination that were being transported in reality, and the various pieces of infrastructure that were created to facilitate this movement. In an economy of exchange, as the infrastructures of translation became evident, objects and mediations began to lose some of their hierarchical separation. One paired example might serve to make the point. On its completion in 1829 a single finely bound "collected" copy of the French *Description de l'Égypte*, with its 26 volumes of text, 11 volumes of plates, and accompanying *Atlas*, could weigh up to 280 kilograms, the "mamut" volumes of illustrations weighing around 20 kilograms each alone.[10] The weight of the entire 1,000-copy edition, steered through the Imprimerie impériale by the *Description*'s executive editor Edme-François Jomard between 1802 and 1829, thus approached 280 tonnes. The material monumentality of this endeavor did not go unmarked. The *Atlas* of the imperial edition was "of such extraordinary dimensions that Brunet observes that its use was impossible excepting to those persons who had procured a piece of furniture expressly designed to receive it," notes an English summary of the work in 1838.[11] Indeed, this problem so struck Jomard, the engineer-editor of the *Description*, that he designed exactly such a piece of furniture, a cabinet developed specifically to allow the book it contained to be consulted. Drawings of this image-carrying vehicle were themselves printed and published by the manufactures of the piece, Sieur Morel, "fabricant d'ébénistaires."[12] The whole made a curious mediatory loop in which a description on paper attained such physical dimensions that an infrastructure had to be designed and built to carry it, which in its turn became a mediated description. There was an explicit element of doubling in all this. Jomard's "appropriate piece of furniture" answered "the purposes both of a bookcase for

144 *Part I: Cargoes 1530–1910*

containing the work and of an inclined table on which it might be conveniently displayed."[13]

The double-function, tilt-topped casket that contained all Egypt was designed in 1817. Two decades later, in another mediated action that organized tilting, moving, and doubling, an obelisk that had stood for three thousand years before the palace complex at Luxor was moved to Paris and placed on a pedestal at the center of the Place de la Concorde.[14] The obelisk tipped the scales at 230 tonnes, weighing rather less than the collected *Description de l'Égypte* whose every copy translated it in image (it was illustrated in *Antiquités*, vol. 3, plates 2–7). But in their monumental qualities the two objects required similar handling. Where Jomard produced an apparatus both to tilt up the *Description* for consultation (the table), and to house it during periods of rest (the book case), the engineer who was appointed to move the obelisk, Apollinaire Lebas, designed a cradle that could tilt the needle for lowering and re-erection, and constructed a removable bow for a ship named *Louqsor*, designed specially to carry it. *Louqsor* realized an eighteenth-century dream of creating a modern cargo vessel able to undertake the journeys across open seas and deep into the land. Built in Toulon, she crossed the Mediterranean in spring 1831, navigated up to Luxor during that year's Nile flood, redescended the Nile to Rosetta, made her way to Le Havre via the Bay of Biscay and navigated up the Seine to the French capital by summer 1833.[15]

In the case of the Luxor obelisk, as with the *Description*, the infrastructure that supported translation was mediated as a part of the object itself. Where the Sieur Morel produced a printed pamphlet about the *Description*'s storage-cabinet-cum-display-table, Lebas and Léon de Joannis, the first lieutenant of the recovery expedition the French sent to Luxor, published visual descriptions of the processes surrounding the obelisk's translation to Paris. Joannis's book, *Campagne pittoresque du Luxor* (1835) recorded the half-rotated obelisk in the process of descent in Luxor and showed it end-on, creeping toward the Nile over the empty Egyptian sands.[16] Lebas's *L'obélisque de Luxor. Histoire de sa translation à Paris* (1836) compared his machinations around the Luxor obelisk with ancient and Renaissance projects for moving needles in Rome, providing fine fold-out illustrations showing the complicated systems for moving the obelisk up the embankments of the Seine.[17] Not content with printed reproduction, he commissioned also architectural miniatures portraying the transport infrastructure

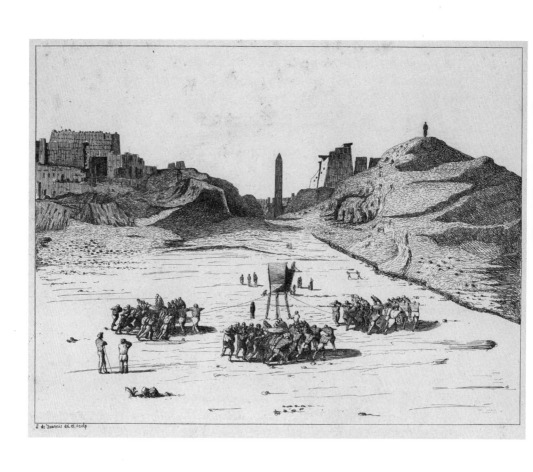

"Vue de la partie orientale du chemin qu'a suivi l'obélisque pour venir à bord."
From Léon de Joannis, *Campagne pittoresque du Luxor* (Paris, 1835). National Library of Sweden.

of the project for public exhibition. Both the tilting scaffold and the roll-on / roll-off *Louqsor* were modeled, the bow of the latter shown wide open.[18] Here, as in the account of consulting the enormous *Atlas* of the *Description*, the infrastructural requirements created by the gyration of a monumental object on a journey from storage to display were key. Lebas's drawings and models fixed on moments of hiatus in the translation north. The story of moving Cleopatra's Needle to London, with its relation to empire; its focus on technological hiatus; its narrative of success against all odds (high-seas, struggling tow ships, and tilting *immeubles*) was, then, a replay of a famous cultural event forty years old.

Tipping and Rolling

To write about this strange entanglement between artifacts, their mediation and the infrastructure that supported their translation is in no way to trivialize the problematic phenomenon of moving ancient remains toward particular centers of power. Rather it represents an attempt to open up a new perspective on the culture that became involved in these processes.[19] A dynamic that celebrated the infrastructure of movement through image applied across a wide range of artifacts in the early nineteenth century. The same characteristic of instability that the *Illustrated London News* conveyed in its story of Cleopatra's Needle also applied to objects of design whose physiognomies required active decision.

Of the objects moved in colonialization, some were tiny and pertained to the bodies of those doing the colonializing—pills and pill bottles; pins and pin cushions; combs, hats, and bodices. Others where large and carried the containers housing such objects. Crates, ships' cabins, and baggage trains transported personal effects as well as other items more obviously classified as cargo. As the century progressed other movable objects were produced as monumental as the ancient remains that European hegemony sought to displace. Ships, railway locomotives, iron railway bridges: all manner of objects moved around the globe.[20] Already by 1800 the potential in movement of certain of these objects was being mediated, in ways direct and subliminal. To take a curious example, the traveling interiors that carried colonialism to its destinations were characterized by a particular kind of furniture, used in ships' cabins and in the temporary quarters, military and

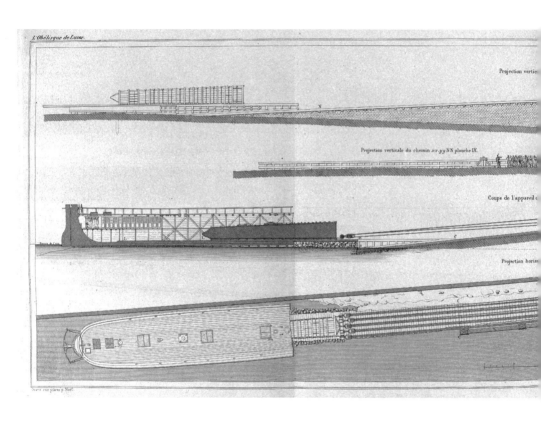

Longitudinal cross section, showing the unloading of the obelisk below the Place de la Concorde, Paris, August 1834. Lithograph from Apollinaire Lebas, *L'obélisque de Luxor. Histoire de sa translation* (Paris, 1839). National Library of Sweden.

Pl. VIII

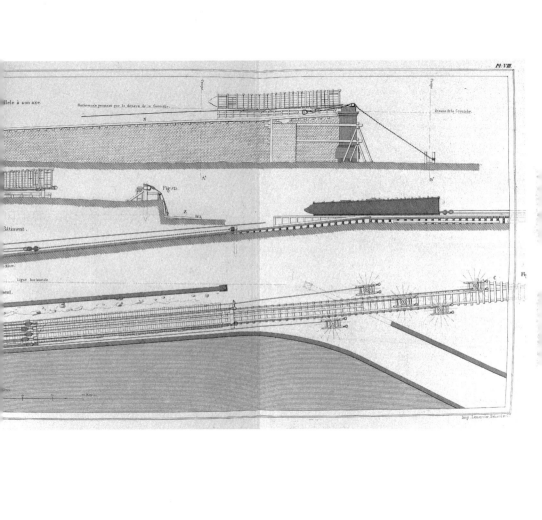

lele à son axe.

Horizontale passant par le dessus de la Corniche.

N

dessus de la Corniche.

Fig. 2.

A'

B'

Z

Bâtiment.

Rive.

Ligne horizontale

ment.

C

Fig.

Rive.

Mètres.

Imp. Lemercier, Paris.

civilian, on which colonial expansion relied. Known in English as "campaign" furniture, sometimes as "patent" furniture, these pieces were characterized by a necessary quality of metamorphosis, which grew from the need that they function in two distinct registers: opened up to create a domestic environment for the traveler; collapsed to allow for easy transportation.[21] This principle of metamorphosis could attach itself to items designed for otherwise very different milieux. In a ship's cabin, a dining table might collapse into a sideboard, which in turn could compress into a polished mahogany box for stowage. In a military camp a bookshelf or a wardrobe could always, by necessity, close up into a traveling case. The beautiful wardrobe steamer-trunks of the late nineteenth and early twentieth centuries, produced by firms such as that of Louis Vuitton, were the direct descendants of such devices.[22]

In the second decade of the nineteenth century this metamorphic quality became a feature of domestic furniture intended for quite stationary destinations. "Campaign furniture," born of the needs of translation, became a fad. Like most fads, increased popularity relied on the presence of its subject in the minds of a wide public. The attention became visible in literary settings: crucial scenes in Jane Austen's *Persuasion* (written between 1815 and 1816 and published in 1818 by John Murray) played out in the neat harborside home of Captain Harville, pensioned out of the navy, who furnished his domestic quarters with "ingenious contrivances and nice arrangements . . . to turn the actual space to the best possible account."[23] The type of multifunctional furniture this description implies was already on sale in the London showrooms of Thomas Heale. The company most associated with it, grounded by Thomas Morgan and Joseph Sanders in 1801, had established a wide media presence by the time Austen was composing her novel. Their firm produced illustrated broadsheets addressed to famous figures such as Sir Joseph Bankes; it advertised both in the London and the regional press, featuring regularly in the monthly *Ackermann's Repository of Arts, Literature, Commerce, Manufactures, Fashions and Politics* and claimed a special relationship with Horatio Nelson, supplying furniture both for his country house at Merton and in all probability for his last flagship, HMS *Victory*. Morgan and Sanders named their premises "Trafalgar House" and their best-known product, a chair that turned into a set of library steps, was christened the Trafalgar Chair.[24]

COLOR PLATE 9

The novel furniture of Morgan and Sanders included any number of transformational devices—chairs and sofas that turned into beds, sideboards that disgorged dining tables, writing desks that morphed into terrestrial globes—all of which circulated in image. Like the architectural interiors they were intended to fill, and in their references to the tradition of campaign furniture, these objects articulated a state of being two things at once and implied two geographies—both a removed "there" and an intimate "here." Like Jomard's cabinet for the *Descripton de l'Égypte*, and like the pieces of infrastructure designed to move the Luxor obelisk, here metamorphosis became a design principle; its representation a crucial trait. Transformation, in advertising and in image, was celebrated and highlighted.

Objects in Flux

This interaction between the circulation of images, the circulation of objects, and the circulation of images about the circulation of objects formed a particular nineteenth-century pattern. Through mediation a "this-and-thatness," or a "here-and-thereness," became an articulated quality of the objects in question. Whether related to geographies, obelisks, traveling trunks, or furniture, systems of mediation recorded a principle of flipping, of vibration. The ubiquity of sea travel and its furniture, the epic description of unknown territories, the collection and removal of valuable objects from exotic locations, all implicated multiple geographical presences, multiple histories, multiple scales of movement.

During the 1820s and 1830s this focus on actions that tipped ever greater objects into the news, and on the systems of infrastructure that permitted this movement, continued to prove a preoccupation across European culture in surprising ways. To be sure, key examples related to the display of colonial power and spoke to earlier triumphs of empire. Fifteen years after Napoleon's abdication, the French transportation of an Egyptian obelisk from Luxor could still be read in terms of a narrative that identified Paris as a new Rome and that paired nineteenth-century French industry with similar feats of removal in antiquity.[25] But the narrative potential of removal and reorientation emerged also in other contexts of national endeavor, which overlapped histories of a different, if related, kind. In one case at least, the threads visible

in the later nineteenth-century reporting about Cleopatra's Needle—a concern with instability, the narrative of heroic removal connected to national identity, and the presence, center stage, of a designed object that performed the circumlocutions that the narrative required—were all clearly present.

From 1826 to 1831, as the French dream of moving an Egyptian obelisk to Paris gestated, the Prussian state, its fortunes reestablished after the Congress of Vienna, undertook a series of actions that used architecture and engineering to display its prowess through the removal of archaic granite. Rather than following the antique Roman precedent of looting and removing monuments that had already been fashioned by ancient human agency, the Prussian king, Friedrich Wilhelm III, started from raw stone. In an action more pharaonic than imperial, he commissioned the architect/mason Christian Gottlieb Cantian to collect from the Rauen Hills in Brandenburg a porphyry-like material out of which to turn a vast, granite *tazza* or bowl.[26] The precedent for creating such artifacts was antique, most notably evidenced by examples displayed in Rome, although *tazze* in antiquity, like obelisks, were actually fabricated in Egypt.[27] Where celebrated events such as moving the Luxor obelisk introduced notions of instability into architectural objects already designed, in Prussia this narrative of the unstable began to be applied to a monument in the making. The *tazza* would be something like a super-scaled piece of campaign furniture: an object that in its physiognomy spoke to two possibilities of existence at once. For five years stonecutters, architects, and their royal Prussian patron indulged in a process that ended with the installation of an enormous circular basin in front of the steps of the newly opened Königliches Museum, now the Altes Museum, on the Museum Island in Berlin. Its positioning and support were negotiated with the museum's architect, Karl Friedrich Schinkel, and it was conceived in relation to the design of the museum's entrance sequence.[28]

As with the Luxor obelisk, a narrative can be constructed around the creation of this *Granitschale* (granite bowl) that emphasizes how its "this-and-thatness," its "here-and-thereness," responded to the way it brought points far distant into contact. Like campaign furniture, the *Granitschale* spoke to the possibility that this unstable condition might somehow be introduced into, might be figured in, the design object per se. To these rich elements the project in Berlin added another dimension of instability

Drawing concerning the works to upend, split, form, and transport the Grosse Markgrafenstein in the Rauen Mountains. Ludwig Friedrich Wolfram, *Vollständiges Lehrbuch der gesammten Baukunst*, vol. 1, 1835, plate 1. Internet Archive.

in its references to the early history of the earth itself. Mysteriously there existed in the Brandenburg forests a number of immense granite boulders that had no relation to the lithography of the local region. Such rocks, later termed "erratics" or *Findlinge* (literally, "strays," or "foundlings") became notorious during the second two decades of the nineteenth century as natural philosophers and nascent geologists tried to explain their widespread presence across the German plain and into the foothills of the Swiss Alps.[29] Seemingly both rooted to the ground and at odds with their surroundings, these odd, lumpen objects formed a puzzle. Too large to have been moved by man, always made of granite, apparently heterogeneous to their context, they inhabited the lowland country from Lübeck to Brandenburg in the north, and the mountainous Valais region around Lucerne in the south. But they seemed to come from elsewhere.[30]

Cantian was to produce for King Friedrich Wilhelm a *tazza* bigger than any that had been made in antiquity by removing a segment of one such stone, a single enormous pink granite boulder known as the Grosse Markgrafenstein, situated in the forest on a ridge above the Spree river 70 kilometers from Berlin. Throughout 1827 and 1828 his team up-ended and split the 7.5-meter-high Markgrafenstein into three pieces; worked the central section, weighing about 200 tonnes, into the rough-cut form required; moved the nascent bowl, 6.2 meters in diameter, its weight now whittled down to 75 tonnes, to the Spree on wooden rollers; and shipped it by barge to the city. It spent the years 1829 and 1830 inside a shed with a small steam engine, undergoing a continuous and very gradual process of fairing and final polishing, and was installed at its appointed position outside the museum on November 14, 1831.

As well as signaling Prussian technological genius and demonstrating how modern could equal ancient industry (working porphyry was notoriously difficult and had defeated Renaissance artisans), the granite bowl in Berlin was connected to a scientific debate about the origins of the *Findlinge*. The controversy touched an international cast of illuminati that included William Hamilton and Johann Wolfgang von Goethe, and permitted many of the insights that grounded the modern discipline of geology. Whether they were remnants of mineral deposits dissipated by vast oceans (the so-called Neptunist hypothesis, supported by Goethe, who believed that the pink granite in Brandenburg was a remnant of

an *Urberg*, an ancient, eroded native Prussian peak); whether they had been thrown high out of the bowels of the earth through volcanic activity (a Vulcanist explanation, which related to Hamilton's researches around Vesuvius); whether they had been displaced by inconceivably vast sheets of ice or propelled by a deluge of mud (both theories existed in parallel and Goethe was among others in intuiting the possibility that an ice-age had preceded the present climatic period), *Findlinge* such as the Markgrafenstein connected contemporary experience to a history that was antediluvian and mobile.[31] They suggested a tumultuous past, one which could not be explained without admitting that the earth beneath the feet of the increasingly mobile nineteenth century was itself in flux.[32]

The process of moving and erecting the *Granitschale* was documented through the creation of vivid images. This mediation was projective as much as it was descriptive, part of the fabric of the moving itself. A series of small paintings produced from 1830 to 1831 by Johann Erdmann Hummel, professor of perspective at the Berlin Akademie der Künste, emphasized particular aspects of the process: tipping and infrastructure. They conveyed the bowl's material quality together with the combination of surface polish and geometry that allowed it to invert and metamorphose its surroundings in reflection, turning the world upside down.[33] In a very literal way, these paintings conflated the object with the image. The *Granitschale* as depicted by Hummel contained within it a series of distorted, repeated, and reflected views; the bowl was as much mirror as matter. In a view from below, showing a fictionalized version of its final setting before the museum, spectators hang up-ended while gravel and green grass replace blue sky in the inverted space created by the bowl's perfectly polished underside.[34] A second image portrays the bowl under construction. A glimpse through an open door, mirrored in the convex surface of the *tazza* at the center of the view, appears to give on to the primeval forest where the Markgrafenstein was found; the reflections of the windows round about reveal a location within the city, at the Packhof trading wharf where the final fairing of the bowl was completed. A third painting, now lost, captured the work in preparation for removal to the museum island, showing the moment of tipping, when the status of the *tazza* changed, and the world reflected in it slid and reassembled itself.[35]

COLOR PLATE 10

COLOR PLATE 11

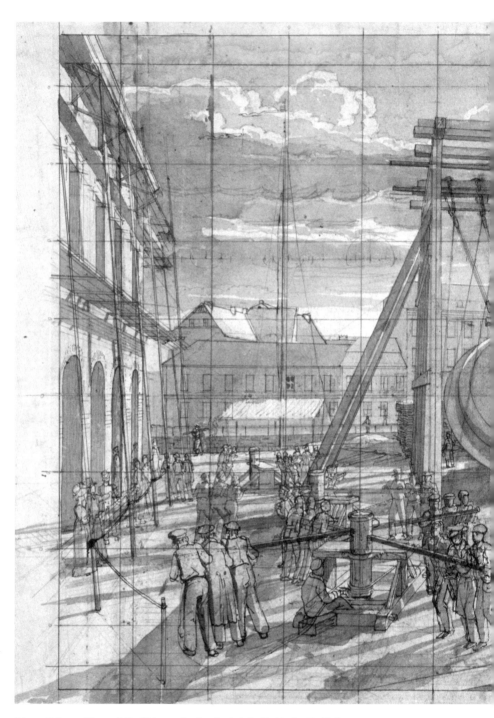

Johann Erdmann Hummel. "Aufrichtung der Granitschale im Packhof zu Berlin,"
preparatory drawing, 1831. Stadtmuseum, Berlin.

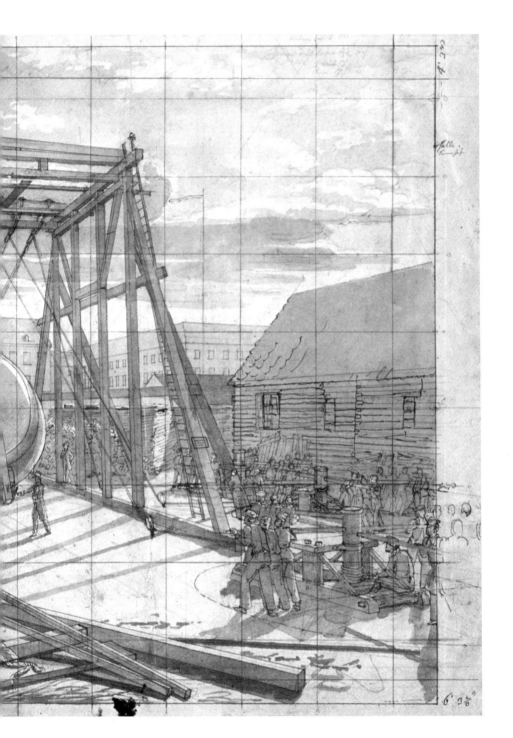

The majority of elements that characterize the mediated story of Cleopatra's Needle were already present in these narratives of giant bowl construction, of folding furniture, or of obelisk removal. One aspect appeared only in the last-named history: the coincidence of a narrative of tipping with a mass, illustrated means of accounting. As the Luxor obelisk was being placed on its plinth in Paris in 1836, developments were occurring that supercharged the ways in which mediation interfaced with the material world of objects. In 1832 a British periodical, the *Penny Magazine* published by the Society for the Diffusion of Useful Knowledge, had begun to circulate images, often of antiquities, together with edifying articles explaining their significance, aimed at a working-class British audience. It claimed one million readers in its first three years.[36] A year later *Le Magasin pittoresque* was launched in Paris, published in weekly editions that juxtaposed images and text; it reached a one-hundred-thousand circulation within twelve months.[37] *Le Magasin pittoresque* discussed the Luxor obelisk in its autumn 1836 editions and in January 1837 provided a detailed account of the day the needle was erected.[38] This added a new dimension to the mediation of the event. Like the Berlin *Granitschale*, the placing of the obelisk was conserved in a single-copy, high-color oil painting, a COLOR PLATE 12 panorama by François Dubois.[39] And indeed, multiple prints of the scene were produced for sale. But as well as this, with its presence in the illustrated press, the obelisk's installation on the Place de la Concorde entered into a new space of mass media communication.

Celebrating their ambition to form "a kind of contemporary review to memorialize great events in art, science or industry," the editors of *Le Magasin pittoresque* noted the imperial and Napoleonic genesis of the French project of obelisk translation and the connections this created between Paris and Rome.[40] Their revue would rely on illustration, demanding from "the pencils of our artists the drawings necessary to fix the trace of these evolving operations and to represent the mobile apparatus which set the needle of Luxor upon its pedestal."[41] The fact that it was the trace of an operation these illustrations fixed, and that the editors' interest lay in representing the apparatus around the obelisk as much as the details of the monument itself, is emphasized in the full-page spread that dominated the issue. The magazine's artist recorded

Cover, *Illustrated London News*, October 17, 1877. National Library of Sweden.

Sphinx towing *Luxor*. From Léon de Joannis, *Campagne pittoresque du Luxor*.
National Library of Sweden.

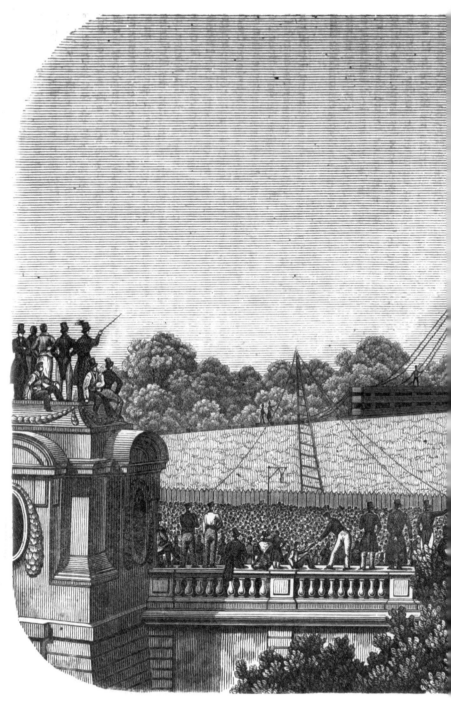

"Erection de l'Obélisque de Luxor, Place de la Concorde, October 25, 1836."
Le Magasin pittoresque, January 2, 1837. Gallica.

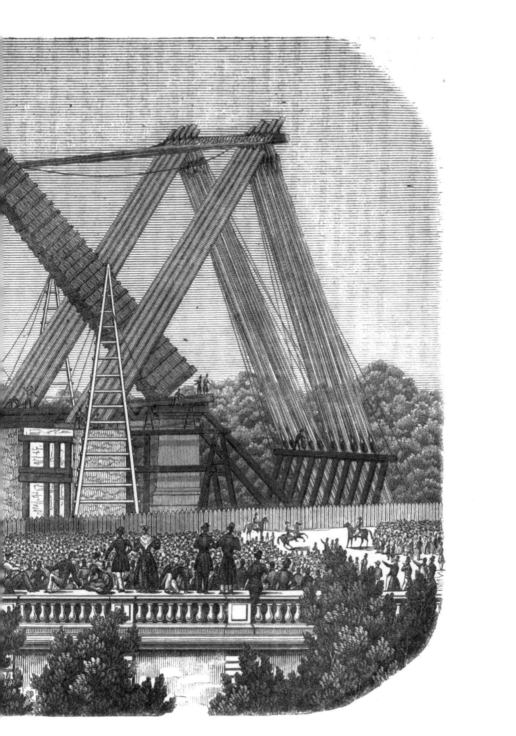

the event at its most critical state, the needle hanging inclined over the heads of the Parisian crowd as it was rotated into position. Like the spectators at the real event, readers of the piece had to crane their heads in order to see the spectacle. The horizon of the image occupied the long vertical dimension of the portrait-format magazine, and viewing it required a head-tilting hiatus and a necessary interruption of the textual narrative it accompanied.[42]

As the illustrated press became established, such new ways of reading objects became habitual. The *Illustrated London News* (from 1842), the *Illustrirte Zeitung* (from 1843), *Harpers Magazine* (from 1850), and *La Monde illustrée* (from 1857) all made copy out of the removal of large objects.[43] What would this new means of accounting do to the artifacts it described? It would, by definition, emphasize that aspect of them that privileged the transitory. It would speak of provenance and processes rather than static outline. The simultaneity of "news," of a construction that presented situations in terms of change, would become ubiquitous. And subject to the scrutinizing gaze of news media, objects, even very stationary ones, revealed themselves to a very large public as implicating conceptually several possible states of existence. The obelisk arriving at the Place de la Concorde no longer occupied a permanent and definite location; it was a multifaceted, hybrid construction caught midtrajectory.

The symbiosis that developed between news media and such objects of design involved a sensibility implicit already in early nineteenth-century constructions such as the architectural interior or metamorphic furniture. But the implications of this symbiosis changed as the century progressed. With the increasing hegemony of the illustrated press as the dominant means for describing the world, design began to be conceptualized in a context that implied a kind of built-in event, or tipping, as a quality of the object. At some point this concern with hiatus started to impact not only the reception of objects (how they were understood) but their inception (how they were conceived). Particularly, a theme of doubleness, of ovidian change, began to color engineering in the decades after the illustrated press sprang into life, and an evolution from a mediated emphasis on crisis (i.e., emphasizing the significance of hiatus for the purposes of news reporting) toward a design emphasis on hybridity (i.e., embedding hiatus as a principle of projection) can be seen. Compare two of the engineering projects mentioned above. Isambard Kingdom

Brunel's famously innovative design for the 1847 *Great Britain* had a degree of hybridity that was quite functional: as the first trans-Atlantic screw-steam passenger ship, she continued to carry a full sailing rig, as many smaller steamships of her generation did. A decade later in the *Great Eastern* this hybridity had been fetishized at another level. That ship was a behemoth, gargantuan, a hermaphrodite in belts and braces.[44] It had double boilers, a double hull, and doubly doubled propulsion systems (both paddles and a screw propeller, as well as a sailing rig).[45] It was originally christened *Leviathan* and then, in popular parlance, the "monster ship," a name that similarly invoked a sense of disturbing duality.[46]

The container that transported Cleopatra's Needle played very well into this narrative of monstrous hybridization. It was designed by Benjamin Baker, partner of the British engineer John Fowler. Baker was never a ship designer. But he was already a famous innovator, a tunneler responsible for, among other things, the underground infrastructure of the Metropolitan Railway.[47] His solution to the problem of transport in the case of Cleopatra's Needle bore remarkable similarity to the system for creating the world's first "tube" railway tunnel, completed in 1870, whose opening was also celebrated in detail by the *Illustrated London News* (October 30, 1869), and which was serving twenty thousand riders a week at the time the issues reporting the moving of the obelisk were being read. Where this prototype for the London "Tube" relied on excavating the clay under the Thames and bolting together a series of prefabricated cast-iron rings to form a watertight structure beneath the river, the container in Alexandria was built by assembling a similar series of wrought-iron rings around the outside of the obelisk to create a watertight shell above the ground. Within this structure the obelisk occupied roughly the same position as a railway car would in a tunnel on the Underground.

The obelisk was placed precisely in the center of its circular container, like a bolt in its nut, a disposition carefully drawn in cross section on the *Illustrated London News*'s March 10 description of the project. You might think that if the aim was to build a stable ship it would have been best to position the obelisk as low as possible in its transporter—after all, the principle of hydrostatic stability is to make sure that the center of gravity is below the center of buoyancy, a key principle first extensively applied in ship design by Fredrik Chapman in the eighteenth century, and well understood by the second half of the nineteenth.[48] In this case, though, tunnel

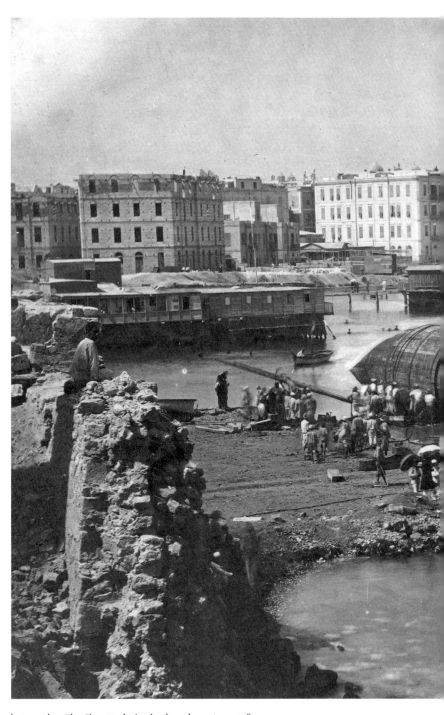

Unknown photographer. The *Cleopatra* during her launch, ca. August 1877. Bridgeman Images.

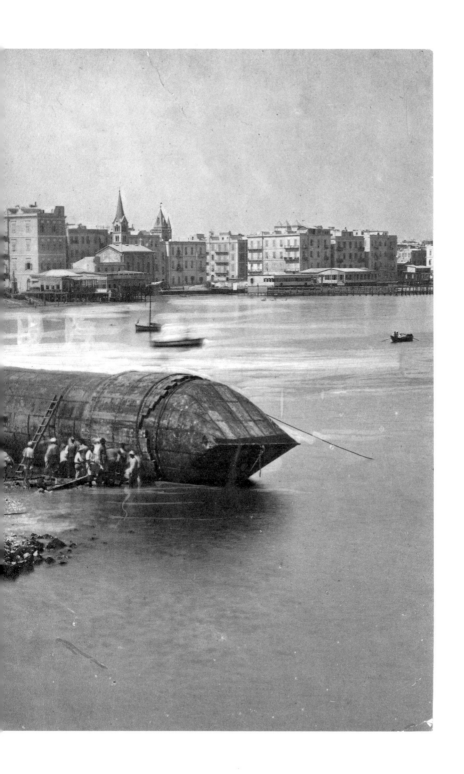

engineering placed the obelisk in exactly the position to produce the most unstable ship in the world. The center of gravity of the square obelisk and the center of buoyancy of the circular container coincided, with the result that as a ship, *Cleopatra* had no more stability than a beach ball. Why did the intelligent Baker adopt this solution? Because there was one more phase change that the extraordinary engineering project to move the needle envisaged. Once this piece of reverse tunnel engineering was completed around the land-bound obelisk, the contraption changed identity. Before becoming a ship, it was treated as an enormous garden roller, and trundled, all 400 tonnes of it, sideways, revolving around the spindle of the obelisk toward the sea. Not just tunnel, barge, lighter, or pontoon, this object was also a wheeled vehicle, if only of the most primitive kind, with the needle as its axle.

Strangely, there was in this piece of nineteenth-century hybridization a classical allusion. Where Domenico Fontana and Apollinaire Lebas had consulted ancient sources on the moving of obelisks, Baker repeated a principle given in book X of Vitruvius's *De architectura* describing machination.[49] Vitruvius had narrated the story of Chersiphron and his son Metagenes, who were responsible for moving the materials used to build the Temple of Diana at Ephesus. Columns and architraves had been turned into the axles of primitive machines which transported these architectural elements by rolling them sideways, allowing great weights to be transported that could never have been moved on sledges or carts over soft roads. Baker's solution for moving the needle over the sand to the sea in Alexandria followed the same technique: if as a ship the *Cleopatra* inevitably rolled very badly, this was because as a wheel she rolled very well.

The device that would transport the obelisk was several different things at once, then—out-of-the-box engineering solution; cigar-shaped submarine; oversize roller; classical allusion. This uncertainty in conceptual identity made the object both difficult to describe and lead to the near fatal events that took place in the Bay of Biscay. The *Illustrated London News* recorded these phase change moments as they tracked the story, but their character is already celebrated in the central image of the spread published March 10, 1877. The image of yawing records very well the engineering attitude behind the design process for moving the obelisk. The central place given in newsworthy illustration to instability, uncertainty, volatility—to situations that are outside conventional

orientation—is also embedded into this particular piece of engineering logic: a system of thinking that destabilized classes of object, allowed a suspension of existing hierarchies, and which removed design problems from the certain linear narrative of craft tradition. *Cleopatra*'s newsworthy instability was a direct consequence of this attitude to design. When the ship finally arrived at Gravesend in January 1878, portrayed by the *Illustrated London News* for once on an even keel, this link between mass media reporting and a developing design sensibility of hiatus was still emerging. The rest of the nineteenth century demonstrated its increasingly overt presence. That narrative can be traced both in the evolution of engineering design and in architecture, and it runs through the creation of both mobile and immobile objects.

Hiatus as a Design Principle—1877 to 1897

In the years after *Cleopatra*'s miraculous recovery, as London developed its international infrastructural tentacles and the needle sat on the newly constructed Victoria Embankment, the twinning of monstrous engineering and visual news dissemination became more explicit. During the 1880s Benjamin Baker and Sir John Fowler projected a bizarre hybrid structure—Was it an arch? Was it a beam?—across the Firth of Forth in Scotland. A human demonstration of the bridge's static principle was widely circulated in magazine issues and supplements including the *Illustrated London News* (at least three different version were produced and used in media illustration).[50] Caught in the mechanics of the illustrated press, the men in these pictures were petrified—or ferrified— posing humorless in their bowler hats, fixed forever by news media in a steel engineered truss (the most famous version portrayed the Japanese engineer Kaichi Watanabe, suspended at the center of the image, who acted for Baker and Fowler as a foreman during the construction of the bridge).[51] In the issues of the *Illustrated London News* that described the completion of the project (October 12 and 19, 1889), similar bowler-hatted human figures are shown imprisoned in riveting cages, carried like small parasites up the legs of the behemoth, their existence predicated by the bridge, rather than the other way around. This kind of reporting was endemic. At the end of the century Baker was at work in Egypt again, now engaged in damming the Nile. The Low Dam at Aswan

"Man Sitting on a Model Cantilever, to Show the Mechanical Principle of the Forth Bridge."
Illustrated London News, October 19, 1889. National Library of Sweden.

was completed in December 1902, and provided a news narrative conditioned by a play of emotive imagery and engineering-as-event.[52] As the groundworks took shape across a 1½-mile (2 km) expanse of drained riverbed, a series of images were catapulted into the international media along with dramatic accounts of the work. When the first channel through the Nile cataract was closed on May 17, 1899, the depth of the water was "about 30 feet and the velocity of current nearly 15 miles an hour. In the case of another channel, the closing had to be helped by tipping railway wagons, loaded with heavy stones and bound together with wire ropes, making a mass of about 50 tons [each], to resist displacement by the torrent."[53] These spectacular pieces of engineering—the bridge and the dam—were as thoroughly mediated as the moving of an obelisk to London had been in the 1870s. The *Illustrated London News* portrayed the hybrid nature of both constructions; the dam became a new addition in a series of monumental sites advertised by image along the Nile; the bridge was inscribed in the tradition of the *mirabilia mundi*, as an eighth wonder of the world.[54]

This unusual mediation of the humanly constructed world—of moving obelisks, stranded ships, railway rolling stock precipitated into cataracts, water coursing through dams, men imprisoned in bridge girders—had implications also for the conceptualization of architecture. In one sense it undermined any idea that building, of even the most monumental kind, remained reliably anchored to site. The Forth Bridge was conceived in the wake of a disaster in which an equivalent long-distance railway bridge across the Tay estuary, 40 miles to the north, vanished overnight in a storm. In its edition of January 10, 1880, the *Illustrated London News* included in its disaster coverage an image of twisted rails terminating at the broken bridgehead, stormy waters receding into blackness beyond.[55] Similar lessons about the transience of monumental structures could be read in press reports of engineering operations in Egypt. The dam at Aswan was not constructed without opposition. Baker's French colleague in the international commission that deliberated the project's feasibility, the École Polytechnique-trained Auguste Boulé, argued against the proposal because of the damage it threatened to the temples at Philae, upstream of the structure, that were set to be flooded by the retained stream.[56] Baker maintained in response that if obelisks could be moved for the greater good, then so too could temples, in this case by lifting them with "elevating screws," worked by "the well-drilled

"Panorama of Philae as inundated by the Great Dam at Assouan, Egypt."
The Universal Art Co., 1904. Library of Congress.

Panorama of Philae as inundated by the great dam at Assouan. Egypt.

"Highlanders in Native Costume at the Great Forth Bridge, One and One-Half-Miles Long, Spanning the First of Forth, Queensferry, Scotland," Keystone View Company, 1916. Library of Congress.

11—Highlanders in Native Costume at the Great Forth Bridge, One and One-Half Miles Long, Spanning the Firth of Forth, Queensferry, Scotland.

SECTIONAL VIEW OF THE CLOCK TOWER.

MODE OF RAISING THE GREAT BELL.

MOVING THE GREAT BELL.

o' the shaft. All being completed, the centre of gravity found, the cradle was then raised by means of a fine new crab, made for the purpose, placed immediately over the aperture of the shaft. Eight men, four to each handle, then drew it up. As the drum of the crab revolved and drew up its burden, the chain which accumulated upon it was passed from the drum to a smaller crab behind, so as to prevent any possible jerk arising from the slipping of the links, and also to avoid accumulation of weight. The cradle had attached to its sides four friction-wheels, which played upon the guide-timbers—as seen in the diagram—to ease the ascent. The chain was made expressly for the work, and was tested link by link. It is nearly 1800 feet long. It was made at Newcastle, by Messrs. Crawshay, and tested under the superintendence of Mr. Thomas Quarm, the clerk of the works to the new Palace of Westminster, and Mr. James, of Broadwall, Blackfriars. We believe we are right in saying that Mr. Quarm arranged the whole of the plan for the raising; and Mr. James has carried it out with his usual ability, aided by his able superintendent, Mr. Hart. Our large Illustration will explain the mode used for the ascent better than our description. The bell is seen just entering the clock-room, where it rested the first time: it was then turned mouth downwards and drawn up to the bell-chamber, seen in our Sketch. The work of hoisting has been an arduous and anxious affair for all engaged, and we hope their labours will be appreciated.

The quarter bells of the Clock Tower were raised to their places last week, awaiting the ascent of their ponderous chief to commence active duties.

The crab which was constructed to hoist the great bell gives 101lb. of power for every pound of force applied to the handle. As each handle is turned by four men, and as each man applies a force of 15 lb., without overstraining himself, an aggregate power of 12,000 lb. in round numbers is obtained at each turn of the handle. This force would seem tremendous; but then it takes

ten revolutions of the handles to wind up one foot of the chain, and fifty revolutions to complete one complete round of the drum. Five hundred revolutions cover the latter with chain, when it has to be cleared, and the chain that has been hauled up transferred to another windlass. When the bell was raised from the ground to the clock-room (a distance of 190 feet) it had to be restored to an upright position, fresh arrangements to be made, and a further haulage of forty feet accomplished to the bell-chamber.

The exact dimensions of the bells are:—great bell, 7 ft. 6 in. in height, 9 ft. diameter at the mouth; weight, 13 tons 10 cwt. 3 qrs. 15 lb. Of the quarters: 1st quarter: weight, 1 ton 1 cwt. and 23 lb.; 2nd: 1 ton 5 cwt. 1 qr. 2 lb.; 3rd: 1 ton 13 cwt. 2 qrs. 13 lb.; 4th: 4 tons 13 cwt. 2 qr. 12 lb. The notes of the bells are respectively—great bell, E sharp; 1st quarter, G; 2nd, F; 3rd, E (octave to great bell); 4th, B; and the reading of the chimes is, taking the notes as represented by the stave figures—1st quarter: 1, 2, 3, 4; half-hour: 5, 2, 9, 4—2, 1, 3; 3rd quarter: 1, 3, 2, 4—4, 1, 1, 3—1, 2, 3, 4; hour: 3, 1, 2, 4—3, 2, 1, 3—1, 3, 2, 4—4, 2, 1, 3, when the great bell will strike the hour. The latter will be struck on ordinary occasions with a hammer, but the clapper will be available for the announcement of great events, such as every loyal Englishman deprecates. It is expected that in calm weather the sound will be distinctly heard throughout a radius of five miles, measuring from the tower.

Mr. Walesby, of Waterloo-place, writes thus concerning the quarter bells:—"The four bells for indicating the quarters of each hour at the new Houses of Parliament are, it appears, to be of such notes that we may say they would be respectively the first, second, third, and sixth of a peal of ten; or, in musical notation, G sharp (first bell), F sharp (second), E (third), B (sixth); the hour bell being the tenth, or E, an octave below the third bell. So far so good, provided that each proves satisfactory as regards quality of tone, relative pitch, &c. But, with the utmost deference to the

gentlemen intrusted with the superintendence of these matters, I think their arrangement a very tedious and inappropriate one for such very large bells, the notes of which will be so grave as to render it necessary to strike each bell in considerably slower succession than is usual with any other chimes in this kingdom. The following brief and simple composition, if performed upon the bells in very slow time, would, in my opinion, proclaim the quarters in a more intelligible and melodious manner:—

	To be indicated by bell.
1st quarter	1 2
2nd quarter, or half-hour	1 2 3
3rd quarter	3 2 1 3
4th quarter, or hour	1 2 3 4—10

In order that all persons whenever they hear the chimes may clearly understand which quarter is indicated without becoming impatient of listening, I have, it will be perceived, inserted only two notes for the first quarter, three for the second, and four for the third, concluding in each instance with the third bell (E, the keynote), thus affording repose to the musical ear. There are also four notes for the fourth quarter, which, however, is distinguished from any other by the introduction of the sixth bell (B, the dominant note), which calls for and is followed by the tenth, or hour bell (E, the fundamental note), with grand effect."

"Mode of Raising the Great Bell." *Illustrated London News*, October 16, 1858. National Library of Sweden.

garrison at Assouan" with "military precision." The new dam would hold; the monuments around it would move: "The condition of the temples when raised would be unchanged, as every stone would remain as originally laid by the builders. From the artist's point of view the appearance would be enhanced, because the temples would rise out of a wide, placid lake, whereas when now visited by tourists the Nile is low, the stream insignificant, and Philae Island appears to stand in a hollow."[57] In the event Baker saw to the underpinning of the temples, but not their leavening.[58] Nevertheless, the possibility once voiced, existed. After the dam's completion, and following a subsequent operation to raise its height, dramatic images circulated, in the *Illustrated London News* among other outlets, of the flooded temples being visited by boat. Seventy years later, as the Aswan High Dam was completed and the Nubian plain above it submerged, international cooperation would see to the physical relocation of a whole collection of monuments, including those at Philae, in highly mediated interventions that moved them above the rising waters.[59]

But the nineteenth-century illustrated press's concern with movement and translation had surely a more immediate effect on the way in which architecture could be thought. Architecture was central for this promiscuous means of reporting the world. The press was "filled to the brim with images and descriptions of buildings, cities, streetscapes, and landscapes."[60] Not only were accounts of architecture able to inform public opinion through this widespread inclusion, but the kinds of view the papers permitted also informed architecture. The press tended to juxtapose and compare, flattening hierarchies that divided objects into separate classes, setting up equivalences of an unlikely kind. The "Composite Column" of the *Illustrated London News* from March 10, 1852, juxtaposed images of John Gilbert's painting *Aladdin's Present to the Sultan*, two portraits of a "Crocus Hedgehog" in and out of bloom, the "Removal of a large tree in Ipswich" and a vignette of a contorted train passenger attempting to read a piece of passing advertising.[61] Architecture took on a lively quality in such forms of presentation. On one side, the juxtapositions of the press created bizarre architectural and geographical compressions: "drawings of Indian temples are placed next to a prospect of Constantinople or a street scene in Copenhagen; a bird's eye view of Piazza del Popolo flanks sketches of a recent earthquake in the West Indies or riots in New York."[62] On the other the press also froze moments, with the

implication that whatever was viewed was in an arrested state of change. In the world thus reported, the uncertain instant, the transient no-man's land between expedition and arrival, was elevated in importance. Reporting on the completion of the new Houses of Parliament in its October 16, 1858, issue, the *Illustrated London News* fixed on the moment when their great bell was suspended, mid-hoist, within the tower of Big Ben.[63] Permanent buildings were treated as equivalent to other much more mobile structures in such reporting. The story of Cleopatra's Needle provides a kind of *quod erat demonstrandum* of this equivalence. In the news, both the vessel and the needle it contained were inscribed within the same logic of paradoxical capsize. The engineered object and the architectural set piece appeared similarly translative. It became possible to see the architectural monument not as something consecrated around ideas of stability or permanence, but as part of a world in flux.

Moving Architecture

COLOR PLATE 13

In 1849 the *Illustrated London News* published a review of the Royal Academy spring exhibition in London, in which Charles Robert Cockerell, professor of architecture at the academy, exhibited a drawing titled *The Professor's Dream*.[64] The work, saturated in detail and monumental in dimension (it measured 44 × 67 inches), presented a kind of *capriccio* in which architectural monuments from across Europe were herded together like steers at a cattle auction, restrained by a fence made up of Egyptian monuments in the foreground, and backed by the peaks of the pyramids at Giza. In what Cockerell's collaborator John Eastly Goodchild called a "sort of semi perspective," the ground on which these jostling architectural beasts stood was elevated in a series of platforms as one moved up the picture.[65] The Egyptian structures that formed the holding pen were at level zero; marginal notes confirmed that the Greek stock was raised 30 feet, younger Roman examples were at 60 feet, and the youngest in this architectural herd, dubbed "medieval and modern," 90 feet above the fence. The whole is seen through a yellow sandy haze, as if stirred up by thousands of stampeding, heavy feet.

The educated audience at the Royal Academy would have seen these visual techniques in the context of similar works by other

Charles Robert Cockerell. Comparative drawing of ancient and modern architectural monuments. In H. Bellenden, *Sir Christopher Wren, with Some General Remarks on the Origins and Progress of Architecture* (London, 1833). Library of Congress.

1. Porcelain Tower, Nankin, China.. 200	14. Colosseum, Rome (584 ft. in length) 157	28. Temple of the Giants, Agrige[nt
2. St. George's Hall, Liverpool .. 85	15. Friburg Cathedral 385	29. Parthenon, Athens ..
3. Tomb of Theodoric, Ravenna, about 50	16. Temple of the Sun, Baalbec .. 120	30. Second Pyramid, Gheezeh ..
4. Chichester Cathedral.. 271	17. Temple on the Ilissus, Athens abt. 25	31. Strasburg Cathedral ..
5. Victoria Tower, Westminster .. 331	18. Erechtheium, Athens .. ,, 35	32. Rouen Cathedral .. af
6. Boston Church, Lincolnshire .. 292	19. Chartres Cathedral 403	33. Eleanor Cross, Waltham ..
7. Taj Mahal, Agra 220	20. Church of Ste. Geneviève, Paris.. 274	34. Cologne Cathedral ..
8. York Cathedral.. 198	21. The Monument, London 202	35. Great Pyramid ..
9. Temple of Bacchus, Teos .. about 50	22. Amiens Cathedral 383	36. St. Peter's, Rome ..
10. Alexandrian Column, St. Peters-	23. Church of St. Theobald, Thann abt. 320	37. St. Paul's, London ..
burg 154	24. Royal Albert Hall, London .. 154	38. Albert Memorial ..
11. Column of July, Paris 154	25. St. Stephen's Cathedral, Vienna.. 441	33 {Obelisk, Luxor ..
12. Torre Asinelli, Bologna 370	26. Torazzo of Cremona 396	{Prophylon ..
13. Bell Tower, St. Mark's, Venice .. 323	27. Hôtel des Invalides, Paris 310	40. Bow Church, London..

"Heights of Some of the Great Buildings in the World Compared to the Forth Bridge."
The Illustrated London News, October 19, 1889. National Library of Sweden.

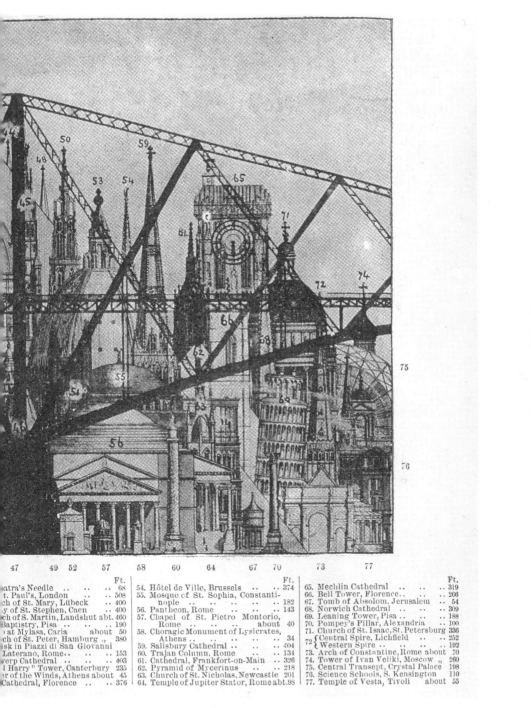

architects and academicians, John Soane and Joseph Gandy among them.[66] But the thematics in this image—its gathering together of examples from a diverse geography; its ambition, through such removal, to create a new kind of interpretive space around these objects; its articulation of juxtapositions that can seem, simultaneously, comfortable and bizarre—relate it closely to the founding concerns of illustrated newspapers.[67] The drawing extended the scope of contrast and juxtaposition made in an 1828 print that Cockerell prepared for the *Library of Useful Knowledge* series, a work that compared St. Paul's Cathedral in London to other monuments abroad and was published by the same organization that started the *Penny Magazine*. In its 1849 Royal Academy Exhibition review, the *Illustrated London News* reminded its readers how the current exhibit related to Cockerell's earlier woodcut. In the press's eyes Cockerell's work was very much part of an infrastructure of information that the press itself exemplified: "many of our readers will recollect, in common with ourselves, the good services Mr. Cockerell rendered a few years back to the memory of Sir Christopher Wren."[68] The gathering and juxtapositions in the drawing repeated the heterotopic logics of the illustrated press, whether produced in the *Illustrated London News*'s "Composite Column" or in its more general juxtaposition of buildings and landscapes from separated geographies. This image, like those spreads, trounced geographic separation and dealt in unexpected juxtaposition.

The Professor's Dream also performed an infrastructural operation that takes it straight out of the context of atmospheric works by Gandy and Soane and positions it within hailing distance of contemporary imagery about heavy lifting. Already in 1848, the platforms on which its various tiers of buildings were arranged (Greek, Roman, modern) performed an operation with some of the same aims as the one Baker later envisaged for the Philae temples above Aswan. To avoid the great Pyramids of Giza being lost in a rising tide of more recent monuments, Cockerell lifts their bases 90 feet above the datum line on which the other Egyptian monuments stand. In certain respects Cockerell's image can be seen as yet another piece of nineteenth-century infrastructure that moved objects.

That the imaginary exhibited in *The Professor's Dream* contributed to nineteenth-century canons of architectural composition cannot really be debated. Every City of London office design that clustered domes and spires together, every Imperial Institute

Building, every Cragside lookalike was, in some respect, a built confirmation of the same compositional principle.[69] But the image was made later to speak of another emerging compositional condition as well. As the *Illustrated London News* reported the completion of the Forth Bridge in 1889, Cockerell's composition moved onto the pages of the paper.[70] Behind a *grisaille* of silhouetted steel struts, a reduced copy of Cockerell's "drop scene," on which *The Professor's Dream* was based, presented a familiar menagerie of buildings against the outline of Baker and Fowler's giant bridge. In this image, the composite space of nineteenth-century architectural projection and the hermaphrodite space of monstrous engineering infrastructure were superimposed. Much like the stylistically heterogeneous city that was growing ever larger around the *Illustrated London News*'s offices on the Strand, its thousand different styles built over Joseph Bazalgette's newly coherent sewer system, its various blinking riverside windows overlooking Cleopatra's Needle and the Victoria Embankment that carried sewerage, water, gas, and underground trains beneath the city, the image conflates architectural variety and infrastructural continuity.[71]

In this last superimposition we can perhaps find an explanation for the recurring nineteenth-century preoccupation with the moving about of large masses. If singular objects were to include a variety of states, styles, destinations, or identities, some other kind of foundation, some principle whereby identities could be maintained even as they shifted, was needed to prevent the resulting experiences dissolving into chaos. In this respect the ghost—the perceived if shadowy and partial presence—of the infrastructure that guaranteed translation required representation. Infrastructure needed to be articulated, seen out of the corner of the eye, acknowledged by a sideways glance, for the teeming nineteenth-century world to make sense.

What moved across this Forth Bridge that the press so assiduously illustrated? A very wide variety of things. Minerals that provided motive power (the bridge connected the developing coal fields of Fife with the markets of industrial and residential England), goods of all sorts, passengers. In this sense the bridge served variety. Goods wagons pronounced their diverse geographical origins; human traffic came in three "classes" and was carried in railway carriages that marked this hierarchy on their sides.[72] Above the railings, sailing over the Firth of Forth, variety traveled in both directions. But beneath, all these various classes of thing traveled

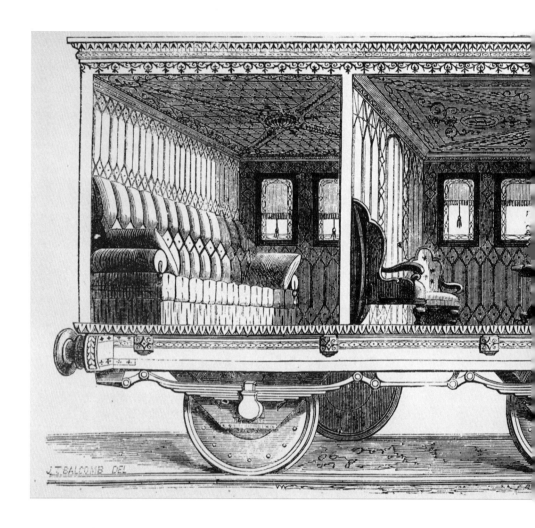

"Illustration Depicting the Interior of Queen Victoria and Prince Albert's
Royal Carriage . . . ," 1869. Alamy.

on variants of the same rolling stock—4 feet 8½ inches gauge track; rolled steel rails, 3 feet diameter wheels supporting cars between 15½ feet in length for goods wagons and 32 feet for passenger coaches.[73] In some sense infinite variety depended on finite specification. The railway provides a fecund place from which to view that relationship, so characteristic of the developments that took place in the nineteenth century and so closely connected to the mediation of the infrastructure of movement on which it relied. The railway carriage, as long as an obelisk, as mobile as a ship, as comfortable as a domestic saloon, rode an infrastructure where two principles met. It merged into a single assembly the distances that, since the start of the century, had made certain kind of experiences resonate. The possibility that "there" might be slid, with invisible effort, to "here"; the pedagogic potential of juxtaposition; the simultaneous experience of adventure and security: all found fruition in railway travel. It made the experience of these resonances as widely available as did the media of the illustrated press, and it supported the growth of other kinds of infrastructure associated with them.[74]

Within this mediation of variety, nonstandard members of society were made to stand as avatars communicating a more widely experienced reality. Very special examples of humanity got their own very special carriages. At the opening ceremony of the Forth Bridge on March 4, 1890, the Prince of Wales was pictured inserting the last rivet into its construction; his portly image in the *Illustrated London News* captured him standing beside the railway carriage in which he arrived.[75] The carriage was possibly GWR wagon 248, one of a pair constructed for the Royal Family in 1881 at the Great Western Railway Works in Swindon and used on various UK railways. This was a radical equipage 43 feet long carried on two four-wheeled bogie-cars, rather than the six wheels that a carried ordinary mortals up and down the shining lines.[76] Some idea of its furnishings can be gathered from the various contemporary royal carriages still in existence.[77] These were traveling palaces, plush and gaudy as the elephant-borne howdah of an Eastern emperor.

The prince's mediated involvement with railway travel did not end here. An Eastern emperor is exactly what Albert Edward became at the death of his mother in 1901. Crowned King Edward VII of the United Kingdom, Emperor of India, and King of the British Dominions in August 1902, one of his earliest acts as a potentate was to order a new train. Now sporting two carriages

supported on dishy white-tired six-wheeled bogie-cars, it was to be manufactured at the Wolverhampton works of the London and North Western Railway Company.[78] *The Graphic* illustrated paper reported, with images, on its sumptuous apartments: the day-rooms, bedrooms and dressing rooms (one of each for king and queen, done in "white enamel," in "colonial style," electrically heated to "exactly the right temperature," their satinwood furniture "inlaid with ivory"); the king's smoking room (provided with "electric cigar lighters"); the servants quarters ("equipped with electric plugs") and, importantly, its glazed, steam-heated, observation balconies, from which the changing world could be viewed by, and could view, the royal personages inside.[79]

This train, only one of a series of such vehicles produced in the first years of the twentieth century, provided a safe and princely base for residential wandering. Edward went on to commission carriages for travel over other UK lines, and in 1903 the South East and Chatham Railway (SE&CR), which connected London to the channel ports and thus to the continent, supplied rolling stock for royal travel across Europe. The king's wider wandering through the first decade of the twentieth century—to Biarritz each spring, to his nephews' and nieces' multiple capitals across Europe and Eurasia—was conducted behind the plate glass of an SE&CR "continental saloon."[80] Such meanderings were imitated worldwide in trains commissioned for rulers, elected and hereditary, while illustrated papers inspired by the culture of the railways described the equipages. "What is perhaps the most luxurious saloon coach ever built," commented a 1910 issue of *The Locomotive and Railway Carriage and Waggon Review*, with almost perfect syntax, "is that about to be shipped to South America as a gift . . . to the Argentinian president for his official use." The coach provided its recipient, José Figueroa Alcorta, who retained the presidency until October that year, with

> a day saloon . . . 17ft 3in long, decorated in the Louis XVI style, with green silk panels and carpet, a real fire-place with a mirror above. . . . Adjoining that compartment is a bedroom also with green carpet and upholstery, furnished with a bedstead finished in old gold [and] . . . a bathroom provided with a needle bath and finished with Pavagoni marble with silver-plated fittings. . . . Crossing the central vestibule the

next compartment is a study or library, finished in mahogany throughout with red leather chairs and a red carpet.[81]

Such vehicles, whether shipped over oceans, rolling through jungles, or traversing daringly engineered bridges, became ever more architectural in their interior appointments, able to resolve, with apparent ease, the impossible contradiction of rooted domesticity and infinite navigational range. And they made these things available for an increasingly large audience. By 1910 the same engineering works that had produced continental royal saloons for Edward VII was building SE&CR "Pullman" coaches for the general public, their names inspired by the European destinations with which they were connected in the mind's eye: "Florence," "Valencia," and "Sorento" buffet cars connected to "Corunna," "Savona," and "Clementina" parlor cars.[82] The international work of this company included sleeping and family cars for the Buenos Aires Western and Buenos Aires Pacific Railways, the latter in "'plum pudding' mahogany, inlaid with shaded satinwood and tulip, in the Adam and Sheraton style," each with an "observatory opening from a saloon provided with a fireplace with a white marble mantle, five easy chairs, . . . an electric punkah fan, etc."

To be sure, these experiences were reserved for a small elite. To create them often required exploitation; they facilitated the traverse of landscapes, ecologies, and cultures that their very being threatened. Histories of modern things in motion have to navigate this paradox: that the seductive romance of trajectories is always mortgaged to an infrastructure of labor, frequently one of strife.[83] Nevertheless the seductive romance of this kind of movement— the openness implied by an effortlessly moving train—did do something to change imaginaries that reached far beyond the people these technological wonders benefitted. Without forgetting the underbelly of infrastructure, this potential is important to acknowledge.

Three decades elapsed between the placing of the Cleopatra's Needle on the Victoria Embankment in 1879 and the departure of the first SE&CR "Florence" buffet car from Victoria Station in 1910, a little way to the west. In that time the magical experience of architectural and geographical translation had become literal in

another way. The rolling that in 1877 had been associated with wild seas and shipboard disaster had become emblematic of the irresistible, sure-footed advance of steam-powered railway travel. Tipping, an action that had revealed the inherent instability of even the most permanent of architectural objects earlier in the century, had become something that well-heeled travelers did to the porters that moved their luggage at every station from London to Lubjana, from Riga to Rome. Though their rapid movement railway cars shuffled geographically discrete locations together, creating for their occupants after-images that likened the dream of Cockerell's professor, in which landscapes, cities, and monuments of heterotopic origin were jostled together. They represented, perhaps, the absolute possibility of an architecture newly mobile, in which the Vitruvian triad of virtues—commodity, firmness, and delight—could be satisfied without the need for an anchoring in place. Ovidian in their potential to curate transformation, endowed of an essential "here-and-thereness" and "this-and-thatness," rolling on squealing flanges, constantly tipping between motion and rest—these wheeled edifices signaled a condition in which dwelling and wandering were linked in a new way. Translation itself had become an architectural experience.

Part II: *Dispatches 1450–1590*

Dealing with Decorum

During the nineteenth century, architects professionalized. Societies and institutes defending the interests of architects, as opposed to more generally advancing the cause of architecture, were founded midcentury in the United Kingdom (1834), Switzerland (1837), Ireland (1839), France (1840), Spain (1849), and the United States (1857); slightly later in the Low Countries and Germany (Belgium, 1872; Germany, 1903; Holland, 1908). That professional formulation involved certain recurring concerns. One was of identity: What sort of role was at stake when individuals claimed "architect" as a title? Another was of education and entitlement: Just who should be allowed to make such claims? Others were of roles and duty: What were the ethical dimensions of architectural practice? What was the balance sheet of expectation and duty when architects were engaged to project actions in return for financial reward? In all these concerns there was also an element of history: Where did assumptions about title, education, role, duty come from? How had the practice of architecture, whose framework was to be explicitly regulated in such acts of institutionalization, emerged? Particularly, how could the implicit relation between the essentially national idea of a shared set of values and the vested and private character of special interest organizations be resolved?

In the same years—between 1860 and 1900—historical focus changed for those interpreting the one period that could be seen as central in answering these questions. In 1860 the Swiss historian Jacob Burckhardt published *Die Kultur der Renaissance in Italien*, translated into Italian by 1876 and into English as *The Civilisation of Renaissance Italy* in 1878.[1] The book threw an unfamiliar light on the importance of the late Italian trecento and quattrocento in the familiar story that accounted for changes to politics, intellectual culture, and art between the medieval period and the Enlightenment in Europe. Its account was structured around a dual understanding: one being that the Italian Renaissance established the "state as a work of art"—the idea that conventions could be designed and inscribed; and the other being the belief that this same period could only be understood by paying attention to "the development of the individual," to the agency of private initiative and an idea of genius, unfettered by limitations of history or religion, that found its expression in "works"—pieces of material culture, be they paintings, buildings, writing, or other more ephemeral kinds of production like plays, concertos, staged events. Burckhardt's account was to not to go unchallenged, but it formed the context that inspired Nietzsche's development of the idea of the Superman, and it proved a fundamental influence for key twentieth-century interpreters of culture such as Aby Warburg. Particularly, in the decades after the publication of *Die Kultur der Renaissance in Italien*, histories were written of individuals who were active in the period it saw as crucial, portraits that inevitably had to admit or confront the validity of its founding narrative. In 1882, as part of this phenomenon, Girolamo Mancini published the first modern account of the life of Leon Battista Alberti, *La vita di Leon Battista Alberti*.[2] Here, Alberti, who wrote the first treatise on architecture since antiquity, emerged as a quintessentially Burckhardtian figure, a kind of Superman, larger than life. He was at once an athlete and a thinker; he jumped over horses, designed buildings and studied antiquity; he took religious orders, wrote satire, and discoursed with authority about a vast range of disparate subjects.

Without claiming an absolute connection, a resonance exists between these two, undoubtedly separate, historical developments: a movement that set a framework for action and for accounting the value of architects through the establishment of national institutes, and a movement that set an interpretive stance on a historical period, and on the actions of individuals

within that period, that emphasized both statecraft and individual genius. The two chapters in part II ("Dispatches") take on certain aspects of the superstructure put in place in these nineteenth-century constructions. In some sense the writing of Burckhardt and Mancini made available dispatches—detailed personalized accounts of contemporary actions—from the time in which the architect, as a prominent societal figure, had emerged. The interpretation of these dispatches reemphasized characteristics that might be espoused by such figures, which in turn have influenced how architects have constituted themselves as figures to this day. One of these is the abiding interest architects have had in decorum; another is the way in which architects define works; and a third is the means by which architects claim authorship. In providing an alternative account of what architecture includes, I propose a different lens for looking at what architects do, and how that doing should be accredited. The following pages return to two key Renaissance architectural treatises in an attempt to reconfigure our understanding of these concerns.

"The thing most highly praised in the art of building is to judge well what is appropriate [*De re enim aedificatoria laus omnium prim iudicare bene quid deceat*]." So wrote the lawyer and humanist Leon Battista Alberti near the conclusion of his instaurational work *On the Art of Building* (*De re aedificatoria*, ca. 1452).[3] In this, the first modern treatise on architecture, Alberti's words introduce a concern that has remained central to architectural discourse ever since. His discussion of *quid deceat* frames one of the parameters by which architects have been judged, and by which they have claimed to operate in Western cultures for more than five and a half centuries. Although the habitual thinking that leads architects to justify their actions based on decorum (that is to say, "appropriateness") is subject to periodic challenge, the concept seems deeply embedded in the discipline's psyche. But the way in which the rule of appropriateness has been used—or misused—in architectural discourse since Alberti has been affected by subtle changes of emphasis that separate our world from his. The implications of decorum have varied significantly over time, and so have the kinds of action that decorum is used to justify. How to understand these changes, and to understand the context for Alberti's original statement?

One way is to consider the prehistory of decorum before it was adapted into the emerging discourse of architecture during the fifteenth century in Italy.[4]

In one sense this narrative begins with Vitruvius, whose text on architecture Alberti adapted in writing *De re aedificatoria*, and who used *decor* to describe a kind of beauty through propriety in buildings.[5] But the first context in which Alberti met decorum probably lay elsewhere. Like other members of the humanist culture that formed him, Alberti produced texts on diverse subjects (from cryptography to canines, from flies to Florence cathedral) through the medium of ancient and primarily Roman sources. The language of the texts the humanists produced was never neutral but rather part of a rediscovery—or reinvention—of the antique tradition of oratory: the art of making representations brilliantly and persuasively on a subject.[6] Central among the authors these humanists studied and wished to emulate was the Roman statesman, lawyer, scholar, and philosopher Marcus Tullius Cicero. The corpus of his work was extensive and central to the humanist stance.

In Cicero, decorum was significant in two contexts. On the one hand, the aging Cicero advanced its moral dimension in *De officiis* (*On Duties*), recommending it to an errant patrician class as an ideal of behavior.[7] On the other, in *De oratore* (*On the Ideal Orator*) Cicero identified decorum as an attribute of oratorical style. It was one of four attributes to be precise along with "correct use of the language," clarity, and what he called *ornatus*, which recent translations term "distinction".[8] Alberti would have read Cicero, and almost certainly this definition, during his education in rhetoric and law. Indeed, Alberti's words on *quid deceat* turn out to be almost a paraphrase of Cicero's observations contained in the shorter work *Orator*: "As in life so in rhetoric, nothing is more difficult than to judge what is appropriate [*quod deceat*]."[9]

To rethink the role of decorum in architecture, it is important to link Alberti's use of *quid deceat* to Cicero—and to Cicero on oratory—for three reasons. The first is archaeological. Alberti, educated as a humanist, is likely to have read Cicero before ever he encountered Vitruvius, and to have read him in the context of advocacy; that is, Alberti read Cicero's words on technique in oratory in a situation in which they surely held a particular practical significance. The second reason is intellectual. Cicero's ambivalence about decorum goes beyond the Vitruvian notion of the

term; for understanding Alberti's intent, and for readdressing the history of decorum after Alberti, that complexity is important. The third reason is interpretational. Alberti's meeting with Vitruvius was almost certainly informed by Poggio Bracciolini's discovery of an early copy of *De architectura* in the library of the monastery of St. Gall in 1415/1416, which he brought to Rome. Braciolini, like Alberti, was a member of the papal curia, and his researches were driven by an agenda to recover unadulterated antique texts in order to better understand that lost world that so fascinated the humanists. His investigations in Switzerland were made during the Council of Constance and he netted, in the same haul that brought Vitruvius to light, the most complete known copy of Cicero's legal writings (at Cluny) and, alongside Vitruvius in St. Gall, works by another author central for the humanist understanding of antique oratory, Marcus Fabius Quintilianus (Quintilian). Alberti, then, encountered Vitruvius as part of this more general endeavor to interpret ancient texts, and particularly ancient texts on oratory. The use of terms, and his introduction of concepts, in *De re aedificatoria* was informed by this intellectual context for which the writings of Cicero were central.

Moral Decorum and Rhetorical Decorum

Vitruvius used the concept of decorum in the first half of his treatise, that is in books I through VI, and again in his discussion of the figurative processes of "finishing" in book VII.[10] The term *decor* is introduced as a rule of appropriate appearance, translated in one recent work as "the correct appearance of the work using approved elements and backed by authority."[11] This authority derives either from *statio*, "prescription" (what the experts think); *consuetudo*, "custom" (what is already done in a place by a population); or *natura*, "nature." Decorum in this context, then, is primarily a rule of "the fitting" as "the like"—a rule of identity. Buildings should be like what has been done before, like the constructions of nature, like the experts opine. Temples to healthy deities should stand in healthy places; manly gods should have columns with manly proportions; grand houses should have grand entrances and so on.[12]

In *De architectura* such statements underline how stasis and control are necessary architectural qualities. Vitruvius infers that there should be no upsets in this notion of decorum, no surprises;

everything should perform in the way it is expected to; everything should remain in its place. Although later in his treatise Vitruvius introduces the possibility that this rule will sometimes be broken, the quality attributed to the actual rule itself—its stated ambition—has no language for exceptions.[13] Only relationships of likeness can be admitted into its theoretical frame, and although the rule emerges in a discussion of difference between various families of ornament (the variations between Doric and Ionic columns, for example, which Vitruvius connects to differences between the Dorian and Ionic races), this difference is defined only through a language of exclusion. Racial mixing would be a fundamental problem for the rule of decorum as articulated in the first part of *De architectura*. Temples made of both Ionic and Doric elements would become meaningless, unstable.[14] Indeed, the only way in which the rule of decorum can become flexible, and exceptions be admitted, will be when it finds itself to be inconsistent—when the various clauses of the rule are in contradiction with themselves—when *consuetudo* argues for a different solution from *natura*, for example, or *statio* from *consuetudo*.

The origins of this rule in Vitruvius have been traced to antique writing on both rhetoric and ethics.[15] The absolute and authoritarian tendency of the rule as explained here, its emphasis on correctness and its overtones of morality, all tend toward its expression in works on ethics. Particularly, Cicero's *On Duties* (*De officiis*) encapsulates the idea of the moral, absolute code of decorum reflected in Vitruvius's text. For example, the argument that the scale and complexity of houses should somehow match the status of their inhabitants, found in Vitruvius at I, 11:6, is likely to reflect a common sense piece of advice in Cicero's *De officiis*: "in the home of a distinguished man, in which numerous guests must be entertained and crowds of every sort of people received, care must be taken to have it spacious."[16] Both statements are made to justify extravagance within a moral frame. But for Cicero, even when advice is being given about a moral kind of appropriateness, there is an inbuilt ambiguity around decorum. *De officiis* binds the problem of building appropriately to questions of change and impression—decisions that were appropriate in one set of circumstances may not remain so: "But if it is not frequented by visitors, if it has an air of lonesomeness, a spacious palace often becomes a discredit to its owner." Although Cicero shares with Vitruvius an emphasis on the propriety of *quod deceat*, an emphasis that appears based in the

morals of stoic philosophy, this emphasis is immediately bounded by caveats; decorum in architecture is a complicated matter, compromised by considerations of sensory reception (what impression is made on an individual observer) and temporal performance (the permanence of architecture confronted with the impermanence of occupancy). For Alberti, the absolute statements made about decorum in the first part of Vitruvius would have been seen against this understanding of the significance of instability and change.

This complexity is underlined in Cicero's discussion of the place of decorum in oratory. Why it is that for Vitruvius in books I to VI architectural decorum can be summed up by rule and illustration, but for Cicero rhetorical decorum is the *most* difficult aspect of oratory? First, there is the problem of rules and appropriateness: decorum is outside art. "The essence of an art is to see that what you do is appropriate, though on the other hand, this is the one thing that cannot be taught by art."[17] Second, there is the problem of context and variables. Decorum emerges in Cicero's *De oratore* when the speaker is asked to find the style that will best fit shifting mood and changing circumstance at the point of delivery. Its aim, amoral and expedient, is to ensure that oratory should persuade. That ability, to persuade, is the thing that defines the good orator, and it is a quality well worth seeking: "Who is it who sends shivers down your spine? At whom do people stare in stunned amazement when he speaks?"[18] "It is, of course, obvious that no single style is fitting for every case or every audience or every person involved or every occasion. . . . So it seems that there is really no rule I could give you at this point."[19] Finally, there is the problem of psychology: that the fitting is sometimes dull. Orators such as Cicero were acutely aware that to be effective, they needed to spice their orations with the unexpected. To predict when the fitting would suddenly no longer serve the overall purpose of rhetorical decorum—to say what will persuade—is a difficult thing indeed, requiring a "nose" (or *nous*) rather than a set of prescriptive rules.

Oratory and Memory

Within the tradition of oratory, mechanisms were developed for preserving speeches in memory. This mnemonic system, discussed in a fragmentary way in the antique texts the humanists read, and an object of some fascination for them, suggested an

unexpected potential for the unexpected itself in the creation of effective visual compositions. The system relied conceptually on dividing the act of memory into a series of memorized places, *loci* (ordered, familiar to the orator who, in his mind, always pursued the same route through them), and images, *imagines agentes* (associated with the points to be developed in any individual speech, which the orator then placed on these *loci*). Such recall involved perambulating, mentally, through the familiar places to discover the individual images deposited in them, which by their striking quality serve as a reminder of what is to be said.

This analysis, familiar from Frances Yates's classic research during the 1960s, introduces an intriguing complexity into the theory of oratory by explaining that the order of the "fitting" will not be sufficient to ensure that a composition will be effective.[20] For while the *loci* in the mind of the orator may be well ordered, the central principle about the *imagines agentes*—the images that fill them and which strike the emotions and awake recall—is that they must be unnatural, contradictory, against expectation.

> A sunrise, the sun's course, a sunset are marvellous to no one because they occur daily. But solar eclipses are a source of wonder because they occur more seldom, and indeed are more marvellous than lunar eclipses, because these are more frequent. Thus nature shows that she is not aroused by the common ordinary event, but is moved by a new or striking occurrence.[21]

There is a place, a hierarchically crucial place, for the "unfitting" in such a theory of reception and of memory. Consequently this body of theory must acknowledge a logic that runs counter to the principle of decorum as defined in a moral frame. It must describe the complexity that the unfitting is sometimes appropriate; or that misplacement is sometimes crucial to creating an assembly that performs effectively.

> We ought, then, to set up images of a kind that can adhere longest in memory. And we shall do so if we establish similitudes as striking as possible . . . if we assign to them exceptional beauty or singular ugliness; if we ornament some of them, as with crowns or purple cloaks . . . or if we somehow disfigure them, as by introducing one stained with

blood or soiled with mud or smeared with red paint, so that its form is more striking.[22]

Whether or not this background was implicit in Vitruvius's references to decor, it was familiar to Alberti and to the culture in which he moved. Both the art of memory itself, and its organizing division of experience into places that provided order and images that impressed themselves on memory by "striking" the emotions, were fundamental aspects of intellectual habit in the culture that produced Alberti and his texts. At one level the discipline of law, in which Alberti received his university education, relied on practical aspects of the art;[23] at another, the philological work and rereading of the early humanists, among them Alberti's teacher Gasparino Barzizza, reappraised the somewhat intractable passages on the art of memory in ancient texts on rhetoric.

The impact of the rhetorical art of memory on Alberti's thinking is evident in various contexts in his work where the mnemonic distinction between place to give order and dynamic image to excite or impress is repeated. And at crucial points in Alberti's descriptions, the potential of this movement as an element in creating effective visual composition is also rehearsed. As well as all his other texts, Alberti turned his hand to the fashionable task of writing witty after-dinner fables, another genre that humanists resurrected from antiquity. In two of these so called *Intercenales* ("dinner pieces"), using words recalling those in the theories of memory, Alberti suggests that images create a moral impact by making use of distortion or impossible juxtaposition. In the fable *Picturae* ("Paintings"), he describes a set of images that provide effective "councils for living wisely."[24] They signify the virtues and vices using *corporeal similitudes* and an architectural disposition similar to those recommended in *Rhetorica ad herennium*, the text Bracciolini had recovered from St. Gall and a primary source for the humanists' knowledge about memory cited above.[25] *Anuli* ("Rings"), another dinner piece, also contains images that signify ideas, here represented as *imprese* on signet rings, images to be imprinted into wax.[26] Both kinds of image act as guides to moral conduct, and both embrace contradictions, combining striking oppositions or invoking movement. Thus such images emerge as those of a figure half human, half goat with a crown made of buzzing hornets and wasps (portraying "Injury"), of a virgin growing a beard (to signify the ideal of maidenly openness combined with

bearded maturity), or an elephant's ear caught in a net (again figuring simultaneous receptivity and discrimination). The use of opposing, moving images to convey a moral message is also celebrated in Alberti's seminal text on painting, *De pictura*, where, following Lucian, he praises Apelles's portrayal of Calumny.[27] The painting combined hideous figures that communicated behavioral vices with chaste representations of the fixed virtues; together these formed an effective composition. Like Giotto's portrayal of *Envy* in the Scrovegni Chapel in Padua, whose writhing snake-like tongue picks out her own eyes, Alberti's compositions embody action; they trade in the conventionally impossible. They can be explained in terms of distortion away from normative rules, or the temporary union of heterogeneous, moving elements. This attention to the potential importance of juxtaposition and opposition in visual composition introduces into Alberti's theoretical system a concern with that which is against expectation.

Decorum in De re aedificatoria

In as much as it formed the background against which Alberti understood Vitruvius, this rhetorical conception of the fittingness of the unfitting is likely to have affected his interpretation of the broader scope of Vitruvius's argument. A close reading of *De re aedificatoria* reveals not only Alberti's awareness of the antique theory of oratory and reception but suggests how this awareness colored his understanding of Vitruvius's treatment of various parts of architecture: the significance of *aedificatio* (the appointment of appropriate place and materials), *gnomonice* (orientation through relating astronomical observations to conditions on the ground), and *machinatio* (the governing of moving bodies).[28]

While Alberti repeats or adapts some of Vitruvius's "prescriptive" rules that define the decorous in terms of, say, the syntax for the compilation of column assemblies, he is very careful indeed to include these as reports of ancient theory. In his first reference to the column and its importance as an element in his theory of architecture, he states that these rules are not his own recommendation and warns not to take them prescriptively.

> Although other famous architects seem to recommend by their work either the Doric, Ionic, Corinthian, or Tuscan

division as being the most convenient, there is no reason why we should follow their design in our work, as though legally obliged. Rather, inspired by their example, we should strive to produce our own inventions, to rival, or, if possible to surpass the glory of theirs.[29]

This initial passage focusing on the column is significant in terms of Alberti's understanding of *quod deceat*. In it, the first of Vitruvius's principles of decorum is explicitly denied; *statio*, that which the experts recommend, cannot unreservedly act as a guide for what will be appropriate in the future. For Alberti, as for Cicero, the roots for this complex statement appear allied to traditions relating to the creation of striking visual compositions.

In *De re aedificatoria* the Vitruvian notion of decorum, of appropriateness in appearance and placing, of adherence to norms, of rectitude, propriety, and modesty of expression, is certainly emphasized. But Alberti's recommendations about the composite column show that this emphasis is introduced only as one side of a duet. Although the power of architecture in *De re aedificatoria* is guaranteed through principles of order and permanence—of appropriate placing—Alberti maintains that architecture cannot be explained solely in terms of the correct distribution of elements defined by its *lineamenta* to create a secure and ordered frame according to *consuetudo*, *statio*, and *natura*. Architecture itself must be experienced; buildings are also like images, their tangible *structura* as striking and sensible as the intangible *imagines agentes* of the art of memory. In these terms, architecture may gain an emotional power through misplacement as well through "fitting" appropriateness. In order for architecture to be, its *structura* must be moved; indeed movement is key to architecture's potential to create moving compositions. The three parts of architecture defined by Vitruvius—*aedificatio*, *gnomonice*, and *machinatio* (to repeat: the appointment of appropriate place and materials; orientation through relating astronomical observations to conditions on the ground; and the governing of moving bodies)—are vividly alive in Alberti's account of the *res aedificatoria*. Just as *gnomonice* and *machinatio* impinge on the principles that guarantee mnemonic effect (the distinction between the sun's course and a solar eclipse for example, or the artificial nature of striking images) so they inform effect in architecture and are key to Alberti's notion of decorum.

The principle is neatly summed up in Alberti's dedication written for his earlier treatise on painting, *Della pittura*.[30] In honoring Brunelleschi as an architect, and in introducing a text dedicated to explaining how effective visual compositions can be created, Alberti explores how the unprecedented movement of material creates the beautiful and the divine in architecture. The case is made through *ekphrasis*, in this case a eulogy over the dome of the cathedral of Florence, that great *gnomon* completed during the 1470s, which provided orientation and location to the entire Florentine nation. This text is so important for the history of architecture that it is worth giving in an extended citation, both in the original Tuscan *volgare*, in Cecil Grayson's authoritative English translation, and in a slightly adjusted version of my own. Before its significance can be discussed the context of its writing also needs to be briefly sketched. Here is the passage:

> Chi mai si duro o si invido non lodasse Pippo architetto vedendo qui struttura si grande, erta sopra e' cieli, ampla da coprire con sua ombra tutti e' popoli toscani, fatta sanza alcuno aiuto di travamenti o di copia di legname, quale artificio certo, se io ben iudico, come a questi tempi era incredibile potersi, cosi forse appresso gli antichi fu non saputo né conosciuto?[31]

And thus Grayson:

> Who would be hard or envious enough not to praise Pippo the architect on seeing here such a large structure, rising above the skies, ample to cover with its shadow all the Tuscan people, and constructed without aid of centering or great quantity of wood? Since this work seems impossible of execution in our time, if I judge rightly, it was probably unknown and unthought of among the ancients.[32]

Alberti composed this dedication at a very particular moment. He wrote it in 1435 or 1436, probably in Florence, during Pope Eugenius IV's period of residence there following the removal of the papal court from Rome. Masaccio's *Trinità*, the first large-scale fifteenth-century work that used the potential of perspective to create emotion, had just been completed in the nave of Santa Maria Novella, its vivid fresco colors glinting bright. Ghiberti was

at work on the relief panels that would make up the *Porta di Paradiso*, later to be installed in the Baptistry before Santa Maria del Fiore, where Brunelleschi's first experiments with perspective apocryphally took place. The area around the cathedral was an enormous building site surrounding the very final stages of closing the dome over the church. This was among the largest structures ever erected in Christendom, with a span as great as that of the ancient Roman Pantheon, its interior dimensions a reflection of the heavenly temple as described in the book of Ezekiel. The church had been under construction for seventy years; the crucial process that produced its dome had been going on for sixteen.

In that process Brunelleschi had been engaged principally as an inventor of mechanics and machinery: payments to him, which began in 1417, initially covered expenses for models that represented the evolving method for the dome's construction. The Opera del Duomo assigned responsibility for the building to a collaborative committee rather than to an individual *capo maestro* (master builder, in the Tuscan *volgare*), almost certainly because of the logistic and technical challenges it imposed. But Brunelleschi's increasing status in the project over time reflected the continuing importance of his prowess. To complete the dome a system had to be devised to measure the work; Brunelleschi organized leveled areas along the river on which these calculations could be made. The dome was conceptualized as a series of interconnected arches and rings; Brunelleschi provided models of the complex shaping required. Moving the materials required machines that challenged constructional practice; Brunelleschi evolved new forms of geared mechanisms to control the enormous lengths of rope involved in hoisting.[33] At the point Alberti's dedication was written these machinations were entering their final and thus most dramatic stages. The dome was about to be closed; its 25,000-tonne structure hung over an ever-decreasing hole at its center, slowly focusing into an oculus. Men, machines, their lunches and building materials, were ascending steps and ladders, or being hoisted on ropes, to a working platform 80 meters above the street. The structure was imminent rather than completed. Brunelleschi was titled *architetto* for his expertise relating to this endeavor; the expertise itself concerned, primarily, *machinatio*.[34]

In Alberti's dedication to Brunelleschi, this work—and for the moment let me blur whether work here refers to the nearly completed object or the multiple processes that were continually

completing it—calls attention to itself for its lack of precedent: "our fame should be all the greater if without preceptors and without any model to imitate we discover arts and sciences hitherto unheard of and unseen." Next the unique size and active impression of the project are praised: it raised material "towering above the skies."[35] Last, as if to emphasize the unnaturalness of the process of creating this structure, the feat of the building's construction is noted, which, "if I am not mistaken . . . people did not believe possible in these days and was probably unknown and unimaginable to the ancients."[36] Thus, where Alberti's description of the column in *De re aedificatoria* specifically contradicts the first of Vitruvius's tenets for what constitutes the decorous, his praise of Brunelleschi's project for the dome in *Della pittura* contains a refutation of all three. The work is praised because it ignores *statio* (the experts would believe it impossible), *consuetudo* (it is wholly unprecedented), and *natura* (Brunelleschi's energetic action put material where it did not naturally belong; the construction process suspended this material in air).

In celebrating such mechanical skill the text also contains a hint that machination was an essential element in the discourse of *De re aedificatoria*. Alberti had a number of artistic contacts to choose from in finding an appropriate addressee for his treatise. Florence was full of figures directly known for their prowess in painting and sculpture: Ghiberti, Donatello, Masaccio. Yet he chose Brunelleschi, and he celebrated specifically Brunelleschi's prowess in architecture, a facility that was specifically related not only to *aedificatio* in Vitruvian terms (the creation of permanent architectural works), but also in some sense to *gnomonice* in its potential to provide orientation though complex calculation, and to *machinatio* in its central role of governing the moving of bodies. The emphasis in Cecil Grayson's English translation that identifies the "work" celebrated by Alberti with the final form of the dome can reasonably be questioned. A rendering might be made of Alberti's dedication, as in my translation below, that pinpoints Brunelleschi's artifice, as much as the material result of that artifice, as the center of attention:

> Who, hard or envious, would not praise Pippo the architect on seeing here so much material fly into the skies, sufficient to cover with its shadow all the people of Tuscany, put in place without any help from beams or copious amounts of

Part II: Dispatches 1450–1590

timber; which artifice certainly, if I judge well, just as it was incredible to perform in these times, so perhaps among the ancients was neither known nor recognized?

Brunelleschi is saluted here by Alberti for his potential to motivate action, rather than for a skill in completed composition, and for his daring "misplacements" rather than for decorously following established rules.

Regardless of nuances in translation, this text suggests that for Alberti the issue of *quod deceat* is likely to have been one of some delicacy. *Della pittura* identifies characteristics of the Florentine dome that are praiseworthy and which underlie its significance as indicative of the Florentine urban experience. Alberti is surely saluting the building's appropriateness to its urban context, an appropriateness that grows from the way in which it creates a visually effective, highly memorable point in the sensorial experience of the city. This effect is created, however, not through adherence to established principle or a hidebound, conservative idea about appropriateness, but through some uncanny sense of the unexpected, a "look, no hands" magician's trick, surprising but perfect in effect.

This description of the dome of the cathedral of Florence introduces an elusive quality into its praise from which we might define two objectives for the architect, objectives that also emerge in *De re aedificatoria*, composed fifteen years later. On one side architectural composition in that treatise, just as in Vitruvius's description of *aedificatio*, must produce a fixed and ordered frame for human action; for Alberti the whole fabric of society relies on such architectural definition; people and things are to be kept in their place.[37] Yet at the same time the architect must create striking, effective compositions that wake emotion, because through its visual impact, Alberti maintains, architecture has the power to directly influence men to the good.[38] And that creation must allow a central place for the temporary, for the transgressive, for the unnatural, for the "out of place."

Here Alberti departs from Vitruvius, though he keeps company with his oratorical ancestors. Vitruvius maintains the centrality of moral decorum whether he is discussing building organization or the fictional fresco paintings that finish buildings and which produce effects on their surfaces.[39] The unnatural must always be shunned; the expected and established must be trumpeted in

such descriptions. For Alberti and his humanist contemporaries, on the other hand, such limitations did not apply.[40] They derived their understanding of the effectiveness of visual works primarily from their studies of the art of oral composition, translating the maxims of oratory into the visual world. In terms of that projection, decorum was a complex matter, as difficult to predict as *quod deceat* would be in an oration by Cicero, born of a complex relationship between the need to place and the need to misplace. In architecture, this in turn produced an ambivalence in the role of the architect in ruling between these two desires. Architects must, somehow, provide both a fixed datum and convey variations and distortion within this frame.

Aedificatio, Gnomonice, Machinatio, *and Decorum*

If this analysis can be taken to represent Alberti's position, then his idea of *quod deceat* was a powerful one indeed. Yet this sensibility was not to prove central to the discourse of architecture as it developed during the later fifteenth and sixteenth centuries. Following the dissemination of Alberti's treatise, a particular interpretation of decorum, primarily understood as a principle of conformism and propriety, and closely aligned with its use in Vitruvius, became central to the discourse of architectural theory. The dominance of this tradition is surprising. The philological endeavor of interpreting Vitruvius developed considerably in the second half of the fifteenth century. Following the interpretive work of Giovanni Sulpizio da Veroli, Fra Giovanni Giocondo, Cesare Cesariano, and Daniele Barbaro, Vitruvius was accessible in the sixteenth century in a way he had not been in the fifteenth.[41] Yet as Vitruvius became better known, as it became easier to read the treatise whole, and as the full elaboration of the argument developed around *aedificatio*, *gnomonice*, and *machinatio* could be sensed, discussions around decorum in architecture became less nuanced. Although the treatises of both Alberti and Vitruvius implied a place for fluid variation, discussions about sixteenth-century decorum became ever more bounded by the moral, restrictive and dictatorial aspects associated with the term. The reasons for this are complex, but one of them related to an ambivalence emerging in the architect's position with regard to authority, an ambivalence grounded in the definition of the figure of the architect laid out in Alberti's own

work, and one which created a context in which the notion of a Vitruvian moralized code of decorum was of particular use to the discipline of architecture.

The tendency is already evident in perhaps the most influential of all Renaissance architectural treatises, Sebastiano Serlio's *Libri di architettura*, which reintroduced central elements of the reductive Vitruvian sense of decorum.[42] *Decoro* in Serlio is introduced as a rule of adherence to order and to mimesis. *Decoro* stands in opposition to that which is *licentioso*, licentious, outside the field of the same, and where the boundaries that define that field have been broken.[43] At first sight this may seem but a small step away from Alberti's requirement that to be appropriate, architecture must both place and misplace its material. Yet although the shift from Alberti to Serlio is subtle, and although without a doubt Serlio uses *licentioso* to describe an architectural quality rather than as a pejorative term, some kind of philosophical watershed appears to separate the two authors. In the Albertian/Ciceronian model of rhetorical decorum any opposition between *quod deceat* and license would be meaningless; the adherence to and breaking of rules forms part of the maintenance of decorum, which is why giving rules about decorum is so difficult. In Serlio a hierarchical relationship is implied; there is a gravitas in decorum that allows license only in certain, well-defined, situations; decorum comes first, license afterward; decorum reigns and provides the ground. With this interpretation decorum will increasingly reacquire the moral dimension implicit in Vitruvius's definition, and *quod deceat* will become a prescriptive category, implicitly related to norms and mores—expected patterns of behavior or practice as defined by expert privilege or an indigenous mass. "What is fitting" will no longer be a reactive quotient changing with the winds of the moment but will give way to "what should be" according to a predetermined classification.[44]

The way in which architectural discourse developed the notion of decorum was quite particular. The potentially rich definition implicit in Cicero and the antique discipline of oratory, which the humanists adapted to describe architectural action and in which difference played a central role, shifted in texts on the theory of architecture toward a discourse of decorum that emphasized the authority of similitude. This tendency toward theoretical simplification is also found in at least one other case where architectural theory borrowed concepts from another discipline. In

Renaissance architectural treatises, similes with music were central. Since antiquity, music (like rhetoric) had been acknowledged as a liberal art endowed with a relatively complete theoretical frame (summarized in Boethius), and its theory had evolved spectacularly in the fourteenth and fifteenth centuries through the development of polyphony.[45] In Alberti's day, music was central, and theorized in relation, to the creation of effects in religious and secular ritual. The consecration of the dome of Santa Maria del Fiore, for example, was celebrated by an epic motet, composed by Guillaume Dufay, that translated the architectural qualities of the building into polyphonic music, and which utilized the striking effects of harmony played out against disharmony to create rhythm, anticipation, and conclusion.[46] This development was in turn theorized: fifteenth-century treatises existed that explained how discords could be used in polyphonic composition to convey specific moods appropriate to particular places in the temporal frame of the work.[47]

In borrowing from musical theory, again via the filter of Vitruvius, architectural theory reemphasized the notion of the perfect harmonies and the mathematical relationships that define them as the basis for recommending architectural composition: the "theory of proportion."[48] But architectural theory conspicuously neglected to take up the highly evolved discourse in the theory of music that gave an account of how discord, contrast, juxtaposition, and contradiction were fundamental to the production of compositions that moved the senses. Thus adopting the notion of a moralized, hierarchically primary decorum, which appears as rather selective in the context of the theory of oratory, is balanced by selectively adopting perfect harmony from the theory of music. Both these disciplines—music and oratory—celebrated difference as a central plank of good composition, but in borrowing from them architectural theorists tended to play down this significance.[49] Why, then, in architectural theory, was a discourse of difference only admitted as an exception to a preordained, correct discourse of propriety and rectitude?

Alberti's claim about the beneficial effects of architecture early in his treatise appears to be a key statement of position. His words reflect a similar claim about the art of the painter in *De pictura*: both painting and architecture can move men to the good through the effect they have on the senses.[50] This potential implies a translation to the visual of a power associated in antiquity with the

effects of aural experience—in music, poetry, or oratory.[51] In *De re aedificatoria*, Alberti attributes this potential to the articulation in the composition of a "divine sense of beauty"; and this stimulation, Alberti maintains, is the architect's primary aim.[52] Building is seen in Alberti's text as the medium through which beauty can be sensed. But Alberti's formulation of the architect's role introduces an additional level of complexity into understanding the mechanisms of how such buildings might be realized. The architect, Alberti maintains, "is no carpenter"—architects do not build. Although they "will hardly be able to avoid having sole responsibility for all the errors and mistakes committed by others" they do not supervise the building site but allot that responsibility to a "zealous, circumspect, and strict clerk of works."[53] Thus, although their task is to control architectural composition in such a way that beauty can be articulated through it, they act at one remove from actual execution. Much of the development of architectural theory follows from how the "Albertian" architect must navigate this divide.

Alberti's separation of the architect from the theater of building, and his claim for the sovereignty of this figure, had profound significance following the dissemination of his treatise, as the architectural discipline developed. In fifteenth-century Italy authority over building projects was linked either to authority over the building site, that is, the authority of the *capo maestro*, or to the authority of the patron.[54] Alberti's treatise, which declared architects to be severed from these doubled sources of authority, placed architects in a special position. Albertian architects, if they are to survive, must establish by some means an authority over execution that they do not possess themselves, per se. To cover the authoritative gap that results, Albertian architects will turn increasingly to rhetoric, both to do all that can be done to exercise influence without authority and to lay claim to a vicarious authority through which they can exercise their own judgment. Thus in architecture, uniquely, it would be possible to argue that the ancient discipline of oratory held a double significance for the evolution of Renaissance and modern discourse. The power of the orator's speech celebrated by Cicero, to send "shivers down your spine" must be matched both by the power of a building to "move an enemy," and the capacity of the architect to persuade, rather than command, the patron and the patron's builders. This means that at the level of the potential attributed to the work, oratory provides the origin

by which the building is understood to affect an audience (archi-tecture explained in terms of a discourse originating in antique considerations of rhetoric and the art of speech). At the level of the artist, the orator provides a model for the architect (whose actions in relation to the theater of building suddenly have an affinity with those of the orator arguing a case).

Alberti provided the first modern definition of the architect as one who makes representations.[55] And these representations, like those of the orator, have a first duty to persuade. The tools that the nascent discipline of architecture evolved (spectacularly) during the Renaissance—the treatise, the drawing, and the scale model—all are characterized by their capacity for persuasion. If architects share the powerlessness of the orator to dictate how an audience will behave; if their methods and tools also have a base in rheto-ric, then the appeal of an absolute and moral decorum as a means to invest architectural argument with an external authority can be understood. Although Cicero in practice could be scurrilous, his jokes scandalous, his timing split-second, he made his appeals ultimately to ponderous tradition and the maintenance of a posi-tion of moral rectitude. Similarly, the aspects of character that must be advertised for the Albertian architect tend to be those of propriety, conformism, respect. What the Renaissance theory of architecture lacks is a metatreatise that considers the mechanics of architectural persuasion as frankly as *De oratore* considers the mechanics of rhetorical persuasion. And thus it remains very hard to discern the gap between the pronounced primacy of a moral rule of architectural decorum and a more complex, and no doubt more sophisticated, rhetorical practice of architecture.

From the sixteenth century onward, architects consistently used arguments based in decorum as central rhetorical props in their endeavor to wield control over the action of building. Indeed, we might suggest that the wide-scale adoption of the Serlian scheme affected the way architectural discourse developed through the nineteenth and up until the end of the twentieth century. Since architects during the gestation (and at the birth) of modernism used a moralized rhetoric of appropriateness, defined in terms of societal need, to argue their case, modern debate and criticism was played out on a field that took the moral authority of the fitting

as its given topography. Yet, although the conceptual category of decorum was one that Western architects continued to use, and to use deftly, until the mid-twentieth century to argue their case to society at large or to influential members in that society, the category has proved a double-edged weapon in more recent times. Arguments based in decorum as "the authority of the fitting" play a role in the debates around architecture in postindustrial Western societies that the architects in those places frequently question. Discussions around urbanism and heritage, where the relation between new construction and existing urban or landscape conditions has to be considered, can be particularly acrimonious in this regard. In many countries, particularly in Europe and the United States, contemporary architects live with planning legislation that addresses the aesthetic value of the built environment primarily through the index of the appropriate as equated with the like. Although such assumptions can be challenged, the language of conservation, which tends to be the language in which discussion about change in the built environment is made, is usually predicated on how what is proposed "fits in with," "respects," what is already there.

This kind of structure must clearly be challenged. For one thing, it produces a discourse that has few theoretical tools to deal with heterogeneity at the urban level (what happens if the "context" is already, of itself, contradictory?). To make that challenge, however, we do not have to discard the relevance of decorum for architectural discourse. Rather, we need to reassess the term and to find a better meaning for it. Regarding the history of decorum, it becomes clear that to define it as the equation of the right, the like and the fitting is only one possible course. At a time when architectural theory is renegotiating the terrain that the twentieth century mapped out for it, why not consider alternative definitions of decorum? The Ciceronian/Albertian notion of *quod deceat*, apparently amoral, underwritten by a theory about affect, and based on an appreciation of the value of the "unfitting," provides an intriguing historical background for contemporary attempts to make a place in architectural thought for the other, or to evaluate architecture in terms other than the category of the same.

Domenico Fontana and the Vatican Obelisk

Many of the internal and external structures of expectation surrounding architectural practice today assess the value of architectural agency through judgments of the "built work," its originality and functionality. Palladio, for instance, has been celebrated through architectural history based on valuing, as an artistic act, the creation of new "works" for which he has been declared the author. This "work-author" connection continues to effect how architects think about themselves, how others see them, the way in which they approach their tasks, and the roles they claim within project processes.[1] Not least, and most vibrantly, it continues to dominate architectural education: undergraduates who begin a course of study with the word "architecture" in is title still experience a situation in which they will be judged on the basis of a representation they make of an imagined, and complete, building. Often, still, the assumption will be that in order for an architect to be taken seriously—Priztker-prize seriously— substantial parts of their work will need to be constituted by the projection of constructions that are new, and in which material is assembled into new forms.

How did this come to be the case, and how can we challenge that model of architectural "work"? Alberti's *De re aedificatoria* in some ways foreshadowed this emphasis in our modern system of valuing architects. In defining a model of architectural work

that emphasized the significance of projective composition—the description of a design proposal in terms of the disposition of the outlines that define its surfaces—the sixteenth-century theorists who followed Alberti marginalized, in their written representations about architecture, questions about building process.[2] This played out as a side effect of the radical development of graphical representation that the logic of Alberti's *De re aedificatoria* predicted. When architecture was drawn, in the decisions taken about what things were worthy of drawing lines around, a refractive index was set up that adjusted the image of what an architectural work included. Drawn architecture tended to suggest that the work lay in a description of the projected final artifact.

In many ways this development was surprising, indeed counterintuitive. Like Alberti, the architectural writers of the early sixteenth century took Vitruvius as their source, and in researching Vitruvius described ever more clearly the complex whole that made up his treatise—its almost perfect balance between providing a guiding account to inform architectural placement (the definition of the lines and angles that make up building superficies) and a rich description of architectural process (the claim that architecture rules over the moving of bodies, from waters to planets to projectiles). But, even though sixteenth-century studies of Vitruvius illustrated lavishly, and translated with great attention, the sections of his treatise concerning movement—contemporary architectural treatises privileged the representation of the static over the temporal. The consideration of mechanics, cosmology, flow, and ballistics (in whatever form) found almost no space in the canonical texts by which generations of author-architects advertised their wares to potential clients.

The accreditation systems of architecture are now beginning to embrace a more nuanced definition of what constitutes valued architectural work—evidenced for example in the election of the recent Pritzker laureates Anne Lacaton and Jean-Philippe Vassal (2021) or Diébédo Francis Kéré (2022), or even, perhaps, in the Pritzker jury's motivation for the nomination of David Chipperfield for the prize in 2023. But it is noticeable that this reassessment has to be made within an infrastructure still dominated by the canonical account, put in place in the sixteenth century, that makes architects the authors of buildings that are new, static and permanent. The defining systems of architectural representation—at all levels from contract to claims of intellectual property to systems of

drawing—must be twisted a little to acknowledge the significance of other process-based, curatorial or transient kinds of work.

This contemporary shift reflects an intriguing equivalent moment that occurred immediately after the sixteenth-century architectural representational paradigm was itself established. By the 1570s in Italy architect's treatises suggested that architectural virtue could be communicated in the projection of line-drawings of permanent structures. Buildings, real or imaginary, floated seductively on pristine pages. Villas, churches, palaces, bridges lay flat between princely gold-embossed leather bindings, or open to view on costly inlaid *studiolo* tables. But in 1590 Domenico Fontana, in one of the most elaborate of all sixteenth-century architectural treatises, challenged what kind of virtue might be articulated in engraved lines. In his *Della trasportatione dell'obelisco vaticano, et delle fabriche di Nostro Signore papa Sisto V*, suddenly architectural work concerned something other than the definition of lines and angles. The objects that Fontana included as evidence of his architectural skill were not necessarily ones he had designed. Rather, they were often preordained objects that he had moved. In terms of Vitruvius's three departments of architecture, Fontana's projects concerned *machinatio* (and perhaps *gnomonice*, for the most important one concerned setting up a gnomon) rather than solely *aedificatio*. The following pages explore the wider implications of the creation of *Della trasportatione dell'obelisco vaticano* and are intended to be useful for a developing contemporary discussion relating to how we think about roles and credit in architectural design today.

In the opening sections of *De re aedificatoria* Leon Battista Alberti proclaims that the work of an architect can gain that person fame and credit, or conversely shame and blame: "He must calculate . . . the amount of praise, remuneration, thanks and even fame he will achieve, or conversely . . . what contempt and hatred he will receive, and how eloquent, how obvious, patent and lasting a testimony of his folly he will leave his fellow men."[3] How then, according to Alberti, should this judgment of the virtue of an architect be made? The answer is that architects will be subject to judgment via the physical compositions their agency produces.[4] Much, he makes clear, depends on the "arrangement of the parts" in those compositions. According to an idealized Albertian account of

the world, the architect will be able to define that arrangement autonomously and in advance, having taken into account all the circumstances of the context.[5] This "art of arrangement" is both a prediction of where the superficies that make up a projected building will be and a guarantee of their phenomenal success (meaning the effectiveness on all levels of the object that is created following the architect's instructions); it corresponds very closely to the Vitruvian *aedificatio*. The emphasis in Alberti is very much on "placement"—the prediction of the proper position for elements in built compositions. At the commencement of the treatise Alberti informs the reader that "the whole matter of building is composed of *lineamenta* (lineaments) and *structura* (structure or material). . . . It is the function and duty of *lineamenta*, then, to prescribe an appropriate place."[6] In this respect *De re aedificatoria* was fundamental to the development of the modern notion that an architect can be read as the author of a new work. Architects will be judged through judgments about the superficies of the buildings that their agency produces.

If *lineamenta* defines where things should be put, the other side of Alberti's definition, *structura*, concerns everything that has to be put there. Alberti's arguments, in *De re aedificatoria*—and in other texts he produced that consider the effectiveness of various kinds of phenomenal compositions within the world (notably, buildings, paintings, statues, and ciphers)—suggest that an equal and slightly distinct virtue resides in the action of placing things: that is to say, in the ability to organize the world such that its materials come to rest in a particular position.[7] In the architect's case the first kind of virtue appears bound up with notions of stasis—a kind of inevitability that emerges when the world is arranged according to a particular vision, as if things could not be arranged in any other way ("nothing could be altered but for the worse," as Alberti writes in *De re aedificatoria*). But the second kind of virtue must be all about striving, effort, motion, and movement: the action of placing physical stuff, of relocating it and reforming it from one state to another.[8] Alberti relates this virtue specifically back to the question of how architects are judged, but with a notable caveat. Placing is also an activity that exposes the architect to judgment; in this case however, the risk-to-reward relationship is somewhat skewed:

> Whenever you intend to move great weights, it is as well
> to approach the task gradually, with caution. . . . Nor will

you receive as much respect and praise for your ability if your undertaking follows your plan and succeeds, as the disrespect and contempt for your temerity if it fails.[9]

In one sense this double emphasis in Alberti follows logically out of the structure of Vitruvius's *De architectura*, which Alberti was adapting and clarifying for a modern audience. Vitruvius also dwells to a great extent on methods and formulae for guaranteeing that the "placement" of elements in experienced compositions will be "correct." At the same time, Vitruvius classifies the actions of an architect into three fields, of which one is this facility to predict what placement will be correct in a composition. As we have seen, the other actions that Vitruvius describes for the architect concern precisely the problematics of moving material into the position where it will be effective: *De architectura*, books VII to X, consider fluid material systems, the principles of mechanics and the construction of machines that move things about.

Alberti's *De re aedificatoria* reflects *De architectura*, and the overlap between these two accounts of the art of building was to become crucial in defining the principal system of valuing architects' work during the fifteenth and sixteenth centuries. But it is very unlikely that Alberti's distinction between *lineamenta* (defined places, predetermined by the architect in advance of construction) and *structura* (the material stuff that must be moved to fill those places) emerges out of Vitruvius. Alberti has a general predilection to consider the skill of artists—those whose agency makes manifest compositions that are experienced in the world—in precisely these terms. Artists are to be valued for their ability to predict correct "placement," on the one hand, versus their skill in arranging the executive actions that make this idea of placement tangible in a particular place and time on the other. This is evident throughout Alberti's oeuvre and emerges before the period in which the text of *De re aedificatoria* was crystallized. It is present in Alberti's definition of the art of painting as the action of placing stuff (paint) into sets of predetermined outlines (places) to produce experiential compositions to be judged (*De pictura*, 1435); it emerges in his description of the art of the sculptor, who can predict the position of the superficies of a body that will be occupied by the material the sculptor has the skill to carve; it is evident also in the theorization of the system of ciphers made in *De componendis cifris*, which relies on a distinction between an understanding of

letter "places" that guarantee the meaning in a text and material letter "sounds" that fill those places and make the text manifest—audible to the ear or legible to the eye.[10]

As was the case with decorum, Alberti's thoughts about placing emerge out the humanist experience of the antique tradition of oratory—the positioning of words to create effective political speeches:[11] Oratory is an art of placing in real time. Its theory analyzes the skill of how to assemble words, at one crucial moment, in order to achieve the aim of persuasion. Like his understanding of decorum, Alberti's ideas about how artists and artistic works operate are indebted to this schooling in oratory: that the creator can be judged by the sensorial effect of the composition produced; that the skill of the creator is to be found both in producing that composition where everything is in the "right" place, but also in an almost magical facility for placing those "things"—be they words, letters, stones, or timbers that make up the composition—to best effect.[12]

A number of interesting things result from applying a theory on one mode of human activity (the production of political speeches in the extremely specific context of the Roman Senate) to another (the multiple processes involved in ordering and organizing the built environment for human habitation). One is the emergence of the "project" (in the modern sense) into architectural thought. Political orators have a project—an intention about how the world should be—that goes beyond "fitting" their words to the circumstances. The idea that within architectural agency a wider ethical and political stance is at stake—that the architect somehow has a responsibility and a potential beyond providing this or that tyrant with comfortable accommodation—can be dated from Alberti's infiltration of the methods of oratory into the question of how to organize building practices. Extrapolating a method for building out of the praxis of speech making also had to navigate very obvious, and obviously tricky differences between these two things. Political speeches, and speeches in general, are compositions that are always new and transitory, whereas the production of buildings is just the opposite: turgid, slow, mortgaged to existing conditions, encompassed by conflicting desires, and very unlikely to be comprehensible in terms of a dazzling display of juggling from a sole author. What happens when a system based on valuing "placement" and "placing"—in which the relation between these two can be fluid, inevitable, and under

Part II: Dispatches 1450–1590

the sole control of a single mind and voice—encounters a context dominated by existing superstructures where many voices and minds meet?

Representation in Renaissance Architectural Treatises

Notably, *De re aedificatoria* is unillustrated. It lays the basis for a discipline of architecture that was to become obsessed with graphic representation, while making its own representations in text alone. In the set of architectural treatises that followed Alberti's *De re aedificatoria* the modern architectural system of graphic representation was invented and eventually came to dominate over text. This change has been much studied and to good effect.[13] One aspect about it that still seems important to note is the frictional relationship between the messy context of building and the ideals of a system that valued architects by judging the built compositions they were involved in creating. Graphic representation can be seen as very useful in resolving this friction. It provided sixteenth-century architects, and their emergent discipline, with a prosthetic, a prop through which judgments could be made about architectural virtue without those judgments resting on realized built production. Through representation virtue could be judged ex ante; drawings, models, renderings showed the effects of a building before it was there, and presented, no doubt in the best possible light, every aspect of "placement" that the architect sought to produce.

This founding condition appears familiar. Architects continue to love drawings, in which the intractable conditions that characterize a building site can be set aside, eclipsed by the vision of a projected future, glimmering like the light that shone for Jay Gatsby as he gazed across Long Island Sound. F. Scott Fitzgerald's depiction in *The Great Gatsby* of such an anticipated resolution is a quintessentially modernist image: "Gatsby believed in the green light, the orgiastic future that year by year recedes before us. It eluded us then, but that's no matter—to-morrow we will run farther, stretch out our arms farther."[14] Although the comparison is extreme in its reach, it encapsulates an experience that might be intuited for every architect between 1450, when *De re aedificatoria* was written, and 1925, when the novel was published, as it embodies an eternal hope for closure and clarity that is borne outside

Settentrione: Questi quadretti sono ciascuno uno stadio ilquale stadio è 375 braccia:∞

ba
375

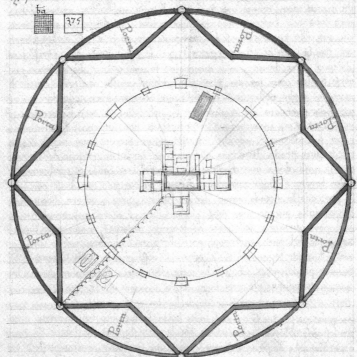

I nella testa doriente Io fo lachiesa maggiore & inquella doccidente fo
ilpalazzo reale lequali grandezze alpresente non tocho pche quando la
faremo allora intenderete tutto dalla parte della piazza inuer setten
trione Io fo lapiazza demercatanti laqual fo largha uno quarto dista
dio cioe nouanta tre braccia & tre quarti & lungha mezzo stadio & dalla
parte meridiana della piazza fo unaltra piazza oue sora come dire uno
mercato & iui suendera cose damangiare & come e labeccheria & frutte &
herbe & altre simili cose plobisogno della uita delhuomo & questa sora lar
gha unterzo distadio & lungha due terzi cioe braccia dugento cinquanta a
presso diquesta intesta glifo ilpalazzo delcapitano dacanto appresso lacor
te/ che solo lastrada lasparte & inquella demercatanti dauna testa fo ilpa
lazzo delpodesta & dallaltra parte opposita quello doue siuiene laragione de
comune. Dalla parte settentrionale fo laprigione comune laquale uiene desse
drieto alpalazzo della ragione Dalla parte orientale dacanto della pia
zza fo lerario cioe doue sisa & conserua lamoneta & appresso ladoghana.
nella piazza delmercato sora come o detto ilpalazzo delcapitano & dauna

Antonio di Pietro Averlino. Plan of Sforzinda, from the *Libro architettonico*,
Codice Magliabechiano: II-I 140—Folio 43r, ca. 1465. CBNF/Scala Archives.

the possibilities of realization. As virtual buildings, architectural drawings and models have this one great quality—because they can be controlled completely and securely by the will of the architect, like the form of a novel can be controlled by its author, they permit a necessary fiction of precise accomplishment.[15] In them that steady green light burns clear.

The kind of architectural virtue that can be communicated persuasively through drawing is, or tends to be, concerned with placement. Drawings make it possible to experience in advance and at a distance the visual effect of a built composition—of what I will call a built work. Other kinds of work in which architects might be involved—political negotiation, lobbying, organization of workforces, knowledge of mechanics such that great weights can be lifted—can certainly be described visually but not, perhaps, to such great effect. By nature such work is process-based, mortgaged to the specific circumstances of context and site, and transient. Machination, which facilitates but does not finally condition that "correct disposition of the parts such that nothing could be added or taken away," remains invisible to systems of representation developed to record that disposition.

In these terms, the development of the architectural treatises that emerged in Europe, first in Italy and then rapidly in other geographic locations between the middle of the fifteenth and the end of the sixteenth centuries, contains two inverse tendencies. On one side, architect-authors steadily lift the architectural project away from the actuality of building process. On the other, the proportion of text to image slowly but surely moves in the image's favor. Both tendencies can be seen in the first treatises recognized as such after *De re aedificatoria*. Alberti had made his first paean to an artist/architect by celebrating Brunelleschi's actions relating to the dome of Santa Maria del Fiore in Florence, work that was as much about translation as it was about delineation. *De re aedificatoria* subsequently projected an equivalence for these two activities: architects gain fame through the delineation that defines *lineamenta* and through translation that moves *structura* into the places that *lineamenta* ascribes. But for Antonio di Pietro Averlino, composing a *Libro architettonico* in the 1460s, architecture resided firmly in the description of built compositions, never in the discussion of building operations.[16] He paints for his patron Francesco Sforza, "the duke," evocative pictures in words of the unrealized city of Sforzinda; he draws the streets, squares, and palaces of that neverland

in hard line. The images are relatively few but their subject is clear: the architectural work described is one of delineation. This singular focus is qualified in the *Trattato di architettura* composed in two versions between 1479 and 1492 by Francesco di Giorgio Martini.[17] Francesco di Giorgio wrote as an established practicing architect (and used that title), and his reputation was securely anchored in questions of building. In the *Trattato di architettura* the governance of process is still key to the virtue articulated by the author. But here instead the shift toward drawing is revolutionary. The manuscript presents a flood of machines in image—cranes for lifting and carrying, catapults, water wheels, winches—jostling with and surrounding the text, competing with equally beautiful portrayals of forts, palaces, and city walls.

Francesco di Giorgio was educated enough to read (and indeed to translate) Vitruvius, and in his treatise the Vitruvian parts of architecture are very much alive: *aedificatio* is plaited tight together with the filaments of *gnomonice* and *machinatio*. Yet in treatises composed after 1500, as knowledge of Vitruvius became more certain, the Vitruvian triad that defined architecture's scope was treated unequally. The *Libri di architettura* of Sebastiano Serlio, published from 1530 onward, are a case in point.[18] Serlio's printed books are as full to the brim with drawings as were Francesco di Giorgio's manuscripts. But the subject of these drawings has a different emphasis. The multiple means of projection on which Serlio dwells—*ichnografia, profilo, ortografia, sciografia,* and *scenografia*—all concern, in one way or another, the representation of the permanent architectural work. His plates present in greater and greater detail the result, the full stop, the final effect of defined superficies. They say little about how these edifices move from idea to building; from paper to stone. This bias is reflected in turn in interpretations of Serlio. Authoritative commentaries on the *Libri di architettura* concern themselves almost exclusively with nuances of Serlio's intention around the projection of built works as artefacts, modern and ancient.[19]

If the sixteenth century inherited an art of building that acknowledged the fundamental importance of both the static and the moving, by midcentury the sovereignty of the former, carried in the fragile medium of paper prints, was entirely established. The treatises published by author-architects such as Jacopo Barozzi da Vignola or Andrea Palladio reflect this. Vignola's *Regola delli cinque ordini d'architettura* was printed in Rome in 1562; Palladio's *I quattro*

Francesco di Giorgio Martini. Diagram of machines from the *Trattato di architettura*, 1467.
Musei Reali Torino.

O dimoſtrato qui adietro la pianta del Tempio rotondo, hora qui auāti ſi uede la parte di ſuo
ri,& anchora quella di dentro, per eſſer coſi rotto eſpreſſamente. La parte di dentro è Corin-
thia, ma tutta l'altezza fin dal pauimento, infino ſotto a la uolta, dimandata da qualch'uno Cu
pola, & da certi altri Catino ſarà piedi.lx. La parte meza di queſt'altezza ſarà per eſſa uolta, &
l'altra diuiſa in.v.parti e meza, & una d'eſſe ſarà per la cornice, fregio, & architraue. Poi le.iiii.
parti & meza reſtanti, ſaranno per l'altezza de le colonne, con li ſuoi capitelli & baſe. La miſura
del tutto ſi troua nel detto Quarto mio libro, a l'ordine Corinthio. Li nicchi fra le colonne ſaranno in latitu-
dine piedi.iiii.& in altitudine.x.gli altri che ſono a l'entrar de la porta,& anche a le tre capelle, ſarāno piedi.vi.
e mezo larghi,& in altezza piedi.xv.L'apertura per dar luce al Tempio, ſarà la.vii.parte del diametro di eſſo Té
pio,& ſe farà ne la ſummità de la uolta, ſopra laquale ſia fatto una lāterna uedriata, & queſta luce baſtarà per
il corpo del Tempio, percioche le capelle hanno la ſua luce appartata, come ſi uede ne la pianta, e nel dritto,
coſi dentro come di fuori. La copertura di eſſo Tempio ſi farà di quella materia che tornara piu commoda
nel paeſe, ma di piombo ſara ſempre migliore, facendo gli gradi di quella pietra che nel loco ſara piu in uſo. La
cornice de fuori ſara come quella di dentro, ma piu formoſa de' mēbri, acciò piu longamente ſi cōſerui da
le acque & da li uenti. Et anchora che la capella a l'incontro de la porta poſſi ſeruire per altar maggiore, non
dimeno ſi potra nel mezo del Tempio leuarne un'altro, ilquale ſara ueduto da tutti, come ſi uede ne la pianta.
E perche queſto Tempio non ha Campanile, Sacriſtia, ne anche loggiamenti per miniſtri, ſi potra bene con
buono accompagnamento fare un Campanile, ſotto delquale ſara la Sacriſtia, & intorno le habitationi de' Sa
cerdoti quali ſaranno talmente propinqui al Tempio, che per una uia coperta, uadino da l'uno a l'altro. De la
porta & altri ornamenti, ſi trouaranno ſempre le forme & le miſure. Le miſure delle colonne & de capitelli hā-
no da farſi ſecōdo le miſure che ſono aſſegnate alle colonne poſte nel principio del Quarto libro. Perche eſſen
do la colonna Dorica o Ionica o Corinthia o Compoſita ſarà neceſſario ricorrere al ditto Quarto libro, &
conſeruar ne le compoſitioni l'ordine de le dette miſure.

Sebastiano Serlio. Plan and section of a round temple, woodcut from *I libri di architettura*,
Libro V, *Degli tempii* (Paris, 1547). National Library of Sweden.

E la paſſata charta ho dimoſtrato un Tempio rotondo, aſſai copioſo di capelle, ma qui dauan-
ti ne formarò un'altro, pur anchora tondo, ma con quattro capelle fuori d'eſſa rotondità, cioè
tre capelle, & l'entrata ſua che fa il medeſimo effetto. Fra queſte.iiii. capelle ui ſono.iiii. nicchi,
quali ſeruiranno per capelle chi uorrà, ſi che ſaranno.vii.altari. Il diametro di queſto Tempio è
piedi.xlviii.& altrettanto la ſua altezza. La groſſezza del muro ſarà la.vii.parte del diametro.
La latitudine de le capelle, piedi.xii. per ogni lato, oltra gli nicchi, ne iquali ſono li altari. le.iiii.ca
pelle piccole, ſaranno in latitudine piedi.ix. le capelle quadrate haueranno la luce loro da li lati, ma quanto a
quella del Tempio, ſi farà ne la ſummità de la teſtudine un'apertura, lo diametro de laquale ſi farà de la.v. par
te di quello del Tempio, facendoli dipoi ſopra una lanterna, & come ho detto de glialtri. Sempre ſarò di pare-
re ch'ogni edificio ſia leuato da terra, cioè il ſuo pauimento, fina qualche gradi, che quanto ſarà piu leuato,
tanto ſarà meglio, ma biſogna che li gradi ſiano diſpari, accioche gli ſupplicanti cominciando a ſalire col pie
de deſtro, eſſi anchora col piede deſtro ſi ritrouino al piano del tempio. Queſto uuole Vitruuio nel ſuo Terzo
libro, doue parla di Tempii ſacri. Hora ſe'l paeſe ſarà priuo d'acque & humiditati, ſotto queſto Tépio ſi potrà
fare alcuni oratorii, ma che ſia eſpreſſamente ſotto gran pena prohibito al ſeſſo muliebre a non entrarui den-
tro, perche io ſò quel che mi dico, ma ſiano queſti luoghi riſeruati a' ſacerdoti, o perſone di nore, gia attempa-
te. E perche gli angoli inuitano ſempre a molte immondicie; io lodo ſe riquadri queſto Tempio da un muro di
tanta altezza quanto ſaranno li gradi, accioche facilmente non ui ſi poſſi entrare, & queſti luoghi ſeruiranno
per cimiterio.

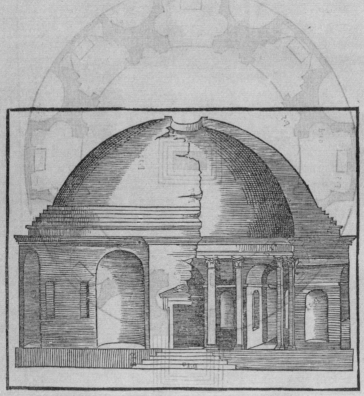

libri dell'architettura in Venice in 1570.[20] In these works graphic representation comprised a complete and developed system, giving rules for the projection of columns or descriptions of complete building compositions. The treatises facilitate a discussion about architecture in which "placement" rules supreme. The description of material architectural process—of "placing"—is almost entirely relegated to a space beyond the pages of the text.

There is a paradox here, one worthy of attention. During the sixteenth century, the architectural discipline created a virtual world in which, with more and more sophistication, buildings could exist without being materially constructed. Given the endless fluidity that emerges in the virtual—drawings can reflect infinite changes in intention in a way that buildings cannot—this world might have been preoccupied by the possibility of change, of the fluidity of intention in which a thousand possibilities can be contemplated in a minute. Instead, in terms of its rhetoric, architecture became more and more concerned with decorum, with the absolute stasis that limits compositions of brick and stone.[21] Peculiarly, the more architecture could exist on paper, the more it considered itself beholden to ideas of the hierarchical value of the absolutely permanent, as if decisions could never be reversed. Although Alberti valued architectural agency in terms that saluted both skill in placement and skill in placing, and although Vitruvius identified both control of static composition and control of fluid process as central to the architect's work, within the system of credit and reward that developed through architecture's encounter with the print during the sixteenth century, process gave way to artifact and permanence trumped transience.

All this has strange implications for the relation of sixteenth-century architectural theory to its antique precursor. Daniele Barbaro's great midcentury interpretation of Vitruvius produced two editions of the *De architectura decem libri*, an Italian translation and commentary first published in 1556 and a Latin edition, together with a reprint of the Italian translation, in 1567.[22] All three editions were illustrated with analytical drawings made by Palladio—Barbaro was one the architect's patrons—and engraved by Johann Chrieger. Palladio's images and Barbaro's commentary changed the shape of Vitruvius. In the unillustrated manuscripts on which Barbaro based his analysis, the various books in *De architectura* were fairly even in length (books III and IV on proportion and temples were slightly shorter, and book X on mechanics

Part II: Dispatches 1450–1590

Daniele Barbaro and Andrea Palladio. Drawings and description of the construction of the Corinthian column, from *I dieci libri dell'architettura di M. Vitruvio*, Book III (Venice, 1556). National Library of Sweden.

Le canalature delle colonne deono effer
uentiquattro, & fi cauano in quefto modo,
che pofta la fquadra nel cauo della canalatu
ra, & girata tocchi in modo con le fue brac
cia dalla deftra, & dalla finiftra gli anguli
delle ftrie, che la punta, ouero angulo del
la fquadra fi moua facilmente, & fenza im-
pedimento col fuo giro toccando. Le grof
fezze delle ftrie, o pianuzzi, fi deono fare,
quanto fi trouerà la giunta nel mezo della
colonna dalla defcrittione fua. Nelle gole
dritte, che fono fopra i gocciolatoi de i
Tempij fi deue fcolpire le tefte di leoni, co

fi pofte, che contra ciafcuna colonna fiano forate al canale, che dalle tegole riceue l'ac-
qua piouana, ma le parti di mezo fiano fode, accioche la forza dell'acqua, che per le tego

le difcende nel canale, non uenga
tra gli intercolunnij, & non ba-
gni quelli, che paffano di fot-
to. ma quelle, che fono fopra le
colonne apparino uomitando
mandar fuori gli efiti delle
acque.

La canalatura della colonna è fat
ta ad imitatione delle falde delle ue-
fti feminili. In quefta fi deue inten-
dere la fignificatione d'alcuni uoca-
boli, & poi il modo di formarli giu-
ftamente. il primo è quello, che
Vitr.chiama Strix: il fecondo quel-
lo, che è detto ftria: il terzo, Anco-
nes. Strix adunque è il cauo, & il
canale ifteffo. ftria è lo fpacio, che è
tra un cauo, & l'altro, detto pia-
nuzzo. Ancones fono le braccia
della fquadra, la quale è fatta da
due regule, che da Vitr.fono dette

ancones, perche fanno come un gomito, che in greco anchon fi chiama. Siano adunque
i canali

was considerably longer than the others). In Barbaro and Palladio's edition this evenness was lost. The books in the second half of the *De architectura* dealing with finishing and machination, and those in the first half that discussed building process, shrank in terms of their dimension in relation to the whole—either to half or to two-thirds their former size. All those in the first half, dealing with *aedificatio*, decorum, and stasis, were enlarged. A treatise that had been balanced in terms of its textual content between a discussion of propriety and fixity on the one hand, and of variation and fluidity on the other, took on a new form.[23] With Palladio's beautiful illustrations the discussion of the static, of prescription, occupied the majority of the plates (with a notable exception concerning the description of the planetary motion). With Barbaro's analytical commentary, decorum became a central focus of the text. Discussions about building process, finishing, mechanics, and the handling of water occupied far less space. One aspect only of the temporal received increased attention. Augmented with a wealth of diagrams, Vitruvius's book VIII on *gnomonice* nearly doubled in size in Barbaro's edition; but then the division of time and space according to the movement of the heavens were two late sixteenth-century (and Counter-Reformation) obsessions.[24]

The sixteenth-century focus on the delineation of the *lineamenta* of classical architecture reflects this shift in interpretation. Vitruvius, like Alberti, spells out how machination can be seen as a central part of the architect's activity, and how the ability to organize materials and processes—to move weights, to organize men—can be as crucial as any other facility in gaining an architect praise or vilification. But, read through a new screen of graphic projection, other aspects of Vitruvius's account resonated more fully with the system that valorized the activities of architects. This resonance emphasized the central and staple virtue of the ability to project decorous and proper composition—in the mind, in models, or on paper.

This shift that moved Vitruvius in translation, and that characterized a broader trajectory in architectural writing after Alberti, reached a kind of zenith in Palladio's treatise on architecture. *I quattro libri dell'architettura* presents a stark contrast to the fullness and nuanced scope of Vitruvius or Alberti. The treatise contains eleven pages of introduction that do much of the same job

as Vitruvius's or Alberti's first books, introducing the subject, its divisions, and discussing education. These are followed by 100 pages that combine image and text and 99 full-page plates with drawings of completed or ruined buildings. The whole of these 199 sheets concern stasis, destination, and the definition of superficies; an army of complete constructions, fully ornamented and kitted for combat. Palladio has exactly zero pages—none at all—to deal with the issues of the temporal and the fleet, concepts that enlivened Vitruvius's ancient account, which had inspired Alberti's and which found their way in illustrated form into the manuscript treatise of Francesco di Giorgio Martini. There are no drawings of machines; none of levers; none of pumps or hydraulics or planetary orientation; none of cranes or wagons or shipping. Through the combination of textual description and ever more lucid architectural drawings, architectural works in *I quattro libri dell'architettura* consist of projected buildings that are drained of almost all their material quality. The "stuffiness" of materials is dealt with in minimal chapters of four paragraphs each (twelve for metals). Almost nothing is said about the issue of moving these things about, although a few paragraphs are devoted to the structural make-up of foundations and walls.[25] Equipped with the treatise, we could accurately say where everything should go in order to fix the world, but we would have no idea of how to get it there.

This is not to say that architects such as Palladio neglected or were unskilled in such other arts. Indeed, Palladio was clearly established as an authority over all aspects of building process; his constructed projects, serene as they seem as completed compositions, frequently involved extremely challenging technical situations on site. Building a Venetian church is as much a project in transport logistics, static calculation involving uncertain, underwater foundations, and judgments about the vagaries of climatic change as it is about experimental composition or the superimposition of multiple typologies into a single facade. Palladio used levers and ships and pumps. Yet such processes are not at the center of Palladio's books of architecture. What must be communicated there, fundamentally, are the projected surfaces of compositions read as built or projected works. A further 450 years of history shows that it is through precisely those projected works that architecture as a discipline has chosen to value Palladio and claim him as one of history's greatest architects.

d z. parallelo grammo.

il mouimento del $\begin{cases} \text{Concentrico. } b \ d \ a. \\ \text{Epiciclo. } K \ b \ z. \\ \text{Eccentrico. } z \ t \ e. \end{cases}$ angoli eguali.

Il fole fi uede all'uno, & all'altro modo nel punto z. per
la linea d z.

reno in una. Ma nelle lunghezze mezane proportionalmen-
te è grandiffimo, & ne i punti dal giogo egualmente diftanti
fono gli agguagliamenti eguali, & tanto maggiori, quanto
fono piu uicini alla lunghezza piu lunga. il mezano moui-
mento adunque dal principio dello Ariete, fecondo l'ordine
de i fegni, fe ne ua fin alla linea del mezano mouimento, fi
come il uero mouimento è fin alla linea del uero mouimen-
to: d'indi cominciando fi conduce: la doue lo argomento del Sole, o quello arco del zo-
diaco, che è intercetto dalla linea del giogo dello eccentrico fecondo l'ordine de i fegni, & la li-
nea del mezano mouimento; & è cofi chiamato, perche da quello fi argomenta l'angolo dello ag
guagliamento, il che quando è nel femicircolo inferiore, la linea del mezano mouimento, ua
inanzi la linea del uero: ma quando paffa il femicircolo, allhora precede la linea del mezano mo
uimento. & però di fopra fi fottragge, & qui fi aggiugne al mezano mouimento, accioche fi
poffa cauare il uero mouimento. ma per hora lafcierò, che il lettore ricorra al Maurolico, che
pur troppo mi pare hauere l'altrui opra operato, bifogna bene auuertire di porre in qualche prin
cipio la radice del mezano mouimento, fopra la quale egli fi poffa in quello inftante, che uole-

a b g. lo eccentrico d. il fuo centro.
e. il centro del mondo.
a d g. la linea del giogo.
b. il centro del fole.
e z. la linea del mezano mouimento parallela dlla li-
nea b d.
e b. la linea del uero mouimento.
b e z. angolo è l'equatione.

mo calcolare il mezano mouimento del fole. Da quefta
radice fi ua offeruando il uero mouimento, fecondo la fcien
za de i triangoli piani. Imperoche da tre linee, che lega
no tre centri cioè quello del mondo, quello del deferente,
& quello del fole tre angoli fi uedeno nel triangolo da effer

a b g. il concentrico d. il fuo centro.
t z. lo eccentrico h. il fuo centro.
e z. lo epiciclo g. il fuo centro.
d b. & g z. eguali.
d z. parallelogrammo.

il mouimento. $\begin{cases} \text{del concentrico } a \ d \ g. \\ \text{del epiciclo. } e \ g \ z. \\ \text{dello eccentrico } t \ b \ z. \ \text{ouero } t \ d \ g. \\ \text{del giogo dello eccentrico } a \ d \ z. \end{cases}$

Gli angoli t b z. & e g z. fono eguali.
L'angolo a d g. eguale a gli angoli. $\begin{cases} a \ d \ t. \\ t \ d \ g. \end{cases}$

formato, l'uno è l'angolo dello agguagliamento, gli altri due fono quelli, che formano le due li-
nee,

Daniele Barbaro and Andrea Palladio. Drawings of planetary epicycles and of lifting
machines, from *I dieci libri dell'architettura di M. Vitruvio*, Books IX and X.
National Library of Sweden.

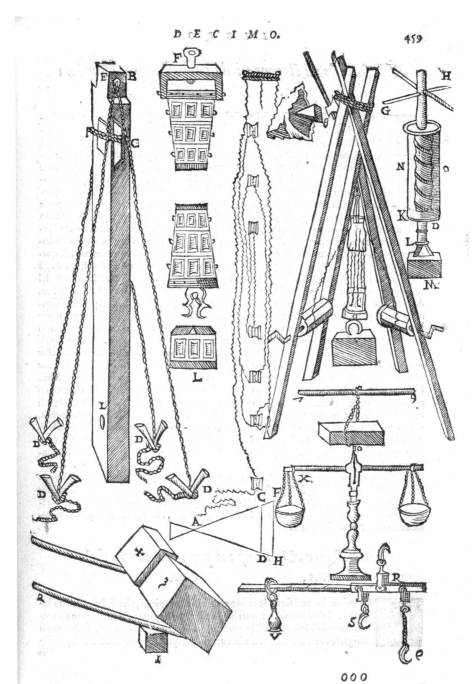

A FANZOLO

Andrea Palladio. Plans and elevations of Villa Mocenico/Marrocco and Villa Trevigiano, from *I quattro libri dell'architettura*, Book II, 1570. National Library of Sweden.

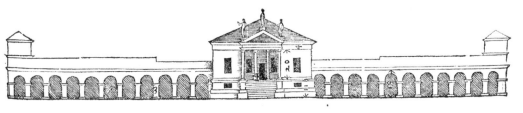

DE I

A particular idea about the architectural work is built into the systems of architectural representation that developed in the second half of the sixteenth century, then, an idea that was in some senses exclusive. In terms of valuing architectural agency, skill in placement, which can be described through graphical projection, is valued over that skill in mechanics and the control of physical labor that places material. One text upends that development. *Della trasportatione dell'obelisco vaticano*, written by Domenico Fontana and published in Rome in 1590, combines a reevaluation of architectural agency with a lucid description of the experiential impact of construction process.[26] The text is written in part to advertise Fontana's prowess as an architect and appears to conform to the conventions, implicit in the texts of Serlio, Palladio, and Vignola, that such publication required: Fontana stands as the author; the book combines text, costly production, and fabulous illustrations; and it describes phenomena that, since the framing of architecture as an artistic and intellectual discipline at the start of the modern era, must be considered as architectural works.[27]

At first glance the book's frontispiece emphasizes its alignment with this tradition.[28] Here Fontana is represented, like Vignola, beard bristling in three-quarter view. He stands at a table bearing the tools essential to his calling, clutching an architectural body, that of an obelisk, to his breast. The suggestion is one of ownership between a built work presented via a projective drawing and the architect pictured: the obelisk stands on Fontana's table among his other possessions. But on closer examination we find disturbances in this reading. There is something strange both about the placing of the obelisk on Fontana's table (overbalancing on the rear edge) and about the positioning of Fontana's hands. The right appears to have got caught up in the chain and medallion hanging around his neck—why, we wonder, must Fontana run chains through his fingers in order to hold the obelisk? And the fingers of the left hand appear to be in motion, as if holding the obelisk required constant effort; as if it were a snake, or a fish, hard to grasp, apt to escape. What, kind of work, then, is Fontana describing to articulate his virtue?

Della trasportatione dell'obelisco vaticano defines architectural work in terms of processes as much as objects. The subtext of the

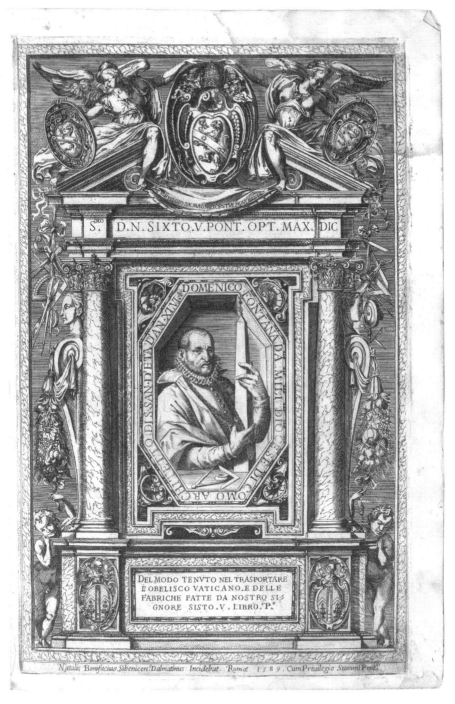

Frontispiece. Domenico Fontana, *Della trasportatione dell'obelisco vaticano* (Rome, 1590).
National Library of Sweden.

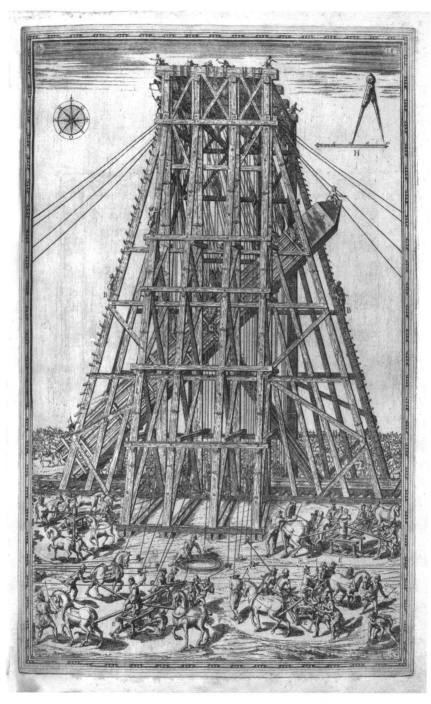

Domenico Fontana, *Della trasportatione dell'obelisco vaticano*, plate 18.
National Library of Sweden.

frontispiece, like the text of the title, is very explicit about this. The medal Fontana holds out is the material token of a decision made by Sixtus V, and through Sixtus by the Roman people, precisely to honor Fontana's architectural judgment.[29] This reward was given not for any normal definition on Fontana's part of "lines and angles" in a projected artifact, or for a conventional demonstration of his predictive knowledge of the correct place for all the parts in a composition such that "nothing could be added or taken away but for the worse." Indeed, it was not given for defining the lineaments of any object at all. Rather, it was awarded for his prowess is designing and organizing a process. Of the several projects in Fontana's treatise, the most spectacular, which gives its name to the book and which informs the frontispiece, concerns moving an Egyptian obelisk, which since antiquity had stood on the Vatican hill on the flank of what became St. Peter's Basilica in Rome. In 1585 Fontana obtained the commission to translate the obelisk to a new location axially before the facade of the church, then in the process of reconstruction, in what is now known as Piazza San Pietro. The work took a year and a day, from September 25, 1585, to September 26, 1586. It consisted of moving a single piece of stone, weighing around 400 tonnes, a distance of 250 meters.[30]

Fontana's goal was to translate the obelisk without material change or damage; he added very little to its physiognomy—a couple of tiny feet and a pedestal, in fact. The crafty and aging Michelangelo, who refused the commission, provided a succinct summary of the risks-to-rewards ratio the project offered an aspiring sixteenth-century architectural ego. "What if it breaks?" he asked. What indeed? Fontana invented the extraordinary process entailed by moving the obelisk "so it wouldn't break." He created therefore not a projected artifact but an event—a staging. This presented problems. Technically, moving the obelisk in 1590 was obviously a very difficult task. The strongest motive power units at the time were horses or oxen, capable of exerting a continuous force of around 450 pounds (200 kg) in an unsteady horizontal direction; the strongest cable able to transmit this force could take something over 20,000 pounds of tension (8 tonnes, 40 times what the horse could move). The obelisk was a single piece of stone, 114½ palms high by Fontana's calculation (around 25 meters), weighing 963,537 $^{35}/_{88}$ pounds (Fontana calculates the weight to this precision), about 8,000 times as much as a horse could lift through direct traction. But it was also already a challenge to dignify such

an action in theoretical terms, even if successfully completed, as architecture.[31] As his compatriots from Serlio to Vignola to Palladio had shown, architectural works consisted of new compositions whose outlines could be recreated virtually through a new method of drawing, by marking black outlines that recorded lineaments directly onto the flat space of the printed page. But in Fontana's case there was nothing "new" to draw. Delineating the obelisk would only reveal a monument that already existed. In this case the result of architectural skill could not really be communicated using the habitual means of representation available. It is perhaps this condition that resonates with the hand gestures in Fontana's richly detailed frontispiece. And it is this condition that adds richness to Fontana's architectural treatise. For Fontana did succeed in vindicating this other kind of work: this happening experienced by a crowd of thousands; this lifting, rotating, and dragging of a gargantuan object; this organizing, bullying, and negotiating the context that allowed such motion was communicated, evocatively and with much success, in the form of a book. Much of the intriguing quality of the treatise emerges from its ambition to celebrate the idea of an exemplary architectural work as consisting of things that move, via the conventions evolved to describe architectural compositions that stayed still.

Fontana accomplished this task through carefully composed plates and an accompanying text.[32] The plates follow almost completely conventions of architectural draftsmanship developed to represent architectural works as artifacts: plan, section, and elevation; perspective; and a filtering of contextual information to communicate content. All these were theorized early in the fifteenth century, in Raphael's famous letter to Leo X and in the drawings of Serlio, Peruzzi and Antonio da Sangallo.[33] And all are used through Vignola and Palladio to underline the centrality of defining lineaments to the architect's task. Yet Fontana's depictions clearly articulate not the final, static, monumental capacity of the obelisk itself, but the moment before this capacity is realized: the drama of placing—or displacing—what, for the extended duration of the moment in the book, must be considered a temporary, movable, and ephemeral object. The drawings deserve to be studied as a series, but the ways in which Fontana adjusts convention in order to achieve his aims, and much of the alternative idea of the architectural work implicit in the treatise, can be exemplified by looking carefully at one image.

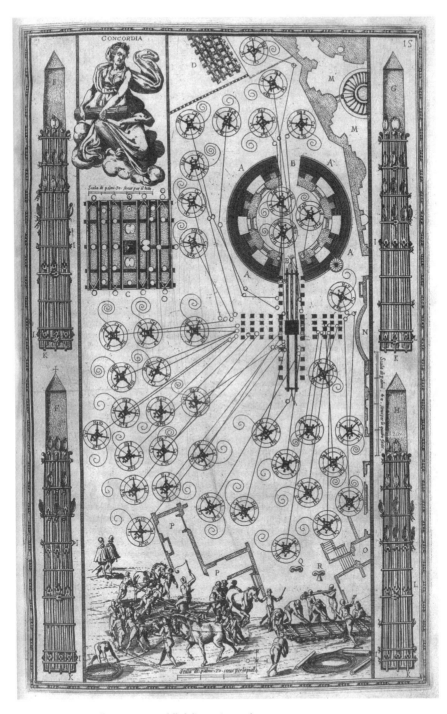

Domenico Fontana, *Della trasportatione dell'obelisco vaticano*, plate 15.
National Library of Sweden.

Plate 15 in Fontana's series is based on a plan representation of the urban space that surrounded the obelisk in the position it occupied south of the cathedral before his work. This consisted of a rough piazza containing the needle and a circular fourth-century sacristy (shown central and free standing on the plan), edged by the construction of the church to the north (on the right) and by dwellings to the south and east (whose walls show as fragments in conventionally hatched plan).[34] Within this space, Fontana created a series of patterns. At the center is a cross of small squares marking the assembly of temporary piles that made up an enormous scaffold, which Fontana called the *castello*. This was a temporary structure built around the obelisk in which Fontana would first pivot and then lower it. Filling the remaining space of the paper and the experiential urban space contained by the permanent structures already mentioned, he marked a further set of revolutions. Forty crosses—each circumscribed by two concentric rings, each with a kind of piglet's tail and mouse's nose—are connected by lines to small circles that cluster in their turn in and around the squares marking the central cross.

Transient Artifact and Permanent Process

In this drawing Fontana makes visible what is usually excluded from architectural representation—the temporary supports, tools, workers, and scaffolding that allow material construction to come into being. Indeed, Fontana's whole work revolves around such objects, challenging that hierarchy that usually privileges the representation of the built over that of building. But because such a hierarchical order was already inscribed into the systems of representation Fontana was using, he has to twist the rules of those systems to make his description. A reading of Fontana's picture starts naturally outside the plan with the scene at the base, which provides both a foreground introduction and implicitly a foundation for the meaning of everything else. This scene represents only things that move and whose manifestation is temporary—horses and stevedores with whips in hand circumambulate an inanimate windlass. As you move from the perspective scene into the plan drawing it is clear that each of the circles in the swarm filling the plan's space represents such an assembly. In this translation from perspective to plan, however, the most "temporary" objects are

lost to the conventions of representation (the people and animals disappear) and what remain marked on the paper are the outlines of the slightly more permanent and inanimate objects on which they exert force—windlasses, ropes, and the rotational track of the moving figures. So the first stepping point highlighted in this combinatory drawing is that between animated objects (that move freely and diurnally) and inanimate ones—winches and ropes.

The next step in the drawing is one between varying orders of permanency in temporary objects concerning whether their job is to move (rotationally or linearly) or to guide movement (to resist force and orientate translation). The articulation of this spatio-temporal step between classes of transience and permanence is also built into the representational convention of the picture. The slippery nature of the windlasses is indicated by their contrasting degrees of rotation in plan relative to the axis of the picture; the nature of the *castello* orientates its cross orthogonally on the paper. The *castello*, which anchors the picture, might be seen as a kind of pin connecting the worlds of building (as an action) and buildings (as artifacts)—or perhaps one could say as one side of a central link in the chain of connection the drawing suggests, between the class of the temporary and the class of the permanent. Like the windlasses, the *castello* is a temporary manifestation—it existed during one year in two different locations, and its internal material connections were designed such that all the elements in its assembly could be reused and disappear into other constructions. But its classification as temporary becomes highly complex, for what is most important about the *castello*, in fact, is its absolute permanency in relation to the enduring moment in which the obelisk must be lowered from vertical to horizontal. The *castello* must not move: movement here would spell disaster. Thus the *castello* derives an aura of permanence through its task of resisting and modulating forces that are absolute and permanent. And so the whole of Fontana's drawing, as this section of the whole event, becomes orientated around the orthogonal propriety of this object. The *castello* can be seen as the stationary element around which all the other urban structures revolve, and in its representation only fixed items concerned in the movement of the obelisk are shown. There is therefore a very subtle change of drawing convention between the windlasses and the *castello*; in drawing the latter, the lines representing the mobile rope disappear and only the beams that will support the obelisk

Details from Domenico Fontana, *Della trasportatione dell'obelisco vaticano*, plate 15.
National Library of Sweden.

and the pulleys that will channel the motive forces are the cables are shown.[35]

The permanence and fixed nature of the *castello* are spelled out clearly in the detailed plan superimposed, at larger scale, midway up the picture. The main part of this plan shows the blocks (doubled pulleys are shown with a doubled ellipse) and beams that were to channel forces in a reflected ceiling plan view (i.e., a view imagined looking up from the underside). But this plan too includes a representational flip. At the center, the obelisk is seen from directly above as opposed to beneath, the lines of its pyramidal top crossing at the center. As the image moves from describing a temporary-but-permanent object (the *castello*) to a permanent-but-transient one (the obelisk), the view it provides is inverted. This logic also embraces the peripheral images of the obelisk in profile that surround the plan. The four elevational drawings that frame Fontana's drawing never show the obelisk directly. Each view is protected by a sheathing layer, lying between the obelisk and the *castello*, between the obelisk and the viewer's eye, and between the obelisk and harm. Following elevation convention, the representation here is nearly lifelike again, showing the blocks and tackles that will move the object; the detail of iron connecting rods and bindings; shadow relief on the bundled timbers. Together this assembly of straps and pulleys and timbers creates the device that allows a translation between two contrasting notions of the absolute: the one temporary and permanent (an obelisk that will last until the end of the world but that will soon move); the other the constructional and platonic (a network of forces that act on this object and condition its placing, manifest in the *castello* that will last a year but in which movement is untenable).

From the clothed obelisk it is possible to descend into the plan drawing of the picture again to follow a further set of steps. Where the drawing up to now has communicated the absolute, and in platonic terms "permanent," nature of the seemingly transient (windlasses, *castello*), it now relates the temporariness of apparently permanent structures. *Lineamenta*, those lines and angles that define the superficies of buildings as artifacts and which can so easily be represented by drawing, may be absolute in space. But Fontana's twisting of convention makes clear that they are provisional in time. A transience conditions architecture-as-artifact that effects every single permanent structure represented in Fontana's picture. Directly above the *castello* at the center of the plan,

and heavily hatched, stand the walls of the circular fourth-century sacristy, gashed top and bottom by the invisible and partial path of the obelisk as it is lowered to horizontal. Away to the bottom left of the plan, walls and towers of houses occupy space at the bottom of the paper, but others have been demolished, Fontana explains in the legend, to make space for the operation. At the head of the picture (the composition is closed by a timber paling) fencing must be removed to allow access to the "sledge" that will later transport the obelisk to its destination. Finally, to the right of the drawing stands the church around which all this activity will take place, shown as two separate and disconnected things. In the upper section of the plan is the new construction around the dome of St. Peter's not yet built; in the lower section, the wall of the Constantinian basilica, in the process of demolition. Any hierarchical order assumed between the significance of determining placement in permanent structures and organizing the placing of their "transient" construction is challenged in this drawing. The permanent condition it alludes to concerns not only the absolute nature of the context of forces that produces change in buildings—that move materials and re-place objects—but the also the constant translation, removal, and transience of what we usually think of as solid built works that these forces act upon.

Architectural Work

Fontana's treatise is not a projective set of instructions about how to move the obelisk. It is, rather, a reflective account a posteriori (and four years in the making) about having moved it. In terms of its historical context, this account is significant in that it curates and makes visible an aspect of the architectural work that goes beyond the definition and recording of projected artifacts. Indeed, the significance of the architectural work articulated in the drawings only really emerges as we read Fontana's description of the logistic context of legislative, economic, and ecological agency that was necessary to support the project. Working outward from the obelisk, Fontana lists the following: the calculations in building statics made to estimate its weight; the design of the timber *castello* that should bear and rotate this mass; the sourcing and geographical transport of the timber; the papal bulls required to secure (at the right price) the commodities and assistance involved; the estimate

of the number of horses (and therefore the amount of horsepower) required as motive force; the breaking strain of hemp cable; the supply of the hemp; cable manufacture; the stabling of the horses; the removal of men; the provision of foodstuffs; the dignitaries that attended the ceremony to lower the obelisk; the events that made up that ceremony; the time of each event—and so on.[36] What makes Fontana's treatise more than an engineering manual is the boundaries that he refuses to emplace, the way in which he calmly takes his readers across ravines that would usually require a change of direction or indeed a full stop. The architectural virtue of the treatise lies exactly in this: for Fontana there is simply no distinction to be made between an account of the commissioning competition; his machinations to obtain the job; obelisk weight calculation; foundation digging; the iconography of the medals cast into the foundation; the procurement of building materials; the contents of the papal bull for requisitioning material; papal ceremonial; a list of dignitaries; a ringside account of the lifting process. A trumpet sounds; a bell rings; windlasses turn; trees are felled; horses are stationed; a scaffold creaks under strain; iron rings are sliced like butter; a cardinal takes up his position. All these aspects—prosaic, sacred, technical, historical—are treated with equal weight. The description is worthy of Bruno Latour.[37]

Fontana is aware that this pregnant moment of moving the obelisk, like a piece of military strategy hanging in the balance, is at the center of a national network of supply, transit, climate, and administration that is and must be ongoing. To record this and to give it virtue (which is what Fontana achieves in his treatise) is to do a number of interesting things. Fontana is obviously interested in architecture as an action, as the "placing of material," in Alberti's terms. There is also a strong resonance between Fontana's textual description and Vitruvius's observations in books VIII to X of *De architectura*. Indeed, the project is as much about *gnomonice* as it is, obviously, about *machinatio*. What was the obelisk, after all, but one of Vitruvius's shadow trackers? What was the leveling process to form its final resting place but an example of Vitruvian best practice set up for the orientation of cities?[38] Sixtus's reorientation of Rome toward Christian redemption used ancient pagan architectural principle to facilitate its execution. One image appears particularly pregnant in terms of this analogy with Vitruvian city founding: as portrayed by Fontana, the obelisk erected on the Piazza San Pietro appears to predate any other humanmade construction on

the site. It appears as the orientating gnomon, placed in advance of other built structures on what is still an empty plane peopled by tiny wandering figures and their mobile equipages.

In this respect Fontana may be indebted to interpretations of Vitruvius that were to inform later commentaries on the *De architectura*. This strand started early in northern texts based on Vitruvius, for example, John Shute's *First and Chief Groundes of Architecture* (London, 1563), emphasizes the engineering aspects of the architect's role, and this understanding was strong in the Vitruvian thought developed by John Dee and evident all the way through English attributions of architectural virtue to Inigo Jones and Christopher Wren.[39] But it seems important also to reiterate the extent to which this treatise appears bound to Alberti's notion that architects will be judged according to the experienced composition their agency produces. Technical and mathematical details; bureaucratic machinery; spectacle, including the identity of the audience; and religious rites—all are bound together into an idea that must still be interrogated in terms of architects, authors, and works. Fontana's drawing signals the experiential presence of the discovered permanencies that are implied by the invisible path of the obelisk or the rotations of the temporary windlasses. Like a political speech or a piece of music, this transient work created powerful responses; the agency that controlled it could certainly be judged through this effect.

In looking at architecture we are still conditioned to a great extent by representational systems that facilitate the judgment of architectural agency via the description of projected artifacts. At their most extreme, Fontana's illustrations appear to develop a system of representation that directly confronts this tradition, as radical as any drawing from Cedric Price or Superstudio. It might be suggested that the transient events Fontana's text describes hold a secondary status—that they cannot be viewed as part of the syntax that makes the built environment meaningful, or that is central in judging the designers of that environment. But although the experience Fontana conveys is partly emotive—horses strain, windlasses creak, hemp cable groans—behind this lies a choreographic scheme; fixed relationships of contract and risk; links that, although not manifest permanently in any one location, have their own kind of permanence through repetition. The phenomena amount to another urban pattern replete with its own tightly controlled formal structure.

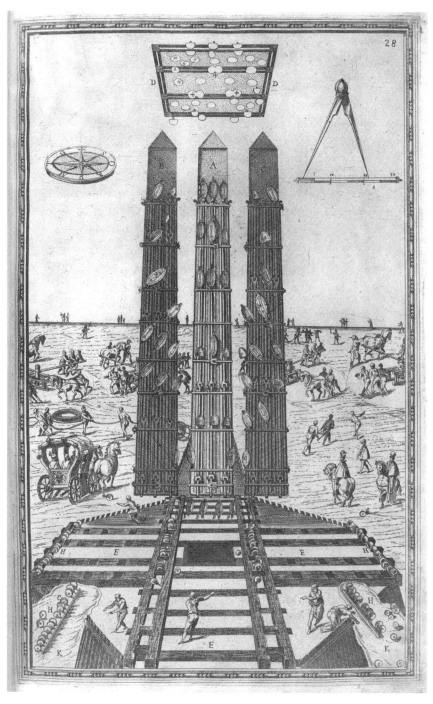

Domenico Fontana, *Della trasportatione dell'obelisco vaticano*, plate 28.
National Library of Sweden.

Fontana's distortion of Renaissance modes of architectural representation—and his celebration of the architectural significance of process—appears valuable in theorizing architectural agency today. The move to redefine the architectural work as something process-based is of particular relevance at several levels. The materials we use to build, what we have to do to them in order to make them serviceable, where they come from, and the ways in which we join them together, are all matters suddenly fraught with potential in a sustainable society. Fontana's description of the logistic background to moving the obelisk has the same panoscopic fascination that emerges in life-cycle cost analysis today. In reevaluating architectural agency, our acknowledgment of the management of such webs will become increasingly central. To include, as Fontana's treatise does, this "theater of construction" within the definition of the architectural is to make visible the technological, carbon-significant processes on which habitation depends. For architectural works are defined, precisely, by their spectacular quality: to call something a work is to make it visible—to criticism and to aesthetic judgment. Once elements of process are integrated in to the notion of the architectural work the stakes are raised in regard to such processes. They become matters of central import to the self-definition of architecture as a discipline. This changes how one values a Le Corbusier or a Cedric Price, or more recently a Diébédo Francis Kéré or a Lacaton & Vassal. An implicit definition from all this would be to describe architecture as "the art of getting things moved about from one place to another, at a rather slow speed, with the intention that they will stay for a while and create value." This art would include all the parts of architecture celebrated in Alberti and Vitruvius. In it the traditional facility of architects to define the lineaments of compositions would no longer be separated from the architectural significance of material processes through which those lineaments become incorporated.

This accounting system would also challenge fundamental habits in architectural history. Intriguingly, Fontana has never been treated particularly kindly in the history of architecture. His removal of the obelisk was celebrated in Giovanni Baglione's undiscriminating *Le vite de' pittori, scultori, architetti ed intagliatori* (Naples,

Part II: Dispatches 1450–1590

1642), and he was the only architect included in Giovanni Pietro Bellori's *Vite* (Rome, 1671), on account of the same action. Yet Bellori's selection itself was rapidly criticized as outdated on stylistic grounds (Bellori supported traditionalists like Maderno against, say, Borromini).[40] In later accounts Fontana's building projects (which included the Lateran Palace and additions to the Quirinal Palace) were criticized for their monotony and lack of imagination. This image stuck, particularly among the writers who developed architectural history as a discipline during the twentieth century in relation to the discourse of architectural modernism. For Siegfried Giedion, Fontana belonged to "that artistically mediocre generation of architects between Michelangelo and the rise of the Roman Baroque. His taste was as flavorless as that of his client."

This was the canonical voice of Renaissance architectural history from the 1940s (when Giedion slammed Fontana) to the 1970s (when Ludwig Heinrich Heydenreich and Howard Saalman toasted Brunelleschi). With it, manly historians selected out individuals, endowed them with genius (or criticized its absence) and watched their travails. A figure such as Fontana, who wrote only about his trickery in moving great weights, must be dismissed for his turgid facades and his lack of rhythm. The technically brilliant Brunelleschi must needs be a visionary speaking truth to a chorus of opposition: "by actively defending and carrying out his own, personally conceived design in the face of the Duomo building commission, he was also defending, perhaps for the first time in history, the standpoint of the solely responsible architect against the anonymous authority represented by the *Operai*," as Heydenreich had it.[41] Reassess the contours of the architectural work, and we can say to these dead historians, "What nonsense!"

Architectural history now may bear little relation to architectural history fifty years ago. But we are still producing volumes on the buildings of great architects at prodigious rates. We are still training architectural students who identify their own bodies with the outlines of the new buildings that they imagine creating. Despite quiet challenges to this dominant tendency, despite acknowledgments of networked authorship or nuanced, temporal agency, many of the goals of architectural practice, and much of the subject matter of architectural history, remain entangled with assumptions about artistic intention exhibited in permanent material form. In reclaiming the centrality of process to architectural authorship, this must change.

Part III: *Vehicles 1890–1960*

The Tenants' Furniture

It is time to speak of the twentieth century. For Virginia Woolf or F. Scott Fitzgerald, writing for European and American audiences in the mid-1920s, an almost unbridgeable chasm seems to have separated that time, conditioned as it was by the aftermath of traumatic conflict, from the nineteenth century in which they were born. Nevertheless they wrote, as did Proust, in the shadow of events lost. In the 2020s, perhaps, that remoteness is starting to characterize our relations to the 1900s, removed to the other side of an invisible barrier by experiences of trauma and change. The two chapters that follow are devoted to the role memory plays in a reading of architecture that focuses on things that move. Both study changes that are in process now, as this book is being written, carried out in the shadow of distinct patterns of experience that were distilled into architectural projects during the middle years of the twentieth century. And in both cases the explanation of how one time can effect another emerges out of considering the role of vehicles, and the quality of vehicularity, in accounting for the relationship between memory and architecture, in metaphorical and in quotidian measure.

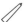

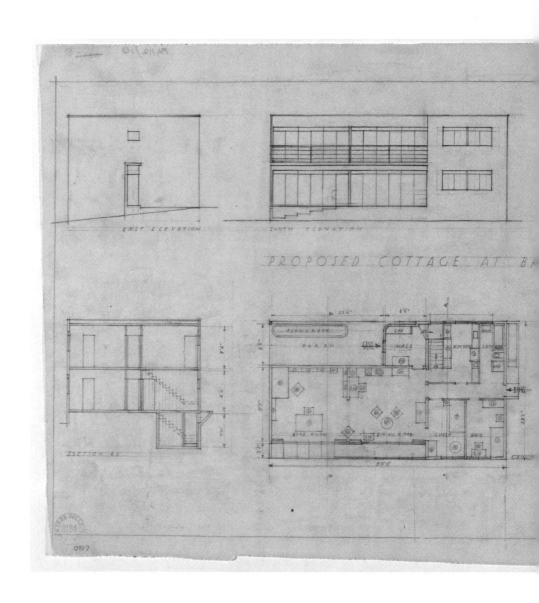

Godfrey Samuel / Tecton. "Cottage at Bromley for Dr. Saxl and Dr. Bing," 1934.
RIBA Drawings Collection.

NORTH ELEVATION

WEST ELEVATION

FOR DR SAXL AND DR BING

SECTION B.B

SCALE 1/2" TO 1'0" G. SAMUEL ARCHT.

In a typical early-stage client's letter a rather atypical client, Gertrud Bing, reacts to a design from the architect Godfrey Samuel made in London during autumn 1934.

> Dear Mr. Samuel,
>
> We are simply delighted with the new design. It is absolutely what we should like to have. Even our furniture will go into the house, and there will be space besides to store things.[1]

COLOR PLATE 14

A drawing of this "Proposed Cottage at Bromley for Dr. Saxl and Dr. Bing" shows a neat modernist house intended for the slopes of Elstree Hill.[2] Horizontal in emphasis and clearly inspired by continental models, the building has two floors with two separate entrances, one labeled "Saxl," the other labeled "Bing." Inside, some ambiguity. Partly, the main functions are doubled, as if this is actually two houses—two kitchens, two bathrooms, two dining rooms, two "book rooms"; partly they are shared, as if it is one—a single maid's room, a furnace room; partly they are absent altogether—there are bedrooms for a "guest," a "son" and a "daughter," but no mention of sleeping arrangements for the clients themselves. It is a curious double/single house, for two separate-but-not-separate people.

Dr. Bing is Gertrud Bing: forty-two years old, German by birth and the assistant director of the Warburg Institute, the research organization established in the 1920s around the activities of the German historian Aby Warburg. Dr. Saxl is Fritz Saxl: forty-four years old, Viennese by birth, the director of the same institute, and married with two children. The "our" in Bing's letter refers to the sum property of Bing and Saxl, and the letter forms part of a short correspondence for an abortive project to build a house (without Saxl's wife) for a new life together. That new life has been rerouted by frightening geopolitical events. The Warburg Institute has moved from Hamburg, its activities under threat in National Socialist Germany. Saxl, Bing, and their colleague Edgar Wind, with an extraordinary intervention from UK academia, have orchestrated the removal of the institute—furniture, bookstacks, photographic equipment, and the sixty thousand books of its library—to England under the pretext that the Warburg family would "lend the Library to London for a three-year period."[3] The

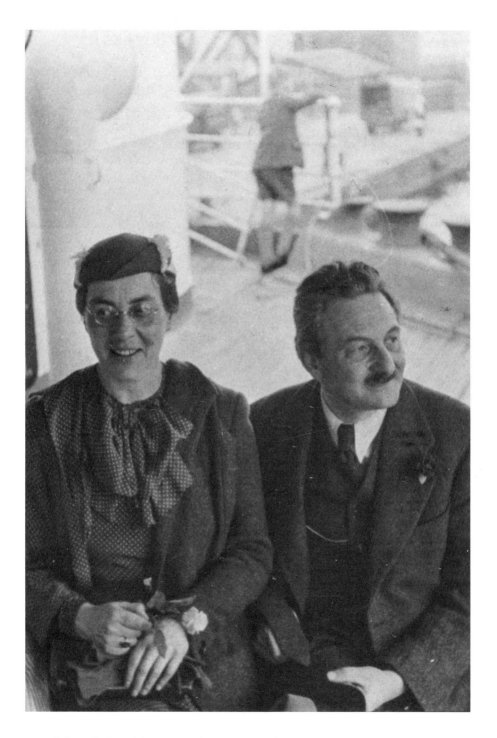

Gertrud Bing and Fritz Saxl, late 1930s. Warburg Institute Archive.

pair have been together in England a little under a year, unpacking the library and reestablishing the institute's activities.[4]

The project for a cottage at Bromley is the fourth of six architectural projects orchestrated around the Warburg Institute between 1922 and 1958. Warburg himself was central in commissioning the first two of these. In his native Hamburg a purpose-designed building, the Kulturwissenschaftliche Bibliothek Warburg, was completed in 1926 to accommodate his remarkable library. From 1927, together with Saxl, he developed an exhibition installation within a radical conversion that created a planetarium for Hamburg out of a disused water tower (completed in 1930, six months after Warburg's death). When the Warburg library was transferred to London in 1933, and despite the political uncertainties that caused its sudden emigration, this pattern of architectural engagement continued through bespoke projects designed by the avant-garde architectural partnership Tecton during the 1930s, in a conversion within the strange interiors of the British Imperial Institute in Kensington during the 1940s, and finally, with the construction of a new permanent home completed in 1958, as part of the University of London on Woburn Square in Bloomsbury. The directors of the Warburg Institute were occupied with questions of architectural arrangement, then, continuously over a thirty-five-year span.

Warburg's library has proven an enduring object of fascination across disciplines, partly because of its relationship to the wider system of insight that his thinking implied;[5] partly for how it informed the work of a group of academic disciples, Saxl and Bing included.[6] In all this work the special character of the architectural spaces that housed this thinking has been tacitly admitted, but until very recently has never studied as whole.[7] The organization of the library required a principle of spatial recombination.[8] What Warburg called "the rule of the good neighbour" required that books should be catalogued and stored in small associative groupings, their location dictated by a changing horizon of research: a new idea might lead to a new spatial disposition.[9] The Kulturwissenschaftliche Bibliothek constructed in Hamburg attempted to regulate this restless need by dividing Warburg's book collection over four floors, each identified with a major theme, or "problem," for the library's research: *Bild* (1st floor), *Orientierung* (2nd), *Wort* (3rd) and *Handlung* (4th).[10] The building that was finally constructed to house the institute in London adjusted slightly that

order: "Image" (1st floor), "Word" (2nd), "Orientation" (3rd), and "Action" (4th). In both cases, an identity emerged between the spatial organization of the building and the intellectual organization of a set of ideas around cultural memory.[11]

This formal relationship was part of a wider pattern of resonance between *Bildung* and building: Aby Warburg's fluid theories of meaning and cultural survival were entangled with the architectural spaces that the Warburg Institute commissioned and occupied in manifest ways. The scholars of the Warburg Institute furnished their buildings with collections of familiar objects that moved from one to another. But in addition they furnished them with particular nuances of meaning through rituals of translation, relocation, and circulation in which these objects were implicated. What resulted was an architecture that one could call "vehicular," in as much as its impact was connected to the way in which things—image-things or material-things—were carried about, as much as to the formal compositions they took on. Warburg's instincts about how cultural memory operated—in a series of echoes, sometimes unexpected, where scenes or objects from the past suddenly create oscillation in later periods and in geographically remote locations, almost like rogue waves traveling across oceans—provided a model for how movement, gesture, and repetition in action might be central for creating a vibrant architectural experience.

Image Vehicles

At the start of the twentieth century Aby Warburg posited a connection between the circulation of images, the emotive power of physical movement, and the development of art and culture. Warburg was very much a child of the circulatory nineteenth century, of its obsession with moving and its saturation by media. Like Thomas Hope he was an errant member of a powerful banking family. He inherited a banker's interest in questions of circulation and a capacity for identifying new contexts where investment might lead to unexpected profit. His brothers (four in all) concerned themselves with maintaining the position of the family business (Max Warburg was chairman and Franz a director of M. M. Warburg & Co. in Hamburg) and with developing family and

Aby Warburg in Arizona, April 1896. Warburg Institute Archive.

international financial ties in the United States (Paul Warburg lay behind the establishment of the American Federal Reserve, and Felix married into the Loeb banking family and became managing partner with the New York house of Kuhn, Loeb & Co.). But Aby's concerns were with cultural capital. The markets he exploited provided new kinds of evidence about the visual cultural production—sculpture, painting, architecture—of the European Renaissance and of Eurasian antiquity.

In trying to make sense of the past, and in interpreting what was at stake in the production of visual art through history, Warburg and his closest collaborators became sensitive to the material lives of images; that is to say, to the biographies of the devices and artifacts that carried representations (books, prints, paintings, sometimes tapestries or domestic furnishings) from one place to another. In such biographies the question of movement arose in several ways. Warburg maintained that the transmission of cultural influence through time and space—for example the reemergence of antique characteristics in the art of fifteenth-century Florence—could not be explained without some kind of material transfer in which visual imagery and shifting, interpretive, associations were carried physically from one location to another. Using this model, it became possible to plot "flows" of cultural information across space and time, and from around 1911 Warburg produced maps of the *Wanderstrasse* along which this cultural influence was supposed COLOR PLATE 15 to have traveled. At the same time, this analytical model suggested that there was a connection between the motive and the emotive quality of images. Warburg and his followers were interested in how antique representations of movement and force (in text and image) would recur in visual art in the future, attributing a special potency to representations that, in whatever way, signaled action through frozen movement. This idea was elaborated in studies of how antique imagery entered fifteenth-century Florentine painting, and it was exemplified through the analysis of a series of iconic female figures—a maid bearing a basket in Ghirlandaio's *Birth of St. John the Baptist*; Botticelli's figurations of *Primavera* and *The* COLOR PLATE 18 *Birth of Venus*. In all of them the motive and the emotive were connected. Warburg christened the assemblies that allowed parcels of antique signification to migrate through history *Bilderfahrzeuge*— "image-vehicles"—capturing in an elegant way the combination of imaginary association and material construction that this idea of cultural transference implied.[12]

Aby Warburg. *Bilderatlas Mnemosyne*, panel 7. Photograph, квw, Hamburg, 1929. Warburg Institute Archive.

Aby Warburg. *Bilderatlas Mnemosyne*, panel 79. Photograph, KBW, Hamburg, 1929.
Warburg Institute Archive.

Ever translative himself—he traveled between Hamburg and Florence from the 1880s and toured the United States during the 1890s—Warburg pursued these interests with a small group of colleagues with whom he collaborated closely. They included his wife, the artist Mary Hertz; the philosopher Ernst Cassirer; the philologist Franz Boll; and particularly the scholars Fritz Saxl, who Warburg supported as a postgraduate student and appointed in 1914 to help curate his library, and Gertrud Bing, recruited in her turn by Saxl in 1921. During the 1920s these collaborations produced an unfinished *Bilderatlas Mnemosyne*, which began to distill an ecology of links Warburg saw between images produced at separated times and in remote contexts. They also traced historical entanglements between superstition and ratiocination in cosmology, as part of a broad investigation into what the Warburg scholars entitled "orientation," the systems whereby cultures produce senses of meaning and belonging.[13]

The metaphor that identified cultural memory with spatial and temporal displacement had strong contemporary resonance during a period in which a geography of predetermined routes, manifest in of the development transcontinental railways, shipping, and even global air travel, became central. The Warburg family was intimately associated with the owners of Hamburg-Amerikanischen Packetfahrt-Actien-Gesellschaft (HAPAG), the shipping line that connected Hamburg and New York, and traveled via HAPAG ships between a leafy summer villa overlooking the Elbe and mansions on the Upper East Side. The first Compagnie Internationale des Wagons Lits "Orient Express" train ran direct from Paris to Constantinople in 1889, the same year Warburg contemplated "Filippino Lippi's hypernervous mobility" during his first trip to Florence.[14] Its services reached Baghdad by 1930, when the exhibition that articulated Warburg's understanding of the history of astrology and astronomy opened at the Hamburg Planetarium.[15] Warburg traveled (for free, sponsored by the directors of the railroad) from Baltimore to New Mexico in 1895 and 1896, on an expedition to see the lands of the Pueblo Indians, and regularly between Hamburg, Florence, and Rome after 1890. A long period of illness kept him at the Bellevue Sanatorium in Kreuzlinge, Switzerland, from 1921 to 1924, on the shores of Lake Constance where the Zeppelin company tested their monumental airships over waters stormy or still (their most successful machine was named *Bodensee*

after the lake). As he recovered, his doctor, the eminent psychiatrist Ludwig Binswanger, found him "taking care of the details of his departure (saloon car)";[16] the journey involved his brother Felix chartering a special railway car to transport Aby and various assistants from Switzerland back to Hamburg. Such journeys and the vehicles that made them combined carriage and image, and the experience of them wormed its way deep into Warburg's history of "Contemporary Life in Motion," as the title to panel 28–29 of the *Bilderatlas* had it. Recording geographies from Baghdad in ancient Eurasia to London, Paris, or Hamburg in modern Europe, maps he made of the routes along which influences traveled from the past mirrored contemporary railway guides that charted how journeys could be made in the opposite direction. Images of traveling vehicles—from ocean liners to Zeppelin airships—infiltrated the plates of the *Bilderatlas*, jostling for space with emperors' heads on antique coins or diagrams of Renaissance astronomy (panels C and 77/79 in the recently reconstructed version).

This apparatus of travel informed Warburgian metaphor: the Palazzo della Ragione in Padua was "the size of an airship hangar"; an essay analyzing the contents of two fifteenth-century tapestries that celebrated the deeds of Alexander the Great was titled "Airship and Submarine in the Medieval Imagination." But in this identity with relocation there was always an added architectural dimension. In the *Bilderatlas*, in panel after panel as the project was iterated during the 1920s, buildings appeared, captured through black and white photography as complete compositions and as a near infinite series of fragments bearing sculpture, reliefs, and inscriptions. The Warburgian focus on the problem of orientation also involved architecture directly. The systems that Warburg saw as creating cultural identity were expressed in buildings. A concern with translation in dwelling emerged finally in Warburg's own artistic pastimes. In Pasadena he photographed a large, white clapboard villa making its way slowly across the city on the back of a low-loader. In Hamburg he consulted for the HAPAG shipping line on the interior design of the saloons for their transatlantic liner *Bremen*. Something of this simultaneous urge to facilitate movement and to predict fixed and precise architectural position ended up in the first building that was commissioned to accommodate the most important component of Warburg's own interior life, his library.

Aby Warburg. The House on Wheels, photographed in Pasadena, 1896.
Warburg Institute Archive.

The Kulturwissenschaftliche Bibliothek Warburg
(KBW), 1924–1933

> From floor to ceiling the walls were covered in books . . .
> the pantry became a stack room, heavy shelves were
> hanging dangerously over doors, in the hall, on the
> landings, in the drawing rooms of the family, everywhere
> books, books, books.[17]

In 1923, with Aby Warburg ill, Fritz Saxl was asked to supervise
initial designs for a new building that would move the activities
of the library out of the confines of Warburg's home at 114 Heil-
wigstrasse onto a gap site next door to it in the recently built ter-
race, purchased by the Warburg family for this purpose.[18] Early in
1924 Saxl contacted a local architect, Felix Ascher, who drew up
plans. While this project was necessary because of the library's
expansion, Ascher's drawings suggest that there was also a desire
to reinscribe aspects of the library "as found." The project followed COLOR PLATE 16
the sectional disposition of the big, suburban house attached to
it, and scholars were to work in its stack rooms, whose scale dupli-
cated the "drawing rooms of the family" next door, much as War-
burg and an intimate circle of collaborators had worked in these
spaces.[19] Following Warburg's return to Hamburg that August, the
project went through several iterations involving the city's well-
connected *Baudirektor*, Fritz Schumacher, and a young architect,
Gerhard Langmaack.[20] In that development book stacks were
quarantined from visiting readers and placed over four floors in a
reinforced concrete bunker at the center of the building. Research
was to be undertaken and discussed in a Lese- und Vortragssaal
(reading and lecture room), projecting as a single-story elliptical
space into the garden. The resulting building was christened the
Kulturwissenschaftliche Bibliothek Warburg (usually abbreviated
KBW by Warburg and his colleagues).

At the KBW the library that hovered, half hidden, above the
ceremonial ground story was organized to resonate with the
order of its container. The work of fitting the library to the archi-
tecture was highly collaborative—Bing and Saxl were intimately
involved—and it was iterative. By 1926, Warburg was annotating
the floor levels of the final architectural section: *Kunst*; *Astrologie-
Religion-Philosophie*; *Sprache-Geschichte*; *Krieg-Neuere Geschichte*.[21] By

1927, the final, elegant thematic series of *Bild*, *Orientierung*, *Wort*, and *Handlung* had been defined. Although the contents of the individual sections continued to be debated, the system was used to organize the four levels of book stacks, the books themselves, and the photographic collection.[22] The crystalline intellectual structure of the library—its *idea*—can be said to have emerged through matching a defined architectural organization with a thematic

COLOR PLATE 17

and tentative order of problems. Gertrud Bing, who had the job of thinking through the nitty-gritty of what this process actually meant, left an acute sense of this evolution.[23] She made small notes that listed the subject sections of the library across its various divisions. Positioned over the building's plans these reveal themselves as tracings—notations with which possible arrangements of intellectual order could rapidly be tested against the architecture. As later in Warburg and Saxl's exhibition at the Hamburg Planetarium, architectural and intellectual systems of organization were tightly matched.

The relationship between architecture and bibliographic order at the KBW was modulated also through various pieces of technology. The reading and lecture room boasted a Zeiss epidiascope projector, which threw images onto a screen pulled up out of the floor. Book searches used a *Rohrpostapparat* or vacuum postal system to move requests from the reading room to the librarians above. A complicated system of book lifts, conveyor belts, and a lifting table delivered the desired volumes back to the reader on the ground floor. Technological devices translated from the world of commerce, or from very large-scale libraries, became densely packed in a floor plate about the size of an average bourgeois apartment.

This mixture of biblio-architectural order and industrial technology created striking experiences. On completing the building its architect was commissioned to produce a photographic record of its interiors.[24] The album he produced showed how the use and style of the building were articulated distinctly in terms of its division into public areas, sumptuously lined like the interiors of some passenger ship, and private ones, with a much more sparse, machine-like character. Images of the entrance hallway front of house detail a book lift and its associated telephone; the epidiascope dominates the reading room. Behind the scenes an iron, spiral staircase is photographed ascending from reading room to book stacks; the low-ceilinged stack rooms are presented first bare,

Entrance to the Kulturwissenschaftliche Bibliothek Warburg. Photographic album, 1926–1927. Warburg Institute Archive.

Spiral service stair, Kulturwissenschaftliche Bibliothek Warburg. Photographic album, 1926–1927. Warburg Institute Archive.

emphasizing the grid of Wolf Netter & Jacobi "Lipman" steel shelving that later contained esoteric volumes flanking narrow aisles.[25]

These stack rooms had a magical attraction for Gertrud Bing. "The pleasure and charm of handling the books, opening them and 'browsing' as you pass along the aisles can never be replaced by a card index," she wrote.[26] While research officially took place in the controlled context of the reading room, where requests had to be made for individual volumes, and linkages were already predetermined by the subject-catalogue, the wilder regions of the book stacks produced something extra. What made this experience? The books and their juxtaposition to be sure. But also the architecture and its effects. The stack rooms were lit by tube-based strip lighting on the ceiling—"Beleuchtung durch Röhrenlampen" as Gerhard Langmaack noted in the technical description prepared for the building.[27] Both the tubes and their switching gear, "Kettenzüg in den Gängen," or hanging cords in the aisles, are visible in photographs. The Warburg scholars commissioned blinds to be drawn down over the windows, when it was discovered that constant exposure to natural light faded the colored paper strips pasted on to the spines of the books, which indexed the associative search system that the librarians depended on to locate them. The stack rooms, then, were kept dimmed even in daytime, and Bing's "browsing" is likely to have been dependent on this lighting.[28] In 1926 *Röhrenlampen* could only mean mercury vapor lamps, hard industrial fittings normally used in warehouses.[29] Switching on that lighting must have been a magic moment. Mercury vapor took some time to achieve full illumination; the book titles would have emerged from twilight as the lamps gained their unworldly brilliance.

Thames House, 1934–1937

As he evolved his thinking about how cultural ideas spread, Warburg identified buildings such as the Palazzo Schifanoia in Ferrara or the Palazzo della Ragione in Padua as "immense folio pages," which carried images through time, a comparison that projected a direct connection between the notion of a building interior and the notion of a *Bilderfahrzeug*. Buildings, in this reading, became another material support through which image-ideas from the past could be transported into the future. The

extraordinary history of Warburg's own library instantiated this possibility in a very Warburgian way. The KBW can be seen as a machine for storing images, and for elucidating the kinds of connections between them that the notion of the *Bilderfahrzeuge* permitted. The abrupt translation of this collection—photographs, printed books, manuscripts—and its reinscription into a new spatial setting introduced a vehicular character into that machinery. When the Warburg scholars left Hamburg, significant portions of the material fabric that made up the KBW were moved with the collection—the Lipman steel shelving, catalogue draws, tables, chairs, and some timber fittings. In later manifestations of the institute these artifacts, as well as the system of relations in which they participated, lived on in what Warburg might have called a series of *Nachleben*, "afterlives."

While the designers involved with the Warburg Institute in Hamburg had been local, the first building project in London established direct contacts with a more international context. The architect appointed to design the interior that was to house the library was Godfrey Samuel of the avant-garde practice Tecton, created in 1931 by a group of Architectural Association graduates together with the Russian émigré Berthold Lubetkin.[30] Several Tectonites, including Samuel, were members of the Modern Architecture Research Group (MARS), founded to represent British engagement at the Congrès internationaux d'architecture moderne in 1933; in its first years Tecton made a specialty in designing accommodations for exotic arrivals in London. At the same time as developing ideas for the Warburg Institute, they were working on the iconic Penguin Pool, and the Gorilla House, at London Zoo.[31] There were resonances between these projects and those that had dominated the Warburg scholars' experience. While the Gorilla House displayed a semicircular geometry as strict as that found by Saxl and Warburg at the Hamburg Planetarium, the Penguin Pool combined an ellipse and mezzanine balconies to create an effect as theatrical as that of the reading room at the KBW.

Although he did not stay with the group long and had a distinguished 1930s career of his own, Samuel was a founding member of Tecton.[32] His involvement with the Warburg commission almost certainly came about through family connections. His father, Sir Herbert Samuel, was the first figure of British Jewry, leader of the Liberal Party, and previous High Commissioner for the British Mandate in Palestine. In October 1933 Samuel senior discussed

Wolf Netter & Jacobi "Lipman" shelving, stack room, Kulturwissenschaftliche Bibliothek
Warburg. Photographic album, 1926–1927. Warburg Institute Archive.

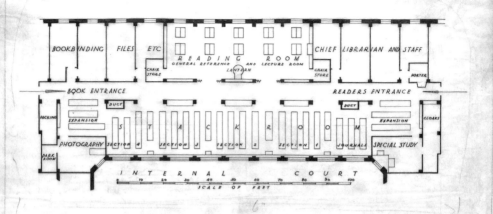

LAYOUT OF WARBURG INSTITUTE
AT THAMES HOUSE WESTMINSTER
ARCHITECTS TECTON (SAMUEL)

THE LAYOUT WAS DESIGNED FOR FIVE PRINCIPAL FUNCTIONS
1. THE READING ROOM A. TO SEAT 20 READERS, OR MORE IF REQUIRED
 B. TO HOUSE CATALOGUE, REFERENCE LIBRARY AND CURRENT JOURNALS
 C. TO PROVIDE FOR LANTERN LECTURES TO AUDIENCES OF ABOUT 100
2. THE STACK ROOM A. TO HOLD 70,000 VOLS. ON SPECIAL STEEL SHELVES WITH 10% EXPANSION
 B. TO ALLOW OPEN ACCESS FOR READERS, WITH SUPERVISION FROM THE PORTER
3. THE SPECIAL STUDY ROOM TO ISOLATE READERS UNDERTAKING MORE CONCENTRATED STUDY
4. THE SENIOR STAFF ROOMS TO BE ACCESSIBLE TO BOTH READERS AND OTHER VISITORS
5. THE WORKING STAFF ROOMS TO BE ACCESSIBLE TO BOTH READERS AND BOOK DELIVERY

THE LAYOUT WAS LIMITED BY TWO CONDITIONS
1. THE ADAPTATION OF A NORMAL OFFICE BUILDING WITH CENTRAL CORRIDOR AND ROOMS EACH SIDE TO THE
 TEMPORARY USE OF THE INSTITUTE
2. THE INCORPORATION OF EQUIPMENT FITTINGS AND FURNITURE FROM THE FORMER PREMISES IN HAMBURG

Tecton. Presentation plan, Warburg Institute, Thames House.
Commissioned for *Library Association Record* article. RIBA Drawings Collection.

the situation of the German Jews at dinner in New York with Felix Warburg, Aby's brother and the main family donor to the institute.[33] Given the timing and Samuel's potential influence, it seems likely that the question of the library move came up.

The library was to be reestablished in Westminster on the ground floor of Thames House, a state-of-the-art office building controlled by another set of Warburg connections, the Mond family.[34] The plan that Samuel developed for the library, a composition as tight and symmetrical as anything else produced by Tecton during the period, oriented the proposed accommodation around a flexible-use space at the center, which served both as a lecture and a reading room.[35] Samuel had been provided with plans of the KBW. Warburg's idea that the space of scientific discovery should be identical with the space of scholarly dissemination, a principle that generated the organization of the institute's building in Hamburg, was reapplied.

The first London manifestation of the Warburg library was in many senses an aspirational reinscription of that lost space. The tables and chairs readers occupied in the reading room, the built-in bookshelves that surrounded them, were all transported from Hamburg. An early sketch for the Thames House interior even included in the design the 45-degree-angled corners of the mezzanine shelving from the Lese- und Vortragssaal at Heilwigstrasse. While the chamfers disappeared in the developed scheme, the shadow of that room remained. In May 1934 a technician from the Zeiss factory in Jena reinstalled the epidiascope projector, exactly on axis as it had been in Hamburg. To support it the Warburg Institute commissioned Samuel to design a bespoke rostrum in oak, stained to match the transported Hamburgian shelving, and curved like the back wall of the original reading room.[36]

The steel Wolf Netter & Jacobi Lipman shelving that had accommodated the main part of the library, and which had been so carefully photographed in Hamburg, was also transported to create the book stacks in London. Encountered on a single level the library was now divided into four sections in a single space, organized in a slight variation from the order adopted in Hamburg: "Religion, Natural Science and Philosophy" (corresponding to *Orientierung*); "Language and Literature" (*Wort*); "Fine Arts" (*Bild*); "Social and Political Life" (*Handlung*).[37] An English firm of metalworkers, G. A. Harvey & Co, were commissioned to produce copies of the Lipman system to extend the shelf run. Bing was

asked to supply the fabricators with samples of the original stacks so that the color could be matched exactly. There was a dispute when it became obvious that Harvey & Co intended to produce the supplementary units in 3-foot rather than 1-meter modules. A slightly exasperated letter from their manager to Saxl refers to "your recent information that the bays will now be 39.37079 inches wide."[38] These Warburg cultural historians were capable of specifying furniture dimensions and architectural positioning to five decimal places in order to maintain the system of order they had created.

As at the KBW, the reading room at Thames House was located at ground floor level, lit by five bays in the facade; as in Hamburg a large amount of was sky visible. In one sense, to sit here was to sit again in the atmosphere of a building lost: the slanting sun and silver-gray skies would have cast similar interior lights in both places. But even as it reinscribed lost interiors, the Thames House library created new impressions. Where in Hamburg the interior had emphasized the separation of the reading room from its external context, where the librarian's niche had blocked the view and the windowsills were so high that a sitting scholar couldn't see over them, now the relationship between interior and exterior was brought up close. The reading room looked directly out over a London side street, opposite Stephen Courtauld's London Ice Club on one side (an early 1930s society magnet) and the building site for a new office development on the other.[39] Looking up from a text on early Coptic sculpture (say), a reader might be confronted with a moving advertisement on the side builders' van, or the glowing yellow sign indicating a taxi for hire (a cutting-edge development introduced in 1934). There was something new and potent here, as there must have been in the contrast between the bright, timber-lined reading room and that dimmer space of book stacks, with their raw industrial lighting and their view into a white-tiled, sanitary light well, behind. Under the aegis of Bing and Saxl the institute's readers in London could roam its whole collection. The "browsing" Bing had been so enchanted by in Hamburg, a quality of the library manifest in its original domestic setting in Warburg's home but limited by the organization of the KBW to the staff of the institute, now became the use-principle of the library. Linked to the reading room by wide, curtained openings, the books were laid out in full view. The timber-paneled front of house and the hard, industrial back of house, separated in Hamburg,

Photograph of reading room and stack room at Thames House, London. Gertrud Bing,
"The Warburg Institute," *Library Association Record*, August 1934.
National Library of Sweden.

Unknown photographer. Ernst Kitzinger at work in the reading room, Thames House, around 6:00 p.m., summer, probably 1935 or 1936. Warburg Institute Archive.

were set in a direct visual juxtaposition. As at the KBW, this confrontation was recorded in photography and presented through publication, in this case as the first image in the account of the library that Gertrud Bing published in the *Library Association Record* in 1934.[40]

Imperial Institute Buildings, 1937–1958

The Warburg Institute occupied Thames House for only three years, the period negotiated at the removal from Hamburg with the owners of the building.[41] By 1936 discussions were under way that changed the location of the library to the Imperial Institute Buildings in South Kensington. There the Warburg stayed until 1958. In terms of fulfilling the architectural potential within Warburg's system of thought, the occupation of these interiors was crucial. They formed the context for Rudolf Wittkower's meetings with a young Colin Rowe to discuss the symbolic significance of architectural arrangement and proportion, later to be published in Rowe's "The Mathematics of the Ideal Villa" (1947) and in Wittkower's *Architectural Principles in the Age of Humanism* (1949).[42] The rooms at the Imperial Institute formed the context for Frances Yates's investigations into the relations between architecture, memory, and the organization of knowledge, published in *Giordano Bruno and the Hermetic Tradition* (1961) and *The Art of Memory* (1965).[43] They curated the architectural development of this thinking contained in her *Theatre of the World* (1966). And they were the place in which Fritz Saxl, Henri Frankfort, and Gertrud Bing, as successive directors of the institute, worked with the University of London on plans for a new home for the Warburg Institute after 1944.[44]

The encounter with the Imperial Institute put the Warburg library into juxtaposition with a third, phantasmagorical, architecture. Where Thames House had offered the open-plan floorplate of a modern office building, the Imperial Institute offered a suite of double-height rooms within a stylistically eclectic building dominated by monstrous flying stone staircases and endless, monumental corridors. At first, at least, the entire contents of the library could be swallowed by the peripheral shelving these rooms provided, meaning that its other functions were housed among the books, an arrangement very close to that which Felix Ascher had envisaged for Fritz Saxl in 1924. Gertrud Bing, describing the

organization at the Imperial Institute in 1937, was emphatic that the problem of image was still central to the library's activities. This section, now titled "Art and Archaeology," surrounded scholars working in the main reading room, which occupied the second, and largest space in the enfilade sequence. "Language and Literature" occupied the walls around the third and fourth rooms, whose centers were occupied by the photographic collection overseen by Rudolf Wittkower, and by the activities of the *Journal of the Warburg Institute*, coordinated by its editor Anthony Blunt.[45] The final double-height room in the sequence was given over to "Religion, Natural Science and Philosophy" and the mezzanine of the very first to the "History of Social Forms." The order of sections adopted at Thames House had been reversed.[46]

The superimposition of functions that this initial arrangement created was to be short lived. As the library grew, the central areas of the various rooms were gradually given over to free standing book stacks. In 1951 the Warburg was given more space, taking over the suite of enfilade rooms directly above those it already occupied on the ground floor.[47] The arrangement that resulted can be viewed as nightmarish or inspirational. For one young scholar in the Institute, Sydney Anglo, it created a jack-in-the-box quality of unexpectedness. The staff were grouped in a "bizarre atrium, set all around with office doors from which world-famous scholars would pop out and in again—like an apotheosized cuckoo-clock."[48] The same quality of imminent surprise was created by the staircase that the institute had constructed to connect the spaces on the ground and first floor. It rose incongruously out of the room previously occupied by Anthony Blunt and arrived directly into the middle of a new reading room above, through a hole cut in the Victoria structure. As Anglo recalled: "it was an especial treat, when seated there, to hear climbing footsteps of some approaching scholar, to try to guess who it was, and to watch a learned head rising up through the opening in the floor."[49] The organization of the space put the unfamiliar into very intimate juxtaposition with the familiar. It introduced a whiff of the Wurlitzer organ into even the most serious academic debate.

This same quality of violent juxtaposition is evident also in the photographic record of the building made following its expansion in 1952. The first-floor reading room seems chaotic, its central staircase clearly visible, Fritz Saxl (who died in 1949) and Warburg himself staring down impassively from the mantlepiece. On

Imperial Institute Buildings, first-floor corridor, ca. 1890. *The Builder*, 1892.

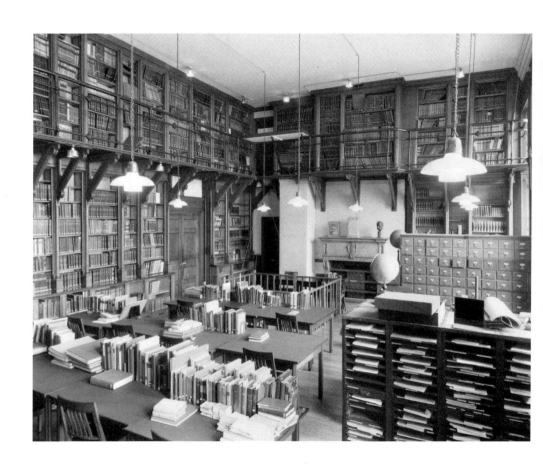

Warburg Institute Reading Room, Imperial Institute Buildings, ca. 1952.
Warburg Institute Archive.

the lower level the juxtaposition between the industrial and the gentlemanly, implicit at the KBW and explicit at Thames House, was compressed brutally. Meter-module metal shelving filled the rooms entirely, surrounded by gothicky timber linings and mezzanine balconies carried on faux-timber consoles.[50] But although visually jarring, this reorganization reestablished the idea that the library consisted of four interdisciplinary bunkers of books disposed across four main spaces. As reported in the Warburg Institute's *Annual Report 1951–1952*, the major sections were now those on "The Image as the Vehicle of Expression and Tradition" ("Archaeology and Art," in room 2) and on "Orientation by means of myth, magic and logic" ("Religion; Science; Philosophy," rooms 4 and 5); the smaller were those on "The significant Act" ("Social and Political Life," room 1) and on "The Word as the vehicle of expression and tradition" ("Literature; Transmission of classical learning," room 3).[51] In this guise the library regained some of its sense of being a recombinatory machine set up in an opulent architectural frame.

Woburn Square, 1958–

How then, were ideas about a new Warburg building gestated within the hallucinatory spaces of the Imperial Institute? And how did the Warburgian preoccupations with *Bilderfahrzeuge*, with gesture and performance as central mnemonic attributes, and with *Nachleben*, the afterlives of authors, objects, images, and cultural constructions, play out when the institute was offered the opportunity to commission a purpose-designed replacement in London for the lost KBW in Hamburg? The proposal for a new building was made within the master plan developed by Charles Holden for the University of London.[52] Initially the Warburg was to form part of a low bi-institutional building together with the Courtauld Institute of Art, with the Warburg library housed mainly in its basement.[53] Events in the early 1950s challenged this arrangement and by 1954 a new scheme was in place to position the Warburg Institute alone on its current corner site, terminating the vista along Torrington Place. The library was to be spread over four floors above the reading room as it had been in Hamburg. Gertrud Bing took over the role of client representative for the project in March 1954 (she was

Stack room, "Art History" (main level), "Topography, Applied Arts" (mezzanine), Imperial Institute Buildings, ca. 1952. Warburg Institute Archive.

already acting director of the institute) and by August that year a final footprint was established.[54]

During this process, the appearance and organization of the "new building" was conceived in very different terms by the various actors involved. For the university and its architect a combined Courtauld and Warburg building was to be low, neoclassical, and, specifically, American:

> It is common ground that the new building should be low in height and have not more than 4 floors in all: (1) Basement, (2) Ground floor, (3) First floor, (4) Top-lit Gallery above. The general architectural style of the building should, (mutatis mutandis) conform in spirit to that of its "parent" institution, the "Fogg Museum of Art" at Harvard University. . . . The material to be red brick with stone dressings.[55]

Drawings from Holden's office in the Royal Institute of British Architects (RIBA) collection show how literally the architects took this assignment.[56] For Saxl, the new building projected memory into the future. Specifying "Needs of the Warburg Institute" in 1945, he dreamed, just as he had in Hamburg, of reader's carrells in the windows of the stack rooms. He confronted Holden on the possibility of squeezing four levels of library into the university's plan for a three-floor building. And he asked that "a small winding staircase should lead from the reading room to the stack rooms."[57] Henri Frankfort, who succeeded Saxl as director, was committed to organizing the library horizontally.[58] Gertrud Bing sought a very different architectural mindset from that exhibited by the elderly Holden and the university's Building Committee. In March 1953 she wrote a contact in Rome asking for advice on alternative designers. The firms suggested in response offered "enough of a flexible continental mind to see what you really need."[59] Both had a fascination with the stark industrial lines of modernism. Yorke, Mardal, Rosenberg—later known as YRM—would go on to design the first buildings at Gatwick Airport; Powell and Moja were architects for the extraordinary Churchill Gardens Estate newly completed in Westminster.[60]

Whatever these disparate ideas about form and appearance, in the end the arrangement chosen for organizing the Warburg Institute had resonances with several of its former homes.

"Mnemosyne" was to be written over the door as it had been in Hamburg.[61] There was something of the KBW in the classicizing fenestration and modular bays of the lecture room proposed at Woburn Square, with its quiet view of leafy gardens and a distant terrace beyond. And the arrangement that Bing approved in 1954, which situated the reading room like a lighthouse, facing London's bustle up Torrington Place, repeated the dramatic juxtaposition created at Thames House, where readers looked directly into the street.

Just as revealing about the way in which the Warburg scholars furnished their new home with memories of the old are the resonances between the stack rooms at Woburn Place and those of its Hamburg ancestor. As in Hamburg, these were arranged in four floors over the reading room. While the area of the building in London was much larger than it had been in Hamburg, in both places books were stored in rooms low in height, filled with stove-enamel metal shelving, and lit by fluorescent tubes that ran above the aisles between them. Drop cords were positioned in a special arrangement directly over the ends of each book stack, the cord threaded through a metal bracket that carried signage identifying the classmarks (library catalogue numbers) to be found in each section. Retrieving a book at the Warburg was a distinctive, gestural experience: you entered the stack room; you located the subheading at a distance and the classmark close to at the end of the stacks; you raised a hand to pull the drop cord, and extracted the book. A "Diagram Showing the Arrangement of Light Fittings and Switching Locations," reveals how much thought went in to this.[62] At its right-hand side is an axonometric view showing the disposition of the book stacks, the lighting cords, and the signage, including the system of classmarks for locating the books. This last detail was not strictly of interest for the electricians and concrete casters for whom the drawing was intended, but it was of such burning importance to at least one person involved in the process that it had to be included.

The drawing appeared in 1956, early in the construction phase (it was used in arranging the location of conduit piping cast into the building's floor slabs), which makes its degree of precision quite startling. The classmarks annotated on the shelving shown in the axonometric detail follow, in order, those for the first section of the library as codified in the 1952 catalogue prepared by Gertrud Bing; indeed, this technical detail locates the stack numbers for

Lecture room, Warburg Institute, 1958. Warburg Institute Archive.

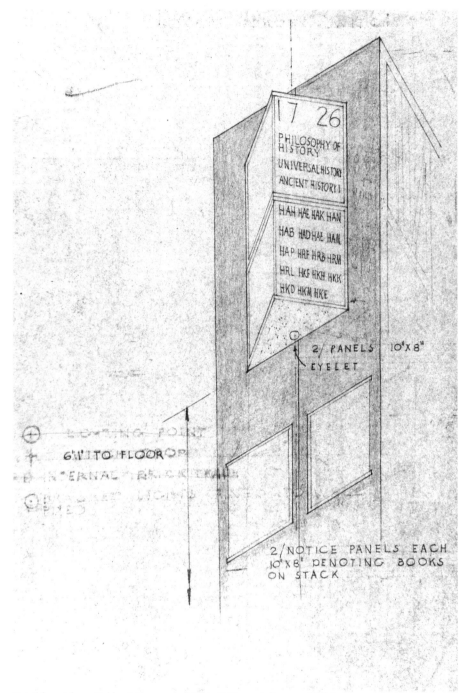

Detail from Adams, Holden & Pearson Architects. Setting-out diagram of lighting points and drop switches in stack rooms, Warburg Institute, September 1956. Warburg Institute Archive.

books on the "History and Social Forms" exactly as they were to be ordered in the building two years later. The drawing makes a triangular connection, then: between the positioning of electrical conduit, which had to be laid out as part of the same process that cast the concrete floor slabs; with the cerebral system of organization that defined classmarks for the library; and finally, with the realm of haptic experience—with the gestures that a user of the library would make in locating a work on the shelves.

Whose mind conceived this eccentric system? The architects were evidently the agents of representation but they were not necessarily the primary movers. Gertrud Bing's opinion of them did not shift very much during the years of commissioning the building.

> The architect has neither taste nor is he able to think through architectural problems and the problems of the institution. As far as I can, I try to forestall the biggest mistakes, but what you cannot foresee happens. I do everything I have to do—and that is a lot and tedious—against a background of profound skepticism.[63]

It seems as likely that the sophistication demonstrated in the drawing, and built into the final building, is a result of Gertrud Bing's "what I have to do . . . against a background of profound skepticism." It was Bing's hand that supplied the documents that linked architectural space to book organization, and then to catalogue headings, in the first manifestation of the library in Hamburg during the 1920s. It was Bing who reported on the updated architecture of the library for the Library Association Record in 1934 and who commissioned Tecton to produce a plan for that article. It was Bing who described "her" arrangement of the library in the eccentric rooms of the Imperial Institute building in 1937 and who commissioned the cataloguing of the rearrangements in 1952. Who else on the client and design team would have been so attentive to the relation between spatial experience and library organization during the final design of the project in the 1950s? The experience described on a technical drawing for the Warburg Institute in 1955 reiterated something discovered in the low-ceilinged stack rooms of the KBW in Hamburg, with their *Röhrenlampen*, and their hanging *Kettenzügen*, thirty years before. There, Bing had found a "pleasure and charm [in] handling the books, opening them and 'browsing' as you pass along the aisles" among steel

Part III: Vehicles 1890–1960

shelving illuminated by "fluorescent tubes, strung together directly on the ceiling between the stacks" with "operation by drop cords in the aisles."

During 1957 and 1958, as the move from the Imperial Institute to the new building became imminent, Bing commissioned schedules of the furniture that could be saved.[64] She issued instructions about restaining individual card catalogue drawers to make sure they matched the new settings.[65] She had plans of the new building color-coded to show each object in each room with its provenance and even asked that the stack room colors be defined by the system used to code book spines in the library catalogue system.[66] Architectural projects always involve painstaking attention to detail, but few clients enter into that detail as Bing appears to have done. The final result of her care was a new library that seems, immediately, to have had a lived-in quality, one in which new rituals of use rapidly took on a habitual feel. Architectural critics and certain academics panned the new building ("like a 1930s telephone exchange" according to Nikolaus Pevsner; "bleak and unthinking" according to Michael Baxandall).[67] But as she unpacked in 1958 Bing took a notably more optimistic tone:

> Even I am beginning to think that we shall be quite happy once routine comes into its own again and the Institute is being used in the normal way. The library is certainly very well provided for, spacious, well-lit, and in a short time it will be also well sign-posted.[68]

The rotational journey of searching that such sign-posting choreographed, from reading room catalogue to stack room signage, and from stack room signage to light switch, to shelf and back to reading room, made for a powerful, haptic experiential pattern. The library produced distinct poses in its readers. Warburg academics would have been less graceful than the figures in Botticelli's *Primavera* that Warburg loved so much, but using the library they echoed his Venus as they stretched fingers toward the hanging lamp cords, his Chloris as they bent to collect index cards to insert between the shelves where books were removed, or his Apollo as they reached up to the shelves to insert them. Like the strange juxtapositional world evinced in panel 77 of the *Bilderatlas Mnemosyne*, in this building gesture makes a bridge between the present and the past.

COLOR PLATE 18

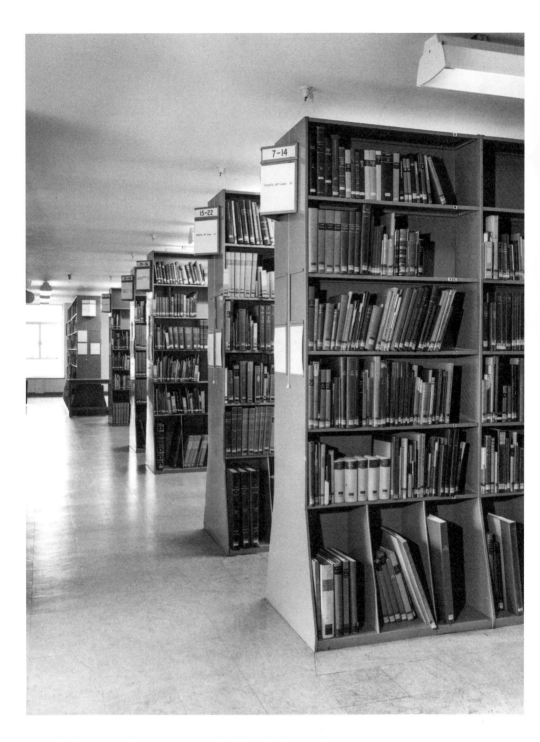

First-floor stacks, Woburn Square, ca. 1960. Warburg Institute Archive.

Bing's letter of delighted anticipation to Godfrey Samuel about her Elstree Hill cottage was written at the end of 1934, when Warburg had been dead five years and as she worked with Saxl to establish the Warburg Institute in the new cultural context of London. By January 1935, uncertain as to whether the institute and library would be further removed to the United States, they had canceled the commission. Her excitement left only a number of letters and a set of design proposals that disappeared into the archives to be revealed as a chance find many years later in research work for this book.

Despite its diminutive size and its ephemeral status, this Cottage at Bromley might stand as a little allegory: for the habits COLOR PLATE 15 of thought that mark Aby Warburg's legacy, and for some of the themes that inform the broader hinterland in architectural history to which that legacy relates. The design, full of humor, bound into an architectural frame a human relationship whose outlines were to remain ambiguous during the lives of its commissioners. It was informed by patterns that reached forward and backward in time—performative patterns of use in which the everyday became ritualized. And it acted as an armature to assemble artifacts that sustained these patterns. If the various incarnations of the Warburg library might be seen as *Bilderfahrzeuge*, vehicular constructions presenting a mixture of texts and reproductions in space and carrying them through time, Saxl and Bing's cottage suggests that this way of conceptualizing architecture might expand beyond the boundaries of an institution specifically dedicated to the research of the past.

In that building on Elstree Hill with its two curious, separated entrances, Saxl was to access the interior from the west through a cut-back porch, mounting stairs to an apartment on the first floor. Bing would enter from the east through a solitary door in an unassuming facade to her accommodation on the ground. Did they anticipate driving down from work in Westminster together on a sunny spring evening in an open Riley (Saxl was a car nut)? Or was Saxl to drive and Bing to take the train? No one now can say. Whichever way it was, in the house, Saxl's apartment lay over Bing's; his sun terrace above hers. Both their interiors linked to landscape—the garden front was to be largely glazed with long

views across open country. But the project was redolent also of the cossetted separation of interior rooms, of separate spaces around separate minds. The house was to be continental in that it was to be warm (a furnace room is the subject of much discussion in the letters). It was to have a basement for preserving "unwanted furniture," those items that could not be left behind, but which found no place in a new organization. And a preoccupation with furniture, with the familiar chattels that moved and provided a foundation for the pattern of a life transposed, returned throughout the project correspondence. Based on an inventory supplied by Bing, Samuel noted on his plan drawing from January 1935 the whereabouts of each piece of furniture Bing and Saxl possessed. The pieces were marked by a numerical key (Saxl's furniture on loan to Bing identified by the prefix "S"); in German fashion, it seems that Bing intended to transport even her kitchen stove from Hamburg, via Queen Catherine Dock in the Port of London, to this suburban idyll in Bromley in Kent.[69]

Despite articulating domestic separation Bing and Saxl were, and remained, a lifelong unit. They lived later in a house in Dulwich, another lush suburb south of central London, in which they inscribed several of the patterns projected in the design for their cottage. The house had two separate entrances, semiseparated accommodations (Saxl's private rooms were on the first floor) and looked over a very English, and very loved, garden. Posthumous descriptions record an intimate connection between personal identity, furniture, and establishment in this setting as well. For Donald Gordon, Bing seemed "always to have been behind a table: ... that desk in the tiny room at the Imperial Institute ... the huge black post-Bauhaus desk in her room in Dulwich."[70] In Michael Baxandall's recollection of the same house "Bing sat at the desk [in Saxl's study]—oneself in a very German chair."[71] The building projected at once a sense of the absolutely temporary and an aura of long-term occupation. "Bing spoke of Saxl's elusiveness, his acceptance of the provisional, his wish to be free: ... yet, and always yet, there was that garden designed and planted and cherished ... a maturity that would take years to come."[72] This curious double quality Gordon summarized as articulating "here and now, place and time, being here, past precipitated in present."[73] A similar nuance of permanency-through-momentary-instantiation is conjured up by the search system evolved for the Woburn Square Warburg library; by the bodily movements this system necessitated; by

Part III: Vehicles 1890–1960

the acute sensory shocks it introduced as drop cords were pulled and color-coded volumes suddenly illuminated. As much as anything, perhaps, this architectural reinscription of the everyday, through furniture and ritual, sustained the Warburg Institute's enduring investigation into the cultural significance of survival. In both places—in the house and the institute—there is a central role for chattels as props in rituals of instantiation, objects that help in anchoring down the world. And in both places an architecture is made exactly of the combination of life pattern, transient objects, permanent frame, and potential removal.

The presence of vehicles in this Warburgian architecture is to an extent metaphorical. If the notion of carriage is central, the occupants of these Warburgian *Bilderfahrzeuge*—the things transported—are totems: they awake responses; they guarantee living relationships; but they are in themselves inanimate. The vehicles that inspired the metaphor, on the other hand, did so through the human experiences they created. A ship, a train, a Zeppelin: as icons, as objects of transport seen, they inspired responses in spectators. But they also, all of them, awoke very powerful experiences for the human subjects who used them, who were carried by them, who saw the world from their windows. In the last chapter of *Things that Move* I turn to this subjective experience—to the sense of locomotion gained in actual, rather than metaphorical vehicles—and consider its significance for architecture during the twentieth century.

Early Electric

Stockholm just got a new a bridge. Fabricated from steel in China, it journeyed to the Baltic from the port city of Qinhuangdao in early 2020. In one way this intercontinental transfer mirrored the journey from Stockholm to Canton (Guangzhou) made by Fredrik Henrik Chapman's East Indiaman *Cron Prins Gustaf* 250 years before. The twenty-first-century bridge is heavier than the eighteenth-century ship was—about three times as heavy in fact—and came as cargo on a still larger vessel, the self-submersible heavy load carrier *Zhen Hua 33*. And the route varied of course. *Zhen Hua* used the Suez Canal rather than navigating the toe of Africa. But the translation of the bridge, like that of the cargoes carried by the Swedish East India company in the 1700s, provided a good index of time-specific logics in trade and the circulation of materials.

The journey of the bridge also prompts historical resonances. At 140 meters long and 45 meters wide it is larger than anything transported by sea during the eighteenth or nineteenth centuries (or by land during the sixteenth). But this contemporary project of urban removal seems similarly exotic to those that transported stone needles from Egypt to Europe in the 1800s, or across Rome two and a half centuries before that. As in these cases, a journey through physical space was duplicated across media, waking self-questioning debate. The environmental impact of shipping

a complete bridge 12,250 nautical miles rather than constructing it locally, the realization that *Zhen Hua*'s 3,700-tonne cargo was a drop in the ocean in relation to the total amount of goods continuously circling the globe, all occupied column inches. Where sixteenth-century publication raised questions about the definition of the architectural work, or nineteenth-century voices of conscience questioned the ethics of Britain and France bagging obelisks, the circumstances that brought *Zhen Hua* from China to Europe highlighted twenty-first-century climate consternation. The Bay of Biscay proved a kind of index for this anxiety. Having navigated the Indian Ocean, Suez Canal, and Mediterranean Sea without mishap, *Zhen Hua* spent a month off the coast of Portugal waiting to continue her journey north. An intense series of storms, characteristic of the worst predictions of anthropogenic change, produced huge swells that barred her progress. For those interested in the story, internet apps revealed a route as complex as the line drawn by Lawrence Sterne to record narrative hiatus in *Tristram Shandy*: a series of zig-zagging loops traced on the surface of the sea and on screens at home while *Zhen Hua*'s captain gauged the safest moment to head north.

The fabrication of the bridge and the long journey from China were necessitated by the removal of one of the most curious architectural monuments produced during Sweden's period as a twentieth-century social democratic welfare state. The golden bridge (presprayed by Chinese laborers) replaces a complex that solved problems of traffic congestion at a place called Slussen in Stockholm. During the 1930s a gleaming, teaming, construction was created on this site, which brought modernist city planning into the center of the city's largely medieval urban fabric. This remarkable design orchestrated a sculpture of curves and ramps at the junction between the salt- and freshwater harbors that lay east and west of the town. On its concrete deck pirouetting lines of traffic circulated around a central rectangular amphitheater; beneath, boats navigated a sea lock (the name of the area, Slussen, derives from *sluss* a canal lock or sluice), steam trains hauled goods along docksides, and Stockholm's first electrified tunnel transported passenger trams to the suburbs. In 1935, as the structure was inaugurated, its uncompromisingly machine-like aesthetics were advertised as a plus. Fifty years later opinions were more divided. Aging gray concrete; dank underpasses—what had been an icon of welfare-state planning had become, in the eyes of the

city government, an eyesore. For late capitalist society, mortgaged to ideas of destination, Slussen, as a transport hub, didn't deliver. A regular accusation was that in its evident concern to orchestrate flow, this 1930s project of traffic organization lacked a sense of place. In 2015 demolition cranes moved in to wipe its infrastructural slate clean. The golden bridge from China was part of a reorganization that was promoted specifically for the way in which it would transform a traffic circulatory into a space for people.

The golden bridge in transit—an enormous ship-borne piece of urban infrastructure circling as it waited to cross the Bay of Biscay—and the swirling ramps at Slussen, which choreographed trams, lorries, and automobiles of smaller dimension—both suggest the experiential significance of movement and of vehicles for architecture. Vehicular concerns provided the backdrop as well as the logic for much of Slussen's design during the 1930s. Although later criticized for its insensitivity to urban context, the project was conceived out of a generosity of spirit that claimed it as part of a continuous set of experiences generated by the city that lay around it, which were created by the interaction between permanent buildings and mobile vehicles. At the same time, Slussen combined the potential of an evolving trio of twentieth-century technologies for which vehicles were central—developments in rapid urban transport, in cinematic film, and in the design of kinetic amusement parks. Contiguous through their common reliance on electric power—for commuting; for lighting; for play—all three technologies changed the experience of time and memory in the twentieth-century city. All of them possessed mnemonic characteristics connected to the way in which things move. Slussen embodied a new sense of place that resulted from this vehicular experience. In this chapter I aim to recount that history.

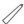

In the debates that preceded its demolition, Slussen was identified as an early type of multilane highway interchange, an ancestor to structures like the Santa Monica / San Diego freeway intersection that Reyner Banham would later "love in Los Angeles."[1] This reading served equally well the cases for preservation and elimination: it claimed the project as a canonical example of a type of structure people really didn't like. But the formal resemblances on which this identification was based were to an extent quite accidental.

Slussen, Stockholm. Aerial photograph, ca. 1935. Stockholms Stadsmuseum.

Although the design, developed between 1930 and 1932, made use of a clover-leaf pattern of connecting traffic ramps similar to auto-bahn junctions in Germany constructed half a decade later, and although it was contemporaneous with the absolute earliest split-level road system built in the United States at Woodbridge in New Jersey, the project in Stockholm had a different raison d'être from these automobile-driven examples. Slussen was developed not as an infrastructural device to let private cars travel faster but as a station: a place of pause; a place of temporary and temporal significance; and a place of transferal that made both a hiatus and a connection with a wider urban narrative. The generators for its design were electrical trams; its prime concern the occupants of these vehicles. The project dealt with a condition of spatial experience that was somewhere between stop and go, as people hopped from being passengers to pedestrians and back again. And it was conceived as an urban set piece, full of offices, shops, kiosks, and restaurants as well as platforms, traffic ramps, and lifts. To invent Slussen required elevations, perspectives, panoramas—devices of architectural mediation—as well as the plans and constructional sections that characterized highway engineering. The significance of the vehicles that were central to this project was understood early on as an architectural, as well as an infrastructural, one. Slussen's static forms in cast concrete and structural steel developed out of understanding a new kind of aesthetic experience of the city in motion, crystallized and distilled through technological innovation that characterized the years preceding its construction.

Three protagonists created this proposal. Yngve Larsson, born in 1881, was the city mayor for infrastructure and led the project; Tage William-Olsson, born in 1889, was recruited as the architect based on his previous visionary planning projects for the city; Gustaf "Gösta" O. F. Lundborg, born in 1898, was the consulting engineer of the city building office.[2] All three had spent formative periods of their young lives in Stockholm—Larsson and William-Olsson grew up in in the city; Lundborg moved there in 1902—periods during which motive technologies completely changed the way in which the city was encountered. Just after 1900, Stockholm began to electrify its main system of urban transport. The full introduction of electric trams after 1905 upended the way travelers navigated the larger urban milieu. As well as being rather quiet, electric trams could move quickly. Like trains, they ranged out into the country-side on dedicated rails, making suburbs quickly accessible. Unlike

Electrical trams at Slussen, under the Katarina elevator, winter 1905.
Spårvagns Museum, Stockholm.

trains, they mixed freely with other traffic in the center of the city. Where street-borne public transport had previously moved more or less at walking pace and could be boarded anywhere, electric trams accelerated and decelerated between dedicated stops. This both sped up life in Stockholm and created moments of pause at particular points. The change emphasized an urban condition that contrasted immersive experience in the street with a new sense of observation obtained within the glazed, fast-moving interiors of the tramcars themselves.

As in other cities, that slight doubling—in which inhabitants could see themselves alternatively as actors and spectators—was repeated in venues of consumption that this new system of urban translation served. Downtown, a Parisian-style department store, Nordiska Kompaniet, opened in new premises in 1915, and a new shopping gallery, Centrum, in 1931.[3] Both catered to the public gaze, setting consumers as actors in an urban scene. New technologies of urban recreation introduced roles of observation and display also into the city's parks. From 1883, Stockholm's first fun fair, Gröna Lund (Green Grove), and from 1891 its open-air museum, Skansen, offered visitors to the city's Royal Deer Park (Djurgården) a doubled experience of participation and spectating.[4] At Skansen, Stockholmers role-played at being farmers, hand cutting hay in the appropriate season. At the fun fairs (two in number by 1923), they rode rides with exotic names such as the Brooklyn Cakewalk and the Zeppelin Carousel.[5] Trams, shopping galleries, open-air museums, and fairgrounds produced embodied experience as well as entertaining spectacle. They woke a lively sense of participation, one in which movement was central. They also encouraged a new sense of identity: to be in these vibrant new venues was to be in several places at once—high in the air and down on the ground; in the city and simultaneously part of a rural scene; on the stage and in the audience.

This kind of experience was endemic for urban societies at the start of the twentieth century, but the weft that wove a communality in the international experiences of the urban came through the development of moving film. In addition to all the stimuli provided by electric transport, developing pleasure parks, and the development of commercial venues, the designers of Slussen lived through a period in which cinema reconfigured the experience of urbanity and the mechanism of the movie camera itself began to imprint the liveliness in big cities on collective memory.[6] In

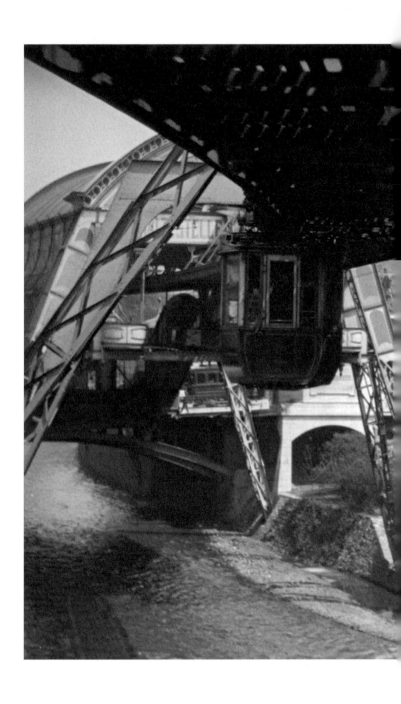

Film still, *The Flying Train* (Schwebebahn, Wuppertal), 1902. Scala Archives/MoMA.

its first years cinema was an urban phenomenon.[7] It filmed what moved against what did not, and the *topos logicus* for such experiments was to record traffic moving against an urban scene.[8] In the short films such experiments produced there was a very close relationship between where the films were shot and where they were shown—the double actions of recording and projecting were conceptually glued together in early cinema. This locality generated empathetic traction: people could "recognize" themselves in the picture. Almost the first example of this powerful technique was local to the childhood experience of Slussen's designers. In 1897 Alexander Promio famously filmed the Swedish king arriving at the Stockholm World Exhibition in the morning and showed the same king the film of his morning arrival in the afternoon.[9] Wherever cinema developed, city dwellers could see the environments they were familiar with reproduced on film in this way. Ubiquitous rather than a luxury limited to the elite, these experiences created a global evolutionary shift.[10]

The juxtaposition of movement and stasis that early film provided for urban audiences played out in two genres. Cameras stationed at fixed points recorded urban patterns that are extraordinary, still, to watch. Traffic is held in urban space in these films like a gas is contained in a vessel, various degrees of pressure resulting in various degrees of atomic agitation. A cyclist swerves to avoid a dray; horses' heads toss; a motorist squeezes in front of an omnibus; and pedestrians swim in between, like lose electrons. As well as recording city movement from a stationary point, early films often created "phantom rides," where the camera reproduced the subjective experience of a passenger traveling on a moving vehicle, a device later integrated into the art of shooting narrative film as the tracking shot. Phantom rides were usually made by mounting the camera on a smooth-running vehicle—sometimes a boat sailing on still water, more often a tram or a railway car. Like fixed-point shooting, tracking shots were used to record familiar scenes. But this second trope could include the openness of landscape as well as vistas of urban or suburban environments. Each technique revealed patterns of experience, repeated in the various loci in which early films were made and shown. On the one side, these films caught the previously indescribable teaming quality of early twentieth-century urban space and offered up its ingredients for analysis. On the other, they caught a condition of being moved

Part III: Vehicles 1890–1960

through this space in an apparently unbroken flow, as if one was both part of, and isolated from, the scene simultaneously.

In combination these two techniques showed the potential interaction of the congestion of urban settings with a sense of continuous, silent, distanced, magical advance. In a film from San Francisco in 1906 the camera, traveling down Market Street on a steadily moving streetcar, penetrates the random traverses of the city as it moves toward an ever-receding vanishing point.[11] In a Pathé film showing the Strand in London around 1910, lorries, buses, barrow boys, and horses coalesce into a single morphological composition.[12] A 1902 film made on the Wuppertaler Schwebebahn suspension railway sums up the eerie feeling many such projections produce.[13] Welding together the experiential potential of three revolutionary developments—electric motive power, advanced transport engineering, and cinematic mediation—it points toward a disembodied experience that was to become central to the twentieth-century imaginary: a sense of silent, apparently effortless flight. In such footage, an ecstatic moment of experience is evoked, one that creates a combination of waiting, reverie, passiveness, and progress.

Stockholm had a special place in this cinematic development, one which was maintained through the years in which Slussen's three designers grew to adulthood.[14] In the first years of the twentieth century Stockholm's many cinematographers constructed another version of the city in panning compositions recording quaysides and bridges, and in phantom rides that traveled its tram routes. The habit of presenting the architecture of the city on film continued through the 1920s and 1930s, where the narrative fantasy of the main feature shown in Stockholm's cinemas was usually preceded by locally focused newsreels.[15] Such films documented the interiors of the glitzy new Centrum shopping arcade and the festivals that took place among the imported cottages at Skansen.[16] They recorded the kinetic architecture that housed the experience rides in Stockholm's fair grounds and the grander events for which the city formed a backdrop.[17] They even recorded the architectural development of the city's own apparatus of cinematic display. The opening of new movie theaters was a regular feature in such films, and these buildings were crucial venues in the city. In 1928 the premiere of the Göta Leon cinema featured in a nationally screened newsreel journal; Flamman, a

Film stills, sequence on Vasagatan, 1909, from *Stockholm. Åktur med Ringlinjen* (Phantom ride on the Circle Line). Svenska Biografteatern SF 2061A. SVT Sveriges Television.

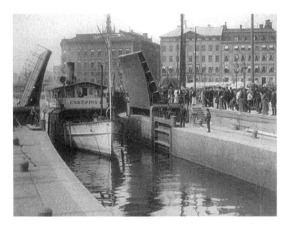

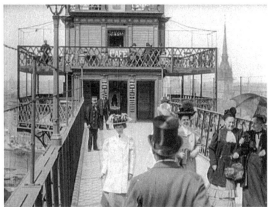

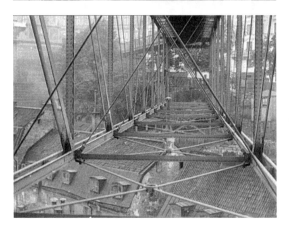

Film stills: lake steamer *Enköping* navigates Karl Johanssluss; view of Karl Johanstorg from Katarina elevator; promenade deck of the Katarina elevator; truss supporting promenade deck, viewed from lift car. From *Stockholm 1909. Katarina Hissen*, Svenska Biografteatern SF 2061C. SVT Sveriges Television.

flagship picture house completed in Stockholm in 1930, screened a Swedish Film Industry newsreel made to coincide with its inauguration.[18] In both cases the intricacies and multiple reflections that celebrated the urban manifestation of cinema are striking. The movies begin with shots of the new buildings under construction and follow up by describing in detail their urban context. People sat in the newly opened auditoria at Göta Leon or Flamman and met, on screen, a compressed history of the city quarter they had just left to enter the building, its landmarks recognizable but its morphology suddenly fluid, flickering before their eyes.[19] What the twentieth-century city was—potentially, culturally, functionally— was changed in these constructions. There was, it could be said, a doubling of doubling. In fun fairs, in pleasure parks, and aboard public transport, the city's inhabitants flickered between being participants and spectators. In the films made about these phenomena they flickered all over again, blown up and flattened into black and white moving images. There were, suddenly, two

Presentation of Centrum shopping gallery and inauguration of Flamman cinema. From SF Veckorevy, February 16, 1931, and February 2, 1930. SVT Sveriges Television.

Part III: Vehicles 1890–1960

Londons, two San Fransciscos, two Wuppertals. And indeed, two Stockholms: one situated in a present of functional problems to be solved (of goods, of transport, of politics, of distribution) and another, flickering within venues like the Göta Leon cinema or the Flamman picture house, that focused on future possibility.

Film and Design at Slussen

Film made the transient aspects of the urban realm suddenly and dramatically present. On screen, vehicles could be seen as they could not really be seen in situ; their fundamental contribution to the creation of urban milieu could be realized. And in its system of accounting, this testament to the permanent presence of objects in motion made it possible for the awareness of what traffic was, of what it meant spatially, to inform projects of urban design.

In 1929 Larsson, Lundborg, and William-Olsson became executive agents for a city commission set up to address the traffic problems of central Stockholm.[20] Particularly they were asked to analyze the area between Gamla Stan, the city's Old Town, and Södermalm, its southern island. The site was a circulatory bottleneck that combined urban pressure (land-borne traffic was squeezed on its journey across the city from north to south), interruption (this movement was traversed by boats traveling east to west through opening bridges), dense urban fabric (the sixteenth- and seventeenth-century structures of the Old Town and the southern island faced each other across it), and open landscape (it provided long vistas across the open water of the city's harbor).[21] But at the same time this place was a focal point in the flickering shadow of Stockholm portrayed on camera during the early twentieth century. It included a central space, Karl Johanstorg (Karl Johan Square), in which the effects of mixed traffic could be seen, and a giant public elevator, constructed by a Belgian firm of ironworkers in 1883 to connect the waterside level of the docks with the high ground on the city's southern island behind, which provided a viewing platform for spectators.[22] Because of its spectacular qualities the site attracted cinematic record. It figured in phantom rides aboard the city's trams. Film captured the trip up the Katarina elevator and the panoramic views of the city revealed in the ascent.[23] By the 1930s recording life in this area was a "darling" assignment for the city's cinematographers.[24] Indeed, this

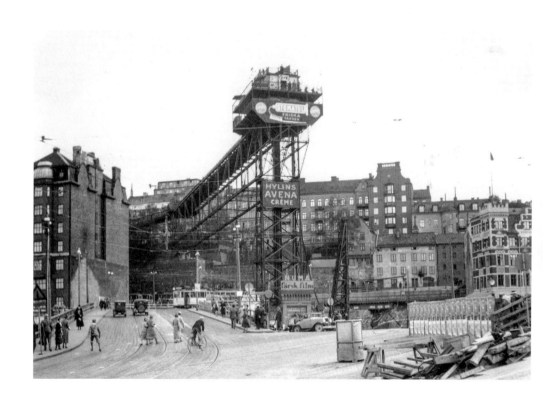

Illuminated sign for Stomatol toothpaste from 1909 and the advert for "Färsk Film" by the Numa Peterson company. The old Katarina elevator, Slussen, ca. 1932. Spårvagns Museum, Stockholm.

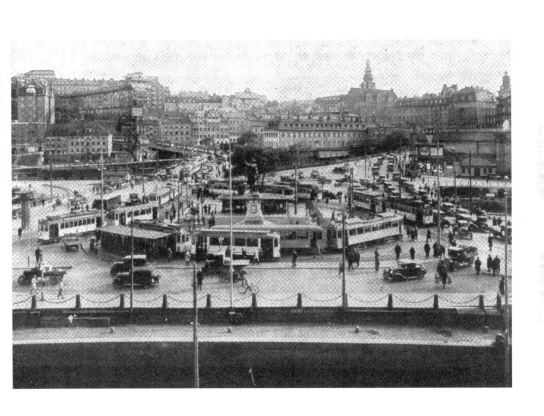

Photograph looking south selected to illustrate the site at Slussen, showing Karl
Johanstorg, the Katarina elevator, and the skyline of Södermalm. From *Teknisk Tidskrift*,
November 1932. National Library of Sweden.

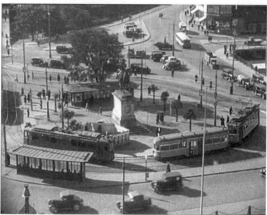

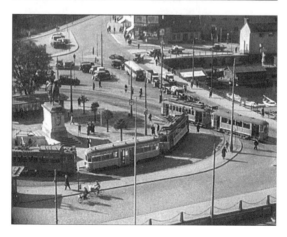

Film stills showing trams moving around Karl Johanstorg. Film based on footage shot in 1928, produced and shown during the initiation period of the 1930s Slussen project. From *Slussen 1932*, Svenska Biografteatern SF 1957. Stockholms Stadsmuseum.

identity was inscribed into the very structures that dominated the site. Photographs of the Katarina elevator show how the ornate brick entrance at the base of its skeletal iron tower was crowned by a sign advertising "Fresh Film" ("Färsk Film"), erected by the Numa Petersons handels- och fabriksaktiebolag (Numa Peterson's Trading and Production Company).[25] As a central actor in early twentieth-century cinema, this company not only held the Swedish licenses for Pathé newsreels until 1915 but was also the country's main provider of both celluloid film and film development services.[26] In such advertising messages Slussen and celluloid were to some extent synonymous. The site that Larsson, Lundborg, and William-Olsson were asked to reconceive was constructed in two different ways, therefore: first, it consisted of a geographically bounded area in the city crossed by a complicated net of routes connecting differing destinations; and second, it existed in a cinematic landscape that constructed its outlines in great detail and which articulated it as a place made by vehicles.

In both its real and its filmic dimensions, Slussen changed over time, a development in which the centrality of the vehicle was manifest. As traffic increased during the first decade of the twentieth century the mixture of vehicles and pedestrians became steadily denser. The congestion worsened during the second decade of the 1900s as more powerful electric motors allowed longer assemblies of tram cars (they grew from about 6 meters to 18 meters length overall). In 1921 extra pressure was put on the system when the tram lines in the north and south of the city were joined.[27] Slussen became known for its traffic jams: long queues of cars and lorries stretched along quaysides waiting to cross the water; knots of articulated trams formed around the central statue of Karl Johan on the square. Traveling north to south, drivers, passengers, and goods entered what the papers began to call *Slusseländet* ("sluice purgatory").[28] This increasing intensity, and the increasingly spatial component of the traffic that created it, showed especially in the filmic constructions of Slussen. The titles of a succession of film segments that mention tunnel proposals, bridge placements, tram traffic and congestion, control towers, and traffic problems in general, bear witness to this.[29] Developments in film editing reinforced awareness of these conditions. By 1930 clips showing Slussen changing over time were being cut together into complex and compelling compositions shown in large auditoria, often with a rhetorical purpose. Through such means urban sites could be cut

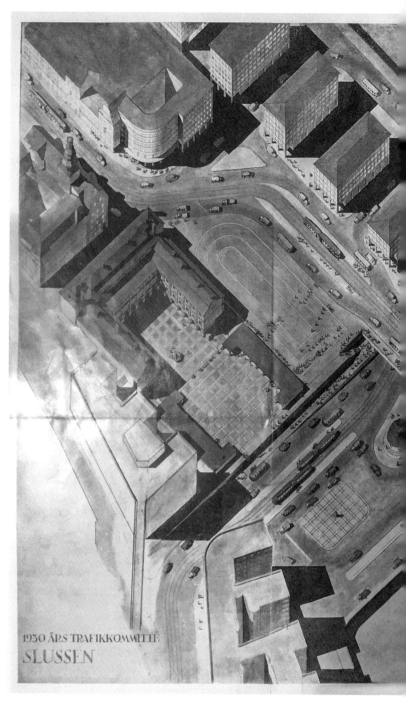

Tage William-Olsson. Aerial view of a project for Slussen, pen and wash, 1930.
William-Olsson family.

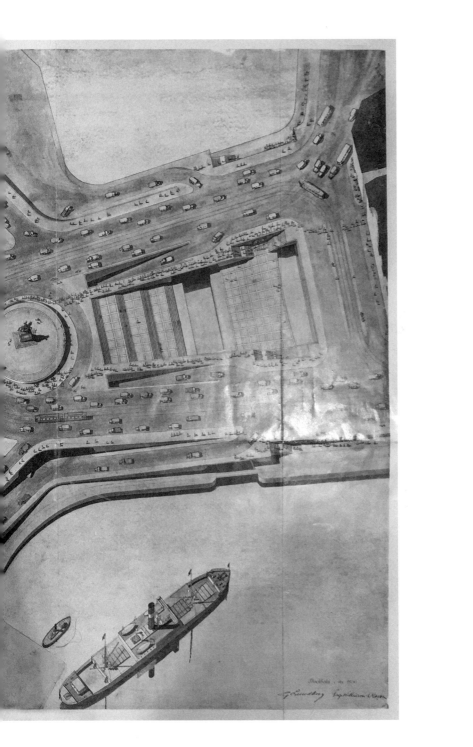

and edited, curated into an entertaining visual display: film could change what in other contexts was considered a major problem into kinetic, almost constructivist art.[30] While the real geography of Slussen produced frustration, its filmic geography, even when it was reporting on that condition, often provided a sense of flow, balancing accounts of congestion with a continued emphasis on movement: on trams gliding, bridges opening, the great Katarina elevator moving regularly up and down.

The designs to regulate the traffic around Slussen sought to move this dimension of entertainment evident on camera back into the real. The first moves made by Larsson, William-Olsson, and Lundborg instilled a sense of the experiential flow onto the geography of the site; their radical proposal for the redesign of roads, tramways, and railway lines derived not simply from addressing the mechanics of the traffic problem they faced, but of engaging with the visual effect this cauldron of vehicles created. In analyzing and describing this situation they adopted a photograph taken at high level, looking directly south over the central square that was the epicenter of the traffic problem.[31] This was not a view that was publicly available—it required access to a private roof—but it was a view familiar from cinema. The vantage point for this image was virtually identical to one used in a 1928 short film showing traffic in the area, sequences of which were reused in a 1932 Swedish Film Industry newsreel (which was thus being aired in local cinemas at exactly the same time that the committee worked on the Slussen project).[32] The image illustrated the condition produced when eleven tramway lines that crossed the site at Slussen merged on to one set of rails to navigate the opening bridge at its center. Where still photography eloquently showed the knot of trams that created many of the traffic problems the designers addressed, film vividly showed how this knot formed and dissolved through time.

This awareness of the temporal rhythm underlying congestion, as well as of the cinematic experience that traffic created, was to become central in the proposals for Slussen. To manifest the sense of movement that films of the area evoked, the designers made a first order spatial reorganization that folded the continuous ground plane of the site, on which trams and motor traffic met, onto a number of interconnected levels.[33] The earliest decision sorted the various tram lines into separate strips, creating an intersection that allowed one set of tram rails to cross above

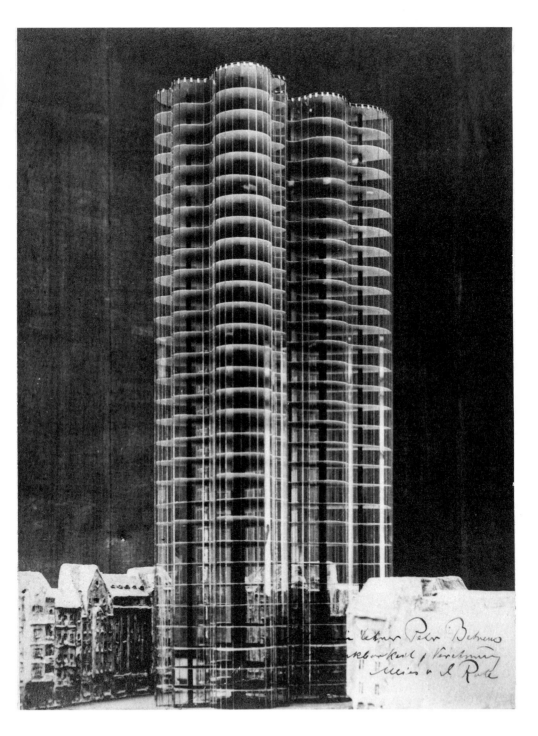

Ludwig Mies van der Rohe. Project for a glass skyscraper, 1925. Drawing Matter.

the other without meeting. The space for stopping was greatly increased, and the surfaces adjacent to the tramlines were widened to allow other traffic to pass. Thus the first radical design departure for which Slussen became famous, the split-level intersection between separated lanes of traffic, emerged out of an understanding of the temporal and spatial characteristics of the rooms created around vehicles, an understanding that only really became possible through the analytical potential of cinematic record. Between 1929 and 1931, Tage William-Olsson produced a series of plans showing the spidery lines of tram rails and their separa-

COLOR PLATE 19 tion into two systems.[34] In all of them, as in early cinema, traffic is treated as spectacle, and architecture is used to promote this spectacular quality, providing multiple locations from which the scene could be seen. In some sense, then, the whole of Slussen was treated by its designers as a movie house.

Stop/Motion

As Slussen's design matured, from 1930 to 1934, a reflective awareness was articulated at a societal level about the implications of film's descriptive potential and about its technical peculiarities. This followed a period in which film started to incorporate an understanding of its early technical apparatus into its narratives. Buster Keaton's *Sherlock Jr.* (1924) turned audiences' attention to the celluloid movie reel with its strips of black and white transparencies, its distinctive fringe of sprocket holes, and the mysterious way in which it recorded time.[35] *The General* (released in 1927 and premiered at the Skandia and Arcadia cinemas in Stockholm the same year), exposed the mechanics of tracking shots in its spectacular train chase sequences.[36]

Unsurprisingly this shiny new time-measuring medium had an emblematic quality that informed cultural production in many contexts. Mies van der Rohe's glass skyscraper project, for example, whose undulating, translucent facades and wafer-thin floors were spread in images throughout the 1920s, incorporated a set of attic sprocket holes, suggesting a fluidity of movement in its facades equal to that provided by celluloid.[37] By 1934 the same rich associative potential was emerging in native filmic productions aimed at Swedish audiences. The emotive and technical aspects of cinema overlap in the Swedish Film Industry's *SF-färden ut i världen*

Buster Keaton, *Sherlock Jr.* Metro Pictures Corporation, 1924. Alamy.

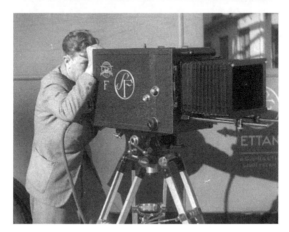

Gunnar Skoglund, Nils Jerring, Knut Martin, and Eric "Bullen" Berglund discuss the technologies of filmmaking. Film stills from *SF-färden ut i världen: Första resan*, 1934. SVT Sveriges Television.

("Swedish film out and about"), shown in almost all Swedish picture houses that year. The journey commences with a group of narrators sitting around a great barrel that spews celluloid strips containing the footage they are about to present; it concludes with a detailed filmic history of the movie camera, including an extended passage showing the internal workings of the Swedish Film Industry machine used to make the recording.[38] While Slussen's site was constructed through film, the proposals for its design were evolved in a context in which the technologies that constructed film were themselves being dramatized and made available as information.

What insights might arise though this technical awareness? Oddly, cinema could only create its illusion of continuity by breaking reality into a series of sudden movements separated by pauses of waiting between them. For the process to work, the film passing through the camera has to be held, stationary, within the gate for sufficient time to expose a frame on the celluloid. The light entering the camera then has to be shut off, and the film moved on so that the next frame can be created through the same process: 24 exposed frames on a strip of celluloid 496.4 millimeters long record one second of time. Even the sound made by silent film— the eerily familiar clatter of the early movie projector—was a tribute to this mechanism that kept tension in the celluloid to turn the reels continuously, while it simultaneously jerked and held the film before the gate. Film's promise of how to dissolve its disjunctive record of reality back into the perception of a smooth, nonhesitant flow was similarly embedded into the technology of projection. Here, a shutter mechanism redoubled the frequency of the flashing, exposed frames recorded by the camera (48 as opposed to 24 images per second; images can be exposed on the retina much more quickly than on celluloid). This trick removed for the viewer all sense that a hiatus of waiting was involved in the mechanism at all. Swedish Film's *färden ut i världen* made these workings absolutely explicit. Its audiences were both immersed in film's projected reality and aware of the mechanics that produced it. What a magical device, in terms of urban observation, the movie camera was! It provided an apparatus that ordered random moments of experience, revealed their patterns, and reduced them to a single line of images moving purposefully ahead, regular as a metronome. Where the melee of atomic behavior exhibited by traffic in a case such as that of central Stockholm resulted in congestion,

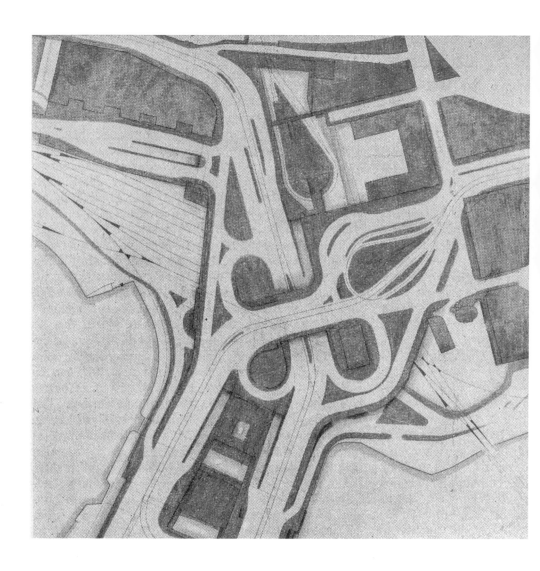

Rendering of Slussen's traffic lanes. *Teknisk Tidskrift*, November 1932.
National Library of Sweden.

frustration, and misery, a movie about that situation, itself based on a condition of stop-and-go, could smooth out jerky, interrupted experience and paint it into a progressive order.

In their very careful analysis of the conditions of transport in Stockholm, Larsson, Lundborg, and William-Olsson saw the traffic chaos of Slussen in terms that strongly parallel sensibilities emerging in film—that it might be possible to order a heterogeneous collection of experiences into a designed sequence; and that through technological design an appearance of flow could be created out of a reality that included a jerky stop/motion. The vehicles in which the designers of Slussen were interested behaved a bit like the succession frames on celluloid film. Trams crossed the urban scene in lines, but they couldn't move continuously. Rather, like the celluloid strip in a movie camera, they needed to pause regularly to absorb contents (their passengers) from the city, or to project them back into the urban realm. The solution to the traffic problems at Slussen relied on sorting out these lines into separate strips such that the temporary stoppage of these vehicles could be accommodated without interrupting the overall sense of flow. In this respect Slussen wasn't an exact precursor to the cloverleaf motorway intersection: it did not facilitate the high-speed interchange of private vehicles. But it did have many similarities to the mechanisms that produced cinematic illusion. Like a movie projector, it had to function with a stop/motion action such that various strips of public transport could enter the apparatus, pause briefly, and leave it again without disturbing the overall flow of experience. It was an assembly that created a space that was temporary yet not temporary—a place of pause made permanent through repeated instantiation.

It is this quality—to think of an urban assembly not in terms of destination but in terms of trajectory—that characterized the new designs for Slussen. Having adopted this strategy to think about public transport, the designers began to consider the conglomerate of pedestrians, cars, bicycles, barrows, and trucks that crossed the site also in terms of their common goals. Vehicles with otherwise unrelated trajectories were now considered as quanta that moved on predetermined lines connecting the major exit and arrival paths onto the site.[39] The spiral ramps that identify Slussen with the development of motorway intersections emerged as the designers investigated how to accommodate the variety of routes that motor traffic had to make in circulating around the trams.

In the triumphant 1935 *Teknisk Tidskrift* article that reported on the final elaboration of the project, Slussen's designers produced diagrams to explain how the traffic machine they had invented was intended to work, giving a filmic twist to this reclassification. Where the trams were marked by the continuous trace of their tracks, the lines of other traffic were represented as a series of closely linked, discrete packages, hurrying along one behind the other, each quasi-vehicle identified with a black indented rectangular frame, with a smaller back oblong inside it, closely followed by its identical neighbors. Here the variety of cars, lorries, barrows, and bicycles has been reduced in diagram to a celluloid-like black and white pattern defining destination—as if these streams of traffic too could be thought of as so many movie reels, to be spliced and housed in the new apparatus. In this analysis something of the quality attributed to trams—as containing experiences that could be absorbed from or projected back into the city—appears to spill over into the description of ordinary means of transport. We might call these ideated representations "image-vehicles," a term suggested both by the similarity of these diagrams to contemporary portrayals of movie-camera mechanics and by photographic documentation of the project as it was rendered in the early years after completion, that portray the image of Slussen carried on the windscreen of a moving automobile.

Here

At its opening in 1935 Slussen was celebrated with a newsreel film, *Från tradiselände till funkisfröjd* ("From tradition's wait to functionalism's fête" would be one translation), which presented the site's history, and explained the new design, using spliced sequences from early urban movies in a composition that reached every Swedish Film Industry cinema in the land.[40] It was narrated by Gunnar Skoglund, Sweden's best known newsreel voice and the same man who had been heard explaining the mechanics of the movie camera in cinemas the year before in Swedish Film's *färden ut i världen*. The film's cinematography resonates with the design sensibility of Slussen as built, and it employed a similar strategy to that used in the inaugural newsreels shown at the opening of the Göta Leon and Flamman cinemas in Stockholm.[41] The action begins with a spectacular fly-over shot of Slussen,

setting the new project into the context of the city. In an opening sequence the king describes the wonders of the traffic system that he is inaugurating, and the camera slides sideways to reveal "Film's Parnassus, Oscar Rydqvist," Stockholm's best known screenwriter, reading a film manuscript in front of Slussen's modernistic structure while he watches the event ("he doesn't have time for many scenes," notes the commentator).[42] The slight tedium of the mumbled royal address is alleviated by a beautiful intercut shot of the tower of the Katarina elevator, reconstituted in the 1935 design as a sophisticated electric passenger car. This piece of infrastructure, central both to the area's history and to its cinematic identity, then becomes a main structuring device in the narrative of the film. Two minutes into the six-minute documentary, a slow wipe creates a diagonal boundary that moves from right to left across the screen, clearly marking off the next section of the film as separate.

To break away from the present and into the history of the site, the gaze of the camera moves aloft in a tracking shot that uses the Katarina lift car as its vehicle, the diagonal movement that removed the king repeated as struts and braces cross the frame. The ascent is shot in the new Katarina elevator; a subsequent tracking descent in the original lift that was demolished to make way for it, observed in a film from 1922. The next four and a half minutes provide a retrospective of Slussen's history, spliced together from films of varying vintage, showing how Stockholm's cameramen recorded their favorite location over time: "1907: peace at Slussen; 1912: the restlessness of the times; 1922: the first trams cross the bridges." Slow panning shots describe the steady increase in the number and mix of vehicles between 1910 and 1930.[43] A binocular mask presents the additional complexities introduced by bridges and boats.

Following this an iris-in dissolve brings in a new theme, illustrating the pressing traffic problems that Slussen solved, while a final similar dissolve heralds the presentation of the current organization. The first iris-in, creating a sense of rotating urgency, introduces the immersive experience of the site during the late 1920s: pedestrians sprint last minute over opening bridges; traffic moves at double speed toward the camera; hurrying feet and wheels are shown close up. The second whirls the narrative back to the present and connects, in an absolutely explicit way, filmic rotary motion to the solution of organizing traffic through a similar orbit. Before it, trams struggle around the figure of Karl XVI

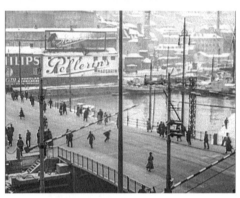

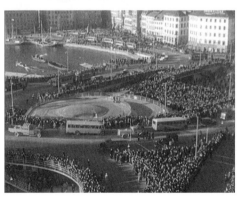
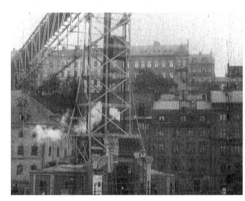

Film stills from *Från tradiseländet till funkisfröjd*. Newsreel celebrating the inauguration of Slussen, *SF Veckorevy*, October 19, 1935.

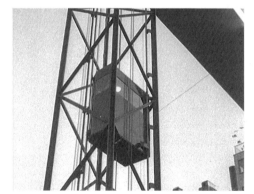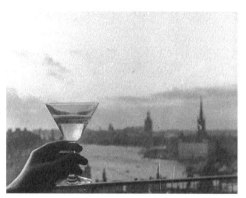

Johan, the first of the Bernadottes and the king's great-grandfather, as he stands central in his square around the year 1928. After the swirling dissolve Karl Johan has been wiped from the scene (balancing the first sliding dissolve that displaced his great grandson) and Slussen, constructed by social democracy, is revealed. The Bernadottes have left center stage; the revolving ramps of the new circulatory gleam smooth.

The film presents all the confused contents of this piece of inner city—cars and kings; bicycles and barrows; trams and trucks; bridges, people and trains—and orchestrates these into one coherent narrative.[44] The technique used—beginning and ending with the new construction; providing a microhistory of its locality through archive footage—is identical to that used in the newsreels that anchored Stockholm's new cinemas to the emotional fabric of the city. In the case of Slussen that microhistory was one of moving objects rather than stationary buildings, and the two main pieces of infrastructure used to structure the film reflect this. One is based on the vertical movement created by the Katarina elevator; the other on an emblem of spinning rotation. Both imply the architecture of Slussen as built and its debt to an embodied and local experience of movement. Two iris-in dissolves; two rotary traffic ramps. Two vertical tracking shots; a new and an old lift.

Elsewhere

At Slussen a combination of building and cinema curated the local, tying a project of urban transformation into the history of its context. In this filmic architecture the new was linked to the past, its adventurousness in some sense guaranteed through a combination of tectonic gesture and filmic expression, a means to create a sense of belonging that was similar to that used in venues where film itself became part of urban experience. In the cinema, this evocation of local identity was a first step in orchestrating an escape from the limitations of locality. Having seen their own environs projected before them, the audience at the inauguration of the Flamman cinema was asked "to forget where you are, and that your life is so much less eventful . . . than that on the silver screen."[45] Although accompanied by expressions of displacement, this kind of apparatus created a subtle join between local

identity and whatever location or chronology film chose to invent. Cecil B. De Mille's *The Ten Commandments* brought Luxor to Stockholm in 1923. United Artist's *Robin Hood* and *The Iron Mask* did the same job for Nottingham Forest and seventeenth-century Paris by 1930 (the latter forming the main feature at Flamman's inauguration).[46] Where Sven Svensson stood one moment, waiting for a tram, Douglas Fairbanks might feature the next, leading his band of merry men or foiling the evil schemes of Cardinal Richelieu. The mechanism of the picture house provided the runway for a flight of fancy in which participants were moved abroad; the juxtapositions it created could be seen either in terms of separation or in terms of connection.

In the urban planning of a traffic intersection one might think that the final aim would be rather different. Usually economic arguments for infrastructural investment derive from the sense that solving local problems saves lost time: urban commuter transport systems are concerned with the doughnut of working experience and not the hole of dreamlike possibility. Yet Larsson, William-Olsson, and Lundborg's rationalist composition of ramps and bridges also contained an element of pure fantasy. While the newsreel celebrating Slussen began with footage of Stockholm filmed from the air, it ended with the king's ascent, via the lift of the Katarina elevator, into Gondolen, a restaurant hung high in the sky directly above the circulating traffic. In that structure a remarkable pas-de-deux took place, in which two visions of escape, seemingly antithetical to the rationalist ethos of Slussen, interacted. Here the memory of mobile, engineered technologies permitted a fluid, even dreamlike, invocation of release in a way that parallels aspects of the physical screening of cinema. Where, at Göta Leon or Flamman, an introductory documentary that reflected local history gave way to narrative flights of film fancy transporting the audience abroad, Slussen spanned between rational traffic engineering on the ground and a fantasy in the air. The result is redolent of a new type of urban, or even super-urban experience that developed internationally during the 1930s, as political systems changed across Europe and as the reach of vehicular travel, as well as the industrialization of vehicle production, extended.

The inaugural film for Slussen closes with a toast made inside Gondolen: as the king holds his champagne glass, autumn afternoon sunshine pours through the windows of the restaurant,

making a silhouette of the cityscape behind. He is standing in a room constructed within the truss that supported a pedestrian bridge stretching out to the tower of the Katarina elevator, which stood in the middle of the Slussen project, from the quay-side headquarters of the Swedish COOP, Kooperativa Förbundet, or KF.[47] As in the 1883 structure it replaced, pedestrians could walk out to the top of this new lift; but where the original structure had presented a roof-top café above the lift itself, the 1930s structure slung this level of catering below the platform of the footbridge.

The COOP was Sweden's largest trade association, its largest nonstate architectural commissioner, and a fundamental limb in the creation of the Swedish welfare state. KF Huset, as the organization's headquarters were known, was included as part of the reimagining of Slussen in William-Olsson's visionary perspectives presented in the late 1920s. KF's in-house architects, Eskil Sundahl and Olof Thunström, reconstructed the existing row of early twentieth-century offices that made up KF Huset in a way that followed William-Olsson's sketches very closely.[48] Reclad, these read like a strip of black-and-white film celluloid, the last block in the strip, which overlooked Slussen's traffic system, resonating with the circular mechanism of the ramps that lay before it. The culmination of this piece of remodeling was the replacement of the 1880s Katarina elevator with a new, more compact electric lift, and the positioning of the restaurant hanging beneath the pedestrian bridge out to its head. The lift pierced all the multiple levels of Slussen's new design, offering a sectional experience of its system of functional separation. The restaurant provided an aerial view over the completed renovation.

Although housed in a structure that brought historical closure into the new project (the monumental truss of the first Katarina elevator was a mediated landmark through film), the design of Gondolen spoke of escape, of the tension between a familiar "here" and a dramatically different "elsewhere." In its naming and in its architectural expression, Gondolen identified Slussen with the most exclusive form of transport that the early 1930s had to offer, travel by airship. Since World War I the possibility of worldwide, lighter-than-air travel had been explored by the British Imperial Airship Programme, by the German Zeppelin company, and by a federal program in the United States.[49] With the airship *Graf Zeppelin*'s circumnavigation of the globe making headlines in 1929 and the risks of airship crashes still only partly understood, these

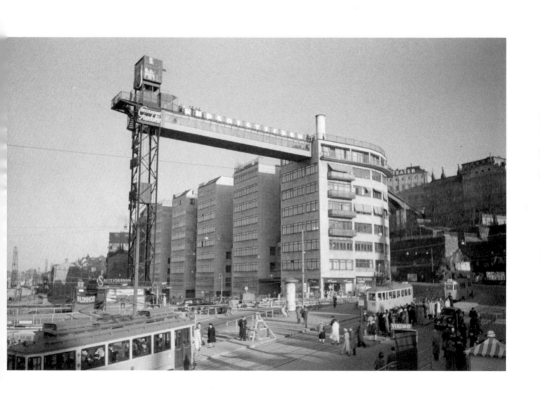

Konsum Förbundet headquarters, Katarina elevator and Gondolen restaurant, ca. 1935.
Stockholms Stadsmuseum.

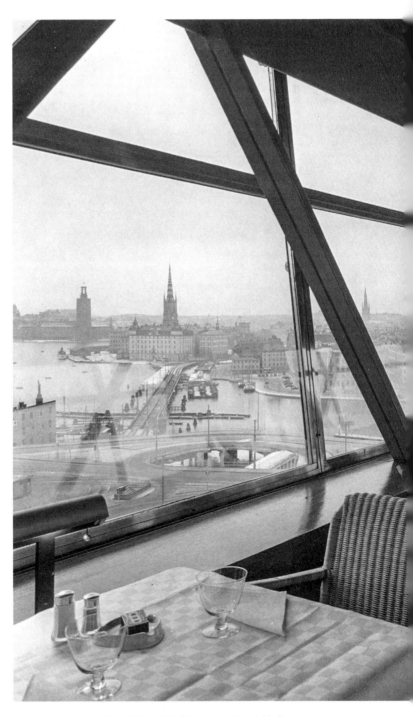

Interior, Gondolen Restaurant. Eskil Sundahl and Olof Thunström / KF Arkitekter, 1935.
ArkDes.

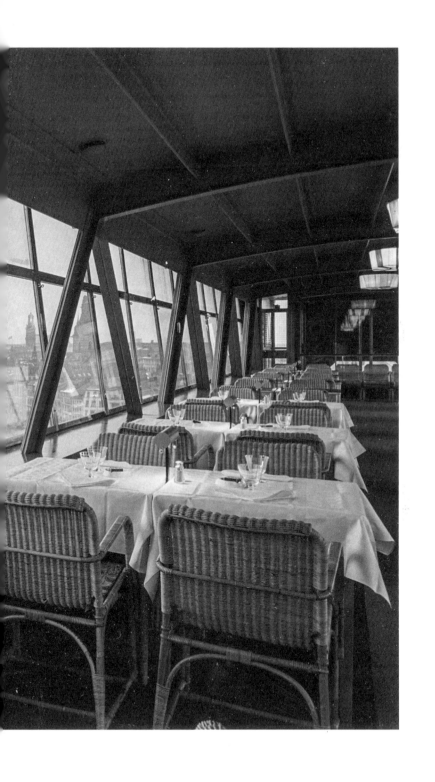

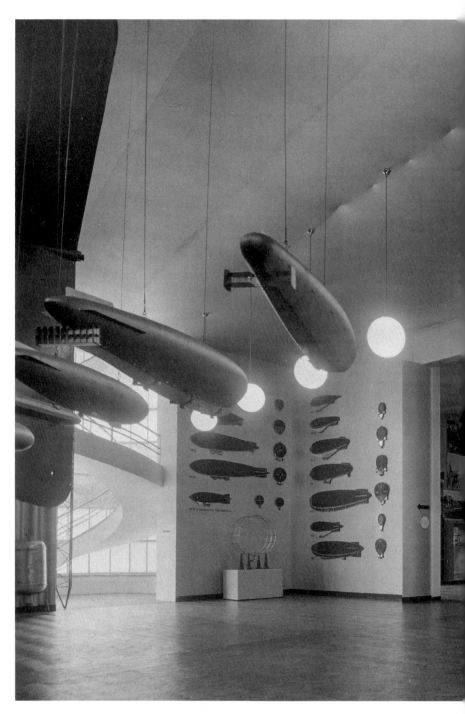

Gio Ponti. "Il più leggero dell'aria," room at the Mostra dell'aeronautica, Milan, 1934.
Triennale Milano.

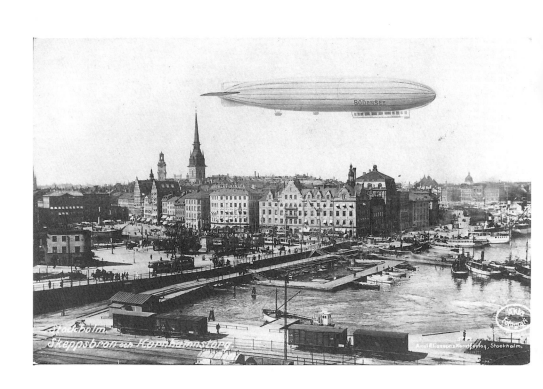

Axel Eliasson Konstförlag. Airship LV *Bodensee* over Slussen, photomontage, 1919.

weirdly beautiful machines embodied a future whose horizons seemed infinitely wide. The possibility they promised was vibrant in the European architectural imaginary during the early 1930s, its potential celebrated, for example in Gio Ponti's iconic exhibition room, titled "Il più leggero dell'aria" ("The lighter-than-air"), for the Mostra dell'aeronautica held at the Palazzo dell'Arte in Milan during the summer of 1934.[50] The conceit of airship identity was carried very far in the design of Gondolen. Its lightweight cane furniture closely resembled the chairs and tables of the British airship R101, promoted in press images of that project. The model for the interior design appears to have been the passenger lounge of Zeppelin's LZ 129, images of which were in circulation after 1930 (the sloping glazed curtain-walling and slanting roof in Gondolen are uncannily close to Fritz August Breuhaus and Cäsar Pinnau's drawings for LZ 129).[51] Larsson, Lundborg, and William-Olsson's COLOR PLATE 20 traffic interchange thus articulated journeys with an extraordinary breath of destination. For Stockholm's commuters the reorganization of the tram system through Slussen was advertised to cut the time to reach the center of the city from the southern suburbs from fifteen minutes to nine. The LZ 129, christened *Hindenburg* for her maiden voyage in early 1936, advertised the possibility of traveling from northern Germany to New York in two and a half days; to Rio de Janeiro in four. Like the movie houses playing films across the city, Gondolen moved its occupants virtually out of everyday Stockholm, collapsing distances like a telescope.

That an urban vision for traffic planning could hold such an idea of distraction sounds unlikely—perhaps even dangerous. Within four years of Slussen's completion the implications of such a fusion would be immortalized in James Thurber's short story "The Secret Life of Walter Mitty."[52] In a 1939 edition of the *New Yorker*, on the eve of a war to be fought in the skies, Thurber introduced the eponymous Walter piloting a "huge, hurtling eight-engined Navy hydroplane" while simultaneously driving his wife across town in their family sedan ("'Too fast! You're driving too fast,' said Mrs Mitty"). And indeed were it only an evocation of an airship, Slussen's restaurant must needs be read in terms of a similar tragicomic disconnect between the aspirations of commuter as hero and reality of commuter as slave. But these different ideas about speed and association—the one intercontinental, the other suburban—met in a more holistic way in Stockholm. In 1919 Axel Eliason, a firm of photographers famous for producing postcards

of the city's landmarks, manufactured an image portraying the first long-range Zeppelin, LZ *Bodensee*, hovering over the site where the Gondolen restaurant was later to be moored. Although the postcard itself was a photomontage, the event it recorded was real: *Bodensee* visited Stockholm in October 1919 and made a tour above the towers and landmarks of the city. The illustrated weekly *IDUN* estimated that 10,000 people gathered to watch the airship land; thousands more watched its ariel tour from rooftops and balconies.[53] While airship travel was far out of the reach of Stockholm's commuters as they crossed the city (the passengers on the 1919 Berlin-Stockholm *Bodensee* trip were exclusive souls such as Axel Wennergren, the founder of Electrolux, or the racehorse owner Josef Berghoff), there was a local memory attached to the image of an airship over Slussen.[54] As almost everything else, this memory was caught on film, in a Swedish Film Industry weekly journal from October 10, 1919; the flyover shot that introduced the film inaugurating Slussen in 1935 was a replay of an exactly similar aerial sequence portraying Slussen, filmed almost certainly from *Bodensee*'s gondola and shown to Stockholm's inhabitants sixteen years earlier.

Fun Fair

The photomontaged, artificially created *Bodensee* conjured up a second precursor to Gondolen, one that brought the fantasy the restaurant projected much nearer to problems of urban engineering, to the material reality of city commuting, and to the earthbound mechanics of the electrified, automotive tramway. East of Manhattan, at the end of New York's urban rail system, lies Coney Island. South of Blackpool in Lancashire, England, opposite the tram terminal, lies the Pleasure Beach. Fronting Copenhagen's main railway station lies the Tivoli amusement park. East of Slussen, terminating its view down the harbor, lies what in the 1930s was Stockholm's equivalent leisure venue, the Royal Deer Park, with two fun fairs spread along the waterfront and the Skansen open-air museum on the high ground behind, its clock tower silhouetted on the skyline. Like the combination of media and architecture that informed Slussen—and like its cousins in New York, Blackpool, and Copenhagen—the Deer Park in Stockholm brought

fantasy and reality close together. On the October day Slussen was inaugurated, the fun fairs and the museum, the summer attractions, stood empty. But Gondolen's passengers would know that at Skansen, come spring, folk would be visiting farmhouses from Sweden's remote regions; that in the Green Grove amusement park they would be boarding a variety of fairground attractions.

The Deer Park carried memories that connected immersive, translative experience with distant geographies, a proximity invoked by creating *topoi*—sometimes fictional, sometimes briefly real—that collapsed the distance separating Sweden from the rest of the world. Periodically the park contained great exhibitions—the 1897 world's fair was sited here (the place where cinema first came to Stockholm), as was its successor, the Art and Industry Exhibition of 1909. The Zeppelin airship *Bodensee*'s 1919 touchdown took place in the Deer Park, on the old miliary exercise grounds behind the diplomatic quarter of the city. "By two o'clock you could read the Berlin morning papers" commented *IDUN*, "it's not so far from Queen Street to Unter den Linden."[55] In 1930 the Stockholm Exhibition advertised modern Swedish design for an international audience in the same location, opposite Skansen along the canal that split the park in two.

In the decades between 1895 and 1935, the park provided an ever-increasing array of mechanisms that reified transient experience and evoked geographical translation. The 1909 Art and Industry Exhibition offered visitors a helter-skelter (an import from the British seaside resort of Blackpool) and a gravity log flume (invented in the United States). In 1931 the Green Grove fairground took over the rollercoaster from the Stockholm Exhibition (another ride that referenced America). Along with the Pariserhjulet (Ferris wheel, 1898), the Brooklyn Cakewalk (1910), and the Hollywoodbilarna (dodgems, or bumper cars, caught on camera in 1928), the fairground's owners commissioned a Zeppelinkarusell (which arrived four years before *Bodensee*, in 1915); Babylon (a mechanical fun palace from 1917); and an Aeroplankarusell (aero-carousel, 1919).[56] To be in the Deer Park was thus to be in many places—Paris, Brooklyn, Hollywood, Babylon—an identity that might be construed under the word "venue" rather than "destination." Another kind of doubling through mechanical translation, this time chronological rather than spatial, applied at Skansen. Here the museum constructed two experience rides in order to link the present and

the past: a funicular railway, built after 1906, and one of Sweden's first escalators, initiated in 1932 and inaugurated by the king in a ceremony almost as fancy as that for Slussen, in 1938. Like the elevator in the Slussen newsreel film, funicular and escalator created a movement back in time, connecting the museum's entrance turnstiles to a never-world plateau of past experience high in the park. Helter-skelters and log flumes, rollercoasters and Zeppelin Carousel, funicular and escalator, all created strong impressions that contributed to memorialize the scene.

The site at Slussen had a preexisting connection to this atmosphere of venue that defined the pleasure park. In the 1970s Yngve Larsson, recalling his actions as a main political agent in Stockholm's urban development, described the site in exactly these terms. As an undergraduate sometime around 1902 he had traveled here for pleasure, paying a taxi to travel round and round Karl Johanstorg, and riding with friends up and down in the Katarina elevator.[57] In the same years the lift provided a platform for circus-like acts of acrobatic daring. On January 18, 1912, Fritiof Malmsten and his brother Helge balanced head-on-head atop the tower, with Fritiof, beneath, mounted on his bicycle; the two were caught in their turn on camera.[58] The redesigned Katarina elevator also identified the new Slussen with the spatial ambivalence of its cousins, the fairground and open-air museum. In its 1930s incarnation, which exaggerated slimness and emphasized the panoramic views that could be gained from the glass lift car, the elevator came close to providing experiences available at the Green Grove fairground. Larsson, Lundborg, and William-Olsson's proposals at Slussen would also include an escalator to move passengers through its various levels, planned in the shadow of the project being developed to move audiences between past and present at Skansen. Gondolen itself makes a final reference to this mental twinning of traffic hub and recreational venue. The restaurant is evocative of an airship, yes, but of an airship mediated using the mechanical contraptions that made up the experience of fantasy travel in the local urban realm. By the time the restaurant was constructed the Zeppelin Carousel at the Green Grove fairground had been superseded by other more advanced rides. But this airship-eatery at Gondolen played in an economy of experience that was aligned with such structures, combining pay-to-enter access and contrived experience.

Film stills: Skansen funicular railway; helter-skelter; log flume, 1909 Art and Industry
Exhibition. From *Stockholm 1909*, Svenska Biografteatern SF 2061B. SVT Sveriges Television.

Film stills: Fritiof and Helge Malmsten atop the old Katarina elevator, Stockholm, January 19, 1912. SVT Sveriges Television.

Gondolen cannot be explained using rationalist explanations of function on which the rest of Slussen was based: it did not solve problems in the way that the traffic engineering beneath it did. But it provided a locus from which the entire order of the new Slussen could be appreciated. As you looked west from the restaurant, you saw lying on the ground something that bore a strange resemblance to an enormous movie camera, its body housing mechanisms that turned halting urban flow into smooth-running experience, its ramps guiding film-reel-like lines of moving traffic. As you looked east, Gondolen provided views toward a site that linked technological innovation with sensory release in the pleasure grounds at Skansen and the Green Grove. The restaurant celebrated the heights of luxury travel, evoking that experience using a cinematic mechanism of displacement. But it also emulated a local destination, highly accessible, where an embodied and affordable feeling of escape could be gained through technological sleight of hand.

What kind of place was being created here? In conceptual terms this construction adumbrated neither the space of unmitigated flow associated with a traffic interchange, nor the stasis of a piazza within the city. Rather it had something of the characteristics of train terminuses, movie theaters and amusements parks—places where people assembled to be transported, physically or virtually, elsewhere. It acted as a relay within a wider field of experience. It bound into its articulation a memory of other objects that existed in other places in that field. Indeed, in a dramatic way, Slussen reified the potential of the motive force that bound all these places together. In Stockholm, as in Wuppertal, Paris, Blackpool, or New York, the elaborate relationships that existed between urban infrastructure and cultural context were electrified. If the Deer Park with which Slussen resonated provided Stockholm with its equivalent to sites such as Coney Island on Long Island or Blackpool Pleasure Beach in the UK, (both opened during the 1890s), or to the Tivoli in Copenhagen (from 1843), then in Stockholm, as in these other loci, the development of such attractions paralleled that of electrically motivated commuter transport. Up until the 1920s tramways were the principal users of electricity in the urban locales that possessed them. In Stockholm a map of early electrical

substations and a map of tram depots are identical. And while the tramways' demand for power was key to the spread of electrical connection, the electrification of leisure venues was often wired into the economy of supply that sustained the trams.

The demand for electrical power created by the trams fluctuated diurnally and seasonally. The amount of power provided by the electrical companies, on the other hand, tended to be constant: because it was delivered through high-voltage direct-current power lines, there was no very easy way of cutting electricity supply when it wasn't needed. And there was no very easy way to store that energy at its point of consumption once it had been produced and distributed. In New York this condition became one of the motives for establishing Coney Island, whose largely electrified amusement rides consumed excess power when the commuter transport system was slack, and whose popularity increased the time span when electrically powered trams could operate profitably.[59] Stockholm too exploited an economic system for using the excess potential energy in its electric system to generate cultural thrill. The amusement park provided a means by which the overhead cost associated with providing sufficient electrical supply to meet peak consumption in the tram system could be met. Trips to the pleasure grounds increased tram use in off-peak periods, producing additional fares for the tram system; the experience rides those people visited used surplus electric power to operate, and generated income to pay for it. In terms of energy consumption, then, tramway and amusement park were part of a single ecosystem. As was the case in Coney Island or Blackpool, the pleasure grounds in Stockholm were located at the terminus of the tramway system that both brought urban audiences and motive power to them. The pleasure park was part of the very development that Stockholm's traffic planners were regulating.

The place Slussen created, then, was not so much identified by a single locus as it was by a field condition; one in a collection of spaces in which resonant effects were created through electrical agitation. These links between urban transport, electrical power, film, and leisure experience were well articulated in Stockholm. The electrical transformer building constructed in 1903 to provide power to the Royal Deer Park (for tramway, exhibitions, fairgrounds and open-air museum) was housed in an ornate building between Skansen and the tram line; a combination of royal, electric, and transportive emblems were carved into its stone

Part III: Vehicles 1890–1960

decoration. It was designed by Ferdinand Boberg, who was also architect for the 1909 Art and Industry Exhibition, a venue that was to be sited slightly east of the substation and which used 10,000 light bulbs to create its experience, recorded carefully in newsreels of the time.[60] Even before the 1930s traffic system was constructed, links and potentials relating to electrical articulation were evident at Slussen. Not only did the original Katarina elevator carry a sign for Numa Peterson's "Fresh Film," but from 1909, at the top of its tower, Sweden's first animated, electrically illuminated advertising billboard blinked messages about Stomatol toothpaste into the night sky.[61] The sign was erected concurrently with the display of electrical potential demonstrated at the Art and Industry Exhibition across the water. The identity between Slussen and the pleasure park was framed by such references to their common exploitation of electric power.

The construction of the 1930s plan for Slussen rearticulated both the centrality of film and the centrality of electric power to Slussen. Tage William-Olsson's most vivid colored perspective of the project adopts the same filmic aerial perspective as several other early visualizations, but portrays the site at night, a brightly lit wonderland illuminated by a grid of hanging, electrically powered globes above the silently moving electric trams. An awareness of how electrical power created effect at Slussen is also evident in documentary photography showing how the complex was lit at night. And in its closing scene, Slussen's inaugural film salutes the centrality of that magic, invisible motive force in the creation of an uplifting social experience. The new Katarina lift car, a "slender functionalist sky-shooter," depends on "spinning ASEA electric motors" to lift "king and commoner up to the glass-display-case restaurant in the sky."[62] Where electricity powered the cameras that recorded all this and the projectors that made that record public; where it allowed the rollercoaster to twist tramlines into ever more unlikely spatial combinations in the sky and permitted Zeppelin rides and aero-carousels to provide an experience of urban flight, at Slussen the same motive power supported both the requirements of an effective transport system and the dream of escape from the city it served.

To acknowledge a productive connection between the earnest job of city planning and the flights of fancy played out in venues such as Stockholm's pleasure grounds and cinemas may require some effort. Fairgrounds and movie theaters tend to be

COLOR PLATE 21

Slussen looking toward Södermalm, 1935. Stockholms Stadsarkiv.

read as places of excess: locations where time is seen as a commodity to be purchased; where surplus capital can be squandered. Urban transport systems, on the other hand, are places where time is seen as a cost to be saved; where spending occurs only in the interest of a greater economy. If a good fairground connotes excess, a good transport system connotes thrift. The lesson of Slussen, a design produced in a socialist welfare state, appears to be different. Here bodily and individual experience are regarded as a kind of capital; the production of such experience through works of kinetic engineering is given value; and the whole, apparently, can become charged with some mnemonic potential that makes sense of the city. This lesson is also about vehicles. The potent carriers central to all these mechanisms were those electric trams, whose silent progress still woke comments during the 1930s as the Stockholm film industry embraced sound and color production and began to market Sweden for audiences abroad. A kind of movie house on wheels, the tram was the place where the whine of electric motors, the glide associated with magical, disembodied motive power, the glass screen that surrounded a moving interior from which the city could be seen like a ballet, and the constant modifications to urban space consequent on the moving cars, all met. To experience a tram was to experience an extremely complex index of the relationships between movement, vehicles, passengers, and urban experience, an understanding that could imprint on projects of design. Stockholm could no more be removed to the continent during

FRONTISPIECE the 1930s than it could during the 1760s. That dream of physical urban translation so poignantly sketched by Carl August Ehrensvärd in the eighteenth century remained as remote in the twentieth. But while Ehrensvärd had to content himself with a small drawn fantasy of removal, his equivalents in Stockholm during the 1930s had very much more advanced possibilities for creating this feeling of freedom. The city could not become an airship. But it could become a fun fair—in the best sense, a place that provided pleasure and equity, a dream factory based on human-scale actions of suspension and removal. This is the charm of Slussen as completed in 1935, with its movie camera ramps and its crazy skyline restaurant.

In the rebuilding of Slussen that necessitated the demolition of all that 1930s invention, such lightness is hard to find. Rotating ramps and skyborne trams have been replaced by an eight-lane road bridge transported from China and some traffic lights. Acres of steps will provide (hopefully) nice places for tourists to sit. But as a celebration of the vibrant, kinetic qualities of the city, Slussen's twenty-first-century replacement appears dull indeed: like a piece of well-landscaped motorway between intersections. Gondolen's suspended restaurant and its glass lift will be preserved, but the infrastructural dance it once surveyed will be played down: a new park, rather than intersecting railways, will lie visible at its feet. The curious journey of the golden bridge, with its gyrations and waitings, is perhaps the only aspect in this new project that preserves some of the dynamic potential of its predecessor. And indeed the arrival of the bridge in Stockholm provided entertainment during the pandemic for the dreary, quarantined city in March 2020. Observers who stationed themselves on Kastellholmen, the point from which Olof Årre drew his beautiful panorama of Stockholm in the 1760s for Fredrik Henrik Chapman's *Architectura navalis mercatoria*, were rewarded by a truly dramatic naval spectacle during the days that the bridge was installed. This included the sight of the enormous *Zhen Hua 33*, whose tonnage exceeded that of the entire fleet Årre pictured, submersing herself to release her cargo; of the bridge, borne aloft on floating pontoons, being shunted slowly into position in the midst of the perspective. But this was a one-off event, finally mundane. While the virtual possibility of lighter-than-air flight evoked at Slussen in 1935 still appears inspiring and futuristic, the intercontinental transfer of thousands of tonnes of steel to form that structure's replacement already appears problematic and outdated. City propaganda motivated the decision to remove the 1935 project with an assertion that we would reclaim Slussen as a place for human meetings: *Från trafikplats till mötesplats* ("from traffic junction to meeting place") ran the publicity slogans. But Slussen never was simply a traffic junction; neither was it a single destination. With its references to kinetic memory, to fun fairs, to pleasure parks and to film, it spoke of a new, and still contemporary, notion of architectural place as multiple; a vehicular construction in which the logic of a single spatial identity is questioned, and in which the duality of a here-ness and a there-ness is inbuilt.

Afterword: Venezia Santa Lucia

Can good history be autobiographical? Gertrud Bing would have answered yes. The writing of history is by its nature conditioned by the experiences of the writer; the absolutely personal and the dispassionately intellectual are joined. There is an autobiographical element to the selection of histories I have presented here. Ships run in my family. Childhood holidays were spent in the extraordinary galleries of the old Maritime Museum in Greenwich, between eighteenth-century models of ships-of-the-line and miniatures showing London's megalomanic nineteenth-century docks. An 1877 copy of the *Illustrated London News* that reported the loss of *Cleopatra* in the Bay of Biscay was a family heirloom: the captain who gave the order to abandon ship, and who provided the eyewitness account reported in the paper, was a thrice-great uncle. The experience of climbing the cupola of Santa Maria del Fiore etched itself into my eight-year-old memory on holiday in Italy and the construction of the dome became the subject of an architectural thesis; Alberti's *De re aedificatoria* and of the interiors of the Warburg Institute were explored during a doctoral dissertation; a journey from my apartment in Stockholm to the city's Royal Library, where most of this book was written, passes the Gondolen restaurant that still hangs above the traffic intersection at Slussen. Nevertheless there are analytical themes that join the stories connected with these memories: a focus on the mnemonic potential of movement experienced within a fixed spatial frame; the close links that exist between wandering and rooted identity; a concern with the emotive potential of technical process, both the everyday and the extraordinary; the relation between mediated image, experience and material artifact.

Permit me, then, one final scene that encapsulates the account of architecture presented in this book, and which represents the elements that bind together its chapters. The year is 1988; I have completed five out of six years in architectural education, and I am playing hooky from school, returning to England after a visit to Venice. At Santa Lucia railway station I await the departure of the "Rialto" Express bound for Milan and Paris, a copy of the 1988 *Thomas Cook European Timetable* in my hand. The train has four sleeping cars, three couchette wagons, a bistro, and sixteen standard coaches, each with a corridor linking nine compartments, their occupants disposed in two rows of three seats face-to-face.

One common feature all these interiors share: in each there is a wide, horizontally split window, the top half opened by sliding it downward over the bottom half; a notice, *È pericoloso sporgersi. Non gettare ojetti dal fenestrino*, cut in light relief into an aluminum sign screwed to the lower sash. It is a warm evening; every sash is open. Heads crowd against the windows looking out; beneath them a corresponding group look up in conversational goodbyes. The anthropometrics of train design and the height of European platforms (always lower than their British counterparts) mean that an average person standing with arm raised outside the train can brush fingers with an occupant reaching down from the open window of a compartment within it. The train is crowded; the station a hum of conversation as perhaps a thousand passengers touch hands with friends on the platform, each live contact a tiny force of attraction holding the long line of wagons in place. A century of technical development means that the change from stasis to movement as the electric drive-unit sets in motion its twenty-four coaches is imperceptible. Suddenly the train is moving. For perhaps half a second the elastic force in the thousand pairs of hands maintains their contact; suddenly that contact breaks. There is a physical release of tension. A sea of people united in parting are now separated into two groups, voyagers and stay-at-homes. For the stay-at-homes, the wall of coaches along the platform edge becomes a void; for voyagers, where carriage windows looked out into the lofty interior of the terminus, they now regard the Venetian lagoon and islands stretching to the horizon. The train gathers speed.

There was in this moment something intensely architectural. Space was made and remade in the redisposition of metal, plastic, and machinery. Rooms altered their character or exaggerated their identity. Emotions were in play. But it was an architectural experience that none of the accounting systems I had learned at architecture school could really describe. It had no single author; it was transient; it did not arise exactly from any act of delineation that defined form, although it was contingent on a series of design decisions governing the artifacts in question. It was not technical, although it relied on orchestrated technologies. It was every day; it was repeated; it was created by a tacit agreement between a community of actors who participated in it and the faceless organizers of the infrastructural systems in which it took place. It was primarily visual and retained as an image in memory. And it was as

powerful as any of the other set pieces I had learned to love in my architectural education: a refined plan; a beautiful window detail; the elegance of a carefully orchestrated spatial sequence; whatever magnificent play of forms in light.

As she completed To the Lighthouse, Virginia Woolf recorded in her diary a first intimation of what was to be her next and perhaps most famous novel, which came to be called The Waves: "A fin breaks far out." The figure of remembered experience as something that might break from the deep, something that needs patient observation to catch and to describe, was one she used repeatedly in *The Waves*, particularly in the speech of Bernard, the narrator-author who seems most of all to carry her voice. And she returned to the image in her diary as she concluded the novel:

> I must record, heaven be praised, the end of *The Waves*. . . .
> How physical the sense of triumph and relief is! . . . I have
> netted the fin in the waste of water which appeared to me
> over the marshes out of my window at Rodmell when I was
> coming to an end of *To the Lighthouse*.[1]

The previous pages are an attempt to place, if not a net around, then at least some marking tags on, a similarly elusive architectural reality.

Acknowledgments

This book was produced within the context of the Oslo School of Architecture and Design. I would like to acknowledge with thanks the support of all my colleagues there who read and commented on the various chapters at various stages. Thanks to Mari Hvattum for the chance to join two ongoing projects within the Oslo Center for Critical Architectural Studies (OCCAS) both of which provided inspiring networks: the Norwegian Research Council-funded "The Printed and the Built. Architecture and Public Debate in Modern Europe" and the EU Hera-funded "PRIARC: Printing the Past. Architecture, Print Culture, and Uses of the Past in Modern Europe." From these contexts I would like to thank also Richard Wittman, Adrian Forty, and Barbara Penner for their valuable comments on the work. For tips on ships, thanks to Desmond Kraege and John White; for invaluable advice and extraordinary insight into the world of Aby Warburg, thank you to Claudia Wedpohl, Elizabeth Sears, and Uwe Fleckner.

Early versions of the project were presented in seminars at the Architecture Space and Society Centre, Birkbeck College, University of London; the V&A / Royal College of Art Design Histories Public Programme; the CRASSH Centre for Research in the Arts, Social Sciences and Humanities at the University of Cambridge; and in the director's seminar series at the Warburg Institute, University of London. My thanks to Leslie Topp, Simona Valeriani, Caroline van Eck, and Bill Sherman for these opportunities. *Things That Move* originated as a research project funded by the Swedish Research Council and was further supported with funding from the Swedish FORMAS Strong Research Environment "Architecture in the Making." I would like to thank both bodies for their support and to thank friends from Sweden who have contributed to the thinking in this book: Thordis Arrhenius, Helena Mattsson, Catherina Gabrielsson, Anders Bergström, and Fredrick Nilsson. For help with sourcing images I must acknowledge the kind help of Maria Bergenman at SVT/Sveriges Television archive, Åsa Märing at Stockholms Stadsmuseum, and to the invaluable reprographics department at the Royal Swedish Library.

At the MIT Press I would like to thank Matthew Abbate and Mary Bagg for patient editing; at home, my family for patiently waiting. Finally, very warm thanks to Thomas Weaver for his wisdom and calm support, and to Mari Lending for her eagle eye and frank advice.

Notes

Introduction

1. Thomas Noble Howe, "Illustrator's Preface" to Marcus Vitruvius Pollio, *Ten Books on Architecture*, trans. Ingrid D. Rowland, commentary and illustrations by Thomas Noble Howe (Cambridge: Cambridge University Press, 1999), xv. Referenced hereafter as Rowland and Noble Howe.

2. The treatise was composed by the architect Marcus Vitruvius Pollio and dedicated to the Roman emperor Caesar Augustus around 25 BCE. On the history of the text see Indra Kagis McEwen, *Vitruvius: Writing the Body of Architecture* (Cambridge, MA: MIT Press, 2003), 1–10, and on its dating, 305n2.

3. Marcus Vitruvius Pollio, *De architectura*, British Library Harley MS 2767. Accessible online at https://access.bl.uk/item /viewer/ark:/81055/vdc_10005 6038850.0x000001#?c=0&m =0&s=0&cv=0&xywh=-2269%2 C0%2C9301%2C5965. Referred to hereafter as Harley.

4. Book I, f.1r–f.17v, 35 text blocks; book II, f.18r–f.35r, 36 text blocks; book III, f.36v.– f.47r, 22.5 text blocks; book IV, f.47r.–f.58r, 22.5 text blocks; book V, f.59r.–f.75v., 33.5 text blocks; book VI, f.75v.–f.90v., 29 text blocks + 1 blank page; book VII, f.90v.–f.107v., 33 text blocks + 1 blank page; book VIII, f.107v.–f.123r, 31 text blocks; book IX, f.123r.–f.139v., 33 text blocks; book X, f.139v.–f.139v., 44.5 text blocks + 1 blank page).

5. This formulation is used in what is still the best English translation of Vitruvius: *The Ten Books on Architecture*, trans. Morris Hicky Morgan (Cambridge, MA: Harvard Univer- sity Press, 1914; reprinted New York: Dover, 1960). Referenced hereafter as Morgan in the 1960 edition.

6. Harley, f.8v.

7. Harley, f.8v.

8. Vitruvius, *De architectura* I, III:1, 16 (Morgan). Rowland and Noble Howe replace "the art of building" with "construction," removing the edifying aspect of *aedificatio*.

9. Vitruvius, *De architectura* I, III:1, 16. The "making of time- pieces" is Morgan's translation. Rowland and Noble Howe use "the making of sundials" and provide descriptor titles for the various books based on this terminology (for example, book VIII becomes "Sundials and Clocks").

10. Vitruvius, *De architectura* I, III:1, 16. Rowland and Noble Howe use "mechanics."

11. On the compositional structure of Vitruvius see, among others, Ingrid D. Roland, "Vitruvius in Print and in Vernacular Translation: Fra Giocondo, Bramante, Raphael and Cesare Cesariano," in *Paper Palaces: The Rise of the Renaissance Architectural Treatise*, ed. Vaughan Hart and Peter Hicks (New Haven, CT: Yale University Press, 1998), 105–121. For a discus- sion of *machinatio* see Bernard Cache, "Vitruvius: Machinator Terminator." in Bernard Cache, *Projectiles* (London: AA Publi- cations, 2011), 119–137, esp. 121. For a thorough investigation of the state of antique treatises on engineering and mechanics see Philippe Fleury, "Le *De architec- tura* et les traités de mécanique ancienne," in *Le projet de Vitruve. Objet, destinataires et réception du De architectura. Actes du colloque de Rome (26–27 mars 1993)* (Rome: École Française de Rome, 1994), 187–212.

12. Leon Battista Alberti, *De re aedificatoria* (ca. 1452), trans- lated as *The Art of Building in Ten Books*, trans. Joseph Rykwert, Robert Tavernor, and Neil Leach (Cambridge, MA: MIT Press, 1989).

13. Leon Battista Alberti, *L'architettura. Tradotta in lingua Fiorentina da Cosimo Bartoli. Con la aggiunta de disegni*, trans. Cosimo Bartoli (Florence: Lorenzo Torrentino, 1550); Leon Battista Alberti, *The architec- ture of Leon Battista Alberti in ten books. Of painting in three books and of statuary in one book. Translated into Italian by Cosimo Bartoli. And now first into English, and divided into three volumes by James Leoni, Venetian, architect; to which are added several designs of his own, for buildings both public and private . . .* (London: Thomas Edlin, 1726).

14. On the development of architectural drawing during the early Renaissance see Vaughan Hart and Peter Hicks, *Paper Palaces: The Rise of the Renaissance Architectural Treatise* (New Haven, CT: Yale University Press, 1998), esp. the introduction by Vaughan Hart, "'Paper Palaces' from Alberti to Scamozzi," 12–19. See also Car- oline van Eck, *Classical Rhetoric and the Visual Arts in Early Modern Europe* (Cambridge: Cambridge University Press, 2007); Alina Payne, *The Architectural Treatise in the Italian Renaissance: Archi- tectural Invention, Ornament and Literary Culture* (Cambridge: Cambridge University Press, 2011).

15. On the structure of Vitru- vius versus Alberti see Caroline van Eck, "The Structure of 'De re aedificatoria' Reconsidered," *Journal of the Society of Architec- tural Historians* 57, no. 3 (1998): 280–297.

365

16. Harley, f.13v–f.17r.

17. Harley, 12r.–13v.

18. Vitruvius, *De architectura* I, V: 7, 24 (Morgan).

19. Harley, f.11v.

20. Vitruvius, *De architectura*, book VII, Introduction, 201 (Morgan). Rowland and Noble Howe maintain this translation.

21. Vitruvius, *De architectura* VII, V: 2, 211 (Morgan).

22. Vitruvius, *De architectura*, VII, VIII: 1–4, 215 (Morgan).

23. Vitruvius, *De architectura*, VII, VIII: 4, 216 (Morgan).

24. Vitruvius, *De architectura*, VII, V, 1–3, 210–211 (Morgan).

25. Vitruvius, *De architectura*, VII, V, 4, 211 (Morgan).

26. The second chapter in part I ("Cargoes") adapts: Tim Anstey, "Economies of the Interior," *Grey Room* 78 (2020): 124–125. Reproduced here in a slightly rewritten form by kind permission of the editors and of MIT Press. The third chapter develops and expands: Tim Anstey, "Moveables," in *The Printed and the Built. Architecture, Print Culture Public Debate in the Nineteenth Century*, ed. Mari Hvattum and Anne Hultzsch (London: Bloomsbury, 2018), 231–236. Reused here with the kind permission of the editors of that collection and of Bloomsbury Publishing.

27. In part II ("Dispatches") the first chapter develops: Tim Anstey, "The Dangers of Decorum," *Architecture Research Quarterly* 10, no. 2 (June 2006), 131–139. Reproduced by kind permission of editors and of Cambridge University Press and the editors. The second develops: Tim Anstey, "Things That Move: Domenico Fontana and the Vatican Obelisk," *Nordic Journal of Architecture* 2, no. 3 (Winter 2012), part of an issue devoted to the theme of "Alteration."

Reproduced by kind permission of Dansk Arkitektførlaget and the editors.

28. The first chapter in part III ("Vehicles") expands on: Tim Anstey, "Moving Memory: The Buildings of the Warburg Institute," *Kunst og Kultur* 103, no. 3 (October 2020). Reproduced here with kind permission of the editors and of University of Oslo Universitetsforlaget.

29. Jorge Luis Borges, "El idioma analítico de John Wilkins," *La Nación* (February 8, 1942), cited in Michel Foucault, *Les mots et les choses: Une archéologie des sciences humaines* (Paris: Gallimard, 1966), 7.

30. See Nigel Nicholson, "Introduction," in *Harold Nicholson: The Diaries 1907–1964*, ed. Nigel Nicholson (London: Orion Books, 2004), xi.

31. Christopher Wood's comment in Barry Flood et al., "Roundtable: The Global Before Globalisation," *October* 133 (2010): 8. For a discussion of the study of things moving in the early modern world, see Meredith Martin and Gillian Weiss, "Introduction," in *The Sun King at Sea: Maritime Art and Galley Slavery in Louis XIV's France* (Los Angeles: Getty Research Institute, 2022), 5; see also 22n19 and 22n20.

32. Virginia Woolf, *To the Lighthouse*, ed. Stella McNichol, introduction by Hermione Lee (London: Penguin Books, 1992 [original London: Hogarth Press, 1927]).

33. Woolf, *To the Lighthouse*, 54–55.

Architecture Aslant

1. Fredric Henric af Chapman, *Architectura navalis mercatoria. Navium varii generis mercatoriarum, capulicarum, cursoriarum, aliarumque, cuiuscun-*

que conditionis vel molis, Formas et rationes exhibens exemplis æri incisis, Demonstrationibus denique, Dimensionibus calculisque accuratissimis illustrata (Stockholm: Holmiae, 1768).

2. On the background to the treatise see Daniel G. Harris, *F. H. Chapman: The First Naval Architect and His Work*, (London: Conway, 1989), 75–85; and, in Swedish, Fredrik Neumeyer, *Fredrik Henrik af Chapman som konstnar och konstfrämjare* (Uppsala: Alqvist & Wiksells, 1944), 24–27 (from which most of Harris's observations derive).

3. "Olof Årre," in *Svenskt konstnärslexikon*, vol. V, ed. Jonny Roosvall, Gösta Lilja, and Knut Andersson (Malmö: Allhems Förlag, 1967), 785–786.

4. On the history of Katarina Kyrka see Marie Nordin Lidberg et al., *Arkitekturguide Stockholm: Guide to Stockholm Architecture* (Stockholm: Bygg Förlaget, 1997), 39; and Lennart Bellberg, ed., *Katarina Kyrka. Återuppbyggnaden 1990–1995* (Stockholm: SIAB, 1995), 20–46. On the artists involved at the Royal Palace see Linda Hinners, *De fransöske hatverkarna vid Stockholms slott 1693–1713* (Stockholm: Stockholm University, 2012).

5. Larrie D. Ferreiro, *Ships and Science: The Birth of Naval Architecture in the Scientific Revolution, 1600–1800* (Cambridge, MA: MIT Press, 2007), xi–xvi, gives a brief overview and a useful literature review of this field. See also Horst Nowacki and Matteo Valleriani, eds. *Shipbuilding Practice and Ship Design Methods from the Renaissance to the 18th Century* (Berlin: Max Planck Institute for the History of Science [preprint 245], 2003) for a review of the development of building and notational systems. For an archive collection of early

treatises on shipbuilding see the Echo History of Ship Design and Construction website from the Max Planck Institute for the History of Science, https://echo.mpiwg-berlin.mpg.de/content/shipbuilding/ship (accessed June 4, 2023).

6. Horst Nowacki, "Shape Creation Knowledge in Civil and Naval Architecture," in Horst Nowacki and Wolfgang Lefèvre, *Creating Shapes in Civil and Naval Architecture: A Cross-Disciplinary Comparison* (Leiden: Brill, 2009), 48–92; Bernhard Siegert, *Cultural Techniques: Grids, Filters, Doors, and Other Articulations of the Real*, trans. Geoffrey Winthrop Young (New York: Fordham University Press, 2015), esp. chap. 8, "Waterlines: Striated and Smooth Spaces as Techniques of Ship Design," 147–163.

7. The enquiry into the reciprocal relations between ship design and building design has been pursued recently in publications that examine the decorative programmes of naval vessels during the seventeenth and eighteenth centuries. See Jan Pieper, *Das barocke Schiffsheck als Architekturprospekt. Architectura navalis im zeitalter des höfischen absolutismus* (Aachen: Geymüller verlag für Architektur, 2019); Maike Priesterjahn and Claudia Schuster, eds., *Floating Baroque: The Ship as Monumental Architecture* (Berlin: BeBra Verlag, 2018) and Magali Théron, "La décoration navale en France entre 1660 et 1830," in *Les génies de la mer. Chefs-d'oeuvre de la sculpture navale du Musée national de la Marine à Paris*, ed. Marjolaine Mourot and Mario Bélan, exh. cat. (Paris: Musée national de la Marine, 2001), 43–65.

8. This formulation is adopted by Meredith Martin and Gillian Weiss to describe their research into the significance of maritime art for interpreting the cultural milieu around Louis XIV, in Meredith Martin and Gillian Weiss, *The Sun King at Sea: Maritime Art and Galley Slavery in Louis XIV's France* (Los Angeles: Getty Research Institute, 2022), 3. Martin and Weiss themselves reflect on the challenge of opening up for discussion within art history a package of material that has been seen as extraneous by previous frames of definition, see Martin and Weiss, *The Sun King at Sea*, 5–6 and 22n19.

9. On Chapman's place in the modern tradition of ship design, see Larrie D. Ferreiro, "Inventing the Metacenter" and "The Great Works," in Ferreiro, *Ships and Science*, 222–246 and 275–278.

10. The plates were engraved by Chapman's nephew and apprentice, the twenty-two-year-old Lars Bogman, later enobled as Lars Nordenbjelke; see Lennart Rosell, "Lars Nordenbjelke," *Svenskt biografiskt lexikon*, https://sok.riksarkivet.se/sbl/mobil/Artikel/14787#/sbl/Mobil/Artikel/8202 (accessed September 20, 2023).

11. On Raphael's letter to Leo X, see André Tavares, *The Anatomy of the Architectural Book* (Zurich: Lars Müller and Canadian Centre for Architecture, 2016), 210–212.

12. See for example Chapman's original drawing for a 110-gun ship preserved in the Swedish military archives, krigsarkivet, Marinens ritningar, Linjeskepp SE/KrA/0492/A 1/39:1–4.

13. The stations' numbering in Chapman's drawings and engravings speaks of a relationship between an abstract, orthographic system that defined surface and a material, constructive one that supported it. In plate 1 they are named using a series o, 3, 6, 9, etc., to 33 as one moves left and c, f, i, through to z as one moves right. In the ship constructed each station would mark the center line of one of the great frames behind the planking of the hull; two additional frames (identified by the intervening numbers) would be placed between each station and their profile interpolated from the sections on the stations adjacent. Thus the hull of the "Frigate built" in plate 1 would have had 60 main frames—33 behind and 26 in front of that which formed the midsection. On the general method depicted in the lines plans presented by Chapman, see Ferreiro, *Ships and Science*, 40–46.

14. In order to find this form a shipwright would use these stations, and the set of developing sections they defined. But the production of a sequence of transverse sections was not enough on its own to guarantee that the hull shape of a ship would be "fair": that the planking laid over the frames would follow the natural spring and curve contained in each piece of timber without fluctuating dips or hollows. Neither could any of these relations be calculated, as ships' hulls were not defined by compounds of known curves but contained continuously changing curvatures and particular reversals of the thrust that resulted in both in smooth convex and serpentine, S-shaped, forms. To construct ships this "fairness" had in some way to be predicted before the hull itself

took shape, in order that the frames positioning the surface of the planking could be cut to the exact profile needed. Partly this could be a matter of experience—of repeating formulae inherited from one generation of shipwright to another. But commissioning large vessels, like commissioning large buildings, usually involved the participation of multiple actors: shipwrights, admiralties, clients, committees. In these cases the practice was, as with buildings, to project the precise form of the vessel in advance of construction, either via a scale model or, increasingly from the seventeenth century, via scaled drawings. The other lines that are traced over the elevations and plans of the ships portrayed in the *Architectura navalis* describe this system of drawing projection in its fully developed form. They represent a kind of X-ray, in which the trace of a system whose main purpose was to project form for an internal audience (commissioning bodies; shipwrights producing cutting templates for the construction of the vessel) has itself been projected onto a highly polished plate for examination by actors both inside and outside that process. For a review of the historical context of this development see Ferreiro, *Ships and Science*, 40–46.

15. Ferreiro, *Ships and Science*, 40–46; and Brian Lavery, *The Ship of the Line*, vol. 2, *Design, Construction and Fittings* (London: Conway Maritime Press, 1984), 23–27.

16. On the development of ship's waterlines as a technique for representation see David McGee, "From Craftsmanship to Draftsmanship: Naval Architecture and the Three Traditions of

Early Modern Design," *Technology and Culture* 40, no. 2 (1999): 209–214; and Siegert, "Waterlines: Striated and Smooth Spaces as Techniques of Ship Design," 147–163.

17. The half-breadth plans, profiles, and body plans in the treatise are all evolutions of what would now be termed "production information": drawings like these had to be made not only to present proposals to navy boards or shipowners but to evolve the key sets of cutting dimensions for the frames for each vessel in a shipyard. This is not the case for Chapman's three-dimensional views. To produce these the whole orthographical matrix with which the lines of a ship were thought had itself to be projected from another angle. Creating the first set of projections that showed a ship's forms revolving in a horizontal plane would involve taking the true "offset" measurements of the sections shown in the body plan (horizontal measurements, using the center line as a datum, at incremental heights), multiplying these measurements by a factor to create compressed offsets as the basis for the oblique view, plotting these to produce the oblique equivalent of the same sections, and translating each new section laterally across the drawing plan by an interval that corresponded to the apparent distance between the perpendiculars of the profile when the ship was viewed from an angle. To create the dramatic heeled views where Chapman's craft lie at odd angles to the horizontal required a further set of calculations to define angles and apparent intervals within

the framing ordinates of the system.

18. *Architectura navalis mercatoria* (English edition of the plates), "Index and description of the draughts contained in this work." In the index the vessels for swift sailing and rowing are presented before the subsection of privateers; in the order of plates the privateers come first. Chapman repeats this order in the introduction to the treatise on ship building that he published to accompany the plates of the *Architectura navalis* in 1775, see Fredric Henric af Chapman, *Tractat om Skeppsbyggeriet, tillika med förklaring och bevis öfver architectura navalis mercatoria &c. genom Fredrich Hindr: af Chapman* (Stockholm: Johan Pfeiffer, 1775), translated as Fredrik Henrik Chapman, *A Treatise on Shipbuilding*, trans. James Inman (Cambridge: J. Smith, 1820), viii: "We will divide [the ships] of all nations into two classes: comprising in one, all small vessels, or those used in short voyages and narrow waters; in the other, all larger ships, or those employed in distant voyages, and calculated for going out to sea."

19. On Chapman's history the best sources (in Swedish) remain Neumeyer, *Fredrik Henrik af Chapman*; and Yngve Rollof, "Fredric Henric av Chapman," *Sjöväsandet*, no. 7 (1958): 457–478. See also Ferreiro, *Ships and Science*, 245–246.

20. On Ehrensvärd see Hans Eklund, *Augustin Ehrensvärd. Målaren, upplysningsmannen, människovännen, byggaren, sjömannen och flaggmannen* (Stockholm: National Museet, 1997). See also Einar W. Juva, "Augustin Ehrensvärd," *Svenskt biografiskt lexicon*, https://sok

.riksarkivet.se/sbl/artikel/16730 (accessed October 2, 2022).

21. Åke Stavenow, "Carl Johan Cronsted," in *Svenskt biografiskt lexikon*, https://sok.riksarkivet.se/sbl/artikel/15695 (accessed October 2, 2022); Carine Lundberg, "Carl Hårleman," *Svenskt biografiskt lexicon*, https://sok.riksarkivet.se/sbl/artikel/1396 (accessed October 2, 2022); Michael Lindgren, "Christopher Polhem," *Svenskt biografiskt lexikon*, https://sok.riksarkivet.se/sbl/artikel/7338, (accessed October 2, 2022).

22. On Fredrik Palmqvist see: "4. Palmqvist, F.," in *Nordisk familjebok: konversationslexikon och realencyklopedi* vol. 20, ed. Theodore Westrin, Ruben Gustafsson, Berg, and Vener Söderberg (Stockholm: Nordisk familjeboks AB, 1914), 1366; on Thomas Simpson see *Nordisk familjebok*. vol. 25 (Stockholm: Nordisk familjeboken, 1917), 590; and Daniel J. Velleman, "The Generalized Simpson's Rule," *American Mathematical Monthly* 112, no. 4 (April 2005): 342–350.

23. On Gilbert Sheldon see the *Swedish Dictionary of National Biography*: Jan Glete, "Gilbert Sheldon," *Svenskt biografiskt lexikon*, https://sok.riksarkivet.se/sbl/artikel/5889 (accessed October 2, 2022). On Henri Louis Duhamel du Monceau, see Nicolas de Condorcet, "Éloge de M. Duhamel," in *Histoire de l'Académie royale des sciences—Année M. DCCXXXII—Avec les mémoires de mathématique & de physique pour la même année* (Paris: Imprimerie royale, 1782), 131–155; and Michel Allard, *Henri-Louis Duhamel du Monceau et le Ministère de la Marine* (Montréal: Léméac, 1970).

24. Daniel Melanderhjelm, *Tal, om de mathematiska vetenskapernas nytta i krigskonsten och alla dess särskilda grenar, hållet i kongl. vetensk. academien vid præsidii nedläggande, den 7:e augusti, 1782* (Stockholm: Johan Georg Lange, 1782). See Rollof, "Henric Fredrik af Chapman," 478–480, for a discussion of the talk. On Melanderhjelm, see the *Swedish Dictionary of National Biography*: Olle Franzén, "Daniel Melanderhielm," *Svenskt biografiskt lexikon*, https://sok.riksarkivet.se/sbl/artikel/9255 (accessed October 3, 2022).

25. Melanderhjelm on Chapman: "Även har Herr Översten och Riddaren av Chapman, 1775, i Stockholm utgivit sin *Tractat om Skeppsbyggeriet*, hvaruti han likaledes av matematiska grunder avhandlat detta ämne och i så mått å daga lagt det sällsynta exemplet att i denna vetenskap förena mycket och grundlig Teori med en berömvärd Praktik." And on Duhamel du Monceau: "Men denna tractat är endast Praktik." Melanderhjelm, *Tal, om de mathematiska vetenskapernas nytta*, 20.

26. Ferreiro is clear that Duhamel du Monceau's *Architecture navale* is a more rigorous text in its structure than Chapman's "unsystematic" *Tractat om Skyppsbyggeriet*; see Ferreiro, *Ships and Science*, 275–277.

27. Ferreiro, *Ships and Science*, 269, 270.

28. On Linné see Tore Frängsmyr et al., *Linnaeus, the Man and His Work* (Berkeley: University of California Press, 1983); "Carl von Linné," in *Svenskt Biografiskt Lexikon* vol. 23, 700–715.

29. Carl von Linné, *Hortus Cliffortianus plantas exhibens quas in hortis tam vivis quam siccis, Hartecampi in Hollandia, coluit vir nobilissimus & generosissimus Georgius Clifford, juris utriusque doctor, reductis varietatibus ad species, speciebus ad genera, generibus ad classes, adjectis locis plantarum natalibus differentiisque specierum. Cum tabulis æneis* (Amsterdam: 1737).

30. Fredric Henric af Chapman, *Tal, om de förändringar, som örlogs-skepp undergått, sedan canoner började på dem nyttjas; hållet för kongl. vetenskaps academien, vid præsidii nedläggande, den 25 julii 1770* (Stockholm: Lars Salvius, 1770).

31. Chapman, *Tal, om de förändringar, som örlogs-skepp undergått*, 20–22.

32. On the development of stability theory through Bouguer and Euler see Horst Nowacki and Larrie D. Ferreiro, "Historical Roots for the Theory of Hydrostatic Stability in Ships," in *Contemporary Ideas of Ships Stability and Capsizing in Waves*, ed. Marcello Almieda Santos Neves et al. (Dordrecht: Springer, 2011), 152–176. Chapman also made use of the method developed by his teacher Thomas Simpson, which began to be adopted by shipwrights in the later eighteenth century and which was known as "Simpon's Rule." On the mathematics of the rule see Velleman, "The Generalized Simpson's Rule," 342–350.

33. *De re aediifcatoria*, book V, 12. See Leon Battista Alberti, *On the Art of Building in Ten Books*, trans. Joseph Rykwert, Robert Tavernor, and Neil Leach (Cambridge, MA: MIT Press, 1989), 136–137. On maritime humanism generally during the Renaissance see Ennio Concina, "Humanism on the Sea," *Mediterranean Historical Review* 3, no. 1 (1988): 159–65.

34. On Alberti's project to raise a ship from Lake Nemi, see Girolamo Mancini, *Vita di Leon Battista Alberti* (Florence: G.

C. Sansoni, 1882), 314–316; and John M. McMannon, *Caligula's Barges and the Renaissance Origins of Nautical Archeology Under Water* (College Station: Texas A&M University Press, 2016), 7–50. Alberti refers both to this project and to his own treatise in ships, *Navis*: Alberti, *On the Art of Building*, 136–137.

35. Lazare de Baïf, *Lazari Bayfii de re navali liber: seu annotationes in L II: De captivis, et postliminio reversis . . .* (Paris: Robert Estienne, 1536). On de Baïf, see Sylviane Llinares, "Marine et anticomanie au XVIII:e siècle: les avatars de l'archéologie expérimentale en vraie grandeur," in *L'archéologie méditerranéenne et proche-orientale dans l'ouest de la France. Annales de Bretagne et des pays de l'ouest: Anjou. Maine. Poitou-Charente. Touraine* 115, no. 2 (2008): 68–69; and McMannon, *Caligula's Barges*, 103–113. Lazare de Baïf's division of shipping into "longships" and "roundships" repeats that of Alberti who defines two forms of vessel: "There are two types of ship: cargo and clipper," *De re aediifcatoria*, 136 (Rykwert).

36. The first book on architecture published by Serlio was Sebastiano Serlio, *Regole generali di architetura sopra le cinque maniere de gli edifici, cioe, thoscano, dorico, ionico, corinthio, et composito . . .* (Venice: per Francesco Marcolini da Forli, 1537).

37. On Barbaro's translation see Louis Cellauro, "Daniele Barbaro and Vitruvius: The Architectural Theory of a Renaissance Humanist and Patron," *Papers of the British School at Rome* 72 (2004): 293–329.

38. The first known use of the term "Naval Architecture" in the title of a treatise is by João Baptista Lavanha, Royal Cosmographer to the Kingdom of Portugal in the late 1500s. Around 1600 he wrote a treatise, "Livro primeiro da arquitectura naval" (The First Book of Naval Architecture), whose structure was based on that of Vitruvius *De architectura*. See Ferreiro, *Ships and Science*, xiii.

39. On the Battle of Lepanto, see among other readings: Roger Crowley, *Empires of the Sea: The Siege of Malta, The Battle of Lepanto and the Contest for the Center of the World* (New York: Random House, 2008); John F. Guilmartin, "The Tactics of the Battle of Lepanto Clarified: The Impact of Social, Economic, and Political Factors on Sixteenth-Century Galley Warfare," in *New Aspects of Naval History: Selected Papers Presented at the Fourth Naval History Symposium, United States Naval Academy 25–26 October 1979*, ed. Craig L. Symonds (Annapolis, MD: United States Naval Institute, 1981), 41–65.

40. On the impact of the battle and for a review of the secondary literature see Jenny Jordan, "Galley Warfare in Renaissance Intellectual Layering: Lepanto through Actium," *Viator* 35 (January 2004): 563–580.

41. Jordan, "Galley Warfare," 567. On the rehabilitation of Herodotus during the late sixteenth century as a trustworthy source for the description of ancient events, see Michal Habaj, "Herodotus' Renaissance Return to Western-European Culture," *Studia Antiqua et Archaeologica* 22, no. 1 (2016): 89–90.

42. Jordan, "Galley Warfare," 567. On the tradition of *naumachia* in Spain, see José Antonio Matthias Royo, "All the Town is a Stage: Civic Ceremonies and Religious Festivities in Spain during the Golden Age," *Urban History* 26, no. 2 (August 1999): 179.

43. Papal projects for moving obelisks went back certainly to the Rome of Nicholas V and earlier proposals can be dated to the end of the fifteenth century. See Brian Curran, Anthony Grafton, and Angelo Decembrio, "A Fifteenth-Century Site Report on the Vatican Obelisk," *Journal of the Warburg and Courtauld Institutes* 58 (1995): 234–248.

44. On the frescoes, see Rick Scorza, "Vasari's Lepanto Frescoes: 'Apparati,' Medals, Prints and the Celebration of Victory," *Journal of the Warburg and Courtauld Institutes* 75 (2012): 141–200.

45. For a limited description of Furttenbach's life see Hanno-Walter Kruft, *A History of Architectural Theory: From Vitruvius to the Present* (London: Zwemmer, 1994), 172–174. Kruft reviews Furttenbach's works on land-based buildings (*Architectura civilis, Architectura privata*) and mentions the *Architectura universalis*, but makes no attempt to include the *Architectura martialis* or *Architectura navalis* in his analysis of Furttenbach's significance for architectural history. On the *Architectura navalis* see Massimo Carradi and Claudia Tacchella, "At the Origins of Shipbuilding Treatises: Joseph Furttenbach and the *Architectura navalis*," Preprint of the Proceedings of the Royal Institute of Naval Architects "Historic Ships" conference, London, December 5–6, 2018, 2–3. Available on request from the RNIA: https://rina.org.uk/resource-library/rina-conference-proceedings/ (accessed July 10, 2023). Furttenbach is also mentioned in Abraham Gotthelf Kästner, *Geschichte der Mathema-*

tik... (Göttingen: Rosenbusch, 1799), 433.

46. Joseph Furttenbach, *Architectura navalis. Das ist: von dem Schiff-Gebäw, auff dem Meer und Seekusten zugebrauchen. Und Nemblich, in was Form und gestallt, Fürs Erste, ein Galea, Galeazza, Galeotta, Bergantino, Filucca, Fregata, Liudo, Barchetta, Piatta: Zum Andern, Ein Nave, Polaca, Tartana, Barcone, Caramuzzala, und ein gemeine Barca ... sollen erbawen werde; Allen, Auff dem Meerpracticirten Liebhabern, Wie auch den Bawmeistern, und Mahlern zu Wolgefallen ... ; Auß selbst gesehenen ... Wrecken: Neen kurtzwiderholter Fürbildung, der in Anno 1571. zwischen den Christen und Türcken fürgegangenen, hochernstilchen, Ansehnlichen Meerschlacht / Sampt vielen Abrissen; und noch darüber. 20 ... Kupfferstücken, complirt, außgerüstet, und ... beschrieben, Durch Josephum Furttenbach* (Ulm: Ionam [Wilhelm] Saurn, 1629).

47. Joseph Furttenbach, *Architectura universalis. Das ist: Von Kriegs: Statt- vnd Waffen Gebäwen. Erstlich, wie man die Statthor vnnd Einlass, zu Wasser vnd zu Land mit Spitzgatter vnd doppelten Schlagbrucken, darhinder dann ein newe Manier der Soldaten Quartier ... erbawen, vnd also vor Feindlichem Anlauff wol verwahren sole ... Zum Andern, wie im Statt Gebäw die Schulen, Academien, Wohnhäuser, Herbergen, Bäder, Gefängnussen vnd Lazaretten, neben andern nothwendigen civilischen Gebäwen zuverfertigen seyen. Drittens, in was Gestalt auff den fliessenden Wassern, die Wehrhaffte Flöss, sowohl auch die Schiff vnnd Formen also zuerbawen ... Zum vierdten, ein Pulfferthurn, ingleichem ein Zeughauss, nach rechter bequemer Manier zuerbawen ... Auss eigener Experientz vnd viel-jähriger Observation zusamen getragen, beschrie-*

ben, vnd mit 60. Kupfferstucken vorgebildet vnd delinirt: durch Josephum Furttenbach (Ulm: Johann Sebastian Medern, 1635).

48. François Dassié, *François. L'Architecture navale, contenant la manière de construire les navires, galères & chaloupes, & la définition de plusieurs autres espèces de vaisseaux. Avec les tables des longitudes, latitudes & marées, cours & distances des principaux ports des quatre parties du monde; une description des dangers, écueils, & l'explication des termes de la marine.* [issued with] *Le routier des Indes Orientales et Occidentales* (Paris: Jean de la Caille, 1677).

49. Dassié, *L'architecture navale,* 3: "Nous avons un grand nombre d'Autheurs quiont amplement traité de toutes les parties des Mathematiques, & principalement de l'Architecture Civile & Militaire; Mais il semble qu'ils ont negligé de nous instruire de *l'Architecture Navale,* par laquelle outre qu'on a découvert le Nouveau Monde, qui a pour le moins autant d'étenduë que toutes les autres parties de la Terre, on a connu encore plusiers Peuples qui vivoient sans Police & sans Religion, & qui sans le secours de cette admirable Science, n'auroient pas esté instruits des lumieres de l'Evangile. C'est par elle ausi que les Princes font connoistre leur gloire aux Nations les plus eloignées, & que par le mouvement qu'elle donne à leurs Armées Navales, elle fait la grandeur, la felicité, l'éclat & la puissance de leurs Empires." The focus on the religious and missionary potential of ships echoes arguments in Georges Fournier's s *Hydrographie* (1643, reissued 1667), whose twentieth book considered "La devotion des Gens de Mer," and noted that a ship might be thought of as a floating mon-

astery: "un Monastere, auquel on est separé du monde, & où on a toujours les yeux au Ciel." Georges Fournier, *Hydrographie contenant la théorie et la pratique de toutes les parties de la navigation* (Paris: Depuis, 1667), 792–794. See Martin and Weiss, *The Sun King at Sea,* 145, 166n84, for the connection between Fournier and Dassié.

50. On the significance of the oared galley for Louis XIV's political program see Martin and Weiss, *The Sun King at Sea,* 29–30.

51. On Charles le Brun see Claude Nivelon, *Vie de Charles Le Brun et description détaillée de ses ouvrages, 1699–1704* [mss, BNF, man. fr. 12987] (Paris: Droz, 2004). On Le Brun's involvement in the French Navy see Martin and Weiss, *The Sun King at Sea,* 50–56; Théron, "La décoration navale en France," 45–47.

52. On Jean Bérain see Jérôme de La Gorce, *Bérain, dessinateur du Roi Soleil* (Paris: Hersher, 1986); Emmanuel Verfasser Coquery, "Les Attributs de la Marine, d'après Jean Berain et Jean Lemoine une tenture d'exception entre dans les collections du Louvre," *Revue du Louvre* 53 (2003): 5, 56–67, 118, 119; and Théron, "La décoration navale en France," 50–53.

53. On Puget's work in Marseilles and Toulon see Magali Théron, "La bonne fabrique et le superbe ornement: Pierre Puget's Ship Decoration," *Sculpture Journal* 24, no. 2 (2015): 145. See also Martin and Weiss, *The Sun King at Sea,* 39, 50–51, 58–60, and on Puget's life more generally Léon Lagrange, *Pierre Puget: Pientre, sculpteur, architecte, décorateur de vaisseaux* (Paris: Dider, 1968).

54. For an excellent summary (in Swedish) of the discus-

sions between Puget, Le Brun, and Colbert and their relation to the development of the Swedish Navy see Neumeyer, *Fredrik Henrik af Chapman*, 5–8. See also Martin and Weiss, *The Sun King at Sea*, 59. In a letter of September 19, 1670, Colbert required that Puget should avoid "si grandes figures aux poupes des vaisseaux ... tous ces grands ouvrages ne servent à autre chose qu'à rendre les vaisseaux beaucoup plus pesans et à donner prise aux bruslots." Reprinted in Pierre Clément, ed., *Lettres, instructions et mémoires de Colbert*, vol. 3, part 1, *Marine et galères* (Paris: Imprimerie impériale, 1864), 275, cited in Meredith and Weiss, *The Sun King at Sea*, 59.

55. Meredith and Weiss, *The Sun King at Sea*, 91 and 119n60.

56. On Vassé see Théron, "La décoration navale en France," 53. For his admission to the academy, *Procès-verbaux de l'Académie royale de peinture et de sculpture, 1648–1793. Publiés pour la Société de l'histoire de l'art français d'après les registres originaux conservés à l'École des beaux-arts*, ed. Anatole de Monaiglon and Paul Connu (Paris: J. Bar, 1875–1909), 356.

57. On the construction history and decorative plan of the *Sovereign of the Seas* see Benjamin W. D. Redding, "A Ship 'for Which Great Neptune Raves': The Sovereign of the Seas, la Couronne and Seventeenth-Century International Competition over Warship Design," *The Mariner's Mirror* 104, no. 4 (November 2018): 402–422, esp. 415.

58. Anthony Deane, "A Doctrine of Naval Architecture," manuscript written for Samuel Pepys, 1670, Pepys Library, Magdalene College, Cambridge.

For Deane's life and work, see Brian Lavery, "Introduction," in Anthony Deane, *A Doctrine of Naval Architecture*, ed. Brian Lavery (London: Conway Maritime Press, 1981), 7–28.

59. Jean-Baptiste Colbert to the Toulon naval intendant Louis Leroux d'Infreville, July 19, 1669, reprinted in Pierre Clément, *Lettres, instructions et mémoires de Colbert*, vol. 3, part I, *Marine et galères* (Paris: Imprimerie impériale, 1864), 147–148. "Il n'y a rien qui frappe tant les yeux, ni qui marque tant la magnificence du Roy que les bien orner comme les plus beaux [vaisseaux] qui ayent encore paru à la mer."

60. Henri Sbonski de Passebon, *Plan de plusieurs bâtiments de mer avec leurs proportions dédié à son Altesse Serenissime Monseigneur Louis Auguste de Bourbon...* (n.d.; the book was probably published in Marseille, ca. 1792).

61. On William Kent's royal barge, see Albert Edward Richardson, "The Royal Barge: Notes on the Original Drawings by William Kent in the Library of the Royal Institute of British Architects," *Journal of the Royal Institute of British Architects* 38 (January 24, 1931), 172–176, and Geoffrey Beard, "William Kent and the Royal Barge," *Burlington Magazine* 112, no. 809 (August 1970): 488–493, esp. 495. The barge was decorated by James Richards, master carver and sculptor in wood to the English crown, who succeeded Grinling Gibbons in the role—the same Gibbons who had trained as a ship carver at Deptford and who had worked with Christopher Wren on the London churches at St. Paul's and St. James Picadilly; Richards performed similar services for Colin Campbell across the road at Lord Bur-

lington's house on Picadilly and worked for Kent later on the carvings for Kew Palace.

62. Henri-Louis Duhamel du Monceau, *Élémens de l'architecture navale, ou Traité pratique de la construction des vaisseaux* (Paris: Charles-Antoine Lombert, 1752); André François Boureau-Deslandes, *Essai sur la marine des anciens, et particulièrement sur leurs vaisseaux de guerre* (Paris: David et Ganeau, 1768).

63. Chapman, *Tal, om de förändringar, som örlogs-skepp undergått*, 11–13.

64. On Le Roy's life, works, and significance for architecture, see Robin Middleton, "Introduction," in Julien-David Le Roy, *The Ruins of the Most Beautiful Monuments of Greece*, trans. David Britt (Los Angeles: Getty Research Institute, 2004), 1–199, 131–132 on his involvement with matters maritime. For a study that suggests a analytical continuity between Le Roy's ideas about architectural history and his speculations on ship design, see Jeanne Kisacky, "History and Science: Julien-David Leroy's Dualistic Method of Architectural History," *Journal of the Society of Architectural Historians* 60, no. 3 (September 2001): 260–289. With reference to Le Roy's work with naval architecture see also, Llinares, "Marine et anticomanie au XVIII:e siècle," 67–84.

65. The argument is set out in Julien-David Le Roy, "Première lettre à M. Franklin sur les Navires des Anciens...," *Observations sur la physique, sur l'histoire naturelle et sur les arts...*, vol. 32 (March 1788), 210–220.

66. Cited in William Cobbett, *Cobbett's Parliamentary History of England from the Norman Conquest until the Year 1803*, vol. 4 (London: Hansard, 1810), 598.

67. Julien-David Le Roy, "Première lettre à M. Franklin," 212.

68. Kisacky, "History and Science," 278–280.

69. Julien-David Le Roy, *Nouvelles recherches: Sur le vaisseau long des anciens, sur les voiles latines*... (Paris: Libraires, 1786), 2: "L'Archipel offre à celui qui y navigue, un spectacle bien intéressant. Il s'y voit sur les bateaux grecs et sur divers bâtiments, toutes les espèces de voilure imaginées par les navigateurs anciens et par les navigateurs modernes."

70. Julien-David Le Roy, "Première lettre à M. Franklin," 213: "Dans les ports que les Russes ont à Cherson sur la Mer Noire, on ne trouverait pas, je le présume, un bâtiment qui, mettant à la voile, allât jusqu'à la première cataracte du Nil. Un navire des Anciens faisait cet immense trajet. Partant des Palus-Méotides il traversait dans une navigation continue la Mer Noire, celle de Marmora, l'Archipel; il cinglait dans la Méditerranée jusqu'à l'embouchure du Nil, remontait ce fleuve, et arrivait en Éthiopie en moins de vingt-cinq jours de navigation."

71. Julien-David Le Roy, "Première lettre à M. Franklin," 213: "une forme très allongée, presque parallélépipédique, peu de creux, peu de largeur, gréé avec des voiles latines. ... Cette propriété des navires des Anciens résultait principalement de ce qu'étant plats par-dessous, ils tiraient peu d'eau."

72. Andrew Peters, *Ship Decoration 1630–1780* (Barnsley: Seaforth Publishing, 2013), 97, 99. On the decoration of the *Sovereign of the Seas*, see Hendrik Busmann, *Sovereign of the Seas: Die Skulpturen des britischen Königs-*

schiffes von 1637 (Bremerhaven: Deutsches Schiffahrtsmuseum; Hamburg: Convent Verlag, 2002).

73. Neumeyer, *Fredrik Henrik af Chapman*, 8–12.

74. Neumeyer, *Fredrik Henrik af Chapman*, 8–12.

75. On French involvement in the Stockholm Royal Palace during the period from 1693 to 1713, see Hinners, *De fransöske hatwerkarna vid Stockholms slott*, generally and esp. 15–20. For the continuation of that collaboration during the 1750s and 1760s see Neumeyer, *Fredrik Henrik af Chapman*, 36–38.

76. Carl Hårleman's drawing for the stern decoration of the brigantine *Prins Gustaf* is preserved in the Swedish Maritime Museum in Stockholm, Sjöhistoriska Museum OR 1033:23.

77. Neumeyer, *Fredrik Henrik af Chapman*, 13.

78. For a description of Ehrensvärd life with excellent reproductions of his extraordinary production of drawings see *Carl August Ehrensvärd. Tecknaren och Arkitekten*, ed. Ulf Cederlöf (Stockholm: National Museum, 1997). On his architecture see Sten Åke Nilsson, "Ehrensvärd arkitekten" in Cederlöf, *Carl August Ehrensvärd*, 233–275.

79. Neumeyer, *Fredrik Henrik af Chapman*, 32, 53–67; and Rollof, "Fredric Henric af Chapman," 513–517, 555–560.

80. On the symbolic and significant strategic importance of the galley for the late seventeeth and early eighteenth centuries see Martin and Weiss, *The Sun King at Sea*, 29–30, 146–155.

81. An example of Chapman's drawings for the Swedish galley fleet is preserved in the Swedish Maritime Museum in Stockholm, "Galär med 22

årpar. Linje-, spant- och profil-ritning," Sjöhistoriska Museum OR 1920. On the significance of the type for the development of the Swedish inshore fleet, and as a response to the geopolitical threat posed by Peter the Great's sponsorship of a Russian galley fleet, see Harris, *F. H. Chapman*, "The Inshore Fleet," 25–50.

82. On the *Amphion* see Neumeyer, *Fredrik Henrik af Chapman*, 38–43 and Harris, *F. H. Chapman*, 87–92.

83. Chapman read Latin and French (he used his own copies of Euler's Latin and Bourguer's French treatises to develop the theory contained in the *Tractat om Skeppsbyggeriet* that accompanied the *Architectura navalis*), so the derivations of de Baïf and Boureau-Deslandes were of as much potential significance to him as those of Duhamel du Monceau or Dassié. It is even possible Chapman knew of the manuscript copy of the Anthony Deane's *Doctrine of Naval Architecture*, which Samuel Pepys left to the library of Magdalene College in Cambridge, as Deane had been consulted by the Sheldon's about the calculation of displacement for Swedish men-of-war.

84. On the geopolitical significance and regulation of the Baltic timber trade, see Sven Erik Åström, "The English Navigation Laws and the Baltic Trade, 1660–1700," *Scandinavian Economic History Review* 8, no. 1 (1960): 3–18.

85. On Solander see *Swedish Dictionary of National Biography*, "Daniel C. Solander," *Svenskt biografiskt lexikon*, https://sok.riksarkivet.se/SBL/Presentation.aspx?id=6118 (accessed June 28, 2023).

86. On Bouguer and the intimate connections between this mission to Peru and his *Traité de navire* see Ferreiro, *Ships and Science*, 2–22.

87. On Grill, see *Swedish Dictionary of National Biography*, "Johan Abraham Grill," *Svenskt biografiskt lexikon*, https://sok.riksarkivet.se/sbl/Presentation.aspx?id=13200 (accessed June 28, 2023),

88. On the history of the Swedish East India Company, see S. Bertil Olsson and Karl-Magnus Johansson, ed. *Sverige och svenskarna i den ostindiska handeln II. Strategier, sammanhang och situationer* (Gothenburg: Riksarkivet, Landsarkivet i Göteborg, 2019); and Lars Olof Lööf, *Sjöfarare och superkargörer. Människor i och omkring Svenska Ostindiska Compagnierna 1731–1813 Part I* (Täby: Riksarkivet i Göteborg, 2021).

89. Ferreiro, *Ships and Science*, 10–20. Bouguer spent from 1735 to 1743 on the Mission to Peru, during which time he composed his *Traité de navire*. Of this period approximately one year was spent at sea. Cook's expeditions occurred from 1768 to 1771, 1772 to 1775, and 1776 to 1779.

90. An extreme example is given by the ships taking part in the blockade of Brest by the British Navy, which continued during all the periods Britain and France were at war between 1793 and 1815. See Quintin Barry, *Far Distant Ships: The Blockade of Brest, 1793–1815* (London: Helion, 2017).

91. Antoine de Sartine, Secrétaire d'État à la Marine, Ordonnance du 7 janvier 1777: "Les figures allégoriques qui étaient nombreuses sur l'avant des vaisseaux etaient d'une exe-cution lente et dispendieuse, et pouvaient server à les faire reconnâitre de loin. . . . L'ornementation ne contient plus un message politique ou une nécessité artistique." Cited in Ronald Portanier, "French Naval Sculpture under the Ancien Régime (1650–1789)," PhD diss., Concordia University, Montreal, Québec, Canada (2018), 89.

92. The drawing is preserved in the Swedish National Maritime Museum in Stockholm: "Det engelska 100-kanonersskeppet VICTORY (1737). Profil-, linje- och spantritning med akterspegel," Sjöhistoriska Museum, OR 2382:1.

93. The 1765 *Victory*'s decoration is recorded in the Admiralty model made at her commissioning and in Nicholas Pococke's commemorative painting *Nelson's Flagships at Anchor*, commissioned in 1806: Nicholas Pococke, "Nelson's Flagships at Anchor," (12588); HMS *Victory* model ship (SLR0516), National Maritime Museum, Greenwich, London.

94. For the still brilliant analysis of Hardwick Hall in terms of the vertical representation of social hierarchy, see Mark Girouard, *Life in the English Country House: A Social and Architectural History* (New Haven, CT: Yale University Press, 1978), 116–125.

95. The order of cabins can clearly be read on contemporary plans. For an overall study of the organization of eighteenth-century shipping, see Brian Lavery, *Shipboard Life and Organisation, 1731–1815* (Aldershot, UK: Ashgate, 1998) and Lavery, *The Ship of the Line*, 130–146, 176–177. For accounts of ships cabins during the late eighteenth century, includ-ing citations of contemporary descriptions of their domestic nature, see also Treve Rosoman, "Some Aspects of Eighteenth-Century Naval Furniture," *Furniture History* 33 (1997): 120–127.

96. A. H. W. Robinson, "The Evolution of the English Nautical Chart," *Journal of the Institute of Navigation* 5, no. 4 (October 1952): 123–130.

97. See the arguments in the following chapter, "Economies of the Interior."

98. On the use of panoramas see Tim Anstey and Mari Lending, "Moving Egypt," in *Images of Egypt*, ed. Mari Lending, Eirik Bøhn, and Tim Anstey (Oslo: Pax Forlag, 2018), 80.

99. On the representation of flora and fauna, see the analysis of Renzo Dubini, *Geography of the Gaze: Urban and Rural Vision in Early Modern Europe*, trans. Lydia G. Cochrane (Chicago: University of Chicago Press, 2002), esp. chapters 3 and 4.

Economies of the Interior

1. See for example the fifteenth-century map drawn for Ptolemy's *Geographica*, translated by Emanuel Chrysoloras and Jacobus Angelus. Here the "Totius urbis habitabius brevis descriptio" includes as part of the oecumene shown at the bottom right "Ethiopia interior" (Harley 7182 ff. 58v–59, third quarter of the fifteenth century, British Library.

2. Jean-Baptiste Le Mascrier, *La Description de L'Égypte contenant plusieurs remarques curieuses sur la géographie ancienne et moderne de ce païs . . .* (Paris: Louis Genneau et Jacques Rollin, 1735), iv–v.

3. Sir William Jones "Essay on the Poetry of the Eastern Nations," in *Poems Consisting*

Chiefly of Translations from the Asiatick Tongues (Oxford: Clarendon Press, 1772), 162–190, 177. Of Persia, Jones notes, "In the interiour parts of the empire the air is mild and temperate."

4. On the origins of the Africa Association, see William Young, "Introduction," in Friedrich Hornemann et al., *The Journal of Frederick Horneman's Travels . . . in Africa, in the Years 1797–8* (London: G & W Nicol, 1802), i–xv. Hornemann's journal appeared simultaneously in France as *Voyages dans l'intérieur de l'Afrique, par Frédéric Horneman pendant les années 1797, 1798* (Paris: André, 1802). By 1796, interior was being used in English to refer to European geography; for example, in Burke's account of the French Revolution. See Edmund Burke, *Thoughts on the Prospect of a Regicide Peace* (London: J. Owen, 1796), 98. After 1800, the term became commonplace in descriptions of the New World. Compare Alexander Mackenzie's *Voyages from Montreal, on the River St. Laurence, through the Continent of North America . . .* (London: T. Cadell, Davies, Corbett, and Morgan; Edinburgh: W. Creech, 1801), with its French translation, *Voyage: d'Alexandre Mackenzie, dans l'intérieur de l'Amérique septentrionale; faits en 1789, 1792 et 1793* (Paris: Dentu, 1803). See also John Mawe, *Travels in the Interior of Brazil* (London: Longman, Hurst, Rees, Orm, and Brown, 1812).

5. Jean-Baptiste Tavernier, *Nouvelle relation de l'intérieur du serrail du Grand Seigneur* (Paris: Olivier de Varennes, 1675).

6. Nicodemus Tessin, *Nicodemus Tessin the Younger: Sources, Works, Collections. Traictè dela decoration interieure 1717*, ed. Patricia Waddy with contibution by

Bo Vahlne (Stockholm: National Museum/Sveriges Arkitektur Museum, 2002).

7. Jacques-François Blondel, *De la distribution des maisons de plaisance et de la décoration des édifices en général* (Paris: Antoine Jombert, 1737).

8. The term appears in references to plates 35, 36, and 43 in Robert Adam, *Ruins of the Palace of Emperor Diocletian at Spalatro in Dalmatia* (London: Robert Adam, 1764), 29, 31.

9. Germain Boffrand, *Livre de l'architecture* (Paris: Guillaume Cavelier, 1745); and Nicolas Le Camus de Mézières, *Le génie de l'architecture, ou l'analogie de cet art avec nos sensations* (Paris: L'auteur et chez B. Morin, 1780). The caption to plate 12 in Boffrand's text describes "la façade de l'interieure de la cour." De Mézières refers to the interior of the Dôme des Invalides and of the Sorbonne. Boffrand, *Livre d'architecture*, 50; and de Mézières, *Le génie de l'architecture*, 17, 19.

10. The term "interior" has a limited use as a descriptor to separate internal and external items of ornament before this, see for example, Adam, *Ruins of the Palace of the Emperor Diocletian*, description of plates p. 19.

11. On the use of exotic detail in Percier and Fontaine's work, see Caroline van Eck and Miguel John Versluys, "The Hôtel de Beauharnais in Paris: Egypt, Rome, and the Dynamics of Cultural Transformation," in *Housing the New Romans*, ed. K. von Stackelberg and E. Macaulay-Lewis (Oxford: Oxford University Press, 2016), 54–91.

12. Charles Percier and Pierre Fontaine, *Recueil de décorations intérieures comprenant tout ce qui a

rapport à l'ameublement . . .* (Paris: E. Hessling, 1801). The text was republished with the authors' textual commentary by P. Didot l'Aîné in 1812.

13. Thomas Hope, *Household Furniture and Interior Decoration* (London: Longman, Hurst, Rees, and Orme, 1807).

14. Apart from using it in his title, Hope does not include the word "interior" in the text. Percier and Fontaine use it mainly as an adjectival term— "decoration(s) intérieure(s)" and "vue intérieure." See Percier and Fontaine, *Recueil de décorations intérieures* (1812), 4, 9, 17, 26.

15. For a close analysis of the stylistic and geopolitical references in French architecture, particularly interior architecture, in the early nineteenth century, with reference to its links to the work of Percier and Fontaine, see Van Eck and Versluys, "The Hôtel de Beauharnais in Paris," 70–83.

16. On the financial history of the Hope family, see Martin G. Buist, *At Spes Non Fracta: Hope & Co. 1770–1815, Merchant Bankers and Diplomats at Work* (The Hague: Bank Mees and Hope, 1974). On Hope's early life and his activities in London, see Philip Mansel, "European Wealth, Ottoman Travel, and London Fame," in *Thomas Hope: Regency Designer*, exh. cat., ed. David Watkin and Philip Hewat-Jaboor (New York: Bard Graduate Center; New Haven, CT: Yale University Press, 2008), 3–21. See also Daniella Ben-Arte, "The Hope Family in London: Collecting and Patronage," in *Thomas Hope*, exh. cat., 193–220.

17. Mansel, "European Wealth"; and David Watkin, "The Reform of Taste in Lon-

don: Hope's House in Duchess Street," in *Thomas Hope*, exh. cat., 8–15, 23–43.

18. Hope was a controversial figure and was ostracized by members of the Royal Academy for attacks on his colleagues, his invective in debates on taste, and his decision to sell tickets to those wishing to view his home. See Mansel, "European Wealth," 15.

19. Hope, *Household Furniture*, 16.

20. Hope, *Household Furniture*, 16.

21. Hope is likely to have read Adam Smith—the fourth edition of *The Wealth of Nations* is dedicated to his uncle, Henry Hope—and his description of interior decoration falls squarely between the classes of "furniture" and "building" that Smith uses in his discussion of the moral effects of fashion and taste in society. See Adam Smith, *The Theory of Moral Sentiments* [1759] (Cambridge: Cambridge University Press, 2002), 227–228.

22. Hope, *Household Furniture*, 4, 6.

23. Watkin, "The Reform of Taste," 29–33.

24. Watkin, "The Reform of Taste," 29–33.

25. The identification of Greece as part of Europe was implicated in the geopolitics of the late eighteenth and early nineteenth centuries. When Hope made his grand tour, Athens was politically part of the Ottoman Empire, and visiting it required a stop first in Constantinople. In England, by 1800, Greece was being claimed as part of mainland Europe. *Guthrie's Geography Improved* (Philadelphia: Mathew Cary, 1795) has Greece drawn into Europe behind a thick red line that extends as far as the west

side of the Bosporus. This identification is repeated on Mercator world maps from the same period; for example, "Europe, from the Best Authorities," in *Brookes Gazetteer* (London: R. Brookes, 1798). I am indebted to Anne-Françoise Morel for highlighting the complexity of this issue.

26. Thomas Hope, "Quarters of the Sultana Validé in the Summer Seraglio" and "Room in a Turkish Palace," in vol. 5, 27367/27368, Benaki Museum, Athens; reproduced in Watkin and Hewat-Jaboor, *Thomas Hope*, exh. cat., 297–298.

27. The Daniells' drawings were printed as the series *Oriental Scenery* (London: Thomas Daniell and William Daniell, 1795–1808).

28. The last panel in the Duchess Street drawing room portrayed ruins in the Roman Forum in a painting by Giovanni Paolo Panini. See Watkin, "The Reform of Taste," 36.

29. Hope, *Household Furniture*, 24.

30. Hope, *Household Furniture*, 25–26. This gave the room a specific position in relation to contemporary literature. Mount Ida, its symbiotic relationship with Constantinople, and its geopolitical significance for the ancient Eastern Roman and modern Ottoman empires had been highlighted, for example, by Edward Gibbon (and Hope cites him in the bibliography to *Household Furniture*). See Edward Gibbon, *The Decline and Fall of the Roman Empire*, 3rd ed., vol. 1 (London: W. Strahan and T. Cadell, 1789), 6–9.

31. Hope, *Household Furniture*, 25–26.

32. Hope, *Household Furniture*, 26–27.

33. [Thomas Hope], *Anastasius: Or Memoires of a Greek; Written at the Close of the Eighteenth Century* (London: John Murray, 1819). Hope claimed authorship in 1820.

34. Hope, *Household Furniture*, 51. Among the titles Hope refers to are Robert Wood, *The Ruins of Palmyra: Otherwise Tedmor, in the Desart* (London: Robert Wood, 1753); Richard Pococke, *Observations on Egypt: A Description of the East and Some Other Countries*, vol. 1 (London: W. Bowyer, 1743); and Frederick Ludvig Norden, *Travels in Egypt and Nubia* (London: Lockyer Davis and Charles Reymers, Printers to the Royal Society, 1757).

35. For a discussion of the immersive effects of early nineteenth-century travel descriptions, see Tim Anstey and Mari Lending, "Moving Egypt," in *Images of Egypt*, ed. Mari Lending, Eirik Bøhn, and Tim Anstey (Oslo: Pax Forlag, 2018), 39–44.

36. Dominique Vivant Denon, *Voyage dans la Basse et la Haute Égypte pendant les campagnes du général Bonaparte* (Paris: P. Didot l'Aine, 1802). See also Anstey and Lending, "Moving Egypt," 41–43.

37. Renzo Dubbini, *Geography of the Gaze: Urban and Rural Vision in Early Modern Europe*, trans. Lydia G. Cochrane (Chicago: University of Chicago Press, 2002), esp. chapters. 3–4.

38. William Hamilton, *Campi Phlegraei: Observations on the Volcanos of the Two Sicilies as They Have Been Communicated to the Royal Society of London* (Naples: Pietro Fabris, 1776–1779).

39. John Sibthorp and Edward William Smith, *Flora Graeca Sibthorpiana* (London: Richard Taylor, 1806–1816).

40. *Description de l'Égypte ou Recueil des observations et des recherches qui ont été faites en Égypte pendant l'expédition de l'armée française*, 23 vols. (Paris: Imprimerie impériale, 1809–1828). On the *Description*, see Anstey and Lending, "Moving Egypt," 44–49; and David Prochaska, "Art of Colonialism, Colonialism of Art: The Description de l'Égypte (1809–1828)," *L'Esprit créateur* 34, no. 2 (Summer 1994): 81.

41. See Hope, *Household Furniture*, 12 ("species of ornament of which I have attempted to present specimens") discussing the problem of incorrect copies of his furniture.

42. Hope, *Household Furniture*, 10. Hope may have had the hand tinting of images in mind.

43. On eighteenth-century systems for representing internal rooms as objects of design, see Robin Evans, "The Developed Surface," in *Translations from Drawing to Building* (Cambridge, MA: MIT Press, 1996), 210–219. For a contextualization of Evans's work in relation to recent discourse on nineteenth-century interiority, see Charles Rice, *The Emergence of the Interior: Architecture, Modernity, Domesticity* (New York: Routledge, 2007), 24–26. For a hint, undeveloped, of the potential overlap between the genesis of representing the geographical and the architectural interior, see Charlotte Gere, *Nineteenth-Century Interiors: An Album of Watercolours* (London: Thames and Hudson, 1992), 20.

44. Elevations, perspectives, and axonometrics are freely mixed in Percier and Fontaine, *Recueil de décorations intérieures*; and Thomas Sheraton, *The Cabinet-Maker and Upholsterers' Drawing Book in Four Parts*

(London: T. Bensley, 1794). The traces of working drawing conventions are visible in both books.

45. *The British Critic* 21 (January–June 1803): 618. For the entire review of the three first English translations of Denon's *Voyage*, see *The British Critic* 21 (January–June 1803): 618–623; and *The British Critic* 22 (July–December 1803): 18–25.

46. On Hope promoting his home, see Mansel, "European Wealth," 15.

47. Anstey and Lending, "Moving Egypt," 61–62; and Barry V. Daniels, "Notes on the Panorama in Paris," *Theatre Survey* 19, no. 2 (November 1978): 171–176.

48. Hope, *Household Furniture*, 51, citing Alexandre Lenoir, *Description historique et chronologique des monumens de sculpture, réunis au Musée des monumens rançais* (Paris: Gide libraire, 1800).

49. Alexandra Stara, *The Museum of French Monuments, 1795–1816: "Killing Art to Make Art History"* (Farnham, UK: Ashgate, 2013); and Stephen Bann, "Historical Text and Historical Object: The Musée de Cluny," *History and Theory* 17, no. 3 (October 1978): 251–266.

50. See Buist, *At Spes Non Fracta*, 522–523.

51. Buist, *At Spes Non Fracta*, 22–69.

52. Buist, *At Spes Non Fracta*, 61.

53. Pierre César Labouchère, Hope & Co., to Alexander Baring, 30 January 1803, in NP1. A4.03, Baring Archive.

54. See Buist, *At Spes Non Fracta*, 57–58, 188–194.

55. The Hopes took responsibility for trading $6.7 million of the $11.25 million in American bonds. Historians tend to assert

that the activities of his banking family have little to do with the sensibilities Hope developed toward architecture and design. See, for example, Buist, *At Spes Non Fracta*; and the contributors to Watkin and Hewat-Jaboor, *Thomas Hope*, exh. cat.

56. *Description de l'Égypte ou Recueil des observations . . . ;* see Anstey and Lending, "Moving Egypt," 44–46.

57. Alexander von Humboldt and Aimée Bonpland, *Essai sur la géographie des plantes . . .* (Paris: Levrault, Schoell et Compagnie, 1805); Alexander von Humboldt, *Voyage aux régions équinoxiales du nouveau continent, fait en 1799, 1800, 1801, 1802, 1803, et 1804* (Paris: Libraire grecque-latine-allemande, 1816–1826); and Malcom Nicholson, "Alexander von Humboldt and the Geography of Vegetation," in *Romanticism and the Sciences*, ed. Andrew Cunningham and Nicholas Jardine (Cambridge: Cambridge University Press, 1990), 169–188.

58. For example, Thomas Daniell and William Daniell, *Antiquities of India . . .* (London: Thomas and William Daniell, 1799), plate 12.

59. Norden, *Travels in Egypt and Nubia*, 116–119.

60. Denon, *Voyage*, 62, 75.

61. John Lewis Burckhardt, *Travels in Nubia* (London: John Murray, 1819), 369, 383.

62. Giovani Belzoni, *Narrative of the Operations and Recent Discoveries within the Pyramids, Temples, Tombs and Excavations, in Egypt and Nubia . . .* (London: John Murray, 1820), 234, 235, cited in Eirik Arff Gulseth Bøhn, "Making a Monument: The Tomb of Seti I and Its After-lives," in Lending, Bøhn, and Anstey, *Images of Egypt*, 112.

63. Diane Harlé and Jean Lefebvre, eds., *Sur le Nil avec*

Champollion. *Lettres, journaux et dessins inédits de Nestor L'Hôte, premier voyage en Égypte, 1828–1830* (Caen-Orléans: Éditions Paradigme, 1993), 260. I am indebted to Eirik Bøhn for this reference.

64. *A New English Dictionary on Historical Principles; Founded Mainly on the Materials Collected by the Philological Society*, vol. 5, H–K, ed. James Augustus Henry Murray (Oxford: Clarendon Press, 1901), 398.

65. The fourth edition of Samuel Johnson's *Dictionary of the English Language* identifies "interiour" only as "the inside." Samuel Johnson, *Dictionary of the English Language* (London: J. and P. Knapton et al., 1785). The 1860 edition of Joseph Emerson Worcester's dictionary defines the geographical and geopolitical sense of "interior" but not the architectural sense. "Interior," in Joseph Emerson Worcester, *Dictionary of the English Language* (Boston: Hickling, Swan, and Brewer, 1860).

66. Stephen Bann, *The Clothing of Clio: A Study of the Representation of History in Nineteenth-Century Britain and France* (Cambridge: Cambridge University Press, 1984).

67. Bann, *The Clothing of Clio*, 251–266.

68. Bann, *The Clothing of Clio*, 263.

69. Bann, *The Clothing of Clio*, 259.

70. A New English *Dictionary*, 398.

71. Walter Benjamin, *The Arcades Project*, trans. Howard Eiland and Kevin McLaughlin (Cambridge, MA: Harvard University Press, 1999), 220–221.

72. Diana Fuss, *The Sense of an Interior* (New York: Routledge, 2004), 3–6; Victoria Rosner, *Modernism and the Architecture of*

Private Life (New York: Columbia University Press, 2005), 127–130; Neil Leach, *Camouflage* (Cambridge, MA: MIT Press, 2006); Charles Rice, *The Emergence of the Interior: Architecture, Modernity, Domesticity* (London: Routledge, 2007), 11–19; and Julia Prewitt Brown, *The Bourgeois Interior* (Charlottesville: University of Virginia Press, 2008), 62.

73. Fuss, *The Sense of an Interior*, 6.

74. On the provenance of Hope's vase collection and his purchase from William Hamilton see Ian Jenkins, "The Past as a Foreign Country: Thomas Hope's Collection of Antiquities," in Watkin and Philip Hewat-Jaboor, *Thomas Hope: Regency Designer*, 119–123. See also Nancy H. Ramage, "Sir William Hamilton as Collector, Exporter, and Dealer: The Acquisition and Dispersal of His Collections," *American Journal of Archaeology* 94, no. 3 (July 1990), 469–480.

75. Jenkins, "The Past as a Foreign Country, 122.

76. On the background to the Napoleonic invasion see Anstey and Lending, "Moving Egypt," 31–38.

77. For accounts of ships cabins during the late eighteenth century, including citations of contemporary descriptions of their domestic nature, see Treve Rosoman, "Some Aspects of Eighteenth-Century Naval Furniture," *Furniture History* 33 (1997): 120–127.

Moving Large Things About in the Nineteenth Century

1. The circulation of *The Illustrated London News* in the 1860s was greatly helped by its proprietor's strategy of expanding the readership to the regional clergy. See C. N. Williamson,

"*The Illustrated London News* and Its Rivals—*Lloyd's Illustrated London Newspaper*, *The Pictorial Times*, and *The Illustrated Times*. Illustrated Journalism in England: Its Development. II," *Magazine of Art* 13 (November 1889–October 1890): 334–340.

2. The needle had been granted as a "present" to the British government by the Pasha Mehemet Ali in 1819 in the wake of the Battle of the Nile. When in 1875 a private benefactor offered to fund, finally, its removal to London, the paper reported minutely on preparations for removing the obelisk. On the history see Brian A. Curran, Anthony Grafton, Pamela O. Long, and Benjamin Weiss, *Obelisk: A History* (Cambridge, MA: Bundy Library, 2009), 257–260.

3. The story was first reported in *The Illustrated London News* on March 10, 1877. The paper reported the loss of the obelisk as a stop-press news item in its Saturday, October 20, issue. By October 27, when the illustrated feature on the accident was published, *Cleopatra*'s tow-ship had arrived back in England and reports had already arrived in London about the obelisk's rescue at sea. The illustrations for the October 27 story, as well as the eyewitness narrative of *Cleopatra*'s loss, were provided by her captain, Henry Carter. The paper followed up with a special supplement on January 16, 1878, which published drawings made by an *Illustrated London News* artist who had been dispatched to Ferrol to cover the story and who accompanied the *Cleopatra* back to Britain, traveling, presumably, on the tug towing the vessel.

4. *Illustrated London News*, August 21, 1847, 124–126, and November 14, 1857, 489–493.

5. Jenkins, "The Past as a Foreign Country," 120–121.

6. Dominique Vivant Denon, *Voyage dans la Basse et la Haute Égypte pendant les campagnes du général Bonaparte* (Paris: P. Didot l'Aine, 1802), vol. 2, 169. *Description de l'Égypte ou Recueil des observations et des recherches qui ont été faites en Égypte pendant l'expédition de l'armée française*, 23 vols. (Paris: Imprimerie impériale, 1809–1828).

7. Tim Anstey and Mari Lending, "Moving Egypt," in *Images of Egypt*, ed. Mari Lending, Eirik Bøhn, and Tim Anstey (Oslo: Pax Forlag, 2018), 41–43.

8. Percy Bysshe Shelley, "Ozymandias," *The Examiner*, no. 524, January 11, 1818, published by John Leigh Hunt, 24.

9. "Mode in which the Young Memnon's Head (now in the British Museum) Was Removed by Belzoni," lithograph by J. H. Newton after a drawing by Belzoni, printed by Charles Joseph Hullmandel, printed in Giovanni Belzoni, *Six New Plates Illustrative of the Researches and Operations in Egypt and Nubia* (London: John Murray, 1822). On the mediation of Belzoni's activities see Eirik Arff Gulseth Bøhn, "Making a Monument: The Tomb of Seti I and Its Afterlives," in Lending, Bøhn, and Anstey, *Images of Egypt*, 101–112.

10. Anstey and Lending, "Moving Egypt," 44–47.

11. Thomas Baring, *A Bibliographical Account and Collation of La Description de l'Égypte, Presented to the Library of the London Institution* (London: Charles Skipper and Kast, 1838), 16.

12. Baring, *A Bibliographical Account*, 20n a.

13. Jomard's design consisted of a mahogany cabinet 1.5 meters wide and 1 meter tall, with the ordinary volumes of plates "laid endwise, in two parallel lines, and those of the larger size across at the top; the texts being disposed of beneath the cover of the cabinet, which could be raised up to any angle of elevation." Baring, *A Bibliographical Account*, 20n a.

14. Anstey and Lending, "Moving Egypt," 167; Bob Briar, "The Secret Life of the Paris Obelisk" in *Ægyptica. Jounral of the Reception of Ancient Egypt* 2 (2018): 76–91; Curran, Grafton, Long, and Weiss, *Obelisk*, 229–255, and 243–246.

15. Briar, "The Secret Life of the Paris Obelisk," 79–88. On Julien-David Le Roy's work with naval architecture see the chapter titled "Architecture Aslant" in this book.

16. Léon de Joannis, *Campagne pittoresque d.u Luxor* (Paris: Impremerie Mme. Huzard, 1835).

17. Jean Baptiste Apollinaire Lebas, *L'obélisque de Luxor: histoire de sa translation à Paris, description des travaux auxquels il a donné lieu, avec un appendice sur les calculs des appareils d'abattage, d'embarquement, de halage et d'érection . . .* (Paris: Carilian-Goeury et V Dalmont, 1839).

18. The models form part of the collection of the Musée des Arts et Métiers, Paris. See Xianwen Zheng, "Shipping the Luxor Obeslisk to Paris," in Lending, Bøhn, and Anstey, *Images of Egypt*, 213–216.

19. For a discussion on the complexities of investigating transoceanic movement, and of circulating objects, see Meredith Martin and Gillian Weiss, "Introduction," in *The Sun King at Sea. Maritime Art and Galley Slavery in Louis XIV's France* (Los Angeles: Getty Research Institute, 2022), 5, 5n19, 5n20.

20. On the implications of technology for imperialism, see Andrew Porter, *The Oxford History of the British Empire*, vol. 3: *The Nineteenth Century* (Oxford: Oxford University Press, 1999); Daniel R. Headrick, "The Tools of Imperialism: Technology and the Expansion of European Colonial Empires in the Nineteenth Century," *Journal of Modern History* 51, no. 2, "Technology and War" (June 1979): 231–263; and Daniel R. Headrick, *The Tools of Empire: Technology and European Imperialism in the Nineteenth Century* (Oxford: Oxford University Press, 1981). On the specific impact of railways see B. R. Mitchell, "The Coming of the Railway and United Kingdom Economic Growth," *Journal of Economic History* 24, no. 3 (September 1964): 315–336. For a still compelling argument about the emotive power of nineteenth- and early twentieth-century technology, focused on the United States, see David E. Nye, *American Technological Sublime* (Cambridge, MA: MIT Press, 1994). For a recent dissection of monumental technologies for nineteenth-century colonialism, see Darcy Grimaldo Grigsby, *Colossal: Engineering the Suez Canal, Statue of Liberty, Eiffel Tower and Panama Canal: transcontinental ambition in France and the United States during the long nineteenth century* (Pittsburgh: Periscope Publishing, 2012). For a fundamental review of the technologies of colonial expansion, and the long shadows these cast, see On Barack, *On Time: Technology and Temporality in Modern Egypt* (Berkeley: University of California Press, 2013).

21. On "patent" or "campaign" furniture and its innovators see "Patent Furniture" and "William Pocock," in *The Grove Encyclopedia of Decorative Arts*, 2 vols., ed. Gordon Campbell (Oxford: Oxford University Press, 2006). See also "Morgan and Sanders," in *Dictionary of English Furniture Makers*, ed. Geoffrey Beard and Christopher Gilbert (Leeds: W. S. Maney and Son, 1986). For a set of campaign furniture patterns see Thomas Sheraton, *The Cabinet Dictionary, Containing an Explanation of all the Terms Used in the Cabinet, Chair & Upholstery Branches, with Directions for Varnish-Making, Polishing, and Gilding . . .* (London: W. Row, J. Mathews, Vernor and Hood, M. Jones & Thomas Sheraton, 1803). See also Nicholas A. Brawer, *British Campaign Furniture: Elegance under Canvas, 1740–1914* (New York: Harry N. Abrams, 2001). On the origins of naval furniture types in the eighteenth century see Treve Rosoman, "Some Aspects of Eighteenth-Century Naval Furniture," *Furniture History* 33 (1997): 120–127.

22. Examples of this military brand of furniture are preserved among the possessions of the two most celebrated British military figures of the early nineteenth century. Metamorphic furniture commissioned for Horatio Nelson's victory is preserved, with the ship, at the Museum of the Royal Navy, Portsmouth, UK. Campaign bookshelves constructed for the Duke of Wellington are preserved at his country house, Stratfield Saye, Hampshire, England (archive reference: Records of the Duke of Wellington's Stratfield Saye, Hampshire and Berkshire, with Welling-

ton [Somerset] estate generally, comprising: Inventory 1939).

23. Jane Austen, *Northanger Abbey* and *Persuasion*, vol 2. (London: John Murray, 1818), 232–233.

24. "Morgan and Sanders," entry in the *Dictionary of English Furniture Makers*, https://www.british-history.ac.uk/no-series/dict-english-furniture-makers/m (accessed July 12, 2023). See also *Ackermann's Repository of Arts, Literature, Commerce, Manufactures, Fashions and Politics* 2 (August 1809): plate 10, 122–123 for a report on Morgan and Sanders Ware-Room at 10 Catherine Street; and 1 (July 1811): plate 29, 40–41 for an example of a metamorphic chair.

25. See for example the editorial published in *La Magasin pittoresque*, 5:e année (1837): 3, 7.

26. See Sibylle Einholz, "Die Grosse Granitschale im Lustgarten. Zur Bedeutung eines Berliner Solitärs," *Der Bär von Berlin. Jahrbuch des Vereins für die Geschichte Berlins* 46 (1997): 41, 44, 58.

27. See Jeroen Stumpel, "The Vatican Tazza and Other Petrifications: An Iconological Essay on Replacement and Ritual," *Simiolus: Netherlands Quarterly for the History of Art* 24, no. 2–3 (1996): 111.

28. For a beautiful account of the creation of the *Granitschale* in relation to the thought of Karl Friedrich Schinkel, see Kurt W. Forster, *Schinkel: A Meander through His Life and Work* (Basel: Birkhäuser, 2018), 137–143.

29. For an account of this debate see Tobias Krüger, *Discovering the Ice Ages. International Reception and Consequences for a Historical Understanding of Climate*, trans. Ann M. Hentschel (Leiden: Brill, 2013), 109–129

and Forster, *Schinkel. A Meander*, 82–90.

30. Krüger, *Discovering the Ice Ages*, 138–139.

31. Krüger, *Discovering the Ice Ages*, 138–139.

32. Goethe participated in this debate both through his activities as a naturalist and rock collector—in 1820 correspondence he speculated about the origins of "die wandrung der Graniteblöcke"—and, in his fiction, where the significance of the findlinge formed a background to the discussions in *Wilhelm Meisters Wanderjahre*, particularly in its 1829 edition. See Jason Groves, *The Geological Unconscious: German Literature and the Mineral Imaginary* (New York: Fordham University Press, 2020), 48–66 and 113–115. See also Michael Niedermeier, "Goethe und der steinige Weg wissenschaftlicher Erkenntnis," *Gegenworte* 9, "Wissenschaft und Kunst" (2002): 83–86. Goethe firmly located the manufacture of the Berlin *Granitschale* within the narrative of antediluvian history. During 1828, as the Markgrafenstein lay in three pieces surrounded by stonemasons' cutting apparatus in the Rauen hills, he produced a note on "Granitearbeiten in Berlin" [about contemporary projects using granite in monumental architecture and sculpture] in his journal *Über Kunst und Altertum*. See Johann Wolfgang von Goethe, "Granitarbeiten in Berlin" and "Der Markgrafenstein" in *Goethes Sämtliche Werke*, vol. 44 (Munich: G. Müller, 1932), 54–57. The section on the Markgrafenstein saluted the endeavor of cleaving it to show artifice, but suggested that the significance of the stone, and therefore of the bowl itself, lay in its potential to resolve the

riddle of a removed, unstable and threateningly mobile history.

33. On Hummel see Birgit Verwiebe, *Magische Spiegelungen: Johann Erdmann Hummel*, exh. cat. (Berlin: Sandstein Verlag, 2021). He was an influential teacher of perspective, optics, and architecture, and a follower of the French mathematician Gaspard Monge.

34. Johann Erdmann Hummel, *Die Granitschale im Berliner Lustgarten*, 1831 (Nationalgalerie, Staatliche Museen zu Berlin).

35. Johann Erdmann Hummel, *Das Schleifen der Granitschale*, 1831 (Nationalgalerie, Staatliche Museen zu Berlin).

36. Mari Hvattum and Anne Hultzsch, "Introduction," in *The Printed and the Built: Architecture, Print Culture, and Public Debate in the Nineteenth Century* (London: Bloomsbury, 2018), 6.

37. Hvattum and Hultzsch, "Introduction," 6.

38. *La Magasin pittoresque*, 1:e année, no. 50 (December 22–29, 1833): 393–395; *La Magasin pittoresque*, 5:e année, no. 1 (January 1–6, 1837): 3–7.

39. On the various representations of the obelisk, see Zheng, "Shipping the Luxor Obelisk to Paris," 213–226.

40. *La Magasin pittoresque*, 1:e année, no. 50 (December 22–29, 1833): 3, 6–7: "Une sorte de *revue contemporaine* destinée à conserver le mémoire de ces grandes evenéménts de l'arte, de la science ou de l'industrie . . ."

41. *La Magasin pittoresque*, 1:e année, no. 50 (December 22–29, 1833): 3: "Les crayons de nos artistes les déssins necessaire pour fixée la trace des opérations successives et representer l'appareil mobile à l'aide duquel

l'aiguille de Luxor à eté dressée sur son piédestal."

42. Andrew Best Leloir, "Erection de l'Obélisque de Luxor, Place de la Concorde, October 25, 1836, *La Magasin pittoresque*, 1:e année, no. 50 (December 22–29, 1833): 4.

43. See Williamson. "*The Illustrated London News* and Its Rivals," 334–340.

44. On the construction of the *Great Eastern* see George S. Emmerson, *S.S. Great Eastern* (Newton Abbot: David & Charles, 1981).

45. The *Illustrated Times* commissioned Robert Howlett to record the construction of *Great Eastern* on camera, as the basis for the engraved views used in publication (often by Henry Vizetelly); see "Howlett, Robert," in *Encyclopedia of Nineteenth Century Phtotography* (New York: Routledge, 2008), 717–718.

46. The term "monster ship" was in use by the time the vessel was launched and is noted regularly in accounts of the experience of the steamer; see, for example, "Return Voyage of the *Great Eastern* from America in August Last" [by H. B. W.], in *The Nautical Magazine and Naval Chronical*, October 1862, 549–553.

47. On Benjamin Baker see "Sir Benjamin Baker," in *Encyclopaedia Britannica*, https://www.britannica.com/biography/Benjamin-Baker (accessed February 10, 2022), and W. F. Spear, "Baker, Sir Benjamin (1840–1907)," rev. Mike Chrimes, *Oxford Dictionary of National Biography*, ed. H. C. G. Matthew and Brian Harrison (Oxford: Oxford University Press, 2004).

48. On the histories and development of naval architectural theory in the nineteenth

century see Larrie D. Ferreiro, *Ships and Science: The Birth of Naval Architecture in the Scientific Revolution, 1600–1800* (Cambridge, MA: MIT Press, 2007), xii, 303–305; and William H. German, "The Profession of Naval Architecture," *Journal of the Royal Society of Arts* 126, no. 5258 (January 1978): 72.

49. Vitruvius, *De architectura* X, ii, 11, see Vitruvius, *The Ten Books on Architecture*, trans. Morris Hicky Morgan (Cambridge, MA: Harvard University Press, 1914; reprinted New York: Dover, 1960), 288; and Vitruvius, *Ten Books on Architecture*, translated by Ingrid D. Rowland, commentary and illustrations by Thomas Noble Howe (Cambridge: Cambridge University Press, 1999), 122.

50. On the background to the construction of the Forth Bridge see Rolt Hammond, *The Forth Bridge and Its Builders* (London: Eyre & Spottiswoode, 1964). Accounts of the bridge's construction were published in *The Illustrated London News* on January 28, 1882 (proposals, elevations and imagined perspective); October 9, 1889; October 16, 1889 (comparative images and structural principle): December 15, 1889 (construction images); March 8, 1890 (report of opening); and by *The Graphic* newspaper (March 1, 1890, and March 8, 1890). The construction of the bridge was also mediated via a collection of "magic lantern" slides, and made available for hire with an accompanying script, by the photographic publishers George Washington Wilson and James Valentine, see Andrew Gill, *How They Built the Forth Railway Bridge: A Victorian Magic Lantern Show*

(Createspace Independent Publishing, 2014).

51. On Kaichi Watanabe, see DPedia online, https://dbpedia.org/page/Kaichi_Watanabe (accessed May 22, 2023).

52. Anstey and Lending, "Moving Egypt," 90–93. For a contemporary example of its publication see "Storing the Nile Waters," *The Graphic*, March 26, 1898, 378; and Benjamin Baker, "The Nile Dams and Reservoir," *Popular Science Monthly* 62 (April 1903): 550–561.

53. Baker, "The Nile Dams and Reservoir," 559.

54. See for example the photographic treatment of the dam by Underwood and Underwood in Anstey and Lending, "Moving Egypt," 92–93, or that of the Forth Bridge by the Keystone View Company in "Stereo Views in Mass Production: The Keystone View Company," *Stereo World* 1, no. 2 (May–June 1974): 2, 8.

55. *The Illustrated London News*, January 10, 1880.

56. See Anstey and Lending, "Moving Egypt," 90; and Casper Andersen, *British Engineers in Africa, 1875–1914* (London: Pickering and Chatto, 2011), 144.

57. Benjamin Baker, "The Nile Reservoir," cited in Andersen, *British Engineers and Africa*, 12.

58. "Engineering Vandalism in Egypt," *The Globe*, February 26, 1894.

59. Lucia Allais, *Designs of Destruction: The Making of Monuments in the Twentieth Century* (Chicago: University of Chicago Press, 2018), 219–258.

60. Hvattum and Hultzsch, "Introduction," 6.

61. *The Illustrated London News*, March 2, 1850, 149.

62. Hvattum and Hultsch, "Introduction," 6.

63. *The Illustrated London News*, October 16, 1858, 350.

64. *The Illustrated London News*, May 26, 1849, 357. Charles Robert Cockerell, *The Professor's Dream*, pencil, pen and gray ink and watercolor, with scratched highlights, Royal Academy of Arts no. 03/4195.

65. Report of John Eastly Goodchild, RIBA Drawings and Archive Collection, Goodchild Album Vol. 8. 80, cited in Anne Bordeleau, "The Professor's Dream: Cockerell's *Hypnerotomachia Architectura*," *Architectural History* 52 (2009): 133.

66. Joseph Michael Gandy, "Comparative Architecture: Architectural Composition to Show the Comparative Characteristics of Thirteen Selected Styles of Architecture," Sir John Soane's Museum: Cat. No. XP6. Soane office, (1–10) RA Lecture Drawings of ancient and modern buildings showing their comparative sizes: "Comparative elevation of St Peter's, Rome, & sections of the Pantheon, Rome, the Radcliffe Library, Oxford & the Rotunda, Bank of England," Sir John Soane's Museum: Cat. No. 23/2/2.

67. Anne Bordeleau, in "'The Professor's Dream,'" 117–130, compared the drawing with stratigraphic maps developed during the 1820s, which codified information about multiple geological levels and identified a time dimension as being inherent in the organization of lithographic strata.

68. *The Illustrated London News*, May 26, 1849, 357.

69. See for example James Bunstone Bunning's London Coal Exchange, designed after 1845 and opened in October 1849. Other notable structures that combined styles in ways

reminiscent were Norman Shaw's Cragside (1869–1900), much imitated and celebrated in Herman Methusius *Das englische Haus* ("The English House") of 1904, and the eclectic Imperial Institute buildings in London (1887–1894), commissioned by Queen Victoria in memory of Prince Albert and designed by Thomas Edward Colcutt. The *British Architect* noted the variation the commissioning committee's brief produced in the competition designs for this building: "very much like asking six Palaeontologists to furnish plans and elevations for a dodo, without supplying them with bones to evolve it from." See *British Architect* 1 (July 1887): 4.

70. *The Illustrated London News*, October 16, 1889, 502.

71. Bazelgette's sewer system was officially opened by the Prince of Wales in 1865 and completed by 1875. The Albert, Victoria, and Chelsea Embankments were completed in 1869, 1870, and 1874 respectively. See Denis Smith, "Sir Joseph William Bazalgette (1819–1891) Engineer to the Metropolitan Board of Works," *Transactions of the Newcomen Society* 58, no. 1 (1986–1987): 89–111. The Circle Line that ran under the Thames Embankments was completed in 1884 and administrated by the Metropolitan Line and District Line railway companies; see J. Graeme Bruce, *Steam to Silver: A History of London Transport Surface Rolling Stock* (London: Capital Transport Publishing, 1983), 12. See also John R. Day and John Reed, *The Story of London's Underground* (London: Capital Transport Publishing, 2010).

72. A useful overview of railway carriage development

Notes

is given at the Great Eastern Railway enthusiasts website, https://www.gersociety.org.uk/index.php/rolling-stock/carriages/types-5-8 (accessed June 28, 2023).

73. Railway gauges in Great Britain were regulated by the 1846 *Railways Regulation (Gauge) Act*, August 18, 1846, C.57, 9–10 Victoriae, AD 1845, Cap. 8 (London: HMSO, 1846), 409–410. For a contemporary account of the dimensions of locomotive and carriage parts, their development, and history see *The Locomotive, Railway Carriage and Waggon Review*, published from 1896 onward. Established as *Moore's Monthly Magazine*, it was published monthy and addressed the global reach of railway development, highlighting contributions from British manufacturers. On various wagon configurations and history see, for example, *The Locomotive, Railway Carriage and Waggon Review* 16, no. 212 (April 15, 1910): 80–86.

74. For an examination of how the development of railways began to change imaginaries at a continental scale during the nineteenth century, see Barack, *On Time*, 21–52.

75. *The Illustrated London News*, March 8, 1890,

76. The carriage is preserved at the Bodmin & Wenford Railway, UK, and its complex history is narrated in John Burden, *Something Special: The Story of the Long and Eventful Life and Restoration of the Oldest Bogie Carriage in the Country: 1881 GWR Special Saloon 9044* (Salisbury: Wessex Books, 2013).

77. Lauren Hubbard, "The Secret History of the Royal Family's Train," *Town & Country*, November 16, 2020.

78. The interior was designed by the successful stylist, manufacturer and interior designer Samuel James Waring. Waring and Frank Murray, the art director of his furnishings company Waring and Gillow, attended the king and queen while they holidayed in Copenhagen following the coronation, receiving instructions for alterations to rooms in the royal palaces and to the royal yacht, *Victoria & Albert III*. The train was to be "as like the yacht as possible." On Samuel James Waring and the activities of Waring and Gillow, see Andrew Saint, "What Became of Waring? Fortunes of an Entrepreneur in Furnishing, Shopkeeping and Construction," *Construction History* 29, no. 1 (2014): 75–97.

79. *The Graphic*, December 30, 1902, 854.

80. National Railway Museum, Royal Trains archive list, Box title: "Royal Journeys sums. 40–76; early 20th cent Cont. tra," item 'Continental journeys of King Edward VII, Queen Alexandra and Princess Victoria. SE & CR royal saloons,'" 1907; "Timetables for various Continental journeys of King Edward VII and Queen Alexandra. SE & CR royal saloons," 1908; "Various journeys on the Continent by King Edward VII and Queen Alexandra. SE & CR royal saloons, nos. 1, 2 & 3," 1909; "SE & CR Royal saloons kept at Calais for Continental Journeys. nos. 1R, 2R & 3R."

81. *The Locomotive, Railway Carriage and Waggon Review* 16, no. 211 (March 15, 1910): 62. The builders were the Amalgamated Railway Carriage and Waggon Company of Saltley, near Birmingham. *The Locomotive* 16, no, 212 (April 15, 1910): 82–85,

reported on the background to the gift, referring to the value of the export orders in a second feature including the plan of the carriage.

82. *The Locomotive, Railway Carriage and Waggon Review* 16, no. 212 (April 15, 1910): 80–81.

83. For a discussion of the paradoxes for studies focusing on mobility in the early modern period, see Daniela Bleichmar and Meredith Martin, "Objects in Motion in the Early Modern World," special issue, *Art History* 38, no. 4 (2015); Anne Gerritsen and Giorgio Riello, eds., *The Global Life of Things: The Material Culture of Connections in the Early Modern World* (London: Routledge, 2016); and David Joselit and Christopher Wood, "Roundtable: The Global before Globalization," *October* 122 (2010): 3–19, esp. 7.

Dealing with Decorum

1. Jakob Burckhardt, *Die Cultur der Renaissance in Italien: ein Versuch* (Basel: Schweighauser, 1860); trans. Samuel George Chetwynd Middlemore as *The Civilisation of Renaissance Italy* (London: George Allen & Unwin, 1878).

2. Girolamo Mancini, *Vita di Leon Battista Alberti* (Florence: G. C. Sansoni, 1882).

3. Leon Battista Alberti, *De re aedificatoria*, IX, 10, author's translation. References throughout this chapter are to the most recent English translation: Leon Battista Alberti *On the Art of Building in Ten Books*, trans. Joseph Rykwert, Robert Tavernor, and Neal Leach (Cambridge, MA: MIT Press, 1988). See also Leon Battista Alberti, *L'architettura*, ed. G. Orlandi and P. Portoghesi, 2 vols. (Milan: Edizione E. Polifio, 1966), and the facsimile of the 1485 edition:

Hans-Karl Lücke, *Alberti Index: Leon Battista Alberti, De re aedificatoria* (Florence, 1485), 4 vols. (Munich: Prestel, 1975–). On the "instaurational" nature of *De re aedificatoria*, see Françoise Choay, *The Rule and the Model*, English trans. of *La Règle et le Modèle* (Cambridge, MA: MIT Press, 1997), 6–11, 16–20.

4. The argument in this chapter developed in the context of key Anglophone reinterpretations of Renaissance architectural theory published in the two decades after 1988. In part these consisted of updated English-language translations of major early modern architectural treatises, most notably those of Alberti (Leon Battista Alberti, *On the Art of Building*, trans. Rykwert et al.); Serlio (Sebastiano Serlio, *On Architecture*, 2 vols., trans. and ed. Vaughan Hart and Peter Hicks [New Haven, CT: Yale University Press, 1996 and 2001]); and Palladio (Andrea Palladio, *The Four Books on Architecture*, trans. Robert Tavernor and Richard Scofield [Cambridge, MA: MIT Press, 2002]). In part they emerged in a collaborative analysis of Renaissance writing on architecture that accompanied this work, see for example Vaughan Hart and Peter Hicks, eds., *Paper Palaces: The Rise of the Renaissance Architectural Treatise* (New Haven, CT: Yale University Press, 1998), an edited collection in which the translators of the texts listed above shared their ideas with colleagues who were working on newer (Perrault) and more ancient (Vitruvius) works. At the same time, this period saw the publication of books which all, in various ways, interpreted the significance of architecture in terms of written traditions

more generally, particularly of antique texts on the effectiveness of the spoken word. John Onians, *Bearers of Meaning: The Classical Orders in Antiquity, the Middle Ages and the Renaissance* (Princeton, NJ: Princeton University Press, 1988), considered its subject in terms of a persuasive power discovered in the ancient art of oratory. In Christine Smith, *Architecture in the Culture of Early Humanism: Ethics, Aesthetics and Eloquence* (Oxford: Oxford University Press, 1992), the significance of speech as a model for architecture was conveyed in the subtitle, while Alina A. Payne's *The Architectural Treatise in the Italian Renaissance: Architectural Invention, Ornament and Literary Culture* (Cambridge: Cambridge University Press, 1999) and Caroline van Eck's, *Classical Rhetoric and the Visual Arts in Early Modern Europe* (Cambridge: Cambridge University Press, 2007) both built literary attention into their main titles. This attention to writing on oratory—one might say to the tradition and analysis of eloquence—as a cradle for theorizing architecture was inspired in its turn by work produced in the context of the Warburg Institute during the 1970s, particularly the seminal publications of Michael Baxandall, *Giotto and the Orators: Humanist Observers of Painting in Italy and the Discovery of Pictorial Composition, 1350–1450* (Oxford University Press, 1971), and *Painting and Experience in Fifteenth Century Italy* (Oxford University Press, 1971). In a discussion that saw an epistemologically smooth evolution from Alberti to Serlio (which I think was the case in these interpretations), "decorum" tended to arrive hard-wired to

fit the context Serlio and his sixteenth-century successors gave to it. In this guise the Italian term derived from the Latin decorum, *decoro*, defined an aspirational, and conservative, condition of propriety against which license (*licensio*) might play. A year after MIT's English translation of Alberti's treatise appeared, Charles, Prince of Wales, published *A Vision of Britain* (London: Doubleday, 1989). That book used an argument couched in the Vitruvian notion of decorum to challenge progressive architectural thinking, and beyond that to question at a basic level architects' notions of what was right. Highly oratorical in nature (and, indeed, first disseminated as a television program), *A Vision of Britain* used a call for decorum dictated by tradition to attack the prerogatives of the architectural profession. And the profession responded in kind (for example, in the following year, a special issue of *Architectural Review* titled "A Primer for the Prince," no. 1126 [December 1990]). Thus during the years around 2000 a discourse on decorum was suddenly placed in a particular position with regard to conflicting ideas about the architect's mandate in society and about the development of the architectural discipline.

5. M. Vitruvius Pollio, *De architectura*. References here are given to Vitruvius, *The Ten Books on Architecture*, trans. Morris Hicky Morgan (New York: Dover, 1960).

6. See Michael Baxandall, *Giotto and the Orators*, esp. chap. 1, "Humanist's Opinions and Humanist Points of View," 1–50.

7. Cicero, *De officiis*, ed. T. E. Page et al., Eng. trans. Walter Miller, Loeb Classical Library

(London: William Heinemann; Cambridge, MA: Harvard University Press, 1938).

8. Cicero, *De oratore*, trans. with introduction, notes, appendices, glossary and indexes by James M. May and Jakob Wisse (New York: Oxford University Press, 2001); see "Introduction," 35–36.

9. The statement is made in Cicero's *Orator*, a short profile that models the ideal orator on his own technique, see Cicero, *Brutus. Orator*, trans. G. L. Hendrickson and H. M. Hubbell, Loeb Classical Library (London: William Heinemann; Cambridge, MA: Harvard University Press, 1939), 70.

10. Vitruvius introduces decorum into his discussion of fundamental principles in *De architectura* at I, II:1–7, 13–15; into his discussion of the dwelling at VI, V:3, VI, VII:7 and VI, VIII:9, 182, 189, 192; and into his discussion of finishing at VII, IV:4, VII, V:4–5, 209, 212 (Morgan).

11. See Onians, *Bearers of Meaning*, 37. Vitruvius, *De architectura*, I, II:5, 14 (Morgan). *Decor* is translated by Morgan as "propriety" and defined as "that perfection of style which comes when a work is authoritatively constructed on approved principles." Onians argues convincingly for a wider definition of *decor* than that implied by propriety, allying the term with decorum and appropriateness.

12. Vitruvius, *De architectura*, I, II:1–7, 13–15 (Morgan).

13. The gap between Vitruvius's formulations and what can be gathered of the practice of building during the early Roman Empire suggests that if we were to understand that practice in Vitruvius's terms, it would be made up only of

a series of challenges to his "rule." Onians, *Bearers of Meaning*, 39–41.

14. Vitruvius specifically condemns this practice, see Vitruvius, *De architectura*, I, II:6, 15 (Morgan).

15. Vitruvius, *De architectura*, 36, 37 (Morgan).

16. *De officiis*, I, XXXIX, 138.

17. *De oratore*, 1.132, 87.

18. *De oratore* 3.53, 238, 239.

19. *De oratore* 3.210, 290.

20. Frances A. Yates, *The Art of Memory* (London: Routledge & Kegan Paul, 1966).

21. *Rhetorica ad Herennium*, trans. Harry Caplan, Loeb Classical Library (London: William Heinemann; Cambridge, MA: Harvard University Press, 1956), III, xxii, 219–221.

22. *Rhetorica ad Herennium*, III, xxii, 219–221.

23. Mary J. Carruthers, *The Book of Memory: A Study of Memory in Medieval Culture* (Cambridge: Cambridge University Press, 1990), 99, 114.

24. "Paintings," in Leon Battista Alberti, *Dinner Pieces*, trans. David Marsh (Binghamton, NY: Medieval & Renaissance Texts & Studies in conjunction with the Renaissance Society of America, 1987), 54–57.

25. The images Alberti describes are to be set prominently in a sequence of places within the architecture of a temple remarkable for its "quantity of ornaments and variety of riches" and contain memorable striking juxtapositions; on the classical precedent; see Yates, *The Art of Memory*, 25, 26.

26. *Anuli* is translated as "Rings" in Alberti, *Dinner Pieces*, 210–217. Signet rings are also associated with the art of memory in as much as antique analogies regarded the

memory as like wax in which images could be imprinted; see Yates, *The Art of Memory*, 22–39. Mark Jarzombek has observed the similarity between the sequence of rings described by Alberti in *Anuli* and medieval mnemonic series described by Ernst Kantorowicz; see Mark Jarzombek, *On Leon Baptista Alberti* (Cambridge, MA: MIT Press, 1988), 48; and Ernst Kantorowicz, *The King's Two Bodies: A Study in Medieval Political Theology* (Princeton, NJ: Princeton University Press, 1957), 59.

27. Leon Battista Alberti, *De Pictura*, III:53. For the Latin and Italian texts (*Della pittura*), see *Leon Battista Alberti, Opere volgari*, vol. 3, ed. Cecil Grayson (Bari: G. Laterza, 1973), 5–107; the reference to Lucian is at 92–93. See also Leon Battista Alberti, *On Painting*, trans. Cecil Grayson, introduction and notes by Martin Kemp (London: Penguin Books, 1991), 88.

28. Vitruvius, *De architectura*, I, III:1, 16 (Morgan). See also the introduction to this book, "Cinnabar and Quicksilver."

29. Alberti, *On the Art of Building*, I, 9, 24.

30. Alberti, *Opere volgari*, vol. 3, 7–8.

31. Alberti, *Opere volgari*, vol. 3, 7–8.

32. Alberti, *On Painting*, 34–35.

33. On the construction of the dome see Eugenio Battisti, *Filippo Brunelleschi* (Milan: Electa, 1976), 114–171, and on Brunelleschi's expertise see 124, 130, 138. On the technical aspects see Rowland Mainstone, "Brunelleschi's Dome of S. Maria del Fiore and Some Related Structures," *Transactions of the Newcomen Society* 42, no. 1 (1969): 107–126. On the history generally see Howard Saalman,

Filippo Brunelleschi: The Cupola of Santa Maria del Fiore (London: Zwemmer, 1980). For an excellent bibliographical overview of the intense period of research on the dome during the 1970s and 1980s see Battisti, *Filippo Brunelleschi*, 114n1.

34. Battisti, *Filippo Brunelleschi*, 150, 156. On the extent of Brunelleschi's technical knowledge see especially 362n25 and 362n26.

35. Alberti, *On Painting*, 34–35.

36. Alberti, *On Painting*, 34–35.

37. A theme linking familial and societal location with architectural expression is developed already in the prologue to *De re aedificatoria*; see Alberti, *On the Art of Building*, "Prologue," 1: "How many respected families both in our own city and in others throughout the world would have totally disappeared, brought down by some temporary adversity, had not their family hearth harbored them. . . ." Similar themes are articulated further in book V in the consideration of the appropriate design of private buildings: Alberti, *On the Art of Building*, 117–121. Alberti's fable *Templum* also relates architectural and societal location, see "The Temple," in Alberti, *Dinner Pieces*, 175–176.

38. Alberti, *On the Art of Building*, VI, 1, 155.

39. For Vitruvius's (restrictive) opinions about decorum in fresco painting see *De architectura*, VII, V: 2–5, 211, 212 (Morgan).

40. On the adoption of rhetorical schema in the composition and interpretation of visual art, see Baxandal, *Giotto and the Orators*, 1–50 and 121–139.

41. On the printed production of Vitruvius treatise in the fifteenth and sixteenth centuries, see Ingrid D. Roland, "Vitruvius in Print and in Translation," in Hart and Hicks, *Paper Palaces*, 103–121; Louis Cellauro, "Palladio e le illustrazioni delle edizioni del 1556 e del 1567 di Vitruvio," *Saggi e Memorie di Storia dell'Arte* 22 (1998): 57–128; and Louis Cellauro, "Daniele Barbaro and His Venetian Editions of Vitruvius of 1556 and 1567," *Studi Veneziani*, n.s. 40 (2000): 87–134. The principal editions were those by Giovanni Sulpizio da Veroli: M. Vitruvius Pollio, *De architectura* (Rome, 1486); Giovanni Giocondo: M. Vitruvius Pollio, *De architectura* (Venice, 1511); Cesare Cesariano: *Di Lucio Vitruuio Pollione De architectura libri dece traducti de latino in vulgare affigurati: commentati: & con mirando ordine insigniti: per il quale facilmente potrai trouare la multitudine de li abstrusi & reconditi vocabuli a li soi loci & in epsa tabula con summo studio exposti & enucleati ad immensa utilitate de ciascuno studioso & beniuolo di epsa opera* (Como, 1521); and Daniele Barbaro: *I dieci libri dell' architettura di M. Vitruvio tradutti et commentati da Monsignor Barbaro Eletto Patriarca d'Aquileggia* (Venice, 1556, illustrations by Andrea Palladio) and *M. Vitrvvii Pollionis De architectura libri decem* (Venice: Francesco de' Franceschi & Giovanni Chrieger, 1567).

42. Sebastiano Serlio, *On Architecture* [*Tutte l'opere d'architettura et prospetiva*], trans. Vaughan Hart and Peter Hicks, 2 vols. (New Haven, CT: Yale University Press, 1996, 2001), 457.

43. Sebastiano Serlio, *On Architecture*, 458.

44. See Vaughan Hart, "'Paper Palaces' from Alberti to

Scamozzi," in Hart and Hicks, *Paper Palaces*, 1–29.

45. The classic analysis of the significance of musical harmony for architectural discourse is still that given in Rudolf Wittkower, *Architectural Principles in the Age of Humanism* (London: Warburg Institute, 1949, rpt. London: Wiley, 1988).

46. Vaughan Hart, "On Sebastiano Serlio: Decorum and the Art of Architectural Invention," in Hart and Hicks, *Paper Palaces*, 140–157.

47. For a general discussion see Karol Berger, *Musica Ficta: Theories of Accidental Inflection in Vocal Polyphony from Marchetto da Padova to Gioseffo Zarlino* (Cambridge: Cambridge University Press, 1987).

48. See Sachs and Dahlhaus, "Counterpoint," in *The New Grove Dictionary of Music and Musicians*, ed. Stanley Sadie (London: Macmillan Publishers, 1980), IV, 834–837.

49. Wittkower, *Architectural Principles in the Age of Humanism*, 41 and esp. part IV, "The Problem of Harmonic Proportion in Architetecture," 104–137. For a critique of the idea that musical theory was central for Renaissance architecture, see Charles Hope, "The Early History of the Tempio Malatestiano," *Journal of the Warburg and Courtauld Institutes* 55 (1992): 109 and n221.

50. Alberti, *De pictura*, II, 27, 62 (Grayson): "Rhodes was not burned down by King Demetrius lest a painting by Protagones be destroyed. So we can say that Rhodes was redeemed by a single picture." Compare with Alberti, *On the Art of Building*, VI, 1, 155.

51. See Smith, *Architecture in the Culture of Early Humanism*, 89–91. For a discussion of the general effectiveness attributed

in fifteenth-century Italy to compositions sensed through sight, see Carroll William Westfall, *In This Most Perfect Paradise: Alberti, Nicholas V and the Invention of Conscious Urban Planning in Rome, 1447–55* (University Park: Penn State University Press, 1974), 39–48; and Baxandall, *Painting and Experience in Fifteenth Century Italy* (Oxford: Oxford University Press, 1991), 15–27, 36–108.

52. Alberti, *On the Art of Building*, VII, 3, 156.

53. Alberti, *On the Art of Building*, "Prologue," 3; IX, 11, 318.

54. The classic account of the changes in the status of the architect in the early Renaissance is to be found in Richard A. Goldthwaite, *The Building of Renaissance Florence: An Economic and Social History* (Baltimore: Johns Hopkins University Press, 1980).

55. "To make something that appears to be convenient for use, and that can without doubt be afforded and built as projected, is the job not of the architect but of the workman. But to preconceive and to determine in the mind and with judgment something that will be perfect and complete in its every part is the achievement of such a mind as we seek." Alberti, *On the Art of Building*, IX, 10, 315.

Domenico Fontana and the Vatican Obelisk

1. See Tim Anstey, Katja Grillner, and Rolf Hughes, "Introduction," in *Architecture and Authorship* (London: Black Dog Publishing, 2007), 6–14; Jeremy Till, *Architecture Depends* (Cambridge, MA: MIT Press, 2010), 5–25.

2. Leon Battista Alberti, *De re aedificatoria*. References in this chapter are to the English translation, Leon Battista Alberti, *On the Art of Building in Ten Books*, trans. Joseph Rykwert, Robert Tavernor, and Neal Leach (Cambridge, MA: MIT Press, 1988).

3. Alberti, *On the Art of Building*, IX, 10, 315.

4. On the various backgrounds to Alberti's identification of the possibility of judging architects through the built work, see Mario Carpo, *The Alphabet and the Algorithm* (Cambridge, MA: MIT Press, 2011); and Tim Anstey, "Authorship and Authority in L. B. Alberti's *De re aedificatoria*," *Nordic Journal of Architectural Research* 4 (2003): 19–25.

5. Carpo, *The Alphabet and the Algorithm*, 20–26.

6. Alberti, *On the Art of Building*, I, 1, 7.

7. In *De re aedificatoria* Alberti makes clear that the architect need not control actions on the building site, but can leave such matters to a "zealous, circumspect and strict clerk of works" (Alberti, *On the Art of Building*, IX, 11, 318). This might suggest a determined disinterest in the action of placing material as an area of concern for architects. At the same time, as was observed in "Dealing with Decorum," the introduction to the Italian edition of Alberti's treatise on painting, *Della pittura*, praises Brunelleschi's virtue in constructing the dome of Santa Maria del Fiore, his which "if I am not mistaken . . . people did not believe possible in these days and was probably unknown and unimaginable to the ancients." For the Italian text, see Leon Battista Alberti, *De pictura*, in *Leon Battista Alberti. Opere volgari*, vol. 3, ed. Cecil Grayson (Bari: G. Laterza, 1973); and see Leon Battista

Alberti, *On Painting*, trans. Cecil Grayson, introduction and notes by Martin Kemp (London: Penguin Books, 1991), 34–35.

8. Alberti discusses actions involving the movement of large weights at the very start of *De re aedificatoria*, in his definition of the value of the architect's work, and at the center of his treatise within the crucial book VI on Ornament. In both cases attention to the mechanical aspects of architecture is divorced from the discussions of materials that occupy books II "Materials" and III "Construction," which deal largely with the function of materials once they are in place. See Alberti, *On the Art of Building*, "Prologue," 3–4 and book VI, 6–8, 164–175.

9. Alberti, *On the Art of Building*, VI, 8, 175.

10. For a comparison of these texts, see Joan Gadol, *Leon Battista Alberti: Universal Man of the Early Renaissance* (Chicago: University of Chicago Press, 1969). On *Descriptio urbis Romæ*, see additionally Mario Carpo, "*Descriptio urbis Romæ*: Ekfrasis geografica e cultura visuale all'alba della rivoluzione tipografica," *Albertiana* 1 (1998): 121–143. For translations of Alberti's mathematical works, including *De componendis cifris*, see Kim Williams, Stephen R. Wassell, and Lionel March, eds., *The Mathematical Works of Leon Battista Alberti* (Basel: Birkhäuser, 2010). *De pictura* and *De statua* were translated with an introduction in *On Painting and On Sculpture: The Latin texts of De pictura and De statua*, trans. and ed. Cecil Grayson (London: Phaidon, 1972). Joan Gadol's analysis of Alberti's thinking successfully demonstrated the structural similarities that exist between *De componendis cifris*, *De*

pictura, *De statua*, and *Descriptio urbis Romæ.*

11. See in this book "Dealing with Decorum."

12. Tim Anstey, "Architecture and Rhetoric," in Anstey, Grillner and Hughes, *Architecture and Authorship*, 18, 19.

13. See particularly Mario Carpo, *The Alphabet and the Algorithm*; and Mario Carpo, "The Making of the Typographical Architect," in Vaughan Hart and Peter Hicks, eds., *Paper Palaces: The Rise of the Renaissance Architectural Treatise* (New Haven, CT: Yale University Press, 1998), 158–169.

14. F. Scott Fitzgerald, *The Great Gatsby* (New York: Charles Scribner and Sons, 1925), 182.

15. See Tim Anstey, "The Ambiguities of *Disegno*," *Journal of Architecture* 10, no. 3 (2005): 295–306.

16. Antonio di Pietro Averlino (Filarete) composed what he called his *Libro architettonico* between 1460 and 1465; it existed in a handful of manuscript copies until a printed edition was produced in 1896. See now Antonio di Pietro Averlino, *Trattato di architettura*, ed. Anna Maria Finoli and Liliana Grassi (Milan: Il Polifilo, 1972).

17. The first versions of Francesco di Giorgio Martini's *Trattato di architettura civile e militare* were composed between 1479 and 1481, at the Royal Library, Turin (Codice Torinese Saluzziano 148); a second version, including a translation of Vitruvius is kept at the National Library in Florence (ms. II.I.141, Biblioteca Nazionale Centrale di Firenze). Printed as Francesco di Giorgio Martini, *Trattato di architettura civile e militare*, ed. Cesare Saluzzo, 1841; see now *Trattato di architettura civile e militare di Francesco di Giorgio*

Martini, *architetto senese del secolo XV* (London: Forgotten Books, 2018).

18. On the publishing history of Sebastiano Serlio's *Tutte l'opere d'architettura et prospetiva*, and for an English translation of the whole, see Vaughan Hart and Peter Hicks, eds., *Sebastiano Serlio on Architecture*, vol. 1: *Books I–V of "Tutte l'opere d'rchitettura et prospetiva"* (New Haven, CT: Yale University Press, 1996), and vol. 2: *Books VI and VII of "Tutte l'opere d'architettura et prospetiva,"* with "Castrametation of the Romans" and "The Extraordinary Book of Doors" (New Haven, CT: Yale University Press, 2001).

19. See Hart, "On Sebastiano Serio: Decorum and the Art of Architectural Invention;" Carpo, "The Making of the Typographical Architect;" and Hart, "Serlio and the Representation of Architecture," all in Hart and Hicks, *Paper Palaces*, 140–185.

20. Jacopo [Giacomo] Barozzi da Vignola, *Regola delli cinque ordini d'architettura* (Rome: n.p., 1562). See Richard J. Tuttle, "On Vignola's Rule of the Five Orders of Architecture," in Hart and Hicks, *Paper Palaces*, 199–218. Andrea Palladio, *I quattro libri dell'architettura* (Venice: Domenico de' Franceschi, 1570), translated as *The Four Books of Architecture*, trans. Robert Tavernor and Richard Scofield (Cambridge, MA: MIT Press, 2002).

21. On the development of Vitruvianism and its relationship to decorum, see Ingrid D. Rowland, "Vitruvius in Print," and Vaughan Hart, "On Sebastiano Serlio," both in Hart and Hicks, *Paper Palaces*, 105–121 and 170–185.

22. Daniele Barbaro, *I dieci libri dell'architettura di M. Vitruvio. Tradotti & commentati da*

mons. Daniel Barbaro eletto Patriarca d'Aquileia, da lui riueduti & ampliati; & hora in piu commoda forma ridotti (Venice: Francesco Marcolini, 1556), and M. Vitrvvii Pollionis, *De architectura libri decem* (Venice: Francesco de' Franceschi & Giovanni Chrieger, 1567).

23. For a manuscript copy of the treatise see Marcus Vitruvius Pollio, *De architectura*, British Library Harley MS 2767. Accessible online at https://access.bl.uk/item/viewer/ark:/81055/vdc_100056038850.0x000001#?c=0&m=0&s=0&cv=0&xywh=-2269%2C0%2C9301%2C5965. A comparison between the shape of the Harley Vitruvius and the edition of Barbaro reads as follows: Harley: books I–VI, 56% of total work; books II–VI, 45% of total work; books VII–X, 44% of total work; Barbaro: books I–VI, 62% of total work; books II–VI, 55% of total work; books VII–X, 38% of total work.

24. See James M. Lattis, "Jesuit Mathematics and Ptolemaic Cosmology," in *Between Copernicus and Gallileo: Christoph Clavius and the Collapse of Ptolemaic Cosmology* (Chicago: University of Chicago Press, 1994), 30–60.

25. Palladio, *I quattro libri*, I, II–VI, 7–10 (Tavernor and Scofield). The whole of Palladio's advice on construction, from foundation to roof, occupies the next three pages.

26. Domenico Fontana, *Della trasportatione dell'obelisco vaticano, e della fabriche di Nostro Signore papa Sisto V* is published in facsimile with an introduction by Paolo Portoghesi in Domenico Fontana, *Della trasportatione dell'obelisco vaticano 1590*, ed. Adriano Carugo (Milan: Edizione Polifilo, 1978),

Notes

and is available in facsimile with an English translation and introduction by Ingrid D. Roland in the CD-ROM series of the Rare Books and Special Collections Division, Library of Congress, as Domenico Fontana, *Della trasportatione dell'obelisco vaticano*, trans. David Sullivan, comm. Ingrid Rowland (Oakland, CA: Octavo, 2002).

27. On the history of Fontana's project for moving the obelisk, see Brian Curran et al., *Obelisk: A History* (Cambridge, MA: Burndy Library, 2009), 103–140; Giovanni Cipriani, *Gli obelischi egizi, politica e cultura nella Roma barocca* (Florence: Leo S. Olschki, 1993); Marcello Pagiolo and Maria Luisa Madonna, eds., *Sisto V*, vol. I: *Roma e il Lazio* (Rome: Istituto Oligrafico e Zecca dello Stato, 1992); and Erik Iversen, *Obelisks in Exile*, vol. 1: *The Obelisks of Rome* (Copenhagen: Gad, 1968). For an analysis of the structure of his printed work, *Della trasportatione dell'obelico Vaticano*, see André Tavares, *The Anatomy of the Architectural Book* (Zurich: Lars Müller and Canadian Centre for Architecture, 2016), 258–269.

28. On the portrayal of architects in sixteenth-century frontispieces see Desley Luscombe, "Inscribing the Architect: The Depiction of the Attributes of the Architect in Frontispieces to Sixteenth-Century Italian Architectural Treatises," PhD diss., University of New South Wales, 2004, 30–42.

29. Curran et al., *Obelisk*, 134.

30. The conversion of weights and distances from Roman into metric measures are my own. The height and weight of the obelisk were calculated by and are recorded in the text, *Della trasportatione*,

9r–10v. On the history of the process, see Curran, *Obelisk*, 103–140.

31. Fontana, *Della trasportatione dell'obelisco vaticano*, 9r–10v.

32. The plates were made by the engraver Natale Beneficio da Sebenico from Fontana's own drawings, see Ingrid D. Rowland, "Fontana, *Della trasportatione dell'obelisco vaticano*" (commentary), in Fontana, *Della trasportatione dell'obelisco vaticano*, 10.

33. On Raphael's letter to Leo X, see again Tavares, *The Anatomy of the Architectural Book*, 210–212.

34. Fontana, *Della trasportatione dell'obelisco vaticano*, plate 18, 15r.

35. There is a change in terms of representation between Fontana's preparatory drawing for this plate and the final engraving, which suggests that this omission was very carefully considered. In Fontana's drawing the lines indicating ropes are carried into the representation of the *castello*; in the engraving these lines are omitted.

36. *Della trasportatione dell'obelisco vaticano*, 5v, 6r–8v (contents of papal bull empowering Fontana to expedite process and collect materials), 9r–10r (calculation of weights), 10r (cables and windlasses), 10v–12v (scaffold and timbers), 13r–15r (process of movement).

37. On the principle of "flattening" as a means to provide a full social description of processes that are often analysed using limited scientific or technical kinds of data, see Bruno Latour, *Reassembling the Social: An Introduction to Actor-Network-Theory* (Oxford: Oxford University Press, 2007), esp. chap. 9, "How to Keeping the

Social Flat." On the use of actor-network theory methods in the analysis of architectural production see Bruno Latour and Albena Yaneva, "'Give Me a Gun and I Will Make All Buildings Move': An ANT's View of Architecture," *Ardeth* 1 (2017): 103–111.

38. See this book's introduction, "Cinnabar and Quicksilver," for the significance of shadow trackers and their use in city orientation.

39. In relation to this, see John Dee, *A Preface to Euclid*, in *John Dee*, ed. Gerald Suster (Berkeley, CA: North Atlantic Books, 2003). See also Frances A. Yates, *Theatre of the World* (Chicago: University of Chicago Press, 1969), and Vaughan Hart, "Inigo Jones' Site Organization at St. Paul's Cathedral: 'Pondrous Masses Beheld Hanging in the Air,'" *Journal of the Society of Architectural Historians* 53, no. 4 (December 1994): 414–427.

40. Giovan Pietro Bellori, *The Lives of the Modern Painters, Sculptors and Architects*, trans. and ed. Alice Sedgwick Wohl et al. (Cambridge: Cambridge University Press, 2005).

41. Ludwig Heinrich Heydenreich, *Architecture in Italy, 1400–1500* (New Haven, CT: Yale University Press, 1974), 5.

The Tenants' Furniture

1. Gertrud Bing to Godfrey Samuel, December 10, 1934. RIBA Drawings Collection. Godfrey Samuel Papers, Series 2: Projects undertaken by Samuel, 1933–1938.

2. RIBA Drawings collection. Tecton Drawings. London (Bromley): Elstree Hill, Lewisham, designs for a house for Dr Saxl & Dr Bing, . . . executive architect Godfrey Samuel, ca. 1934 [PA112/1(1–4)].

3. Lord Lee of Fareham to Max Warburg, letter of invitation for the loan of the Warburg Institute to London, cited in Eric M. Warburg, "The Transfer of the Warburg Institute to England in 1933," appendix to *The Warburg Institute Annual Report*, 1952–1953 (London: University of London, 1953), 15.

4. Eric M. Warburg, "The Transfer of the Institute to England," 13–16; and Elizabeth Sears, "The Warburg Institute, 1933–1944. A Precarious Experiment in International Collaboration," *Art Libraries Journal* 38, no. 4, 2013: 7–15.

5. Warburg's work is collected in an authoritative English translation in Aby Warburg, *The Renewal of Pagan Antiquity*, trans. David Britt (Los Angeles: Getty Research Institute for the History of Art and the Humanities, 1999), including "Sandro Botticelli" (1898); "Francesco Sassetti's Last Injunctions to His Sons" (1907); "Pagan-Antique Prophecy in Words and Images in the Age of Luther" (1920), and "Italian Art and International Astrology in the Palazzo Schifanoia, Ferrara" (1922). A long-term collaboration between Humboldt Universität Berlin, Universität Hamburg, the Warburg Institute Archive, and the publisher De Gruyter is publishing a new original-language edition of Warburg's collected works. The recent and lavish publication *Aby Warburg: Bilderatlas Mnemosyne: The Original*, ed. Roberto Ohrt, Axel Heil, Bernard Scherer, Bill Sherman, and Claudia Wedepohl (Berlin: HKW, Haus der Kulturen der Welt; London: Warburg Institute; Berlin: Hatje Cantz, 2020), accompanied a major exhibition of the same name. For examples of the interest in Warburg since 1998 see among many others: Benedetta Cestelli Guidi and Nicholas Mann, eds., *Photographs at the Frontier: Aby Warburg in America 1895–1896* (London: Merrell Holberton, 1998); Kurt W. Forster, "Introduction" to Aby Warburg, *The Renewal of Pagan Antiquity*, trans. David Britt (Los Angeles: Getty Research Institute for the History of Art and the Humanities, 1999), 1–75; Georges Didi-Huberman, *L'image survivante. Histoire de l'art et temps des fantômes selon Aby Warburg* (Paris: Minuit, 2002), translated as *The Surviving Image: Phantoms of Time and Time of Phantoms: Aby Warburg's History of Art*, trans. Harvey Mendelsohn (University Park: Penn State University Press, 2017); Philippe-Alain Michaud, *Aby Warburg and the Image in Motion* (New York: Zone Books, 2004); Kurt W. Forster, *Aby Warburgs Kulturwissenschaft: Ein Blick in die Abgründe der Bilder* (Berlin: Matthes & Seitz, 2018); and see now Dorothea McEwan, *Studies on Aby Warburg, Fritz Saxl and Gertrud Bing* (London: Routledge, 2023).

6. See particularly the work on the institutional history of the Warburg Institute, and on Warburg's circle, by Elizabeth Sears including: "The Warburg Institute"; "Warburg Institute Archive, General Correspondence," *Common Knowledge* 18, no. 1, "The Warburg Institute. A Special Issue on the Library and Its Readers" (Winter 2012): 32–49 (the entire contents of this issue are useful, especially Anthony Grafton and Jeffrey F. Hamburger, "Introduction," which provides a useful orientation); "Keepers of the Flame: Bing, Solmitz, Klibansky and the Continuity of the Warburgian Tradition," in *Raymond Klibansky and the Warburg Library Network: Intellectual Peregrinations from Hamburg to London and Montreal*, ed. Philippe Despoix and Jillian Tomm (Montréal: McGill/Queens University Press, 2018), 29–57.

7. This question formed the basis of a research project carried out at the Oslo School of Architecture and Design between 2020 and 2022 which resulted in an exhibition, "Warburg Models: Buildings as Bilderfahrzeuge," exhibited at the Warburg Haus, Hamburg, and the Architecture Association, London, between December 2023 and March 2024. On the exhibition see Tim Anstey and Mari Lending, *Warburg Models: Buildings as Bilderfahrzeuge* (Berlin: Hatje Cantz, 2023).

8. See, among the very broad literature on the library, Kurt Forster, "Aby Warburg: His Study of Ritual and Art on Two Continents," trans. David Britt, *October* 77 (1997): 5–24; Anne Marie Meyer and Salvatore Settis, "Warburg continuatus. Descrizione di una biblioteca," *Quaderni storici*, n.s. 20, no. 58 (April 1985): 5–38; and Carlo Ginzburg, "Une machine à pensée," *Common Knowledge* 18, no. 1 (Winter 2012): 79–85. The most thorough study on the Kulturwissenschaftliche Bibliothek Warburg remains that of Tilmann von Stockhausen, *Die Kulturwissenschaftliche Bibliothek Warburg: Architektur, Einrichtung und Organisation* (Hamburg: Dölling & Galitz, 1992). These analyses have recently been complemented by scholars of media history, for example Mick Finch, "The Technical Apparatus of the Warburg Haus," *Journal of Visual Art Practice* 15, nos. 2–3 (2016): 94–106; and Katia Mazzucco, "Images on

the Move. Some Notes on the Bibliothek Warburg Bildersammlung (Hamburg) and the Warburg Institute Photographic Collection (London)," *Art Libraries Journal* 38, no. 4 (2013): 16–24.

9. The "rule of the good neighbour" is cited in Fritz Saxl, "The History of Warburg's Library (1886–1944)," appendix to E. H. Gombrich, *Aby Warburg: An Intellectual Biography* (London: Warburg Institute, 1970), 337. The best explanations of the system remain those given by Gertrud Bing and Edgar Wind in articles written soon after the arrival of the library to London: Gertrud Bing, "The Warburg Institute," *Library Association Record* 35, no. 4 (August 1934): 262–266; Edgar Wind, "The Warburg Institute Classification Scheme," *Library Association Record*, 4th series, 2 (May 1935): 193–195. The evolution of the library and its system (though not its architecture) is minutely traced in Meyer and Settis, "Warburg continuatus," 17–32, which remains the most authoritative work on the material.

10. Stockhausen, *Die Kulturwissenschaftliche Bibliothek Warburg*, 81–90.

11. Claudia Wedepohl, "Mnemonics, Mneme and Mnemosyne: Aby Warburg's Theory of Memory," *Bruniana & Campelliana* 20, no. 2 (2014): 385–402.

12. The development of this thinking can be seen in Warburg's essay "Sandro Botticelli," in Warburg, *The Renewal of Pagan Antiquity*, 157–164.

13. The clearest example of Warburg's use of orientation as a schema for art-historical nalysis comes in his essay on the sacristy of San Lorenzo in Florence, "An Astronomical Map in the Old Sacristy of San Lorenzo in Florence (1911)," and that on the frescos of the Stanza delle Mese in the Palazzo Schifanoia in Ferrara, "Italian Art and International Astrology in the Palazzo Schifanoia, Ferrara (1912)," both in Warburg, *The Renewal of Pagan Antiquity*, 269–270 and 563–592.

14. Warburg described his reaction to Lippi in his 1927 presentation of the aims of the KBW, "Vom Arsenal zum Laboratorium." Aby Warburg, "From the Arsenal to the Laboratory," trans. Christopher Johnson, ann. Claudia Wedepohl, *West 86th* 19, no. 1 (2012): 114. On Warburg's trip to Florence in 1888–1889, see Claudia Wedepohl, "Why Botticelli? Aby Warburg's Search for a New Approach to Quattrocento Italian Art," in *Botticelli Past and Present*, ed. Ana Debenedetti and Caroline Elam (London: UCL Press, 2019), 192–194.

15. On the Hamburg Planetarium, see Uwe Fleckner et al., eds., *Aby M. Warburg: Bildersammlung zur Geschichte von Sternglaube und Sternkunde im Hamburger Planetarium* (Hamburg: Dölling und Galitz, 1993), 250–279.

16. Ludwig Binswanger, "Histoire clinique [d'Aby Warburg]," 1921–24, in *La guérison infinie: Histoire clinique d'Aby Warburg*, ed. Davide Stimilli, trans. Maël Renouard and Martin Rueff (Paris: Rivages, 2007), 53–180.

17. Saxl, "The History of Warburg's Library (1886–1944)," 332.

18. The address is 116 Heilwigstrasse. On the building process see Stockhausen, *Die Kulturwissenschaftliche Bibliothek Warburg*, 42–52.

19. Warburg Institute Archive [WIA], I.3.1, Felix Ascher, Plans and section, Bibliothek Warburg, 1924.

20. Stockhausen, *Die Kulturwissenschaftliche Bibliothek Warburg*, 42–52. On the career of Fritz Schumacher, see Jennifer Jenkins, *Provincial Modernity: Local Culture and Liberal Politics in Fin-de-Siècle Hamburg* (Ithaca, NY: Cornell University Press, 2002), 261–298.

21. WIA, I.4.8.1, Gerhard Langmaack, Kulturwissenschaftliche Bibliothek Warburg, longitudinal section, autograph annotations by Aby Warburg, ca. 1926.

22. Stockhausen, *Die Kulturwissenschaftliche Bibliothek Warburg*, 192–201. Mazzucco, "Images on the Move," 16–24.

23. WIA, I.4.17, Gertrud Bing, notes on positioning of library subject headings, Kulturwissenschaftliche Bibliothek Warburg, ca. 1926.

24. WIA 1.4.20.3, Gerhard Langmaack, presentation album, Kulturwissenschaftliche Bibliothek Warburg, 1926.

25. "Projektplan Gerhard Langmaack. Neubau Kulturwissenschaftliche Bibliothek Warburg, Hamburg," section 5, Die technischen Einzelheiten, part o., transcribed in Stockhausen, *Die Kulturwissenschaftliche Bibliothek Warburg*, 141–143. Wolf Netter & Jacobi also produced steel card-index boxes, trolleys, book stands, and ladders, see *Regale aus Stahl*, undated product catalogue, ca. 1925, Wolf Netter & Jacobi Collection, The Leo Baeck Institute Center for Jewish History, New York, AR7212, box 1/1.

26. Gertrud Bing, "The Warburg Institute," *Library Association Record* 35, no. 4 (August 1934), 266. See also entry by Gertrud Bing, April 29, 1927, *Tagebuch der Kulturwissenschaftlichen Bibliothek Warburg* vol. 2, 123: "Ich würde Heinz Brauer

deshalb den Besuch der Magazine nicht verwehren, weil bei seiner eigenwilligen Arbeitsmethode die 'Entdeckungsreisen' in der BW soviel wert sind. Er hat in den letzten Wochen wichtige und ihn selbst sehr beglückende Funde gemacht durch dieses 'browsing.'" She attributes the term "browsing" to an American researcher, Gladys Reichard.

27. "Projektplan Gerhard Langmaack," section 5, part 0: "Büchergestelle in den Magazinen nach System Wolf, Netter & Jakobi. Beleuchtung durch Röhrenlampen, aneinandergereiht direkt an der Decke zwischen den Gestellen. Betätigung durch Kettenzug in den Gängen." Transcribed in Stockhausen, *Die Kulturwissenschaftliche Bibliothek Warburg*, 143.

28. Entry by Gertrud Bing, March 14, 1927, *Tagebuch Kulturwissenschaftliche Bibliothek Warburg* vol. 2, 73. "Ich bestelle für die Magazine Lichtgardinen, da Signaturen und Einbände der am Fenster stehenden Bücher ganz entsetzlich unter der Sonne leiden. Kostet leider 100 M, ist aber ganz dringend erforderlich."

29. Arthur Aaron Bright, *The Electric-Lamp Industry: Technological Change and Economic Development from 1800 to 1947* (New York: Macmillan, 1949), 386–387.

30. John Allan, *Berthold Lubetkin. Architecture and the Tradition of Progress* (London: RIBA Publications, 1992), 110. Samuel introduced Lubetkin to the group.

31. Allan, *Berthold Lubetkin*, 202.

32. Among other work, a house for the art historian Ellis Waterhouse, Overshot Hall, Oxfordshire, with Valentine Harding, completed in 1938.

33. Telegram, Felix Warburg to Herbert Samuel, September 17, 1933. Jacob Rader Marcus Center of the American Jewish Archives, Felix M. Warburg Papers Manuscript Collection No. 457, box 293/18. Samuel was hosted by Warburg at an official dinner at the Harmonic Club on Tuesday, October 3, 1933, see Jewish Telegraphic Agency bulletin, October 2, 1933.

34. Sears, "The Warburg Institute," 8.

35. Tecton, "Layout of the Warburg Institute at Thames House." RIBA Drawings collection. Tecton Drawings. London (Westminster).

36. Tecton, "Design for Layout of Library and Working Drawings for Lantern Stand, Plans & Details," executive architect Godfrey Samuel, 1934. RIBA Drawings collection. Tecton Drawings. London (Westminster).

37. Bing, "The Warburg Institute," 265.

38. G. A. Harvey & Co. (London) to Fritz Saxl, January 6, 1934. RIBA Drawings collection. Godfrey Samuel Papers, Series 2: Projects undertaken by Samuel, 1933–1938.

39. The London Ice Club opened January 14, 1927, financed and commissioned by Stephen and Jack Courtauld, brothers of Samuel Courtauld, see "Millionaire's Ice Rink," *Canberra Times*, March 17, 1927. The adjacent office development at Cleland House, designed by T. P. Bennett, was completed in 1938.

40. Bing, "The Warburg Institute," 263.

41. Sears, "The Warburg Institute," 8. The formal invitation sent to Hamburg on October 28, 1933 (by Lord Lee of Fareham) offered a residency in London "say for a period of three years," which formed the basis on which space and funding were offered to accommodate the institute. This term came to an end at the end of 1936.

42. Colin Rowe, "The Mathematics of the Ideal Villa," *Architectural Review* 101 (March 1947): 101–104; Rudolf Wittkower, *Architectural Principles in the Age of Humanism* (London: Warburg Institute, 1949); *The Letters of Colin Rowe: Five Decades of Correspondence*, ed. Daniel Naegele (London: Artifice Books on Architecture, 2016), 8–9.

43. Frances A. Yates, *Giordano Bruno and the Hermetic Tradition* (London: Routledge and Kegan Paul, 1964), and *The Art of Memory* (London: Routledge and Kegan Paul, 1966).

44. Fritz Saxl was director of the Warburg Institute until his death in 1948, Henri Frankfort from 1948 until 1954, and Gertrud Bing from 1954 until 1959.

45. WIA, Ia.2.5, Warburg Institute, University of London. Annual Report, 1937–1938. Typewritten document including Gertrud Bing's description of the arrangement of the Warburg library in the Imperial Institute buildings (sides 1–7), dated February 16, 1938. Room 3 was "Dr. Wittkower's room"; room 4 "is the one to be occupied by Mr. Blunt . . ." WIA, Ia.2.5, 1–4. I am indebted to Elizabeth Sears for identifying this source.

46. WIA, Ia.2.5, 4–6.

47. Warburg Institute, University of London, Annual Report 1949–1950, November 1950, 1–2.

48. Sydney Anglo, "From South Kensington to Bloomsbury and Beyond," in *Vorträge aus dem Warburg-Haus. The*

Afterlife of the Kulturwissenschaftliche Bibliothek Warburg, ed. Uwe Fleckner and Peter Mack (Berlin: De Gruyter, 2015), 66.

49. Anglo, "From South Kensington to Bloomsbury," 65.

50. Anglo, "From South Kensington to Bloomsbury," 68. "An immensely tall room . . . with metal walkways all around, each level reached by spiral iron staircases."

51. Warburg Institute, University of London, Annual Report 1951–1952, 1.

52. Richard Simpson, "Classicism and Modernity. The University of London's Senate House," *Bulletin of the Institute of Classical Studies* 43 (1999): 53–61; Eitan Karol, *Charles Holden, Architect* (Donnington, Lincolnshire: Shaun Tyas, 2007).

53. WIA, I.1.7.2, Douglas William Logan, "Memorandum for the Warburg Institute Committee of Management March 4, 1954, from the Principal [of the University]."

54. A developed plan for the Warburg and Courtauld Institute located at the corner of Torrington Place and Gordon Square and Woburn Square, was requested by the principal of the university at a Building Sub-Committee meeting on February 8, 1954, and it was exhibited at the Imperial Institute Buildings after March 1954. Revised drawings of the Warburg Institute only, with a reduced footprint, were presented at a Building Sub-Committee meeting on August 12, 1954. The detailed plan design was finalized by June 1955. WIA, I.7.3, Minutes of the Building subcommittee.

55. WIA, I.7.1.2, "Memorandum for the Building subcommittee—New Courtauld-Warburg Building,"

undated copy, almost certainly from 1945. The Fogg was a parent institution for the combined Courtauld and Warburg Institutes in terms of its brief. Felix Warburg had been one of the major donors for the Fogg's 1920s building campaign. See Kathryn Brush, *Vastly More Than Brick and Mortar: Reinventing the Fogg Art Museum in the 1920s* (New Haven, CT: Yale University Press, 2004).

56. Adams, Holden & Pearson. Elevational and sectional studies for a new building for the Courtauld and Warburg Institutes, ca. 1945, RIBA Drawings collection, Adams, Holden & Pearson. Designs for the Warburg Institute, Woburn Square.

57. WIA, I.7.1.1, Fritz Saxl, "Needs of the Warburg Institute in connection with the projected new building for the Courtauld and Warburg Institutes," June 22, 1945.

58. WIA, I.7.1.1, Henri Frankfort, "Revised Schedule of Accommodation for the Warburg Institute," June 16, 1953. "I have set out how I have reached a total of approximately 17,000 square feet, required for placing the library, as we wish it, undivided on one floor."

59. WIA General Correspondence [GC], W. Fankl to Gertrud Bing, March 15, 1953.

60. Yorke Rosenberg Mardall, *The Architecture of Yorke Rosenberg Mardall, 1944/1972*, introduction by Reyner Banham (London: Lund Humphries, 1973); Alan Powers, *In the Line of Development: F. R. S. Yorke, E. Rosenberg and C. S. Mardall to YRM, 1930–1992* (Chichester: Wiley Academy, 2003); Kenneth Powell, *Powell & Moya* (London: RIBA Publcations, 2009).

61. Stockhausen, *Die Kulturwissenschaftliche Bibliothek Warburg*, 58; WIA, GC, Kenneth Urquhart, Adam Holden & Pearson to Gertrud Bing, December 17, 1957, and June 2–3, 1958.

62. WIA, I.7.1.3, Adams Holden & Pearson. Warburg Institute, University of London, drawing no. LU7588, September 1956.

63. WIA, GC, Gertrud Bing to Walter Solmitz, December 4, 1957. "Aber der Architekt hat weder Geschmack noch ist er im Stande architektonische Probleme und Probleme der Einrichtung wirklich durchzudenken. Soweit ich sie voraussehen kann versuche ich den grössten Fehlern zuvorzukommen, aber was man nicht voraussehen kann passiert eben. Und ich tue alles was ich zu tun habe—und das ist viel und mühsam—auf dem Hintergrund einer profunden Skepsis." I am indebted to Elizabeth Sears for this reference.

64. WIA, I.7.7.2, Adams Holden & Pearson. Warburg Institute, University of London. Schedule B. Existing furniture to be reused in the new building, November 1957.

65. WIA, GC, Gertrud Bing to Kenneth Urquhart, Adams Holden & Pearson, March 18, 1955, 8.

66. WIA, I.7.3, Adams Holden & Pearson. Warburg Institute, University of London. Floor plans, Basement to fourth floor, showing arrangement of furniture, drawing nos. LU 7748–7753, Rev E, after February 7, 1957. On the plan for color-coding the stack rooms according to the library paper strips used on the book spines, see WIA, GC, Kenneth Urquhart, Adams Pearson, and Holden to Gertrud

Notes

Bing, September 24, 1957: "I am looking forward to our meeting on Thursday next, the 26th September at 2.30 p.m. in your office to discuss interior colours for the various Stack rooms. I hope I can take away with me pieces of the coloured papers so that I can get machings (sic) for you to see on Site." Letter transcribed by Elizabeth Sears, to whom I am indebted for this reference.

67. Nicholas Pevsner, "Backyard Mentality" *Architectural Review* 128 (1960): 446–448; Michael Baxandall, *Episodes: A Memory Book* (London: Frances Lincoln, 2010), 119.

68. Gertrud Bing to Raymond Klibansky, April 25, 1958. Deutsches Literaturarchiv Marbach A: Klibansky, XX–XXI, 1.

69. Godfrey Samuel to Gertrud Bing, January 1, 1935. RIBA Drawings collection. Godfrey Samuel Papers, Series 2: Projects undertaken by Samuel, 1933–1938. Itemized list of changes to the project includes: "3. More room for furniture in Living Rooms, (but I think it may be necessary for some of Dr. Saxl's furniture to be used by you); 5. Basement storage for unwanted furniture. (Note: the following pieces of furniture have not been included—Saxl, 9, 10, 23 and 38: Bing 13.) . . . I am returning the schedule of furniture at the same time so that you can identify the pieces in the plan."

70. Donald Gordon, "In Memoriam Gertrud Bing," in Ernst Gombrich, ed., *In Memoriam. Gertrud Bing: 1892–1964*, London 1965, 11. Reprinted in Monica Centanni and Daniela Sacco, eds., *Gertrud Bing. Erede di Warburg. La rivista di engramma*, 177, November 2020, 132. On Bing's contribution, character,

and customs see also Centanni and Sacco, eds., *Gertrud Bing. Erede di Warburg. La rivista di engramma* and Laura Tack, *The Fortune of Gertrud Bing. A Fragmented Memoire of a Phantom-Like Muse* (Leuven: Peeters, 2020).

71. Michael Baxandall, *Episodes*, 114.

72. Gordon, "In Memoriam," 144.

73. Gordon, "In Memoriam," 152.

Early Electric

1. "Reyner Banham Loves Los Angeles," produced by Malcolm Brown, directed by Julian Cooper, episode 57, BBC Series *One Pair of Eyes*, March 11, 1972. For an analysis of the film see Bobbye Tigerman, "Reyner Banham Loves Los Angeles (One Pair of Eyes)," BBC (1972), in *Design and Culture: The Journal of the Design Studies Forum* 1, no. 2 (2009): 234–236. The film was produced a year after the release of Banham's book, a paean to Los Angeles greatest motorway interchange: "The Santa Monica/San Diego Intersection is a work of art, both as a pattern on the map, a monument against the sky, and as a kinetic experience as one sweeps through it." Reyner Banham, *Los Angeles. The Architecture of Four Ecologies* (London: Allan Lane, 1971; reprinted Berkeley: University of California Press, 2001), 70–72.

2. On Yngve Larsson see the *Swedish Dictionary of National Biography*: Göran Sidenbladh, "G. R. Yngve Larsson," *Svenskt biografiskt lexikon*, https://sok .riksarkivet.se/sbl/artikel/11054 (accessed February 27, 2023). See also Larsson's political autobiography, Yngve Larsson, *Mitt liv i Stadshuset*, 2 vols. (Uppsala: Almqvist & Wiksell, 1977). On Tage William-Olsson

see Eva Rudberg, ed., *Tage William-Olsson: Stridbar Planerare och visionär arkitekt* (Stockholm: Stockholmia Förlag, 2004), 14–23. On Gustav "Gösta" Lundborg see the *Swedish Dictionary of National Biography*: Göran Sidenbladh, "Gustaf (Gösta) O. F. Lundborg," *Svenskt biografiskt lexikon*, https://sok.riksarkivet .se/sbl/artikel/9779 (accessed February 27, 2023).

3. Centrum was "Stockholm's most elegant business complex," according to a *Svensk Filmindustri Veckorevy* newsreel film (*Swedish Film Industry Weekly Review*, hereafter *SF Veckorevy*) from February 16, 1931, SF SF703 (1 50 51).

4. On the history of Skansen and its role in 1930s Stockholm culture see Thordis Arrhenius, "The Vernacular on Display: Skansen Open-Air Museum in 1930s Stockholm," in *Swedish Modernism: Architecture, Consumption and the Welfare State*, ed. Helena Mattsson and Sven Olov Wallenstein (London: Black Dog Publishing, 2010), 134–149.

5. On the history of Gröna Lund and Nöjesfältet, Stockholm's second fun fair, see Andreas Theve and Mats Wickman, "Nöjesstaden Gröna Lund," in *Stockholm turiststaden*, ed. Ulf Sörenson (Stockholm: Lind & Co, Samfundet St. Erik, 2008), 108–119; and Margareta Cramér, *Varvet som blev tivoli: byggnadshistoria och arkitektur på Gröna Lund* (Stockholm: Gröna Lunds Tivoli, 2009).

6. This chapter builds on the cross-disciplinary discourse on the cinematic city that developed during the early 2000s. For a summary of work in this field see *Locating the Moving Image*, ed. Julia Hallam and Les Roberts (Bloomington: Indiana University Press, 2013), 1–30;

The Lost World of Mitchell and Kenyon: Edwardian Britain on Film, ed. Vanessa Toulmin, Simon Popple, and Patrick Russell (London: BFI, 2004); and Patrick Keiller, "Film as Spatial Critique" in *Critical Architecture*, ed. Mark Dorrian, Murray Fraser, Jonathan Hill, and Jane Rendell (London: Routledge, 2007), 115–123. On the phenomena of early urban film see Patrick Keiller, "Tram Rides and Other Virtual Landscapes," in *The Lost World of Mitchell and Kenyon*, 191–200; Patrick Keiller, "The City of the Future," in *Picture Perfect: Landscape, Place and Travel in British Cinema before 1930*, ed. Alan Burton and Laraine Porter (Exeter: Exeter University Press, 2007), 104–112; and Patrick Keiller, "Londres, Bombay," *Vertigo* 3, no. 6 (Summer 2007): 38–39, 42–23. For case studies examining the effects of early amateur films see Les Roberts, "Dis/embedded Geographies of Film: Virtual Panoramas and the Touristic Consumption of Liverpool Waterfront," *Space and Culture* 13, no. 1, 2010, 54–74; and Les Roberts, "Making Connections: Crossing Boundaries of Place and Identity in Liverpool and Merseyside Amateur Transport Films," *Mobilities* 5, no. 1 (February 2010): 83–109. For a wider discussion of urbanism in narrative and avant garde cinema see Floris Paalman, "The Theoretical Appearance of the City Symphony," in "City Symphonies—Film Manifestos of Urban Experience," special issue, *Eselsohren. Journal of History of Art, Architecture and Urbanism* 2, no. 1–2 (2014): 15–27.

7. Keiller, "The City of the Future," 104–112.

8. Keiller, "Tram Rides and Other Virtual Landscapes," 191–200.

9. On the early development of film in Sweden see Pelle Snickars, *Svensk film och visuell masskultur 1900*, PhD diss. (Stockholm: University of Stockholm/Aura Förlag, 2001). On the impact of the 1897 Stockholm World Exhibition see Anders Ekström, *Den utställda världen. Stockhlmsutställningen och 1800-talets världsutställningar* (Stockholm: Nordiska Museet, 1994). For an examination of the impact mass media culture had in Sweden during the 1920s and 1930s, with a focus on cinema, see Ylva Habel, *Modern Media, Modern Audiences: Mass Media and Social Engineering in the 1930s Swedish Welfare State*, PhD diss. (Stockholm: University of Stockholm, 2001).

10. For a case study of how this international phenomenon played out in Sweden see Snickars, *Svensk film och visuell masskultur 1900*, 1–2 and 86–94.

11. Miles Brothers, *A Trip Down Market Street before the Fire* (San Francisco, 1906). "Produced as part of the popular Hale's Tours of the World film series, the film begins at the location of the Miles Brothers film studio, 1139 Market Street, between 8th and 9th Streets; it was filmed 14 April 1906, four days before the devastating earthquake and fire of 18 April 1906, which virtually destroyed the entire downtown area. The negative was taken by train to the Miles New York office on 17 April 1906, narrowly saving it from destruction by one day and thus preserving a moment in the history of San Francisco that would soon cease to exist." Description cited, and movie viewable at the Library of Congress online archive, https://www.loc.gov/item/00694408 (accessed January 28, 2023).

12. British Pathé, *London Street Scene 1910–1920*. "London street scene. Wide shot panning on busy intersection. Streets are filled with cars, double-decker buses; horse-drawn wagons of tradesmen; and pedestrians darting across between vehicles. Many pedestrians walking on the pavements past shops; also kiosks are set up on corners." British Pathé online archive, Film ID: 2478.18, viewable at https://www.british pathe.com/video/london -street-scene (accessed January 28, 2023).

13. Deutsche Mutoskop und Biograph GmbH, *The Flying Train*, digital preservation of 35mm film, derived from 68mm film (black and white, silent). Viewable at https://www.you tube.com/watch?v=2Ud1aZFE ofU (accessed July 3, 2023).

14. On the early impact of film culture, around 1900, see Snickars, *Svensk film och visuell masskultur 1900*, 86–92. On the development of film in Stockholm between 1900 and 1920 see Peder Fallenius, *Storbiografens miljöer*, PhD diss., Acta Universitatis Upsaliensis. Ars Suetica 21 (Uppsala: University of Uppsala, 2003), 25–40. On the development of film in Sweden generally see Leif Furhammar, *Filmen i Sverige: en historia i tio kapitel* (Stockholm: Svenska Filminstitutet, 1993, reprint 1998). For the early years of Svensk Filmindustri, see Bengt Idestam-Almquist, *När filmen kom till Sverige: Charles Magnusson och Svenska Bio* (Stockholm: Norstedt, 1959).

15. On viewing habits and typical program make-up see Fallenius, *Storbiografens miljöer*, 33–39, 48, 95.

16. Many early films of Stockholm are available online. Pri-

mary sources are the Swedish Film Archive, https://www .filmarkivet.se/movies/sveriges -huvudstad/, and the repository link provided by the City of Stockholm, https://stockholm skallan.stockholm.se. Collected material can also be searched in the Svensk Mediadatabas, https://smdb.kb.se/. Centrum's inauguration was reported in *SF Veckorevy*, February 16, 1931.

17. Experience rides at Gröna Lund and Djurgården featured in *Paramountjournalen*, May 1928, 36b.

18. Fallenius, *Storbiografens miljöer*, 95–98. Habel, *Modern Media*, 129–130. Göta Leon featured in *SF Veckorevy*, January 30, 1928. Flamman in *SF Veckorevy*, February 2, 1930. The newsreel reporting on Flamman was screened at the cinema's inauguration directly after an overture played by the in-house orchestra just after 8:30 p.m. The film is viewable at filmarkivet.se, https://www .filmarkivet.se/movies/veckor evy-1930-02-03/ (accessed February 28, 2023).

19. Fallenius, *Storbiografens miljöer*, 95. Habel, *Modern Media*, 129–130.

20. Stockholm Stadsarkiv MZ-C68, 1930 års traffikkommitté 1, appendix to minutes of board meeting June 21, 1930, 1.

21. For a compact account of the history of Slussen see Rudberg, *Tage William-Olsson*, 99–104. For a (probably somewhat biased, but highly readable) eye-witness account both of the history and the process of planning the new traffic infrastructure see Larsson, *Mitt liv i Stadshuset* 2, 475–493.

22. On the Katarina elevator and its designer, Knut Lindmark, see Birger Kock and Fredrik Schütz, "Knut Lind-

mark: En pionjär inom kommunikationstekniken," *Daedalus: Sveriges tekniska museums årsbok* 43 (1973): 61–85.

23. Examples of such films: *Stockholm. Åktur med Ringlinjen* [Phantom ride on the Circle Line], Svenska Biografteatern SF 2061A; *Stockholm 1909. Katarinahissen* [Katarina elevator], Svenska Biografteatern, SF 2061C; *Slussplågan i sitt nuvarande skede* [The Slussen torment in its current phase], *SF Veckorevy*, February 21, 1927; *Stockholms hamn, Slussen, 1932* [Stockholm's habor, Slussen, 1932], SF 1957, all archived at SVT Sveriges Television); *Kinografen* [Cinema], 1913, SMDB/Kungliga biblioteket; *Sveriges Huvudstad, 1917* [Sweden's capital, 1917], Svenska Film institutet; *Slussens trafik* [Traffic at Slussen], 1928; *Vy över Slussen med Katarinahissen* [View over Slussen with the Katarina elevator], ca. 1928; *Slussen set från Saltsjön* [Slussen seen from the sea], ca. 1928, all archived at Stockholms Stadsmuseum.

24. The commentary to the film made to celebrate the opening of the new traffic system in 1935 noted that "Slussen var i denna tid ett älsklingsplats för alla journaljagande film fotografer [Slussen at that time was the darling location for copy-hungry film photographers]", *Från tradiselände till funkisfröjd*, *SF Veckorevy*, October 19, 1935, narrated by Gunnar Skoglund, SVT Sveriges Television.

25. The advertising is clearly visible in photographs taken during the 1920s.

26. From 1898 the Numa Petersons handels- och fabriksaktiebolag factory and main office was at Bergsgatan, 300 meters from Slussen. On the

history of Numa Peterson see Marina Dahlquist, "Att saluföra modernitet: Numa Petersons handels- och fabriksaktiebolag," in Anders Ekström, Solveig Jülich, and Pelle Snickars, eds., *1897 Mediehistorier kring Stockholmsutställningen* (Stockholm: Statens ljud- och bildarkiv, 2006), 167–196.

27. Larsson, *Mitt liv i stadshuset*, 475–493. Larsson specifically comments the effect on congestion created by the increased length of the trams and the extension of tram traffic over the bridges at Slussen.

28. On the "slusseländet" see Larsson, *Mitt liv i stadshuset*, 476–477.

29. "Spårvagnskö vid Slussen [Tram queue at Slussen]," *Svenska Biografteater Veckorevy*, May 5, 1919; "Slusstrafiken [Traffic over Slussen]," *Svenska Biografteater Veckorevy*, December 15, 1919; "Tunnelförslag under Södermalm i Stockholm [Tunnel proposals under Södermalm]," *SF Veckorevy*, November 22, 1920; "Broarna över Slussen i Stockholm placeras på sina platser [Placement of bridges at Slussen]," *SF Veckorevy*, February 19, 1921; "Spårvägstrafik över Slussen [Tram traffic at Slussen]," *SF Veckorevy*, April 3, 1922; "Spårvägens signaltorn vid Slussen [Control tower for trams at Slussen]," *SF Veckorevy*, May 1, 1922; "Slusstrafiken [Traffic at Slussen]," *SF Veckorevy*, December 10, 1923; "Trafikträngsel vid Slussen [Traffic congestion at Slussen]," *SF Veckorevy*, April 26, 1926; "Trafikproblemet vid Slussen [The traffic problem at Slussen]," *SF Veckorevy*, October 18, 1926, all archived at SVT Sveriges Television.

30. For reports of the meeting see *Dagens Nyheter*, January

29, 1924, and *Svenska Dagbladet*, February 11, 1924.

31. The photograph was used twice in the mediation of the project, see Carl Thulin, "Reglering av Slussområdet i Stockholm," *Tekniksk Tidskrift. Väg- och Vattenbyggnadskonst*, November 1932, 125, and Carl Thulin, "Reglering av Slussområdet i Stockholm," *Tekniksk Tidskrift. Almänna avdelning*, October 12, 1935, 399.

32. *Slussens trafik*, 1928, Stockholms Stadsmuseum, article 5279. Viewable at https://stockholmskallan.stockholm.se /post/5729 (accessed February 28, 2023). *Stockholms hamn, Slussen, 1932*, SF 1957, SVT Sveriges Television. Viewable at https:// stockholmskallan.stockholm .se/post/29520 (accessed February 28, 2023).

33. On the development of the project see Bosse Bergman and Anders Gullberg, "I Skönhetens, folklivets och framkolighetens tjänst," in Rudberg, *Tage William-Olsson*, 99–129.

34. Bergman and Gullberg, "I skönhetens . . . tjänst," 104–112. The first projects made in 1929 were carried out for *Rådet för skydd för Stockholms skönhet* [Council for the protection of Stockholm's beauty]; those made after 1930 for the *1930 års trafikkommité*. The solutions for organizing the site were also analyzed in diagrams in the 1931 article on the project attributed to Stockholm's director of traffic Anders Lilienberg, see "Den södliga förortstrafiken i Stockholm och slussområdets reglering," *Teknisk Tidskrift. Almänna avdelning*, February 21, 1931, 113.

35. *Sherlock Jr.*, dir. Buster Keaton, prod. Buster Keaton and Joseph w. Schenck. Released in the USA in 1924.

Stockholm premiere October 27, 1924, under the title *Fart, flickor och faror* [Speed, girls, and dangers].

36. *The General*, dir. Clyde Bruckman and Buster Keaton, prod. Buster Keaton and Joseph W. Schenck. Released in the USA in 1927. Stockholm premiere February 2, 1927, under the title *Så går det till i krig* [That's how it goes in war]. On the use of film technologies in film narrative see Ryan Bishop, "The Feeding Machine and Feeding the Machine: Silence, Sound and the Technologies of Cinema," in Bishop, *Comedy and Cultural Critique in American Film* (Edinburgh: Edinburgh University Press, 2013), 22–57.

37. On the design of the glass skyscraper see Dietrich Neumann, "Three Early Designs by Mies van der Rohe," *Perspecta* 27 (1992): 76–97, esp. 82. Neumann notes the paucity of explanations for the fluid curves of the skyscraper.

38. *SF-färden ut i världen. Första resan*, contributions and direction: Nils Jerring, Knut Martin, Erik "Bullen" Berglund, Gunnar Skoglund, Sven Thermaenius, Karl Albers; main narrator: Gunnar Skoglund; prod. AB Svensk Filmindustri, 1934.

39. These were Skeppsbron, Katarinavägen, Hornsgatan, Munkbron, Södra Mälarstrand, and Stadsgården. Thulin, "Reglering av Slussområdet i Stockholm" (1935), 399; Thulin, "Reglering av Slussområdet i Stockholm" (1932), 125.

40. *SF Veckorevy*, October 19, 1935, *Från tradiselände till funkisfröjd*, dir. Gunnar Skoglund, narrator Gunnar Skoglund, prod. AB Svenska Filmindustri. Svenska Filmindustri were Sweden's largest film distribu-

tor and cinema owner during the 1930s.

41. Fallenius, *Storbiografens miljöer*, 96–98; Habel, *Modern Media*, 129–130.

42. Narrative extract from *Från tradiselände till funkisfröjd*: "Medan borgarråd Ingvar Larsson presenterar slussbyggets män, få vi syn på rapporterchampion Åbergsson [och] filmens Parnassus, Oskar Rydkvist, renläsandes hans senaste filmmanuskript. Han hinner säkert inte många scener …"

43. Narrative extract from *Från tradiselände till funkisfröjd*: "1907. Då var allt ganska fridfullt vid Slussen. … Fem år längre fram i tiden … är samma slussbro betydligt mer ansatt av tidens jäkt och rastlöshet. Vi räknar ända till tre bilar. … 1917, … uppe på Katarinahissen hade man en storartad utsikt över det jämmerliga slusselländet. … Den första april 1922 går de första spårvagnarna över broarna mellan söder och norr … Slussen var i denna tid ett älsklingspass för alla journaljagande filmfotografer, och mycket ofta förklarade de sin kärlek för Slussen på följande sätt. … Ja, det var då det. Nu är Slussen ombyggd med en organisationsmästerskap som är ett rekord i vårt land."

44. *Från tradiselände till funkisfröjd* used archive footage from at least ten early traffic-based shorts from the years 1909, 1913, 1917, 1922 and 1928/1931.

45. Inaugural prologue, given at the Flamman cinema, February 1, 1930. Cited in Furhammar, *Filmen i Sverige*, 1993, 177.

46. Cecil B. De Mille's *De tio budorden* (*The Ten Commandments*), featuring Luxor and set in ancient Egypt premiered at Olympia and Odéon in 1923; Douglas Fairbanks Jr. played

in *Robin Hood* at the Palladium from March 28, 1923; Buster Keaton's *Så gå det till I krig* (*The General*) showed at Arcadia and Skandia on February 02, 1928.

47. On the history of Kooperativa förbundet's role as a commissioner of architecture see Lisa Brunnström, *Det svenska folkhemsbygget: om Kooperativa förbundets arkitektkontor* (Stockholm: Arkitektur förlag, 2004).

48. Bergman and Gullberg, "I skönhetens . . . tjänst," 109.

49. For a summary of the incredibly wide literature on airships, and a review of their cultural significance see Douglas Botting, *Dr. Eckener's Dream Machine: The Historic Saga of the Round-the-World Zeppelin* (London: HarperCollins, 2001). For a contemporaneous view see Christopher Sprigg, *The Airship: Its Design, History, Operation and Future* (London: Samson Low, Marston and Company, 1931).

50. On Gio Ponti's design for "Sala il più leggero dell'aria" at the 1934 Mostra Aeronautica see Lisa Licitra Ponti, *Gio Ponti: l'opera* (Milan: Leonardo, 1990); Silvia Cattiodoro, "Gio Ponti dalla scena al grattacielo. Un unico modo" (PhD diss., University of Palermo, 2012), 17–26.

51. On Cäsar Pinnau and his work for Fritz August Breuhaus see Hans-Jörg Czech, Vanessa Hirsch, and Ullrich Schwarz, eds., *Cäsar Pinnau. Zum Werk eines umstrittenen Architekten* (Munich: Dölling & Galitz Verlag; Hamburg: Historische Museen Hamburg/Altonaer Museum, 2016).

52. James Thurber, "The Secret Life of Walter Mitty," *New Yorker*, March 18, 1939; collected in *My World and Welcome to It* (New York: Harcourt Brace, 1942), 72–81.

53. Ebba Theorin, "När Bodensee kom—som budbärare för en ny tid," *IDUN Illustrerad Tidning för Kvinnan och Hemmet*, October 9, 1919, 1–2.

54. Theorin, "När Bodensee kom," 2.

55. Theorin, "När Bodensee kom," 2: "Det är inte så långt mellan Drottningatan och Unter den Linden."

56. A history of these attractions at the Gröna Lund theme park in Stockholm is provided at https://historia.gronalund .com/attraktioner/ (accessed July 21, 2023).

57. Larsson, *Mitt liv i stadshuset*, 475. ". . . bege oss ned till Slussen en dag vid sekelskiftet, det år jag tog studenten och kunde kosta på mig att bjuda några flickor att i droska åka Karl Johans torgs karusell runt runt . . . avslutade vi vårt turistbesök med att för en femöring åka upp med Katarinahissen till Mosebacke och beundra utsikten." The trip to Slussen is articulated in terms of two paying experience rides, first by horsedrawn carriage around the carousel of the central square, second in the steam-powered elevator.

58. Photographs of this event taken by Axel Malmström are preserved in the archive of Stockholm Stadsmuseum, Gerhard Magnussons album, article number graark_10027686. Film footage of the event is preserved in the SVT archives from where it was reused in the early SVT documentary series *Liv och Leverne* (1957–1959) and was presented again in a 1988 documentary on the actors who formed the Swedish broadcaster Radiotjänstens early TV programming during the 1950s. Lennart Ehrenborg and Gustaf Näsström, Minnernas Arkiv, "Att

lära folk tänka med ögonen," dokumentärminnen från TV:s barndom (SVT, 1988).

59. On the logic of Coney Island see Brian J. Cudahy, *How We Got to Coney Island: The Development of Mass Transportation in Brooklyn and Kings County* (New York: Fordham University Press, 2002). On the wider cultural and symbolic significance of its use of electric power see Ramey Mize, "'The Violent Blaze': Electrical Illumination in Joseph Stella's Battle of Lights, Coney Island, Mardi Gras (1913–14)," *Lapis* 1 (May 2019), https:// wp.nyu.edu/lapis/ramey-mize-violent-blaze-joseph-stella/ (accessed February 28, 2023).

60. On Boberg's work see Ann Thorson Walton, *Ferdinand Boberg—Architect: The Complete Work* (Cambridge, MA: MIT Press; Stockholm: Arkitekturmuseet/Statens råd för byggnadsforskning, 1994).

61. On the history of the Stomatol illuminated toothpaste sign, see Thomas Eriksson, *Neon: eldskrift i natten* (Stockholm: Rabén Prisma, 1997), 17.

62. Narrative extract from *Från tradiselände till funkisfröjd*: the journey up into Gondolen is made in "den här funkissmäckra himlastormaren, dess glasspelare hivas i konung och folk upp av elektriskt spinnande ASEA motorer, hissas upp till den restaurang som är [ett] glasskåp under himmelen."

Afterword

1. Virginia Woolf, diary, February 7, 1931, in The Diary of Virginia Woolf, vol. 4, 1931–1935, ed. Anne Olivier Bell (London: Hogarth Press, 1982), 10.

Bibliography

Adam, Robert. *Ruins of the Palace of Emperor Diocletian at Spalatro in Dalmatia.* London: Robert Adam, 1764.

Alberti, Leon Battista. *The Architecture of Leon Battista Alberti in Ten Books. Of painting in three books and of statuary in one book. Translated into Italian by Cosimo Bartoli. And now first into English, and divided into three volumes by James Leoni, Venetian, architect; to which are added several designs of his own, for buildings both public and private.* Translated by James Leoni. London: Thomas Edlin, 1726.

Alberti, Leon Battista. *L'architettura. Tradotta in lingua Fiorentina da Cosimo Bartoli. Con la aggiunta de disegni.* Translated by Cosimo Bartoli. Florence: Lorenzo Torrentino, 1550.

Alberti, Leon Battista. *The Art of Building in Ten Books.* Translated by Joseph Rykwert, Robert Tavernor, and Neil Leach. Cambridge, MA: MIT Press, 1989.

Alberti, Leon Battista. *Della pittura* and *De pictura.* In *Leon Battista Alberti. Opere volgari,* vol. 3, 5–107 [parallel Italian and Latin text]. Edited by Cecil Grayson. Bari: G. Laterza, 1973.

Alberti, Leon Battista. *De re aedificatoria.* Florence: Nicolaus Laurentii Alamanus, 1485.

Alberti, Leon Battista. *Dinner Pieces.* Translated by David Marsh. Binghamton, NY: Medieval and Renaissance Texts and Studies in conjunction with the Renaissance Society of America, 1987.

Alberti, Leon Battista. *On Painting.* Translation by Cecil Grayson with an introduction and notes by Martin Kemp. London: Penguin Books, 1991.

Alberti, Leon Battista. *On Painting and On Sculpture: The Latin Texts of De pictura and De statua.* Edited by Cecil Grayson. London: Phaidon, 1972.

Allais, Lucia. *Designs of Destruction: The Making of Monuments in the Twentieth Century.* Chicago: University of Chicago Press, 2018.

Allan, John. *Berthold Lubetkin: Architecture and the Tradition of Progress.* London: RIBA Publications, 1992.

Allard, Michel. *Henri-Louis Duhamel du Monceau et le Ministère de la Marine.* Montréal: Léméac, 1970.

Anstey, Tim, Katja Grillner, and Rolf Hughes. *Architecture and Authorship.* London: Black Dog Publishing, 2007.

Åström, Sven Erik. "The English Navigation Laws and the Baltic Trade, 1660–1700." *Scandinavian Economic History Review* 8, no. 1 (1960): 3–18.

Austen, Jane. *Northanger Abbey* and *Persuasion.* 4 vols. London: John Murray, 1818.

Banham, Reyner. *Los Angeles: The Architecture of Four Ecologies*. London: Allan Lane, 1971; reprinted Berkeley: University of California Press, 2001.

Bann, Stephen. *The Clothing of Clio: A Study of the Representation of History in Nineteenth-Century Britain and France*. Cambridge: Cambridge University Press, 1984.

Barak, On. *On Time: Technology and Temporality in Modern Egypt*. Oakland: University of California Press, 2013.

Battisti, Eugenio. *Filippo Brunelleschi*. Milan: Electa, 1976.

Baxandall, Michael. *Giotto and the Orators: Humanist Observers of Painting in Italy and the Discovery of Pictorial Composition, 1350–1450*. Oxford: Oxford University Press, 1971.

Baxandall, Michael. *Painting and Experience in Fifteenth Century Italy: A Primer in the Social History of Pictorial Style*. Oxford: Oxford University Press, 1972.

Beard, Geoffrey. "William Kent and the Royal Barge." *Burlington Magazine* 112, no. 809 (August 1970): 488–493.

Bellberg, Lennart, ed. *Katarina Kyrka. Återuppbyggnaden 1990–1995*. Stockholm: SIAB, 1995.

Bellori, Giovan Pietro. *The Lives of the Modern Painters, Sculptors and Architects*. Translated and edited by Alice Sedgwick Wohl et al. Cambridge: Cambridge University Press, 2005.

Belzoni, Giovani. *Narrative of the Operations and Recent Discoveries within the Pyramids, Temples, Tombs and Excavations, in Egypt and Nubia . . .* London: John Murray, 1820.

Benjamin, Walter. *The Arcades Project*. Translated by Howard Eiland and Kevin McLaughlin. Cambridge, MA: Harvard University Press, 1999.

Berger, Karol. *Musica Ficta: Theories of Accidental Inflection in Vocal Polyphony from Marchetto da Padova to Gioseffo Zarlino*. Cambridge: Cambridge University Press, 1987.

Bing, Gertrud. "The Warburg Institute." *Library Association Record* 35, no. 4 (August 1934): 262–266.

Bleichmar, Daniela, and Meredith Martin. "Objects in Motion in the Early Modern World." *Art History* 38, no. 4 (2015).

Blondel, Jacques-François. *De la distribution des maisons de plaisance et de la décoration des édifices en général*. 2 vols. Paris: Antoine Jombert, 1737.

Boffrand, Germain. *Livre d'architecture contenant les principes généraux de cet art, et les plans, élévations et profils de quelques-uns des batimens faits en France & dans les pays étrangers*. Paris: Guillaume Cavelier, 1745.

Bordeleau, Anne. "*The Professor's Dream*: Cockerell's *Hypnerotomachia Architectura*." *Architectural History* 52 (2009): 117–145.

Botting, Douglas. *Dr. Eckener's Dream Machine: The Historic Saga of the Round-the-World Zeppelin*. London: HarperCollins, 2001.

Boureau-Deslandes, André François. *Essai sur la marine des anciens, et particulièrement sur leurs vaisseaux de guerre*. Paris: David et Ganeau, 1768.

Brawer, Nicholas A. *British Campaign Furniture: Elegance under Canvas, 1740–1914*. New York: Harry N. Abrams, 2001.

Bright, Arthur Aaron. *The Electric-Lamp Industry: Technological Change and Economic Development from 1800 to 1947*. New York: Macmillan, 1949.

Brunnström, Lisa. *Det svenska folkhemsbygget: om Kooperativa förbundets arkitektkontor*. Stockholm: Arkitektur förlag, 2004.

Brush, Kathryn. *Vastly More Than Brick and Mortar: Reinventing the Fogg Art Museum in the 1920s*. New Haven, CT: Yale University Press, 2004.

Buist, Martin G. *At Spes Non Fracta: Hope & Co. 1770–1815, Merchant Bankers and Diplomats at Work*. The Hague: Bank Mees and Hope, 1974.

Burckhardt, Jacob. *The Civilisation of the Period of the Renaissance In Italy*. Translated by S. G. C. Middlemore. 2 vols. London: C. Kegan Paul & Co., 1878.

Burckhardt, Jakob. *Die Cultur der Renaissance in Italien: ein Versuch*. Basel: Schweighauser, 1860.

Burckhardt, John Lewis. *Travels in Nubia*. London: John Murray, 1819.

Burke, Edmund. *Thoughts on the Prospect of a Regicide Peace*. London: J. Owen, 1796.

Cache, Bernard. *Projectiles*. London: AA Publications, 2011.

Carpo, Mario. *The Alphabet and the Algorithm*. Cambridge, MA: MIT Press, 2011.

Carpo, Mario. "*Descriptio urbis Romæ*: Ekfrasis geografica e cultura visuale all'alba della rivoluzione tipografica." *Albertiana* 1 (1998): 121–143.

Carruthers, Mary J. *The Book of Memory: A Study of Memory in Medieval Culture*. Cambridge: Cambridge University Press, 1990.

Cederlöf, Ulf, ed. *Carl August Ehrensvärd. Tecknaren och Arkitekten*. Stockholm: National Museum, 1997.

Chapman, Fredric Henric af. *Architectura navalis mercatoria. Navium varii generis mercatoriarum, capulicarum, cursoriarum, aliarumque, cuiuscunque conditionis vel molis, Formas et rationes exhibens exemplis æri incisis, Demonstrationibus denique, Dimensionibus calculisque accuratissimis illustrata*. Stockholm: Holmiae, 1768.

Chapman, Fredric Henric af. *Tal, om de förändringar, som örlogs-skepp undergått, sedan canoner på dem började nyttjas. Hållet för Kongl. Vetenskaps Akademien, vid Præsedii nedläggande den 25:e juli, 1750*. Stockholm: Lars Salvius, 1770.

Chapman, Fredric Henric af. *Tractat om Skeppsbyggeriet, tillika med förklaring och bevis öfver architectura navalis mercatoria &c. genom Fredrich Hindr: af Chapman.* Stockholm: Johan Pfeiffer, 1775.

Chapman, Fredrik Henrik af. *A Treatise on Shipbuilding.* Translated by James Inman. Cambridge: J. Smith, 1820.

Choay, Françoise. *The Rule and the Model.* English trans. of *La règle et le modèle.* Cambridge, MA: MIT Press, 1997.

Cicero, Marcus Tullius. *Brutus. Orator.* Translated by G. L. Hendrickson and H. M. Hubbell. Loeb Classical Library. London: William Heinemann; Cambridge, MA: Harvard University Press, 1939.

Cicero, Marcus Tullius. *De officiis.* Edited by T. E. Page et al. with an English translation by Walter Miller. Loeb Classical Library. London: William Heinemann; Cambridge, MA: Harvard University Press, 1938.

Cicero, Marcus Tullius. *De oratore.* Translated with an introduction, notes, appendices, glossary, and indexes by James M. May and Jakob Wisse. New York: Oxford University Press, 2001.

Cipriani, Giovanni. *Gli obelischi egizi, politica e cultura nella Roma barocca.* Florence: Leo S. Olschki, 1993.

Clément, Pierre. *Lettres, instructions et mémoires de Colbert.* Vol. 3, part 1, *Marine et galères.* Edited by Pierre Clément. Paris: Imprimerie impériale, 1864.

Concina, Ennio. "Humanism on the Sea." *Mediterranean Historical Review* 3, no. 1 (1988): 159–165.

Condorcet, Nicolas de. "Éloge de M. Duhamel." In *Histoire de l'Académie royale des sciences—Année M. DCCXXXII—Avec les mémoires de mathématique & de physique pour la même année.* Paris: Imprimerie royale, 1782.

Cramér, Margareta. *Varvet som blev tivoli: byggnadshistoria och arkitektur på Gröna Lund.* Stockholm: Gröna Lunds Tivoli, 2009.

Crowley, Roger. *Empires of the Sea: The Siege of Malta, the Battle of Lepanto and the Contest for the Center of the World.* New York: Random House, 2008.

Cudahy, Brian J. *How We Got to Coney Island: The Development of Mass Transportation in Brooklyn and Kings County.* New York: Fordham University Press, 2002.

Curran, Brian A., Anthony Grafton, Pamela O. Long, and Benjamin Weiss. *Obelisk: A History* Cambridge, MA: Bundy Library, 2009.

Czech, Hans-Jörg, Vanessa Hirsch, and Ullrich Schwarz, eds. *Cäsar Pinnau. Zum Werk eines umstrittenen Architekten.* Munich: Dölling & Galitz Verlag; Hamburg: Historische Museen Hamburg/Altonaer Museum, 2016.

Daniell, Thomas, and William Daniell. *Antiquities of India . . .* London: Thomas and William Daniell, 1799.

Dassié, François. *L'Architecture navale, contenant la manière de construire les navires, galères & chaloupes, & la définition de plusieurs autres espèces de vaisseaux. Avec les tables des longitudes, latitudes & marées, cours & distances des principaux ports des quatre parties du monde; une description des dangers, écueils, & l'explication des termes de la marine.* [issued with] *Le routier des Indes Orientales et Occidentales.* Paris: Jean de la Caille, 1677.

Day, John R., and John Reed. *The Story of London's Underground.* London: Capital Transport Publishing, 2010.

Deane, Anthony. *Deane's Doctrine of Naval Architecture 1670.* Edited and introduced by Brian Lavery. London: Conway Maritime Press, 1981.

de Baïf, Lazare. *Lazari Bayfii de re navali liber: seu annotationes in L II: De captivis, et postliminio reversis . . .* Paris: Robert Estienne, 1536.

Dee, John. *John Dee.* Edited by Gerald Suster. Berkeley, CA: North Atlantic Books, 2003.

de la Gorce, Jérôme. *Bérain, dessinateur du Roi Soleil.* Paris: Hersher, 1986.

Denon, Dominique Vivant. *Voyage dans la Basse et la Haute Égypte pendant les campagnes du général Bonaparte.* Paris: P. Didot l'Aine, 1802.

de Passebon, Henri Sbonski. *Plan de plusieurs bâtiments de mer avec leurs proportions dédié à son Altesse Serenissime Monseigneur Louis Auguste de Bourbon.* [Marseille?, ca. 1792].

Description de l'Égypte ou Recueil des observations et des recherches qui ont été faites en Égypte pendant l'expédition de l'armée française. 23 vols. Paris: Imprimerie impériale, 1809–1828.

Didi-Huberman, Georges. *The Surviving Image: Phantoms of Time and Time of Phantoms: Aby Warburg's History of Art.* Translated by Harvey Mendelsohn. University Park: Penn State University Press, 2017.

Dubbini, Renzo. *Geography of the Gaze: Urban and Rural Vision in Early Modern Europe.* Translated by Lydia G. Cochrane. Chicago: University of Chicago Press, 2002.

Duhamel du Monceau, Henri-Louis. *Elémens de l'architecture navale, ou Traité pratique de la construction des vaisseaux.* Paris: Charles-Antoine Lombert, 1752.

Ehrensvärd, Carl August. *Carl August Ehrensvärd's Journey to Italy 1780, 1781, 1782.* Translated by Alan Crozier with an introduction by Sten Åke Nilsson. Stockholm: Royal Academy of Fine Arts, 2017.

Einholz, Sibylle. "Die Grosse Granitschale im Lustgarten. Zur Bedeutung eines Berliner Solitärs." In *Der Bär von Berlin. Jahrbuch des Vereins für die Geschichte Berlins* 46 (1997): 41–62.

Eklund, Hans. *Augustin Ehrensvärd. Målaren, upplysningsmannen, människovännen, byggaren, sjömannen och flaggmannen.* Stockholm: National Museum, 1997.

Ekström, Anders. *Den utställda världen. Stockhlmsutställningen och 1800-talets världsutställningar.* Stockholm: Nordiska Museum, 1994.

Ekström, Anders, Solveig Jülich, and Pelle Snickars. *1897 Mediehis-torier kring Stockholmsutställningen*. Stockholm: Statens ljud- och bildarkiv, 2006.

Emmerson, George S. *S.S. Great Eastern*. Newton Abbot: David & Charles, 1981.

Euler, Leonhard. *Scientia navalis seu tractatus de construendis ac dirigen-dis navibus Pars prior complectens theoriam universam de situ ac motu corporum aquae innatantium*. St. Petersburg: Imperatorskaja Aka-demija Nauk, 1749.

Evans, Robin. *Translations from Drawing to Building*. Cambridge, MA: MIT Press, 1996.

Fallenius, Peder. *Storbiografens miljöer*. PhD diss. Acta Universitatis Upsaliensis. Ars Suetica 21. Uppsala: University of Uppsala, 2003.

Ferreiro, Larrie D. *Measure of the Earth: The Enlightenment Expedition That Reshaped Our World*. New York: Basic Books, 2011.

Ferreiro, Larrie D. *Ships and Science: The Birth of Naval Architecture in the Scientific Revolution, 1600–1800*. Cambridge, MA: MIT Press, 2007.

Filarete (Antonio di Pietro Averlino). *Trattato di architettura*. Edited by Anna Maria Finoli and Liliana Grassi. Milan: Il Polifilo, 1972.

Finch, Mick. "The Technical Apparatus of the Warburg Haus." *Jour-nal of Visual Art Practice* 15, nos. 2–3 (2016): 94–106.

Fitzgerald, F. Scott. *The Great Gatsby*. New York: Charles Scribner and Sons, 1925.

Fleckner, Uwe, et al., eds. *Aby Warburg. Bildersammlung zur Geschichte von Sternglaube und Sternkunde im Hamburger Planetarium*. Hamburg: Dölling und Galitz, 1993.

Fleckner, Uwe, and Peter Mack, eds. *Vorträge aus dem Warburg-Haus. The Afterlife of the Kulturwissenschaftliche Bibliothek Warburg*. Berlin: De Gruyter, 2015.

Fleury, Philippe. "Le *De architectura* et les traités de mécanique ancienne." In *Le projet de Vitruve. Objet, destinataires et réception du De architectura. Actes du colloque de Rome (26–27 mars 1992)*, 187–212. Rome: École française de Rome, 1994.

Fontana, Domenico. *Della trasportatione dell'obelisco vaticano*. Trans-lated by David Sullivan with a commentary by Ingrid Rowland. Oakland, CA: Octavo, 2002.

Fontana, Domenico. *Della trasportatione dell'obelisco vaticano et delle fabriche di Nostro Signore papa Sisto V*. Rome, 1590.

Forster, Kurt W. *Schinkel: A Meander through His Life and Work*. Basel: Birkhäuser, 2018.

Foucault, Michel. *Les mots et les choses. Une archéologie des sciences humaines*. Paris: Gallimard, 1966.

Fournier, Georges. *Hydrographie, contenant la théorie et la pratique de toutes les parties de la navigation*. Paris: Soly, 1643, 2nd ed. Paris: Depuis, 1667.

Francesco di Giorgio Martini. *Trattato di architettura civile e militare di Francesco di Giorgio Martini, architetto senese del secolo XV.* London: Forgotten Books, 2018.

Frängsmyr, Tore, et al. *Linnaeus, the Man and His Work.* Berkeley: University of California Press, 1983.

Furhammar, Leif. *Filmen i Sverige: en historia i tio kapitel.* Stockholm: Svenska filminstitutet, 1993, reprint 1998.

Furttenbach, Joseph. *Architectura navalis. Das ist: von dem Schiff-Gebäw, auff dem Meer und Seekusten zugebrauchen. Und Nemblich, in was Form und gestallt, Fürs Erste, ein Galea, Galeazza, Galeotta, Bergantino, Filucca, Fregata, Liudo, Barchetta, Piatta: Zum Andern, Ein Nave, Polaca, Tartana, Barcone, Caramuzzala, und ein gemeine Barca . . . sollen erbawen werde ; Allen, Auff dem Meerpracticirten Liebhabern, Wie auch den Bawmeistern, und Mahlern zu Wolgefallen . . . ; Auß selbst gesehenen . . . Wrecken: Neen kurtz-widerholter Fürbildung, der in Anno 1571. zwischen den Christen und Türcken fürgegangenen, hochernstilchen, Ansehnlichen Meerschlacht / Sampt vielen Abrissen; und noch darüber. 20 . . . Kupfferstücken, complirt, außgerüstet, und . . . beschrieben, Durch Josephum Furttenbach.* Ulm: Ionam [Wilhelm] Saurn, 1629.

Furttenbach, Joseph. *Architectura universalis. Das ist: Von Kriegs: Statt- vnd Waffen Gebäwen. Erstlich, wie man die Statthor vnnd Einlass, zu Wasser vnd zu Land mit Spitzgatter vnd doppelten Schlagbrucken, dahinder dann ein newe Manier der Soldaten Quartier . . . erbawen, vnd also vor Feindlichem Anlauff wol verwahren sole . . . Zum Andern, wie im Statt Gebäw die Schulen, Academien, Wohnhäuser, Herbergen, Bäder, Gefängnussen vnd Lazaretten, neben andern nothwendigen civilischen Gebäwen zuverfertigen seyen. Drittens, in was Gestalt auff den fliessenden Wassern, die Wehrhaffte Flöss, sowohl auch die Schiff vnnd Formen also zuerbawen . . . Zum vierdten, ein Pulfferthurn, ingleichem ein Zeughauss, nach rechter bequemer Manier zuerbawen . . . Auss eigener Experientz vnd viel-jähriger Observation zusamen getragen, beschrieben, vnd mit 60. Kupfferstucken vorgebildet vnd delinirt: durch Josephum Furttenbach.* Ulm: Johann Sebastian Medern, 1635.

Fuss, Diana. *The Sense of an Interior.* New York: Routledge, 2004.

Gadol, Joan. *Leon Battista Alberti: Universal Man of the Early Renaissance.* Chicago: University of Chicago Press, 1969.

Gere, Charlotte. *Nineteenth-Century Interiors: An Album of Watercolours.* London: Thames and Hudson, 1992.

Gerritsen, Anne, and Giorgio Riello, eds. *The Global Life of Things: The Material Culture of Connections in the Early Modern World.* London: Routledge, 2016.

Gibbon, Edward. *The Decline and Fall of the Roman Empire.* 3rd ed. London: W. Strahan and T. Cadell, 1789.

Girouard, Mark. *Life in the English Country House: A Social and Architectural History.* New Haven, CT: Yale University Press, 1978.

Goethe, Johann Wolfgang von. "Granitarbeiten in Berlin" and "Der Markgrafenstein." In *Goethes sämtliche Werke* 44: 54–57. Munich: G. Müller, 1932.

Goldthwaite, Richard A. *The Building of Renaissance Florence: An Economic and Social History*. Baltimore: Johns Hopkins University Press, 1980.

Gordon, Donald. "In memoriam Gertrud Bing." In *In memoriam. Gertrud Bing: 1892–1964*. Edited by Ernst Gombrich. London: Warburg Institute, 1965. Reprinted in Monica Centanni and Daniela Sacco, eds., *Gertrud Bing. Erede di Warburg. La rivista di engramma* 177 (November 2020): 132.

Gottmann, Felicia. "French-Asian Connections: The Compagnies des Indes, France's Eastern Trade, and New Directions in Historical Scholarship." *Historical Journal* 56, no. 2 (June 2013): 537–552.

Grigsby, Darcy Grimaldo. *Colossal: Engineering the Suez Canal, Statue of Liberty, Eiffel Tower and Panama Canal: Transcontinental Ambition in France and the United States during the Long Nineteenth Century*. Pittsburgh: Periscope Publishing, 2012.

Groves, Jason. *The Geological Unconscious: German Literature and the Mineral Imaginary*. New York: Fordham University Press, 2020.

Guidi, Benedetta Cestelli, and Nicholas Mann, eds. *Photographs at the Frontier: Aby Warburg in America 1895–1896*. London: Merrell Holberton, 1998.

Habaj, Michal. "Herodotus' Renaissance Return to Western-European Culture." *Studia Antiqua et Archaeologica* 22, no. 1 (2016): 83–94.

Habel, Ylva. *Modern Media, Modern Audiences: Mass Media and Social Engineering in the 1930s Swedish Welfare State*. PhD diss. Stockholm: University of Stockholm, 2001.

Hallam, Julia, and Les Roberts. *Locating the Moving Image*. Bloomington: Indiana University Press, 2013.

Hamilton, William. *Campi Phlegraei: Observations on the Volcanos of the Two Sicilies as They Have Been Communicated to the Royal Society of London*. Naples: Pietro Fabris, 1776–1779.

Hammond, Rolt. *The Forth Bridge and Its Builders*. London: Eyre & Spottiswoode, 1964.

Harlé, Diane, and Jean Lefebvre, eds. *Sur le Nil avec Champollion. Lettres, journaux et dessins inédits de Nestor L'Hôte, premier voyage en Égypte, 1828–1830*. Caen-Orléans: Éditions Paradigme, 1993.

Harris, Daniel G. *F. H. Chapman: The First Naval Architect and His Work*. London: Conway, 1989.

Hart, Vaughan. "Inigo Jones' Site Organization at St. Paul's Cathedral: 'Pondrous Masses Beheld Hanging in the Air.'" *Journal of the Society of Architectural Historians* 53, no. 4 (December 1994): 414–427.

Hart, Vaughan, and Peter Hicks, eds. *Paper Palaces: The Rise of the Renaissance Architectural Treatise*. New Haven, CT: Yale University Press, 1998.

Headrick, Daniel R. *Technology and European Imperialism in the Nineteenth Century*. Oxford: Oxford University Press, 1981.

Headrick, Daniel R. "The Tools of Imperialism: Technology and the Expansion of European Colonial Empires in the Nineteenth Century." *Journal of Modern History* 51, no. 2 (June 1979): 231–263.

Hinners, Linda. *De fransöske hantwerkarna vid Stockholms slott 1693–1713*. PhD diss. Eidos nr 25. Skrifter från Konstvetenskapliga institutionen vid Stockholms universitet. Stockholm: University of Stockholm, 2012.

Hirschfeld, Nicole E. "Appendix S: Trireme Warfare in Herodotus." In Robert B. Strassler, *The Landmark Herodotus: The Histories*, 824–834. New York: Pantheon, 2007.

Hope, Thomas. *Anastasius: Or Memoires of a Greek; Written at the Close of the Eighteenth Century*. London: John Murray, 1819.

Hope, Thomas. *Household Furniture and Interior Decoration*. London: Longman, Hurst, Rees, and Orme, 1807.

Hornemann, Friedrich, et al. *Voyages dans l'intérieur de l'Afrique, par Frédéric Horneman pendant les années 1797, 1798*. Paris: André, 1802.

Humboldt, Alexander von. *Voyage aux régions équinoxiales du nouveau continent, fait en 1799, 1800, 1801, 1802, 1803, et 1804*. Paris: Libraire grecque-latine-allemande, 1816–1826.

Humboldt, Alexander von, and Aimée Bonpland. *Essai sur la géographie des plantes . . .* Paris: Levrault, Schoell et Compagnie, 1805.

Hvattum, Mari, and Anne Hultzsch, eds. *The Printed and the Built: Architecture, Print Culture and Public Debate in the Nineteenth Century*. London: Bloomsbury, 2018.

Iversen, Erik. *Obelisks in Exile*. Vol. 1, *The Obelisks of Rome*. Copenhagen: Gad, 1968.

Jarzombek, Mark. *On Leon Baptista Alberti*. Cambridge, MA: MIT Press, 1988.

Jenkins, Jennifer. *Provincial Modernity: Local Culture and Liberal Politics in Fin-de-Siècle Hamburg*. Ithaca, NY: Cornell University Press, 2002.

Jones, Sir William. *Poems Consisting Chiefly of Translations from the Asiatick Tongues*. Oxford: Clarendon Press, 1772.

Jordan, Jenny. "Galley Warfare in Renaissance Intellectual Layering: Lepanto through Actium." *Viator* 35 (January 2004): 563–580.

Joselit, David, and Christopher Wood. "Roundtable: The Global before Globalization." *October* 122 (2010): 3–19.

Kaestner, Abraham Gotthelf. *Geschichte der Mathematik . . .* Göttingen: Rosenbusch, 1799.

Karol, Eitan. *Charles Holden, Architect*. Donnington, Lincolnshire: Shaun Tyas, 2007.

Keiller, Patrick. "The City of the Future." In *Picture Perfect: Landscape, Place and Travel in British Cinema before 1930*, edited by Alan Burton and Laraine Porter, 104–112. Exeter: Exeter University Press, 2007.

Keiller, Patrick. "Film as Spatial Critique." In *Critical Architecture*, edited by Mark Dorrian, Murray Fraser, Jonathan Hill, and Jane Rendell, 115–123. London: Routledge, 2007.

Keiller, Patrick. "Tram Rides and Other Virtual Landscapes." In *The Lost World of Mitchell and Kenyon: Edwardian Britain on Film*, edited by Vanessa Toulmin, Simon Popple, and Patrick Russell, 191–200. London: BFI, 2004.

Kisacky, Jeanne. "History and Science: Julien-David Leroy's Dualistic Method of Architectural History." *Journal of the Society of Architectural Historians* 60, no. 3 (September 2001): 260–289.

Kruft, Hanno-Walter. *A History of Architectural Theory: From Vitruvius to the Present*. London: Zwemmer, 1994.

Krüger, Tobias. *Discovering the Ice Ages: International Reception and Consequences for a Historical Understanding of Climate*. Translated by Ann M. Hentschel. Leiden & Boston: Brill, 2013.

Lagrange, Léon. *Pierre Puget: Pientre, sculpteur, architecte, décorateur de vaisseaux*. Paris: Dider, 1968.

Lauro, Giacomo. *Antiquae urbis splendor: hoc est praecipua eiusdem templa, amphitheatra, theatra, circi, naumachiae, arcus triumphales, mausolea aliaque sumptuosiora aedificia, pompae item triumphalis et colossaearum imaginum descriptio / opera & industria Iacobi Lauri Romani in aes incisa atque in lucem edita*. Rome: Giacomo Mascadi, 1612.

Lavery, Brian. "Introduction." In Anthony Deane, *Deane's Doctrine of Naval Architecture 1670*, 7–28. London: Conway Maritime Press, 1981.

Lavery, Brian. *The Ship of the Line*. Vol. 2, *Design, Construction and Fittings*. London: Conway Maritime Press, 1984.

Lebas, Jean Baptiste Apollinaire. *L'obélisque de Luxor: histoire de sa translation à Paris, description des travaux auxquels il a donné lieu, avec un appendice sur les calculs des appareils d'abattage, d'embarquement, de halage et d'érection; détails pris sur les lieux, et relatifs au sol, aux sciences, aux mœurs et aux usages de l'Égypte ancienne et moderne. Suivi d'un extrait de l'ouvrage de Fontana, sur la translation de l'obélisque du Vatican*. Paris: Carilian-Goeury et V Dalmont, 1839.

Le Camus de Mézières, Nicolas. *Le génie de l'architecture, ou l'analogie de cet art avec nos sensations*. Paris: L'auteur et chez B. Morin, 1780.

Le Mascrier, Jean-Baptiste. *La Description de L'Égypte contenant plusieurs remarques curieuses sur la géographie ancienne et moderne de ce païs . . .* Paris: Louis Genneau et Jacques Rollin, 1735.

Lending, Mari, Eirik Bøhn, and Tim Anstey, eds. *Images of Egypt.* Oslo: Pax Forlag, 2018.

Lenoir, Alexandre. *Description historique et chronologique des monumens de sculpture, réunis au Musée des Monumens Français.* Paris: Gide libraire, 1800.

Léon de Joannis. *Campagne pittoresque du Luxor.* Paris: Impremerie Mme. Huzard, 1835.

Le Roy, Julien-David. "Première lettre à M. Franklin sur les Navires des Anciens . . ." In *Observations sur la physique, sur l'histoire naturelle et sur les arts . . .* , vol. 32 (March 1788): 210–220.

Le Roy, Julien-David. *Les ruines des plus beaux monuments de la Grèce : ouvrage divisé en deux parties, où l'on considère, dans la première, ces monuments du côté de l'histoire; et dans la seconde, du côté de l'architecture.* Paris: H. L. Guerin & L. F. Delatour and Jean-Luc Nyon; Amsterdam: Jean Neaulme, 1758.

Le Roy, Julien-David. *The Ruins of the Most Beautiful Monuments of Greece.* Introduction by Robin Middleton, translation by David Britt. Los Angeles: Getty Research Institute, 2004.

Linné, Carl von. *Hortus Cliffordianus: plantas exhibens quas in hortis tam vivis quam siccis, Hartecampi in Hollandia, coluit Georgius Clifford reductis varietatibus ad species, speciebus ad genera, generibus ad classes, adjectis locis plantarum natalibus differentiisque specierum: Cum tabulis neis.* Amsterdam: 1737.

Llinares, Sylviane. "Marine et anticomanie au XVIIIe siècle: les avatars de l'archéologie expérimentale en vraie grandeur." In *L'archéologie méditerranéenne et proche-orientale dans l'ouest de la France. Annales de Bretagne et des Pays de l'Ouest: Anjou. Maine. Poitou-Charente. Touraine* 115, no. 2 (2008): 67–84.

Lööf, Lars Olof. *Sjöfarare och superkargörer. Människor I och omkring Svenska Ostindiska Compagnierna 1731–1813 Part 1.* Täby: Riksarkivet i Göteborg, 2021.

Luscombe, Desley. "Inscribing the Architect: The Depiction of the Attributes of the Architect in Frontispieces to Sixteenth Century Italian Architectural Treatises." PhD diss., University of New South Wales, 2004.

Mackenzie, Alexander. *Voyage: d'Alexandre Mackenzie, dans l'intérieur de l'Amérique septentrionale; faits en 1789, 1792 et 1793.* Paris: Dentu, 1803.

Mackenzie, Alexander. *Voyages from Montreal, on the River St. Laurence, through the Continent of North America . . .* London: T. Cadell, Davies, Corbett, and Morgan; Edinburgh: W. Creech, 1801.

Mainstone, Rowland. "Brunelleschi's dome of S. Maria del Fiore and Some Related Structures." *Transactions of the Newcomen Society* 42, no. 1 (1969): 107–126.

Mancini, Girolamo. *Vita di Leon Battista Alberti*. Florence: G. C. Sansoni, 1882.

Martin, Meredith, and Gillian Weiss. *The Sun King at Sea: Maritime Art and Galley Slavery in Louis XIV's France*. Los Angeles: Getty Research Institute, 2022.

Mattsson, Helena, and Sven Olov Wallenstain, eds. *Swedish Modernism: Architecture, Consumption and the Welfare State*. London: Black Dog Publishing, 2010.

Mawe, John. *Travels in the Interior of Brazil*. London: Longman, Hurst, Rees, Orme, and Brown, 1812.

Mazzucco, Katia. "Images on the Move: Some Notes on the Bibliothek Warburg Bildersammlung (Hamburg) and the Warburg Institute Photographic Collection (London)." *Art Libraries Journal* 38, no. 4 (2013): 16–24.

McEwen, Indra Kagis. *Vitruvius: Writing the Body of Architecture*. Cambridge, MA: MIT Press, 2003.

McGee, David. "From Craftsmanship to Draftsmanship: Naval Architecture and the Three Traditions of Early Modern Design." *Technology and Culture* 40, no. 2 (1999): 209–214.

McMannon, John M. *Caligula's Barges and the Renaissance Origins of Nautical Archeology Under Water*. College Station: Texas A&M University Press, 2016.

Melanderhjelm, Daniel. *Tal, om de mathematiska vetenskapernas nytta i krigskonsten och alla dess särskilda grenar, hållet i kongl. vetensk. academien vid præsidii nedläggande, den 7:e augusti, 1782*. Stockholm: Johan Georg Lange, 1782.

Meyer, Anne Marie, and Salvatore Settis. "Warburg continuatus. Descrizione di una biblioteca." *Quaderni storici*, n.s. 20, no. 58 (April 1985): 5–38.

Michaud, Philippe-Alain. *Aby Warburg and the Image in Motion*. New York: Zone Books, 2004.

Middleton, Robin. "Introduction." In Julien-David Le Roy, *The Ruins of the Most Beautiful Monuments of Greece*, translated by David Britt, 1–199. Los Angeles: Getty Research Institute, 2004.

Neumann, Dietrich. "Three Early Designs by Mies van der Rohe." *Perspecta* 27 (1992): 76–97.

Neumeyer, Fredrik. *Fredrik Henrik av Chapman som konstnar och konstfrämjare*. Uppsala: Alqvist & Wiksells, 1944.

Nicholson, Malcom. "Alexander von Humboldt and the Geography of Vegetation." In *Romanticism and the Sciences*, edited by Andrew Cunningham and Nicholas Jardine, 169–188. Cambridge: Cambridge University Press, 1990.

Nicholson, Nigel. "Introduction." In *Harold Nicholson: The Diaries 1907–1964*, edited by Nigel Nicholson, xi–xiv. London: Orion Books, 2004.

Niedermeier, Michael. "Goethe und der steinige Weg wissenschaftlicher Erkenntnis." *Gegenworte*, vol. 9: *Wissenschaft und Kunst* (2002): 83–86.

Nilsson, Sten Åke. "Ehrensvärd arkitekten." In *Carl August Ehrensvärd. Tecknaren och Arkitekten*, edited by Ulf Cederlöf, 233–275. Stockholm: National Museum, 1997.

Nilsson, Sten Åke. "Om Carl August Ehrensvärds resa til Italien." In *Frusna ögonblick. Essäer tillägnade Anne-Marie Leander Touati*, edited by Henric Gerding, Lovisa Brännstedt, and Renée Forsell, 27–40. Lund: Lund University Press, 2018.

Nivelon, Claude. *Vie de Charles Le Brun et description détaillée de ses ouvrages, 1699–1704* [mss, BNF, man. fr. 12987]. Paris: Droz, 2004.

Norden, Frederick Ludvig. *Travels in Egypt and Nubia*. London: Lockyer Davis and Charles Reymers; Printers to the Royal Society, 1757.

Nordin Lidberg, Marie, et al. *Arkitekturguide Stockholm: Guide to Stockholm Architecture*. Stockholm: Bygg Förlaget, 1997.

Nowacki, Horst, and Larrie D. Ferreiro. "Historical Roots for the Theory of Hydrostatic Stability in Ships." In *Contemporary Ideas of Ships Stability and Capsizing in Waves*, edited by Santos Neves, Marcello Almieda, et al., 1–30. Dordrecht: Springer, 2011.

Nowacki, Horst, and Wolfgang Lefèvre, eds. *Creating Shapes in Civil and Naval Architecture: A Cross-Disciplinary Comparison*. Leiden: Brill, 2009.

Nowacki, Horst, and Matteo Valleriani, eds. *Shipbuilding Practice and Ship Design Methods from the Renaissance to the 18th Century*. Berlin: Max Planck Institute for the History of Science (Preprint 245), 2003.

Olsson, Bertil S., and Karl-Magnus Johansson, eds. *Sverige och svenskarna i den ostindiska handeln II. Strategier, sammanhang och situationer*. Gothenburg: Riksarkivet, Landsarkivet i Göteborg, 2019.

Onians, John. *Bearers of Meaning. The Classical Orders in Antiquity, the Middle Ages and the Renaissance*. Princeton, NJ: Princeton University Press, 1988.

Paalman, Floris. "The Theoretical Appearance of the City Symphony." In "City Symphonies—Film Manifestos of Urban Experience," special issue, *Eselsohren. Journal of History of Art, Architecture and Urbanism* 2, no. 1–2 (2014): 15–27.

Palladio, Andrea. *The Four Books of Architecture*. Translated by Robert Tavernor and Richard Scofield. Cambridge, MA: MIT Press, 2002.

Palladio, Andrea. *I quattro libri di architettura*. Venice: Domenico de' Franceschi, 1570.

Payne, Alina A. *The Architectural Treatise in the Italian Renaissance: Architectural Invention, Ornament and Literary Culture*. Cambridge: Cambridge University Press, 1999.

Percier, Charles, and Pierre Fontaine. *Recueil de décorations intérieures comprenant tout ce qui a rapport à l'ameublement . . .* Paris: E. Hessling, 1801, 2nd ed. Paris: P. Didot l'Aîné, 1812.

Peters, Andrew. *Ship Decoration 1630–1780.* Barnsley: Seaforth Publishing, 2013.

Pieper, Jan. *Das barocke Schiffsheck als Architekturprospekt. Architectura navalis im zeitalter des höfischen absolutismus.* Aachen: Geymüller verlag für Architektur, 2019.

Pococke, Richard. *Observations on Egypt: A Description of the East and Some Other Countries,* vol. 1. London: W. Bowyer, 1743.

Ponti, Lisa Licitra. *Gio Ponti: l'opera.* Milan: Leonardo, 1990.

Porter, Andrew. *The Oxford History of the British Empire.* Vol. 3: *The Nineteenth Century.* Oxford: Oxford University Press, 1999.

Powell, Kenneth. *Powell & Moya.* London: RIBA Publications, 2009.

Powers, Alan. *In the Line of Development: F. R. S. Yorke, E. Rosenberg and C. S. Mardall to YRM 1930–1992.* Chichester: Wiley Academy, 2003.

Prewitt Brown, Julia. *The Bourgeois Interior.* Charlottesville: University of Virginia Press, 2008.

Priesterjahn, Maike, and Claudia Schuster, eds. *Floating Baroque: The Ship as Monumental Architecture.* Berlin: BeBra Verlag, 2018.

Prochaska, David. "Art of Colonialism, Colonialism of Art: The Description de l'Égypte (1809–1828)." *L'Esprit créateur* 34, no. 2 (Summer 1994): 69–91.

Ramage, Nancy H. "Sir William Hamilton as Collector, Exporter, and Dealer: The Acquisition and Dispersal of His Collections." *American Journal of Archaeology* 94, no. 3 (July 1990): 469–480.

Redding, Benjamin W. D. "A Ship 'for Which Great Neptune Raves': The Sovereign of the Seas, la Couronne and Seventeenth-Century International Competition over Warship Design." *Mariner's Mirror* 104, no. 4 (November 2018): 402–422.

Rhetorica ad Herennium. Translated by H. Caplan. Loeb Classical Library. London: William Heinemann; Cambridge, MA: Harvard University Press, 1956.

Rice, Charles. *The Emergence of the Interior: Architecture, Modernity, Domesticity.* New York: Routledge, 2007.

Rollof, Yngve. "Fredric Henric av Chapman." *Sjöväsandet,* no. 7 (1958): 457–478.

Rosner, Victoria. *Modernism and the Architecture of Private Life.* New York: Columbia University Press, 2005.

Rowe, Colin. *The Letters of Colin Rowe: Five Decades of Correspondence.* Edited by Daniel Naegele. London: Artifice Books on Architecture, 2016.

Rowe, Colin. "The Mathematics of the Ideal Villa." *Architectural Review* 101 (March 1947): 101–104.

Rudberg Eva, with Bosse Bergman, Claes Caldenby, and Anders Gullberg, eds. *Tage William-Olsson: Stridbar Planerare och visionär arkitekt*. Stockholm: Stockholmia Förlag, 2004.

Saalman, Howard. *Filippo Brunelleschi: The Cupola of Santa Maria del Fiore*. London: Zwemmer, 1980.

Saint, Andrew. "What Became of Waring? Fortunes of an Entrepreneur in Furnishing, Shopkeeping and Construction." *Construction History* 29, no. 1 (2014): 75–97.

Saxl, Fritz. "The History of Warburg's Library (1886–1944)." Appendix to Ernst H. Gombrich, *Aby Warburg: An Intellectual Biography*, 325–238. London: Warburg Institute, 1970.

Scorza, Rick. "Vasari's Lepanto frescoes: 'Apparati,' Medals, Prints and the Celebration of Victory." *Journal of the Warburg and Courtauld Institutes* 75 (2012): 141–200.

Sears, Elizabeth. "Keepers of the Flame: Bing, Solmitz, Klibansky and the Continuity of the Warburgian Tradition." In *Raymond Klibansky and the Warburg Library Network: Intellectual Peregrinations from Hamburg to London and Montreal*, ed. Philippe Despoix and Jillian Tomm, 29–57. Montréal: McGill/Queens University Press, 2018.

Sears, Elizabeth. "The Warburg Institute, 1933–1944. A Precarious Experiment in International Collaboration." *Art Libraries Journal* 38, no. 4 (2013): 7–15.

Serlio, Sebastiano. *Architettura. Libri 1–5*. Venice: various publishers, 1547–1551.

Serlio, Sebastiano. *On Architecture*. Translated by Vaughan Hart and Peter Hicks. 2 vols. New Haven, CT: Yale University Press, 1996, 2001.

Sheraton, Thomas. *The Cabinet Dictionary, containing an explanation of all the terms used in the cabinet, chair & upholstery branches, with directions for varnish-making, polishing, and gilding . . .* London: W. Row, J. Mathews, Vernor and Hood, M. Jones & Thomas Sheraton, 1803.

Sheraton, Thomas. *The Cabinet-Maker and Upholsterers' Drawing Book in Four Parts*. London: T. Bensley, 1794.

Sibthorp, John, and Edward William Smith. *Flora Graeca Sibthorpiana*. London: Richard Taylor, 1806–1816.

Sicca, Cinzia Maria. "On William Kent's Roman Sources." *Architectural History* 29 (1986): 134–157.

Siegert, Bernhard. "Waterlines: Striated and Smooth Spaces as Techniques of Ship Design." In *Cultural Techniques: Grids, Filters, Doors, and Other Articulations of the Real*, 147–163. Translated by Geoffrey Winthrop Young. New York: Fordham University Press, 2015.

Simpson, Richard. "Classicism and Modernity. The University of London's Senate House." *Bulletin of the Institute of Classical Studies* 43 (1999): 53–61.

Smith, Adam. *The Theory of Moral Sentiments* [1759]. Cambridge: Cambridge University Press, 2002.

Smith, Christine. *Architecture in the Culture of Early Humanism*. Oxford: Oxford University Press, 1992.

Smith, Denis. "Sir Joseph William Bazalgette (1819–1891), Engineer to the Metropolitan Board of Works." *Transactions of the Newcomen Society* 58, no. 1 (1986–1987): 89–111.

Snickars, Pelle. *Svensk film och visuell masskultur 1900*. PhD diss. Stockholm: University of Stockholm/Aura Förlag, 2001.

Sprigg, Christopher. *The Airship: Its Design, History, Operation and Future*. London: Samson Low, Marston and Company, 1931.

Stara, Alexandra. *The Museum of French Monuments, 1795–1816: "Killing Art to Make Art History."* Farnham, UK: Ashgate, 2013.

Stockhausen, Tilmann von. *Die Kulturwissenschaftliche Bibliothek Warburg: Architektur, Einrichtung und Organisation*. Hamburg: Dölling & Galitz, 1992.

Stumpel, Jeroen. "The Vatican Tazza and Other Petrifications: An Iconological Essay on Replacement and Ritual." *Simiolus: Netherlands Quarterly for the History of Art* 24, no. 2–3 (1996): 111.

Symonds, Craig L., ed. *New Aspects of Naval History: Selected Papers Presented at the Fourth Naval History Symposium, United States Naval Academy 25–26 October 1979*. Annapolis, MD: United States Naval Institute, 1981.

Tack, Laura. *The Fortune of Gertrud Bing: A Fragmented Memoir of a Phantom-Like Muse*. Leuven: Peeters, 2020.

Tavares, André. *The Anatomy of the Architectural Book*. Zurich: Lars Müller and Canadian Centre for Architecture, 2016.

Tavernier, Jean-Baptiste. *Nouvelle relation de l'intérieur du serrail du Grand Seigneur*. Paris: Olivier de Varennes, 1675.

Tessin, Nicodemus [the younger]. *Nicodemus Tessin the Younger: Sources, Works, Collections. Traictè dela decoration interieure 1717*. Edited by Patricia Waddy with contributions by Bo Vahlne. Stockholm: National Museum/Sveriges Arkitektur Museum, 2002.

Théron, Magali. "La bonne fabrique et le superbe ornement: Pierre Puget's Ship Decoration." *Sculpture Journal* 24, no. 2 (2015): 141–160.

Théron, Magali, "La décoration navale en France entre 1660 et 1830." In *Les génies de la mer: Chefs-d'oeuvre de la sculpture navale du Musée national de la Marine a Paris*, edited by Marjolaine Mourot and Mario Bélan, exh. cat., 43–65. Paris: Musée national de la Marine, 2001.

Theve, Andreas, and Mats Wickman. "Nöjesstaden Gröna Lund." In Sörenson, Ulf, ed. *Stockholm turiststaden*, 108–119. Stockholm: Samfundet St. Erik, 2008.

Thurber, James. "The Secret Life of Walter Mitty." In *My World and Welcome to It*, 72–81. New York: Harcourt Brace, 1942. (First published in the *New Yorker*, March 18, 1939.)

Tigerman, Bobbye. "Reyner Banham Loves Los Angeles (One Pair of Eyes), BBC (1972)." *Design and Culture: The Journal of the Design Studies Forum* 1, no. 2 (2009): 234–236.

van Eck, Caroline. *Classical Rhetoric and the Visual Arts in Early Modern Europe.* Cambridge: Cambridge University Press, 2007.

van Eck, Caroline. "The Structure of 'De re aedificatoria' Reconsidered." *Journal of the Society of Architectural Historians* 57, no. 3 (1998): 280–297.

van Eck, Caroline, and Miguel John Versluys. "The Hôtel de Beauharnais in Paris: Egypt, Rome, and the Dynamics of Cultural Transformation." In *Housing the New Romans,* edited by Katherine von Stackelberg and Elizabeth Macaulay-Lewis, 54–91. Oxford: Oxford University Press, 2016.

Velleman, Daniel J. "The Generalized Simpson's Rule." *American Mathematical Monthly* 112, no. 4 (April 2005): 342–350.

Verfasser Coquery, Emmanuel. "Les attributs de la Marine, d'après Jean Berain et Jean Lemoine: une tenture d'exception entre dans les collections du Louvre." *Revue du Louvre* 53 (2003).

Verwiebe, Birgit. *Magische Spiegelungen: Johann Erdmann Hummel.* Exh. cat. Berlin: Sandstein Verlag, 2021.

Vignola, Jacopo Barozzi da. *Regola delli cinque ordini d'architettura.* Rome: 1562.

Vitruvius Pollio, Marcus. *De architectura.* British Library Harley MS 2767.

Vitruvius Pollio, Marcus. *I dieci libri dell' architettura di M. Vitruvio tradutti et commentati da Monsignor Barbara Eletto Patriarca d'Aquileggia.* Edited by Daniele Barbaro with illustrations by Andrea Palladio. Venice: Francesco Marcolini, 1556.

Vitruvius Pollio, Marcus. *M. Vitrvvii Pollionis De architectura libri decem.* Edited by Daniele Barbaro. Venice: Francesco de' Franceschi & Giovanni Chrieger, 1567.

Vitruvius Pollio, Marcus. *The Ten Books on Architecture.* Translated by Morris Hicky Morgan. Cambridge, MA: Harvard University Press, 1914, reprinted New York: Dover, 1960.

Vitruvius Pollio, Marcus. *Ten Books on Architecture.* Translated by Ingrid D. Rowland, commentary and illustrations by Thomas Noble Howe. Cambridge: Cambridge University Press, 1999.

Warburg, Aby. *Bilderatlas Mnemosyne: The Original.* Edited by Roberto Ohrt, Axel Heil, Bernard Scherer, Bill Sherman, and Claudia Wedepohl. Berlin: HKW, Haus der Kulturen der Welt; London: Warburg Institute; Berlin: Hatje Cantz Verlag, 2020.

Warburg, Aby. "From the Arsenal to the Laboratory." Translated by Christopher D. Johnson, annotated by Claudia Wedepohl. *West 86th* 19, no. 1 (2012): 106–124.

Warburg, Aby. *The Renewal of Pagan Antiquity*. Translated by David Britt. Los Angeles: Getty Research Institute for the History of Art and the Humanities, 1999.

Watkin, David, and Philip Hewat-Jaboor, eds. *Thomas Hope: Regency Designer*. Exh. cat. New York: Bard Graduate Center; New Haven, CT: Yale University Press, 2008.

Wedepohl, Claudia. "Mnemonics, Mneme and Mnemosyne: Aby Warburg's Theory of Memory." *Bruniana and Campelliana* 20, no. 2 (2014): 385–402.

Wedepohl, Claudia. "Why Botticelli? Aby Warburg's Search for a New Approach to Quattrocento Italian Art." In *Botticelli Past and Present*, ed. Ana Debenedetti and Caroline Elam, 183–202. London: UCL Press, 2019.

Westfall, Carroll William. *In This Most Perfect Paradise: Alberti, Nicholas V and the Invention of Conscious Urban Planning in Rome, 1447–55*. University Park: Penn State University Press, 1974.

Williams, Kim, Stephen R. Wassell, and Lionel March, eds. *The Mathematical Works of Leon Battista Alberti*. Basel: Birkhäuser, 2010.

Williamson, C. N. "*The Illustrated London News* and Its Rivals—*Lloyd's Illustrated London Newspaper, The Pictorial Times*, and *The Illustrated Times*. Illustrated Journalism in England: Its Development. II." *Magazine of Art* 13 (November 1889–October 1890): 334–340.

Wind, Edgar. "The Warburg Institute Classification Scheme." *Library Association Record*, 4th series, 2 (May 1935): 193–195.

Wittkower, Rudolf. *Architectural Principles in the Age of Humanism*. London: Warburg Institute, 1949. Reprint, London: Wiley, 1988.

Wood, Robert. *The Ruins of Palmyra: Otherwise Tedmor, in the Desart*. London: Robert Wood, 1753.

Woolf, Virginia. *To the Lighthouse*. Annotated by Stella McNichol with an introduction by Hermione Lee. London: Penguin Books, 1992 [London: Hogarth Press, 1927].

Yates, Frances A. *The Art of Memory*. London: Routledge & Kegan Paul, 1966.

Yates, Frances A. *Giordano Bruno and the Hermetic Tradition*. London: Routledge & Kegan Paul, 1964.

Yates, Frances A. *Theatre of the World*. Chicago: University of Chicago Press, 1969.

Yorke Mardell Rosenberg. *The Architecture of Yorke Rosenberg Mardall, 1944/1972*. With an introduction by Reyner Banham. London: Lund Humphries, 1973.

Young, William. "Introduction." In *The Journal of Frederick Horneman's Travels . . . in Africa, in the Years 1797–8*, i–xv. London: G. & W. Nicol, 1802.

Index

The MIT Press would like to thank the anonymous peer reviewers who provided comments on drafts of this book. The generous work of academic experts is essential for establishing the authority and quality of our publications. We acknowledge with gratitude the contributions of these otherwise uncredited readers.

This book was set in Haultin by Jen Jackowitz. Printed and bound in Canada.

Library of Congress Cataloging-in-Publication Data

Names: Anstey, Tim, author.
Title: Things that move : a hinterland in architectural history / Tim Anstey.
Description: Cambridge, Massachusetts : The MIT Press, [2024] | Includes bibliographical references and index.
Identifiers: LCCN 2023018102 | ISBN 9780262547505 (paperback)
Subjects: LCSH: Architecture—History. | Movement (Philosophy)
Classification: LCC NA203 .A57 2024 | DDC 720.9—dc23/eng/20230901
LC record available at https://lccn.loc.gov/2023018102

10 9 8 7 6 5 4 3 2 1

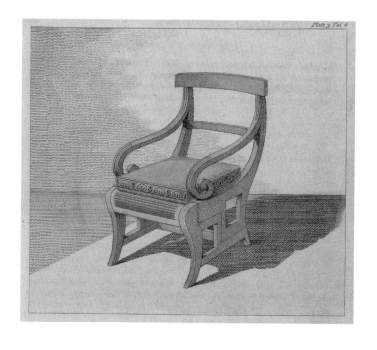

Plate 3 Vol. 6